Byzantium

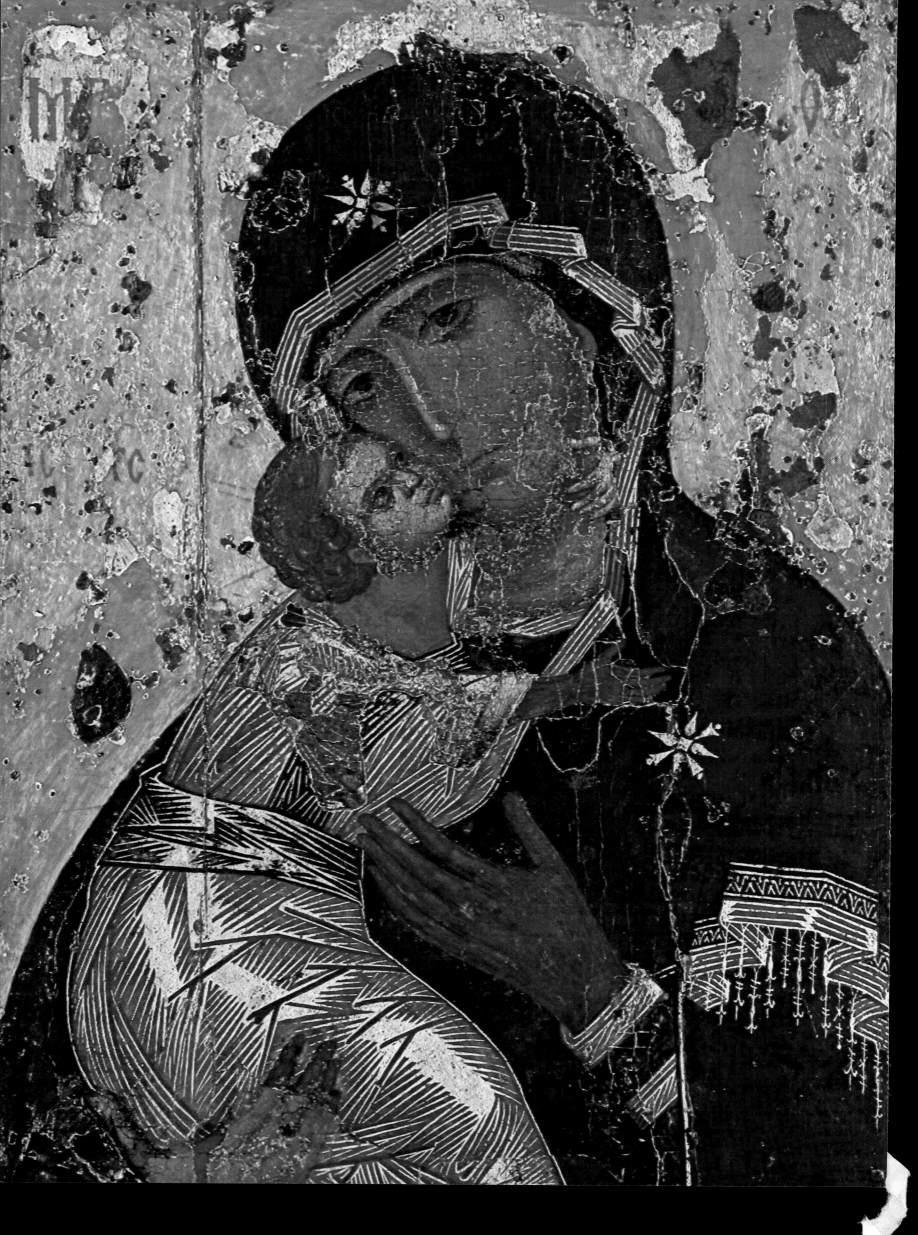

Byzantium

Text by
Munemoto Yanagi
Eiichi Takahashi
Shigebumi Tsuji and
Yasushi Nagatsuka

translated from
the German by
Nicholas Fry

Cassell

London

Virgin of Vladminir, 12th Century, Tretyakov Gallery, Moscow

CASSELL LTD.
35 Red Lion Square, London WC1R 4SG
and at Sydney, Auckland, Toronto, Johannesburg,
an affiliate of
Macmillan Publishing Co., Inc.,
New York.

First published in Great Britain 1978

ISBN 0 304 30193 0

Filmset by Keyspools Ltd., Golborne, Lancashire
Printed in Italy by Arnoldo Mondadori Editore, Verona

Contents

Introduction 7

Ravenna
The Town and its History 18
The Golden Age under Justinian 20
The History and Technique of Mosaic 31
The Development of Byzantine Art 40
The Iconoclast Period 47
Byzantium after the End of the Iconoclast Period
Architecture – Mosaic art – Wall paintings –
Illuminated manuscript

Constantinople
The Hagia Sophia 60
The Geographical Situation and Layout of the City 68
Architecture 82

The Holy Mountain
Monasticism in the Eastern Church I 86
Intellectual background and beginnings –
The institution of monasticism – The History and
culture of the monasteries in the eastern
Mediterranean: Egypt, The Sinai Peninsula,
Palestine and Syria

Monasticism in the Eastern Church II 100
Constantinople – Cappadocia – Greece

Venice and Sicily
Venice and St Mark's 124
Sicily 128

Byzantine Culture and the West 136

The Balkans and Russia
The Post-Iconoclast Period 150
The art of the Comnene and Angelid dynasties –
The art of the Paleologue dynasty

The Balkans 154
The Old Cities of Russia 162
Icons 180

Appendix
Chronology of the Byzantine World 186

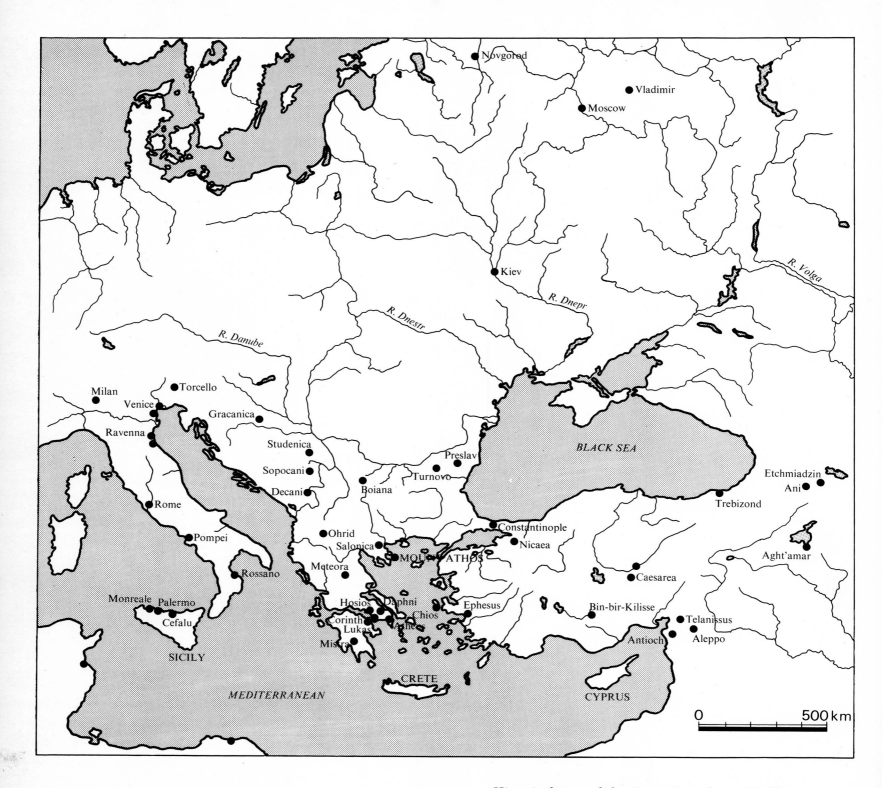

Historical map of the Byzantine sphere of influence

Introduction

History, we are told, is always being rewritten, and this is certainly true of cultural history in general and art history in particular. Quite apart from the problems involved in establishing the authenticity of historical facts, there are always widely differing opinions as to the artistic merits of any particular work. If for example one judges Byzantine art by Classical criteria, it will appear inferior to the works of ancient Greece and Rome and the art of the high Renaissance. In fact these criteria have continued to be used in modern times in judging not only Byzantine art but also the cultural heritage of other epochs and societies. But are there no other criteria than these? Surely there must be a different standard to that used in judging Classical art, which can be applied when we are contemplating Byzantine architecture and icons – those devotional portraits of saints painted on wooden panels which are so characteristic of Byzantine art. For these, surely, there must be some other conceptual principal which we can apply.

Over a century ago, a French archaeologist, Adolphe Didron (1806–1867), discovered the oldest surviving manuscript of the famous painting book used by the Byzantine monks on Mount Athos and made a translation of it. In talking of these monastic artists he said: 'They had little or nothing to do with Greek art' (by which he meant medieval Greek, i.e. Byzantine art). And he continued: 'In the 18th century, the Morea [the inhabitants of the Peloponnese] were still imitating the Venetian painters of the 10th century and the 15th and 16th century painters of Mount Athos. The clothing of the figures was still the same; their form and modelling and colour, as well as the number and depth of the folds – everything had remained the same . . . The Greek artists followed their tradition as blindly as an animal follows its instinct. They painted figures in the same way as a swallow builds its nest and bees make a hive.' Half a century later a Byzantine scholar, Louis Bréhier (1880–1951), rejected this opinion with the words: 'All the research carried out in the past half century proves that this superficial judgment is groundless. Byzantine art developed over a long period, changing deeply and undergoing several periods of regeneration. There is a tendency towards bold confrontations, towards extreme contrasts, and also there are independent schools comparable with the local schools of Romanesque architecture and the schools of painting of the Italian Renaissance.'

Today, half a century since Louis Bréhier wrote these lines, further progress is being made in the historical analysis of Byzantine art and at the same time it is being artistically reassessed, with the result that public interest in the subject has grown appreciably. Nevertheless, this Greek art of the medieval period seems to be much harder of access to many people than ancient Greek art, even though it is closer to us in time.

The name Byzantium is derived from Byzantion, the name of the former trading colony of ancient Greece which is said to have been founded in 657 B.C. by a Greek named Byzas. In the year 330 A.D., the emperor Constantine moved the capital of the Roman Empire to this city, and the name Byzantion was changed to Constantinople. Historically speaking, therefore, the use of the word Byzantine to describe the civilization and culture which subsequently grew up there is not entirely correct. In fact it was European historians of the 16th century who first used the term, and the people of the area of Byzantine cultural influence never describe themselves as Byzantines – they called themselves Romans and considered themselves the descendants of the original Romans. Their official language was Latin.

In the 6th century, however, there was a renaissance of Greek, and by the end of the same century Latin was hardly being used. What the Europeans of the Middle Ages or the Renaissance referred to as Greek culture and art is the same as what we today would describe as Byzantine culture and art.

Byzantine society did not consist of a single people, and there were no actual

'Byzantines'. There was, rather, a heterogeneous group of peoples who shared a common language and a more or less similar culture. At the time of the emperor Justinian, when Byzantine culture was in full flower, its sphere of influence reached in the north-east to the Crimea and the Balkans south of the Danube, and in the west across Italy to the south-eastern part of the Iberian peninsula, including the whole of the North African coast; in the east, its frontier was formed by the upper part of Mesopotamia. Gradually, however, the Byzantine peoples were pushed back into the small area around Constantinople – first by the pressure of the Muslims (after the 7th century), then by the threatening presence of the Slavs and Bulgarians (7th to 9th centuries) and again by pressure from the Crusaders' armies (from the end of the 11th century to the 13th century). These were largely political and military pressures, but either directly or indirectly they had a decisive cultural impact on the peoples of the outlying areas, or at least on those of them who were Christian and not Muslim. In this way, Christian cultures arose among the Copts in Egypt, the Ethiopians, Syrians, Armenians, Georgians, Bulgarians, Serbs, Russians and others. With the exception of the three last named Slavonic peoples, who were not converted to Christianity until later, these peoples seceded from the Byzantine church as a result of differences of theological opinion. They formed their own ecclesiastical organizations, and as a result produced their own distinctive form of Christian culture. The effects of Byzantine cultural and artistic influence on these Christian cultures were various. It did not simply result in derivative, locally coloured versions of the Byzantine original, as many people suppose; rather did the different regions produce their own indigenous cultures. We can therefore describe them collectively as eastern Christian cultures, and their art as eastern Christian art. But by far the most influential in this highly diverse cultural area was the Byzantine culture centred on Constantinople.

Constantinople, the former capital of the Eastern Roman Empire, was conquered by the Muslims in 1453, and established as the capital of the Ottoman Empire under the name of Istanbul. A number of mosques were built in rapid succession. The former Hagia Sophia was partially restored and converted into an Islamic mosque. Other churches and monasteries underwent the same fate. Today the Hagia Sophia (or Aya Sofia), the Chora Monastery (now the Kahriye Camii) and a number of other buildings have been opened to the public as museums. A group of American experts led by T. Whittemore and P. A. Underwood is engaged in removing the frescoes from the Islamic period in order to reveal and restore the Byzantine mosaics underneath.

But these mosaics are only the lifeless relics of a past age. In Greece, by contrast, the Byzantine atmosphere is still alive. The Byzantine tradition was maintained until modern times in the Slavonic countries too, by the influence of the Greek Orthodox Church, but since the coming of the Communist states it seems to be gradually disappearing.

When we hear mention of Greece, we naturally think of Athens. Ninety per cent of all those who visit Greece first go to Athens. And most of them are content to climb the Acropolis and visit one or two museums of ancient art. Scarcely anyone visits the Byzantine churches in the city, and one finds few visitors in the museums of Byzantine art.

There are a number of reasons for this. First of all, ancient Greek art is still popular today, and its supreme monument, the Parthenon, dominates the city from the Acropolis. There are on the other hand no outstanding Byzantine churches in present-day Athens. If one wants to see such a church one must go out to one of the suburbs, to the monastery at Daphni, or visit the monastery church of Hosios Lukas far to the west. Also, the Byzantine churches are still used, and their interiors are dark and secretive. Candles burn in front of the icons, and monks and ordinary believers alike regard tourists as unwelcome intruders in their places of worship. In places such as these, the icons are not regarded merely as works of art.

Ancient Greek art too was originally created with religious intentions, but it

was less exclusive in character, and easily understood by all. As a result it spread over a wide area and was repeatedly imitated – in Italy in the 14th, 15th and 16th centuries, and in the rest of Europe until the 17th and 18th centuries. Even today, students in art schools throughout the world study copies of the ancient Greek sculptures. A similar development of Byzantine art would be unthinkable, because it is a highly individual form of art occurring within a society with very specific characteristics. Byzantine art deliberately rejected the balanced proportions to which the ancient Greeks attached such importance, pursuing its own highly idiosyncratic vision into the realms of the unnatural. Byzantine painting has an individualism and brilliance which approaches the extraordinary mystical effect often found in the painting of esoteric Buddhism. Both have the same hermetic character, both give the impression of a dark and unfathomable profundity.

Byzantine art, and Byzantine culture in general, are essentially religious in character. Moreover the religion from which this character derives is no simple nature cult or naive ancient myth; it is a highly distinctive religion founded on a sophisticated dogma and theology. Questions such as the relative status of God the Father and God the Son, and the relationship between the divine and the human in Christ were central to its teaching, and continually gave rise to heated arguments. In order to establish official dogma on such matters, a succession of church councils were held: the Council of Nicaea (325) was directed against the Arians, who denied the divinity of the Son of God; the Council of Constantinople (381) against the Macedonian school, which denied the divinity of the Holy Ghost; the Council of Ephesus (431) against the Nestorians, who affirmed the existence of two separate natures in Christ – the divine and the human; the Council of Chalcedon (451) against the Eutychians who were adherents of monophysitism; the second Council of Constantinople (680) against monothelitism; the second Council of Nicaea (787) against iconoclasm; and there were still others. The result was a gradual elimination of heretical doctrines. These conflicts did not remain within the religious sphere, however, and developed into social and political struggles, resulting in persecution and rebellion, and leading throughout the Byzantine provinces to an alienation from the imperial Byzantine church and the government. The conflict over the veneration of icons was particularly tragic. The struggle between the adherents of icon worship and the Iconoclasts in the 8th and early 9th centuries produced a period of great upheaval and confusion which marked a turning point in the history of the Byzantine empire and resulted in the final break between the eastern and western churches. A special chapter will be devoted to the problem of this Iconoclastic struggle.

The history of the Byzantine Empire spans eleven centuries. It is a period which has been unjustly maligned; Voltaire called it a 'dark and rapacious age', while for Hegel it was a 'thousand year story of crime, degeneracy and disgrace'. Yet the fact that Byzantium survived so long is a tribute to its vigour, and its history compared favourably with that of ancient Greece, Rome, or Europe. Moreover, through this period it preserved a high degree of cultural consistency in the face of many vicissitudes.

Byzantine culture found its expression not only in religion, but also in all the different fields of worldly endeavour. One example of this is the public education system, which was apparently open to all levels of society. Educational methods roughly followed those of ancient Rome, but they were firmly founded on Christian principles, and most educational institutions – particularly those at elementary level – were closely linked to the churches and monasteries. It would seem that school education was generally given only to boys, while girls were educated in the family or in convents. In elementary school, the seven- to eight-year-old children were given instruction in reading and writing, with the Bible and other religious writings being used as texts; they also learned grammar, syntax, arithmetic, music – especially choral singing – and sport. Secondary schools prepared their pupils for high school education. Here children had to study grammar, rhetoric and philosophy.

The grammar which was learned as a subject from the age of ten or twelve comprised not only grammar in the narrow sense but also poetics, syntax, social history, myths and stenography. Rhetoric, which was taught to pupils of about fifteen upwards, was particularly favoured by those who wished to obtain a post in the church or state administration. At the age of seventeen to eighteen, pupils studied philosophy, which included among other things dialectics, logic, ethics, dogmatics and metaphysics. The development of the ancient philosophers was studied, from Plato through Aristotle and Stoicism to the Neoplatonic school. Philosophy in the wider sense also included mathematics, astronomy, music, physics, geography, zoology, botany and medicine. Anyone who wished to study further went to a high school – which corresponds to the university of today – in about their twentieth year.

The University of Constantinople was founded by Constantine the Great and reorganized in 425 by Theodosius II and his wife Eudoxia, who was renowned for her talent and beauty. It was essentially a faculty of philosophy. The teaching body consisted of ten Greek and ten Latin grammarians, five Greek and three Latin rhetoricians, a philosopher and three lawyers. From this it can be seen that even in the 5th century Greek was already preferred to Latin, which had never succeeded in establishing firm roots in the eastern Christian world. Apart from the capital, Constantinople, which was particularly important for law, the centres of learning were: Athens for ancient philosophy, Alexandria with several faculties, but renowned particularly for medicine and for its library, Caesarea (now Kayseri) for Christian theology and another well-known library, Antioch (Antakya) for rhetoric and other subjects, Gaza also for rhetoric, Ephesus (now Selçuk) for theology, Edessa (Urfa) for Christian theology, Berytos (Beirut) for law, and Salonica (Thessaloniki) for medicine, mathematics and rhetoric.

As we can see, the centres of learning were widely distributed, from the coastal provinces of the eastern Mediterranean to the hinterland of Asia Minor.

Apart from the large towns, which were important centres of education and culture, the monasteries also were active in this field. (The role of the monasteries is dealt with at length in the third part of the book.) Each monastery usually had its own library in which many important old manuscripts were preserved, and functioned as a centre of knowledge and education. Here numerous old documents were copied, and there were also studios for architecture and other technical subjects. Most of these monasteries were destroyed in Islamic times, and have vanished without a trace. However, a group of monasteries on Mount Athos in Greece adopted the traditions of the Byzantine era almost in their original form, and have preserved them up to the present day. Each of these monasteries possesses a library in which many old manuscripts are carefully preserved, and various traditional artistic techniques are still practised there, even though their efflorescence is long since past. The Byzantine monastery, particularly the coenobium or 'monastery of communal living' which took in large numbers of people, originally formed a small, enclosed and self-sufficient community. The monastery buildings, which were surrounded by walls in the manner of a fortified town, generally included a chapel, a library, a dormitory, a refectory, a common room and various workshops. Manual work was as essential a part of the monastic training as prayer and spiritual endeavour, and artistic activities flourished.

The Byzantine monastic tradition founded by St Basil was not split into different orders as was that of the West. This meant that each monastery was relatively isolated, although there was a certain degree of interchange between the different establishments, and each had its own artistic style. If one compares the mosaics in the three monasteries of Daphni, Hosios Lukas and Chios, all dating from the 11th century, one finds considerable differences in a number of features such as the composition, rendering of space and use of colour. At the same time it is known that Manuel Panselinos of Salonica and Theophanes of Crete were both active in quite a number of different monasteries at the end of the Byzantine era, including those on Mount Athos

and the Meteora monasteries of Thessaly. Byzantine artists also spread the 'Greek style' to the borders of the Byzantine Empire in the Balkans, Russia and Italy, when they went there to carry out commissions or fled there through fear of war and oppression. And they undoubtedly took with them both religious writings and books on specific artistic techniques.

The *Painter's Guide* of Dionysios, a handbook of painting techniques and iconography which was preserved in the monasteries on Mount Athos, is widely known today. This volume is probably a copy of the painting book compiled on the instructions of Manuel Panselinos in the 14th century and later copied by a monk named Dionysios of Fourna. The *Painter's Guide* gives instruction in the techniques of mural painting, their iconographic composition and arrangement, the methods of using colour and so on. Similar handbooks are probably carefully preserved in each monastery on Mount Athos. The techniques they describe would have been faithfully followed in the works of restoration and new murals carried out on Mount Athos in the modern period. Each of the Byzantine painters would likewise have used a contemporary handbook of technique and iconography. The most important medieval artistic handbook is the *Schedula diversarum artium*, compiled by Theophilus, who is thought to have lived in the 11th to 12th centuries. It is known throughout the Middle East, and shows strong Byzantine tendencies.

The monasteries spread throughout the territories of the Byzantine empire, and we will return to the subject of their history and management in another chapter. Monasticism was the ideal form of life in the eyes of the members of Byzantine society; the Emperor Theodore II Lascaris described it as 'something most happy without earthly cares'. In art too, it was the accepted ideal to withdraw from the world and strive after God. This idea is reflected in all artistic fields, from architecture to painting and the decorative arts.

Let us begin with architecture. Almost all the elements of Byzantine architecture are concentrated in the internal space of the building. This space does not belong to the material world, but is rather the embodiment of a transubstantial space. The large central dome which is characteristic of most Byzantine buildings represents the holy firmament as if with the intention of supporting it. The figures decorating the walls are naturally arranged in a symbolic order, and thus it is Christ, the almighty God, who appears in the centre of the firmament. His image symbolises the sun as ruler of the heavens. He is normally shown as a half-length figure, his head surrounded by a halo and the whole image also enclosed in a circle. Angels, apostles and prophets are grouped round the image of Christ according to their spiritual rank, appearing suspended in an expanse of pure sky blue or gold which is the embodiment of celestial glory.

This spiritual world neither possesses the third dimension of real space nor is subject to the law of gravity. The corporeal solidity of the figures is something to be overcome. Spatial depth and sculptural form are not painted as such, but are symbolically rendered through strong colour contrasts and clear outlines. The lower parts of the dome, the pendentives and squinches and the vertical wall surfaces are covered with scenes from the early life of Christ. The Annunciation, Birth, Baptism, Transfiguration and Crucifixion, Christ's descent into hell, the Ascension and Koimesis (the death of the Virgin Mary) are all set in earthly landscapes despite their spiritual nature. An interesting and significant feature of these paintings is the way in which they dematerialize the scenes from the material world which they represent. The figures of saints which appear in rows on the lowest level, directly adjoining the floor, are normally idealized rather than actual portraits – simple figures appearing in an abstract space. They are inevitably representational to a degree, but their intention, as we have said, is to overcome the corporeal solidity of human flesh.

From the beginning there was a tendency which reached its climax in Iconoclasm, which considered even these figures unsettling and forbade any representation of the human form. An interesting example from the early

Christian period has been preserved in a suburb of Iznik (formerly Nicaea). Here a mural was found in a tomb some years ago which consists only of the Cross, various birds and plants and symbolic Greek inscriptions. Even in the Hagia Sophia, the great showpiece of Byzantine art, the original murals were devoid of representations of the human form.

Later, not only during the time of the Iconoclastic movement in the 8th and 9th centuries but throughout the Middle Ages, non-figural, symbolic art seems to have been even more predominant than has been supposed hitherto. Art historians tend to interest themselves chiefly in representational subjects and particularly the human form, and their publications often ignore the abstract, symbolic forms which seem to have dominated Byzantine art, particularly in the monasteries. In the chapels of the cave monasteries of Cappadocia in central Asia Minor, there are several hundred examples of these wall paintings with simple, abstract forms far outnumbering the figural representations. This in itself is an interesting indication of the importance of non-representational art in Byzantine or eastern Christian art. There are also quite a number of eastern churches without any decoration at all. In Western Europe too, there are a whole series of medieval churches decorated with non-representational subjects, or devoid of decoration.

Generally speaking, eastern Christian artists depicting spiritual subjects in whatever style, from the figural to the purely abstract, always strove to avoid the intrusion of material and worldly values in their work.

The problem of figural representation brings us to the question of sculpture. It is usually stated that sculpture fell out of use in the Byzantine world. Certainly the statues sculpted in the round which had been so typical of ancient art disappeared at an early date, although the practice of sculpting portraits of emperors continued until the 6th century. The relief, too, with its realistic figures and similarity to three-dimensional statuary, ceased to exist. The last examples are the reliefs on sarcophagi or ivory carvings which continued to be produced until the 5th century. This was not a negative, regressive step, but a more logical consequence of the rejection of material solidity in sculpture as well as in painting. Sculpture underwent a qualitative change. Stone-carving was still practised, but it was mainly applied to two-dimensional subjects of an abstract and symbolic nature. Sculpture left the representation of concrete personalities, such as the figures of saints, to painting, which used colour highlighted with gold, precious stones and enamel to represent these on dematerialized surfaces. Sculpture was restricted to the decoration of objects made of stone: sarcophagi (as in the Ravenna school of the 6th century), pulpits, capitals, rood-lofts and other architectural details. If one regards the statue in the round as the essence of sculpture, this could be considered a diminution of its artistic value. On the other hand, it meant the opening of a new sculptural field which was highly symbolic and ornamental. In particular, it opened the way to a particularly harmonious blending of architecture and sculpture.

But to return to the subject of architectonic space, we have already said that the church was accepted as the house of God, and in itself represented the spiritual cosmos. For this reason the internal space of the church had to be removed from the world and 'spiritualized' by all possible means. Architecturally speaking, a church is no more than a material space bounded by walls, but spiritual space cannot be confined by concrete elements such as walls and domes. The means of spiritualizing architectonic space lies first of all in the structure of the building itself. The four columns which support the main dome in the centre, and the half-domes which surround the main dome on all sides, are the means of representing a striving of internal space towards the infinity of heaven within the main structure of the building. The basilica with its long nave does not show this effect so clearly. The pillars on either side of the central axis direct the attention towards the sanctuary and the semi-dome above.

The chief vehicle of this spiritualization of space, however, is the art of wall painting. At first sight the coloured decoration of the walls has no perspective.

It is flat and two-dimensional, and does not seem to extend the enclosed space as do the murals of ancient Rome and the Renaissance. In the wall paintings at Pompeii and the works of Masaccio, one has the illusion that a window or door has been opened and one is looking at the world outside. Clearly, this effect is intended to achieve an extension of internal space into the natural world, or conversely, to bring the natural world into the architectonic space. But it was this very effect which the Byzantine artists rejected in their murals. Their intention was to spiritualize internal space, to release it into the spiritual world. The space delineated by the paintings is not two-dimensional, nor is it explicable in terms of the material world. It is governed, rather, by a strange kind of 'counter-perspective' whereby all the figures of saints seem to be looking at the observer. As a result, the architectural space and the space of the paintings combine and intermingle, and whoever stands in the architectural space is also partaking of the space of the paintings. The figures of saints are surrounded by a retreating expanse of gold or blue inhabited by twinkling stars and flying angels. The internal space of the building opens onto the infinite expanse of the spiritual world.

The primary task of Byzantine art was therefore to make visible that which was holy and transubstantial, which it did through its treatment of the figures of saints, and to embody the spiritual world in a concrete form, which it did through its treatment of church architecture. In this respect Byzantine art is qualitatively different from the art of the ancient world, which did not aspire to represent spiritual possibilities beyond the world of men. It was a task which fascinated the Byzantine artist and the peoples who flocked around him, and its fulfilment was his great creative achievement.

<div align="right">Munemoto Yanagi</div>

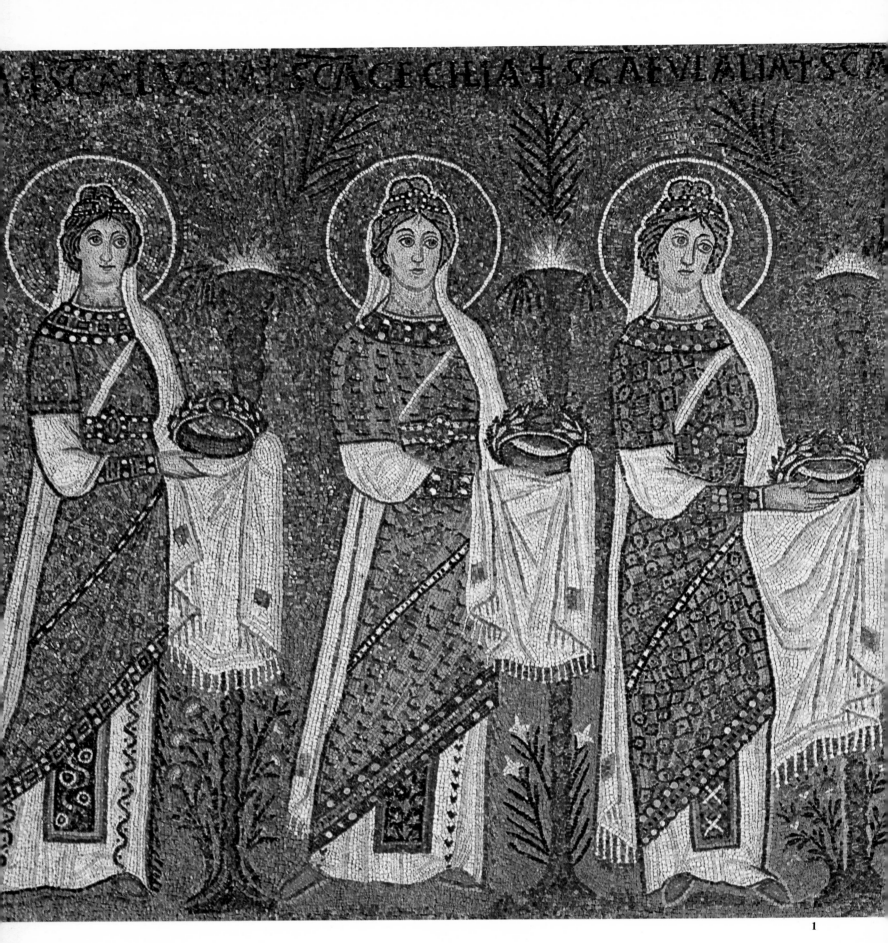

SCA LVCIA + SCA CECILIA + SCA EVLALIA + SCA

1

Ravenna

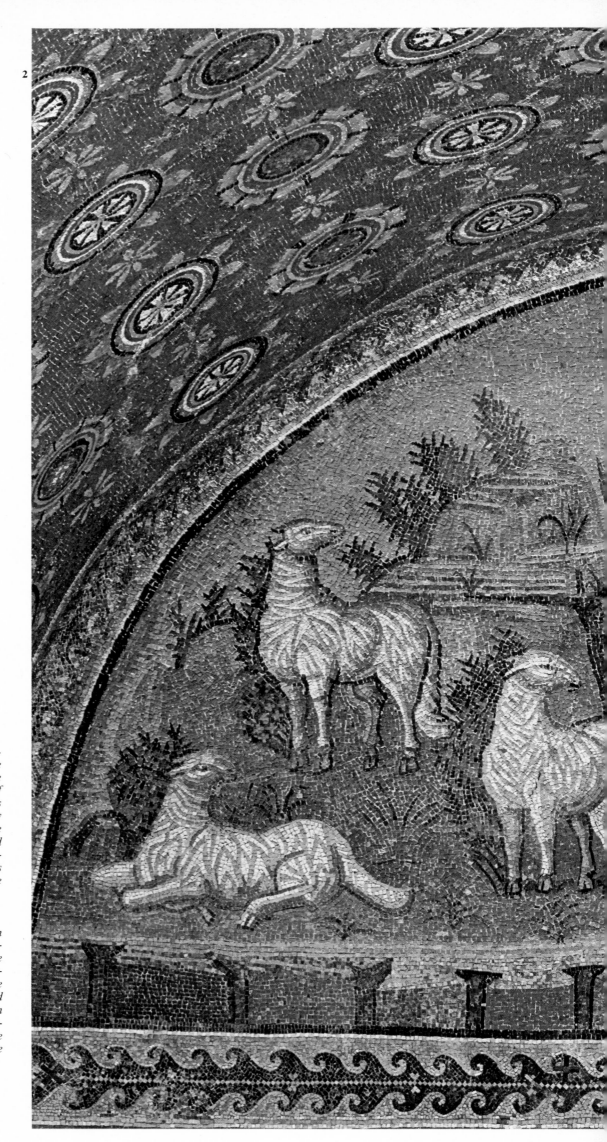

Page 14:
*1 Procession of martyred saints, Sant-
'Apollinare Nuovo, circa 568. The female
saints, who appear on the bottom part of the
north wall, are coming from the direction of
the harbour of Classe, and are facing towards
the Virgin enthroned with her child. The row
of graceful figures on the gold background are
richly attired in the Oriental manner, and
seem to be moving slowly forwards, establish-
ing an almost musical sense of rhythm. This
mosaic is one of the finest works from the time
of Justinian.*

*2 Christ as the Good Shepherd, Mausoleum
of Galla Placidia, mid 5th century. The barrel-
vaulted ceiling of the mausoleum and the dome
are entirely covered in mosaics. The illus-
tration shows the mosaic in the lunette over the
entrance. The theme of Christ as the shepherd
seated among his flock of sheep was often
illustrated in early Christian art and symbo-
lized Christ's protection of the souls of the
Apostles and the eternal rest found by the
souls of the dead in heaven.*

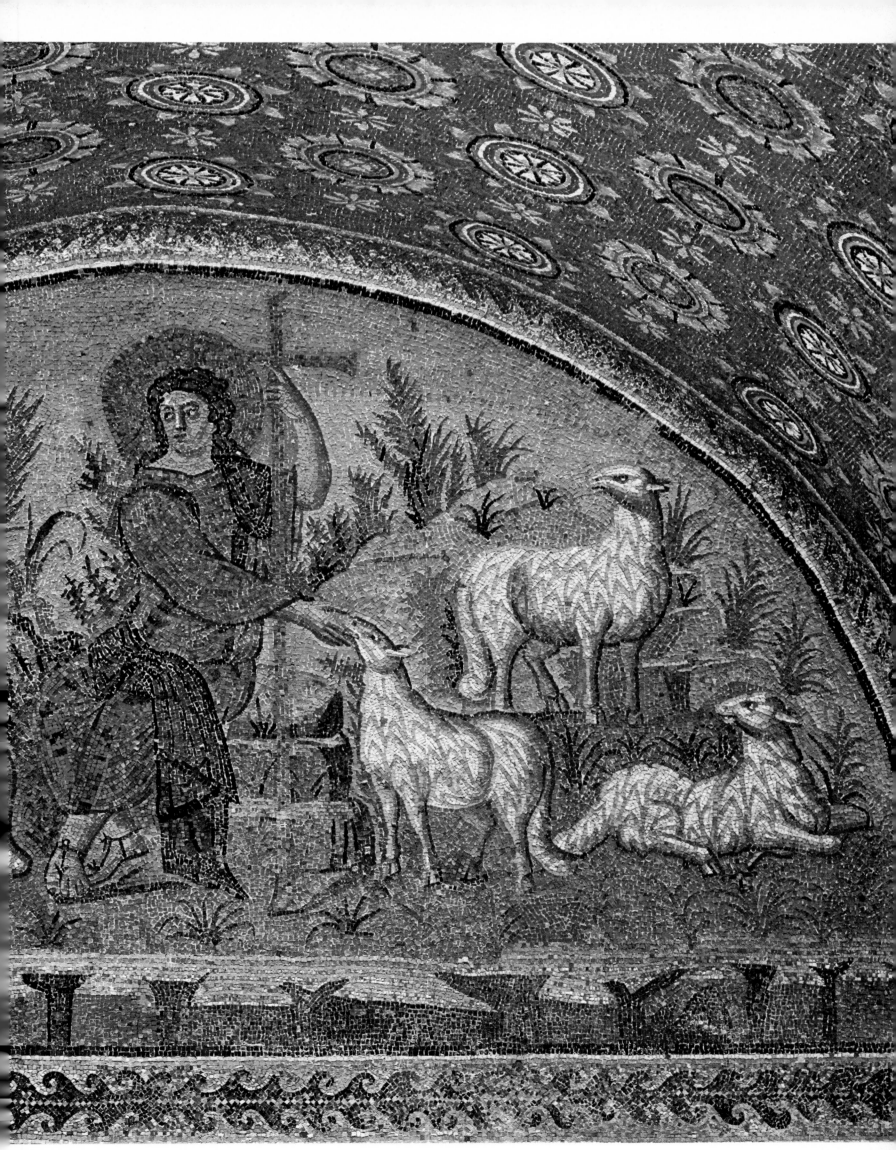

The Town and its History

Renowned as a treasure house of mosaic art, Ravenna is a small town covering some four square kilometers on the Adriatic coast. Today it is less famous than Venice, further to the north, but once it was far more important than the city of canals and played a significant role in European history. Ravenna's beginnings lie in the mists and legend of prehistory, and little concrete evidence of them still remains. It is thought that the Umbrians, as they colonized the broad expanse of the Po basin, built their houses there on piles driven into the swamp at a time before the domination of ancient Rome had reached the area. Ravenna lay to the south of the Po delta, which had once covered a wide area, and was surrounded by lagoons which had formed at the river mouth. To the east of the town was the sea. These unusual natural conditions not only favoured the development of Ravenna as a trading centre but also gave it the character of a natural fortress, from which the northern part of the Italian peninsula could be defended, and which could also be safely supplied from the sea. It was in this frontier town that Julius Caesar made his historic decision to cross the Rubicon on his way back from Gaul to Rome. At the time of the first Roman emperor, Augustus, a naval harbour, Classe, was created on the coast some three kilometers from the town in order to house the fleet of 250 war vessels with which the Romans dominated the Adriatic and the eastern Mediterranean. A fortress was built to defend the harbour, and the town and port were linked by a dyke. The population grew rapidly, the residential area of the town was extended and various public buildings were also erected.

Ravenna thus became a town of major importance for the Roman Empire, which served not only as a barrier to attack from the north, but also as a staging post on the route to the east. As a result of the progressive silting up of the Po delta, the water and marshland which surrounded Ravenna gradually disappeared and it became linked to the mainland from the west. The emperor Claudius surrounded the town with strong defensive walls in the first half of the 1st century A.D., but this did not diminish Ravenna's importance. By the beginning of the 2nd century, under the emperor Trajan, various public works including the building of aqueducts, temples and theatres were well under way, and the former river-mouth settlement had taken on the characteristic appearance of a major Roman town in northern Italy. Waterways of different sizes crossed it in all directions, linking the river with the sea. With its houses reflected in the surface of the canals, Ravenna must have been a town of unusual charm, possibly resembling the Venice of a later age.

In the 4th and 5th centuries Italy witnessed a series of upheavals. The official recognition of Christianity led to the separation of the Eastern Empire from the Western, and the tottering Western Empire was invaded by peoples from the north. These events brought a change in the destiny of Ravenna, emphasizing its role as a natural fortress and point of access to the east. In an attempt to ward off the threat of the Visigoths, Honorius, the powerless ruler of the Western Roman Empire, moved the imperial residence from Milan to Ravenna in 402. The fortress town, famed since ancient times for its impregnability, now took over the functions of the capital of the Western Empire at a time when the latter was being overrun by barbarians and was on the verge of collapse. Twenty-one years later Honorius died. His sister, Galla

Placidia (the c is hard in the Latin pronunciation), who had quarrelled with him and had spent some time at the eastern Roman court at Constantinople, returned to Ravenna. She was accompanied by her son Valentinian III, who was still a minor, and ruled as regent under the protection of the Byzantine court. This Western Empire was one in appearance only, but Ravenna lived up to its title of capital with a burst of building activity. The buildings and their mosaic decorations created under the three generations of rulers from Honorius to Valentinian III established the basis of an artistic tradition unique to Ravenna. The town's existence as a capital under the tutelage of the Byzantine Empire came to an end with the death of Valentinian III in 455. Rome once more became the centre of the Western Empire, but the latter was finally brought to an end by the barbarian prince Odoacer in the year 476. He too made Ravenna his capital, when he established his own kingdom in Italy. The Byzantine emperor considered Ravenna an important strategic point in his campaign to regain dominion over Italy. In a move of some political shrewdness he therefore sent the leader of the Ostrogoths, Theodoric, to Ravenna in 493, to dispose of Odoacer. Theodoric, who had received his education and culture in Constantinople and was a follower of Arianism, made Ravenna his capital in his turn, probably once again with the collusion of the Byzantine court. From there he established the mighty Ostrogoth empire, which included Italy and a part of Eastern and Western Europe. Under this able ruler Ravenna flourished once again. Theodoric built a splendid palace and a number of religious establishments during his reign, which lasted for thirty-three years. His daughter Amalaswintha ruled for a short time at the end of this period, then war broke out between the Ostrogoths and the Eastern Roman Empire, which wanted to bring Ravenna under its dominion. Finally the town was conquered by Justinian's general Belisarius in 540 and brought under the direct rule of the Byzantine Empire. The emperor Justinian now had Ravenna firmly in his grasp, and he designated it an exarchate of the Eastern Empire, and authorized the exarch to take possession of the Italian peninsula and the rest of the western world. The succession of exarchs which now ruled did not always act in Italy's best interests, but for Ravenna the protection of the powerful eastern Roman fleet brought a period of unprecedented prosperity. It became the major centre of trade between east and west, and it was from here that a large number of financiers directed the area's economic affairs. The period is known as the Golden Age of Justinian, and its achievements are reflected in the famous Church of San Vitale and its mosaics (plates 13 to 15). Other churches decorated with magnificent mosaics were either newly built or extended and altered, giving the town a rich, Oriental atmosphere. But this period of great prosperity and artistic activity came to an end with the death of Justinian, and the town fell into decay; finally, in 751, it fell into the hands of the Lombards. Soon after, in the time of Charlemagne, it was incorporated into the Papal States. The harbour of Classe, which had once contributed to the town's prosperity, had gradually and unobtrusively changed into dry land and its fortress had been abandoned.

Ravenna had functioned as a centre of missionary activities in Italy since early Christian times, and its first bishop, St Apollinaris, had been martyred there. This religious and spiritual tradition lived on after the 6th century – in the 8th century the archbishops stood in opposition to the Pope and laid claim to their independence. In the 10th century the bishops of Ravenna were installed as prince bishops under the patronage of the Ottonian Empire, and were appointed in pairs as pope and antipope. Finally, in the 14th century, it was declared a republic. It is well known as the place in which Dante spent his last years, seeking in its mild climate the conditions for a quiet and comtemplative life. It was here also that he wrote the major part of his *Divine Comedy*, before he died in 1321. He was interred near the church of San Francesco. In 1441 Ravenna was incorporated into the burgeoning Venetian Republic, and in 1509 it was included once again in the Papal States. But by this time the splendour and beauty of Ravenna's past had long since been lost.

The Golden Age under Justinian

The rule of the emperor Justinian (527–565) is frequently referred to as the Golden Age of the Byzantine Empire. Byzantium flourished under his exemplary leadership, although it could not escape political weakness both in its internal and foreign relations, and the territory which it controlled was so great that it could be looked upon as a restoration of the former Roman Empire. The adoption of the system of Roman law (the famous Corpus Justinianus) was an important influence on the conduct of internal affairs, and various other constitutional systems were also introduced. Such was the Empire's prosperity that Justinian could afford to build splendid churches in many different places and have them decorated with truly magnificent mosaics.

It is small wonder that the exarchate of Ravenna, which was such an important cornerstone of Byzantine rule in Italy, benefited as much as anywhere from the blossoming of the Empire and its culture. The churches which have survived in Ravenna, and their mosaics, are priceless monuments to the Byzantine past. They bring us face to face with the artistic world of the age of Justinian in all its beauty and splendour, and its idiosyncratic character. They are particularly significant as historical monuments, since apart from the Hagia Sophia in Istanbul and a few others, most of the buildings from this period, including those in Greece itself which are mentioned by the 6th century historian Procopius of Caesarea, have now been lost or considerably altered in appearance. Yet the art of the age of Justinian in Ravenna was not created in a day. Its appearance was the result of a long tradition which had been maintained in Ravenna ever since its elevation to the position of capital of the Western Roman Empire.

Most of the buildings which appeared during the period when Ravenna was the imperial residence of the Western Roman Empire contributed to the founding of this tradition. It is unfortunate that they were later to be senselessly destroyed, together with other buildings in Ravenna from later periods. A few which escaped total destruction still stand today, showing only parts of their original form, and as far as we can judge from what has survived, these buildings display an idiosyncratic character typical of Ravenna. This character has its roots in the Roman tradition and particularly that of Milan, the centre of early Christian architecture in Italy at that time, while simultaneously reflecting the influence of the eastern style of church architecture which was to be found in many places on the borders of the Byzantine Empire.

The so-called Mausoleum of Galla Placidia (*circa* 425 to 450) is one of the oldest surviving buildings from this period (plate 2). Apart from a few unreliable traditions, there is no evidence that this building was actually the tomb of Galla Placidia. The daughter of Theodosius, she was brought up at the court of Constantinople and for political reasons had to marry at an early age the leader of the Visigoths, Ataulf, who had invaded Italy. After the death of her first husband she led an unusual and highly eventful life, which she ended as ruler of Ravenna. With its cruciform ground plan, this small church resembles the Martyrs' Memorial Church which formerly stood on the outskirts of Milan. The four arms of the cross are covered with barrel vaulting and the crossing bears a dome with pendentives. The simple brick exterior is surmounted by a branching hip roof and enlivened by broad blind arcades, while the pediments are enclosed by cornices. The interior provides a remarkable contrast to this simplicity. A mystical, symbolic atmosphere is established by the magnificent scenes from the Life and Sufferings of Christ and their accompanying ornamental motifs, which cover the vaulting and lunettes in gleaming mosaics. These undoubtedly embody the iconographic tradition and the mosaic techniques of early Christian art in Italy, but some of the pictures of saints already carry a hint of Oriental severity in their style.

3 Mosaic on the dome of the Arian Baptistery, circa 500. The Arian Baptistery was so called because it was built in the time of the Ostrogoths, whose king, Theodoric, was a follower of Arianism. The scene in the middle of the dome shows the Baptism of Christ, while the outer section shows the twelve apostles in procession, standing on either side of a throne with a Cross. The mosaic is probably based on the design of the mosaics in the Baptistery of the Orthodox, but has a strong linear movement and gives a foretaste of the direction which the mosaics of Ravenna were to follow later. The dome is constructed of large bricks and crocks.

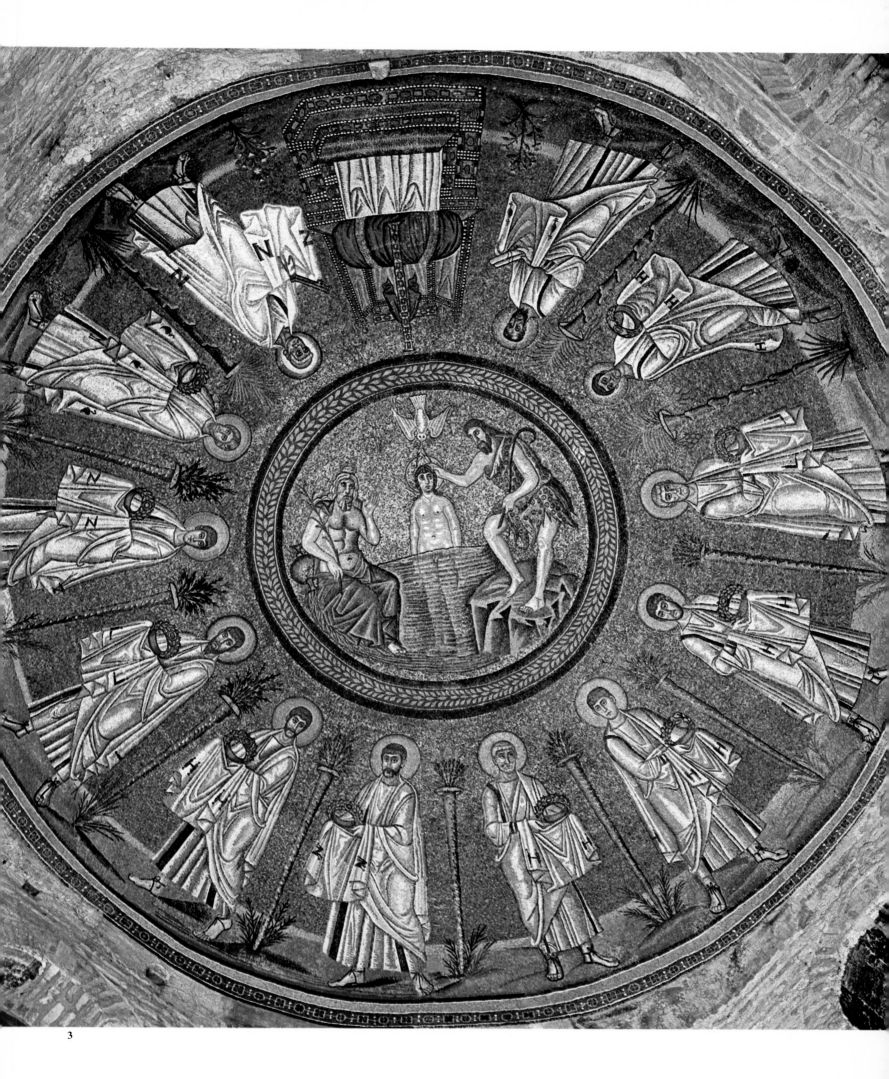

3

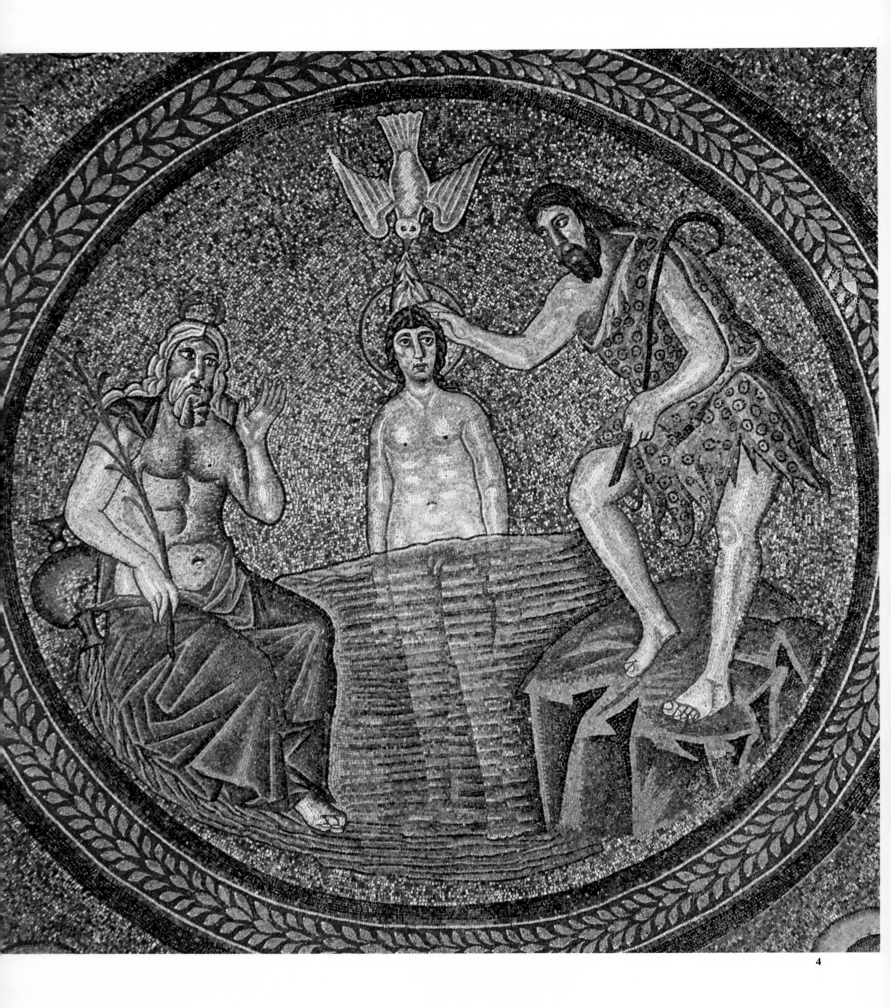

4

The church of San Giovanni Evangelista, which is thought to have been dedicated to St John at the request of Galla Placidia, clearly shows the tendency towards orientalization in the architecture of Ravenna. Designed on a basilical ground plan with a nave and two aisles, this church was probably built between 424 and 434; it was subsequently altered more than once, and has sunk because of the soft ground on which it is built, like most of the other buildings from this period in Ravenna. Nevertheless, it still shows the influence of the style of church architecture of the Aegean littoral, in the polygonal apse with its clear-cut lines, in the style of the vestibule, the large windows of the nave and side aisles, and also the form of the chapel. Two independent chapels project from the apse. This was a novel form in Italy, a style of architecture which can undoubtedly be considered of Oriental origin. Another form which is characteristic of the architecture of Ravenna is the baptistery with an octagonal central ground plan. This basic form was incorporated in baptisteries and martyries in various different places at an early date, but most of these buildings have not survived. The baptisteries of Ravenna are the most important remaining examples in good condition, even though their overall proportions have changed as a result of the sinking of the ground.

Soon after the imperial residence was removed to Ravenna by Honorius, St Ursus, the bishop of Ravenna, completed a large cathedral with a basilical ground plan incorporating a nave and four aisles; he then began the construction of a baptistery belonging to the cathedral and directly adjacent to it. This was called the Baptistery of the Orthodox, or the Baptistery of Neon, since it was completed in the time of Bishop Neon (*circa* 450). Constructed of brick on an octagonal ground plan, this building has four niches facing one another at ground level, while there are windows on all eight sides above. Flanking the windows, there are two double blind arcades on each wall, which were restored in about the 7th century.

In contrast with the simple exterior of the building, the interior is rich and varied, with a dome resting on arches which is fairly unusual for a baptistery of the period. The decoration of the window area, with Ionic marble columns and stucco reliefs possibly representing saints, was also highly novel at the time. The mosaics covering the inside of the dome achieve their effect chiefly through the contrast of translucent dark blue and resplendent gold which are the dominant colours of the interior. They are divided into three concentric zones, each devoted to a particular theme. The medallion at the crown of the dome represents the Baptism of Christ, a theme which clearly reflects the function of the baptistery. The second zone shows the twelve apostles in procession and the third, at the bottom edge of the dome, shows empty thrones, altars and various different symbols, surrounded by a trompe-l'oeil architectural motif (plate 11).

The dome's method of construction is interesting, hollow clay pipes and pumice stone having been used to reduce the weight of the structure. This technique soon became standard for the construction of domes in Ravenna. According to Agnello, a historian who lived in Ravenna in the 9th century, Bishop Neon also commissioned the building of the basilical church of San Francesco. The present form of the church is the result of extensive alterations in the 10th and 11th centuries, but the interior has retained the festive atmosphere of the time of its foundation.

Between the late 5th and early 6th centuries, a second baptistery was built in Ravenna which has also survived to this day. As it was built in the time of the Ostrogoth king Theodoric, an adherent of the Arians, who had been condemned as heretics at the Council of Nicaea in 325, the building is known as the Arian Baptistery. The octagonal ground plan, the brick exterior, the composition of the mosaics in the dome and other features all indicate that this building was modelled on the Baptistery of the Orthodox. It is, however, smaller, plainer and less splendidly decorated than the latter. It would also seem to have changed its form considerably over the centuries. Investigations at the beginning of this century revealed the remains of an ambulatory, which

23

seemed to have had a vaulted roof. Inside the baptistery today, the walls beneath the dome are of bare brick, so that the techniques of masonry and the system of support for the dome are revealed. The mosaics lining the dome, too, are much simpler than those of the Baptistery of the Orthodox. They incorporate only two motifs – the Baptism of Christ, and the procession of apostles arranged in a circle around him – although their representation shows certain stylistic innovations which are not found in the earlier building (plates 3 and 4).

The most representative building of the time of Theodoric in Ravenna, however, is the church of Sant'Apollinare Nuovo (plates 1, 5 to 10). Of basilical form with a nave and two aisles, this building seems to have been a court church, erected by Theodoric near his palace after he had been converted to Arianism. According to Agnello, the historian mentioned above, it was originally consecrated to Christ. Although the part of the church dating from the time of its foundation is built on the simplest possible basilical ground plan with no secondary elements, its design adopted the characteristic features of the period which were to be found in the early basilical churches such as San Giovanni Evangelista, San Francesco and others. These included the polygonal apse which is still recognisable from outside, the large windows set high up on either side of the nave, and the oriental capitals to the pillars. The high window on the west side, and the colonnade with its row of marble columns were incorporated into the main structure in the Renaissance period. The towering campanile which stands nearby is of a fine cylindrical form characteristic of Ravenna and was probably built around the year 1000.

The mosaics which cover both walls of the nave are of the utmost splendour. Divided into three horizontal zones, they show a variety of themes, all related to the life of Christ. Most of the mosaics in the bottom section were completely re-set or partially altered after the churches were taken from the Arians in the time of Justinian and transferred to the possession of the Orthodox Church. This enables us to see all the more clearly in this church the development of mosaic art in Ravenna from the time of the Gothic domination to the period in which the town was an exarchate of the Byzantine Empire. For not only do these mosaics show the technical and stylistic changes which took place, but their rich variety of subject matter incorporates figures and motifs, ranging from Christ himself to the palace of Theodoric, which are an important source of documentary information on the period.

The Golden Age of Justinian is most clearly reflected in the church of San Vitale and its mosaics. This church, with its octagonal ground plan, makes an idiosyncratic use of space which is nevertheless clear and logical in conception. Its construction was probably started immediately after the death of the Ostrogoth king Theodoric by his daughter Amalaswintha, who was known for her enthusiasm for things oriental, and the archbishop Ecclesius, with the financial support of Julianus Argentarius, a rich banker of Greek origins. Ecclesius himself had just returned from a visit to Constantinople with Pope John, and both the basic form of the building and the materials used show that he must have drawn extensively on his impressions of the East when it came to drawing up the plans. The basic structure of the church, with eight large columns supporting the dome and eight galleried compartments surrounding it, is closely related to the central structure of the now demolished church of St John in the Hebdmon Palace in Constantinople, and the church of SS Sergius and Bacchus, which still survives. In fact San Vitale is altogether an exception among Italian churches. The unusual form of the bricks used for the main structure, which are flat and wider than they are long, was hitherto unknown in Ravenna. They were probably produced in Ravenna itself and modelled on the type of brick used in Constantinople. The use of marble from Prokonnesos on the Sea of Marmara for the internal columns and in various other parts of the structure is another indication of the oriental character of this church.

24

Ecclesius died before the church was completed. The building works were continued by his successor Ursicinus, but interrupted in 534 by the violent death of Amalaswintha. It was not until 540, when Ravenna became an exarchate of the Byzantine Empire, that work was resumed under the direction of Bishop Victor. The larger part of the church seems to have been finished during his lifetime, but it was only under Ecclesius' third successor, Maximianus, that it was finally completed. In the year 547, Maximianus conducted a lavish consecration ceremony.

Seen from outside, the church is a clean cut, octagonal structure devoid of superfluous ornament, with broad buttresses providing a strong vertical accent. The presbytery and the apse, which project to the south west as if they were intended to break up the simplicity of the design, add a dynamic element to the overall structure. This unusual exterior form is dictated by necessity, a consequence of the arrangement of interior space which is found in other Byzantine churches, but here takes a particularly extreme form. The essential character of this church is expressed rather in its interior (plates 13 to 15). The interior of San Vitale consists essentially of the eight main pillars and the central dome which they support – or more exactly of a kind of vaulted cloister composed of eight sections. The main supporting columns are linked together by semi-circular arches above and by small semi-domed niches linked by small round pillars. The cross-vaulting which covers the galleries and lofts running round these niches gives added strength to the structure from the outside. The space between the main columns on the south-east side was extended outwards and the presbytery and apse built on and covered with cross-vaulting. The ground plan, which shows eight trapezoidal compartments around a central axis and a long, projecting presbytery on one side, bears a basic similarity to the plan of the church of SS Sergius and Bacchus mentioned above. This church appeared in Constantinople at approximately the same period, and its similarity to San Vitale has often been commented on, so it can justifiably be assumed that both buildings are based on the same conceptual plan.

In the church in Constantinople, the main columns and dome of the octagon are enclosed in a rectangular galleried space, and there is a considerable eclecticism of architectural detail. A wide variety of architectural forms are used, resulting in a somewhat oppressive atmosphere in the interior. The church of San Vitale in Ravenna, however, is based on a more advanced structural concept. There is an effort to embody a clear sense of unity in the overall design, and a visually powerful and rhythmic effect is achieved through an organic combination of niche-like compartments with the curves of the different-sized arches and the lines of the pillars. Together with the carefully designed overall structure this results in a highly unusual spatial effect in the interior.

The visitor who stands in the middle of this central structure and yields to the almost musical harmony of its spatial configuration will be naturally drawn to the presbytery away to the back of the building. Here, resplendent coloured mosaics, gleaming in mystic gold, cover the walls and recall the Golden Age of Justinian. Rich compositions representing the twelve apostles, and the portrait of St Vitalis after whom the church is named, flank the main pillars at the entrance to the presbytery. Both side walls of the presbytery bear legendary scenes from the Old Testament, while a representation of the theophany appears on the semi-dome of the apse. The style of the mosaics is not always consistent – the half-length portrait of St Vitalis belongs to the stylistic tradition of Ravenna's beginnings, while the picture of the theophany is more reminiscent of the Byzantine manner. Together they give the impression of a representative collection of Ravenna's mosaic art.

Two mosaics in particular, which face one another on the side walls of the apse, make San Vitale a treasure house of early Byzantine mosaic art, since no mosaics from Justinian's time have survived in Constantinople itself. These two panels, which represent the emperor Justinian and his wife Theodora with their retinue of officers and ladies of the court, are undoubted

masterpieces of Byzantine mosaic art. They are notable both for their expert workmanship, and for their depiction of the ceremonial splendour of the Byzantine court, so fully expressed here in the idiosyncratic, purely symbolic manner of Byzantine art, which avoided all representations of human feelings and spatial realism.

The church of San Vitale not only represents the zenith of the artistic tradition of Ravenna. As a building it exemplifies the architecture of the Golden Age of Justinian, together with the Hagia Sophia in Constantinople, to which it cannot of course be compared in terms of scale. The Byzantine world was an object of great veneration of the people of the West throughout the Middle Ages. For this reason it was perhaps natural that Charlemagne, the first sole ruler of the Western world, chose the church of San Vitale as his model when he built his Palace at Aix-la-Chapelle at the beginning of the 9th century.

The crowning achievement of the end of the Golden Age of Justinian in Ravenna, however, is the church of Sant'Apollinare in Classe (plates 17 and 18). As the name indicates, it was built to house the tomb of St Apollinaris, the town's first bishop and martyr, near the harbour of Classe, some distance from the town. Today it stands alone and far from the coast, for the harbour has long since been filled in by sand from the Po estuary. The building of this basilica was undertaken by Bishop Ursicinus with the financial help of a banker, Argentarius. It was consecrated in 459 by Bishop Maximianus. Its basilical plan with a nave and two aisles shows that the architectural style of the church of Sant'Apollinare Nuovo had remained alive. Even from the exterior it is evident that the overall structure is a complex one. The spacious interior of the church, which contains two rows of columns in marble from Prokonnesos, is brightly lit by windows in the upper part of the nave and in the side aisles. The square plinths at the base of the columns and the capitals carved with acanthus leaves are typical of Byzantine architecture. The walls and floor are thought to have been originally covered with glittering marble of the same type as the columns. The mosaics which cover the apse and the triumphal arch were probably carried out at the time of the basilica's construction and show a certain tendency towards stylization which reflects the advanced state of mosaic art in Ravenna.

5 *Procession of martyred saints, Sant-'Apollinare Nuovo, circa 568. An area of mosaic on the south wall shows a row of twenty-six martyrs leading from the depiction of Theodoric's palace towards the altar. The crowns in their hands are emblems of victory representing their triumph over death, and the palm trees and the flowers at their feet symbolize the kingdom of heaven. This mosaic replaced the Arian figures which had previously occupied their position, when the building passed into the possession of the Orthodox Church.*

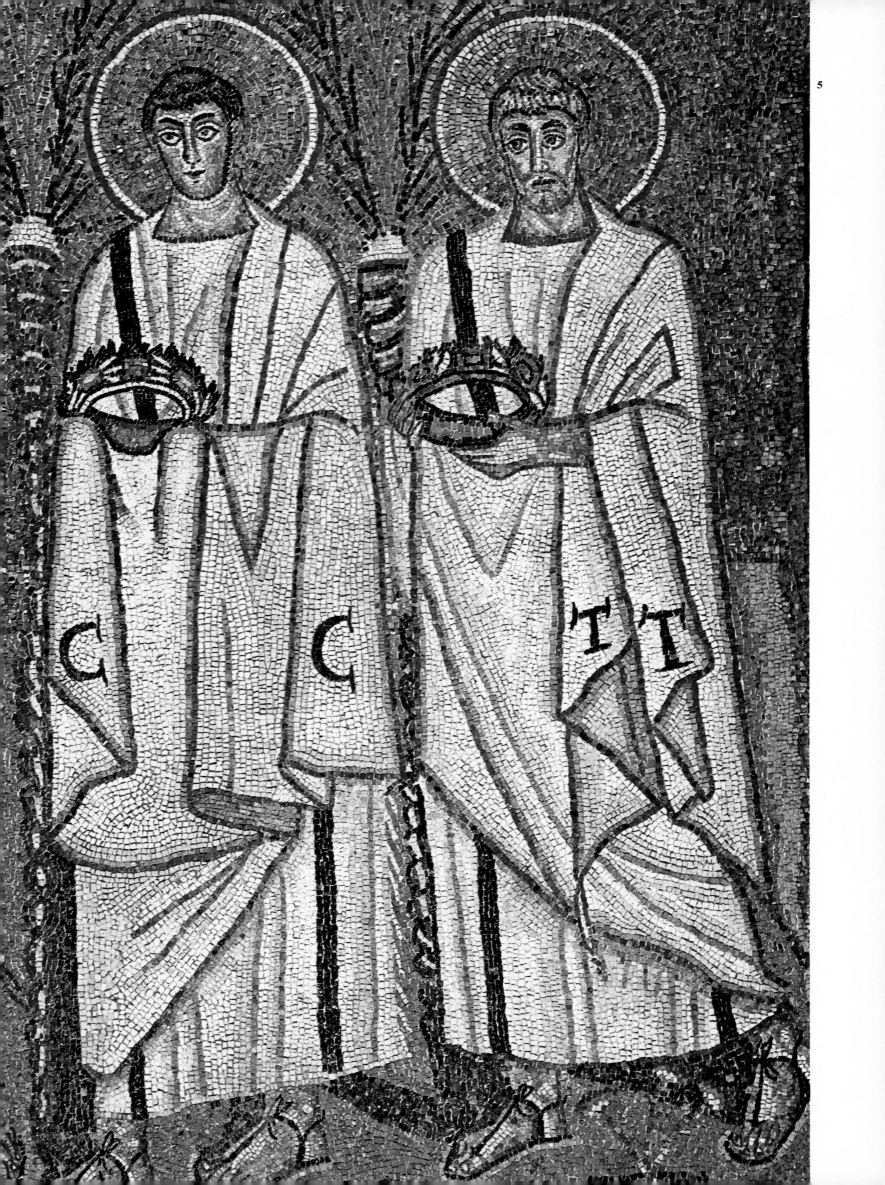

6 Mosaic on the south wall of the nave, Sant'Apollinare Nuovo, 6th century. A traditional basilica with a nave and two aisles, Saint'Apollinare Nuovo was built as the royal chapel of the Ostrogoth king Theodoric around the year 504. The upper side walls supported by the colonnade on the south and north sides of the nave are covered with important mosaics ranging in time from the reign of Theodoric to that of Justinian. Each of the facing wall surfaces is divided into three zones. The uppermost section bears scenes from the life of Christ; in the central zone, on the wall area between the windows, are figures of prophets and saints. The lowest zone on the south wall shows a procession of male martyrs with Christ, and that on the north wall a similar procession of female martyrs with the Virgin Mary and her Child. These mosaic walls in the nave are generally considered to demonstrate a particular phase of development in the style and technique of mosaic work. The church was altered when it became an Orthodox place of worship in the 6th century, and in the 9th century it was consecrated to St Apollinaris.

6

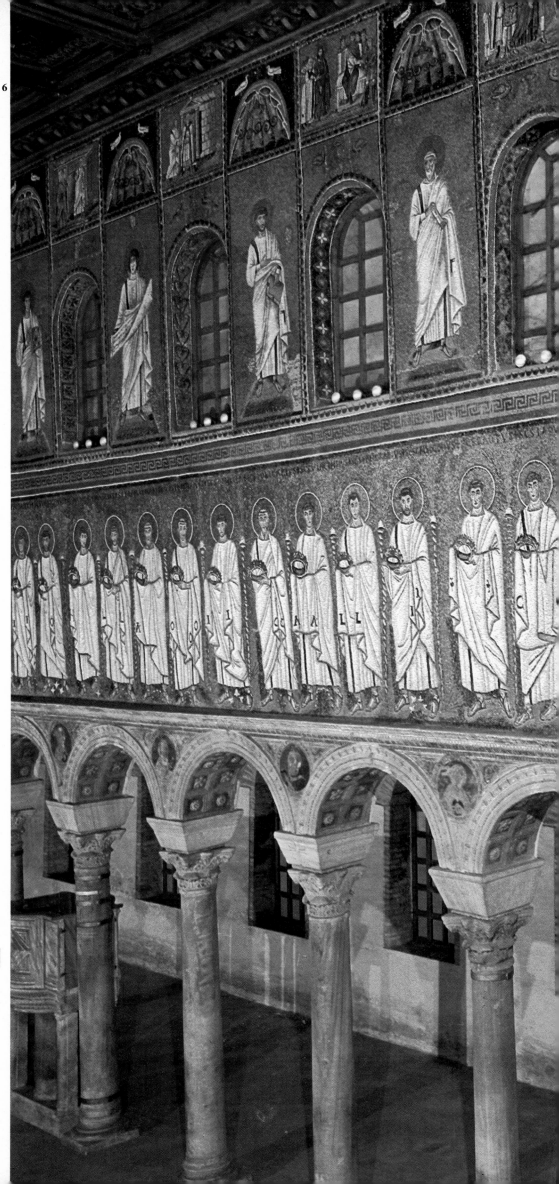

Ground plan of the Church of Sant'Apollinare Nuovo
1 16th century addition
2 Nave
3–4 Aisles
5 Apse
6 Campanile, circa 1000

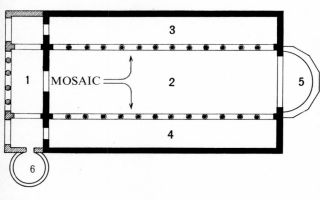

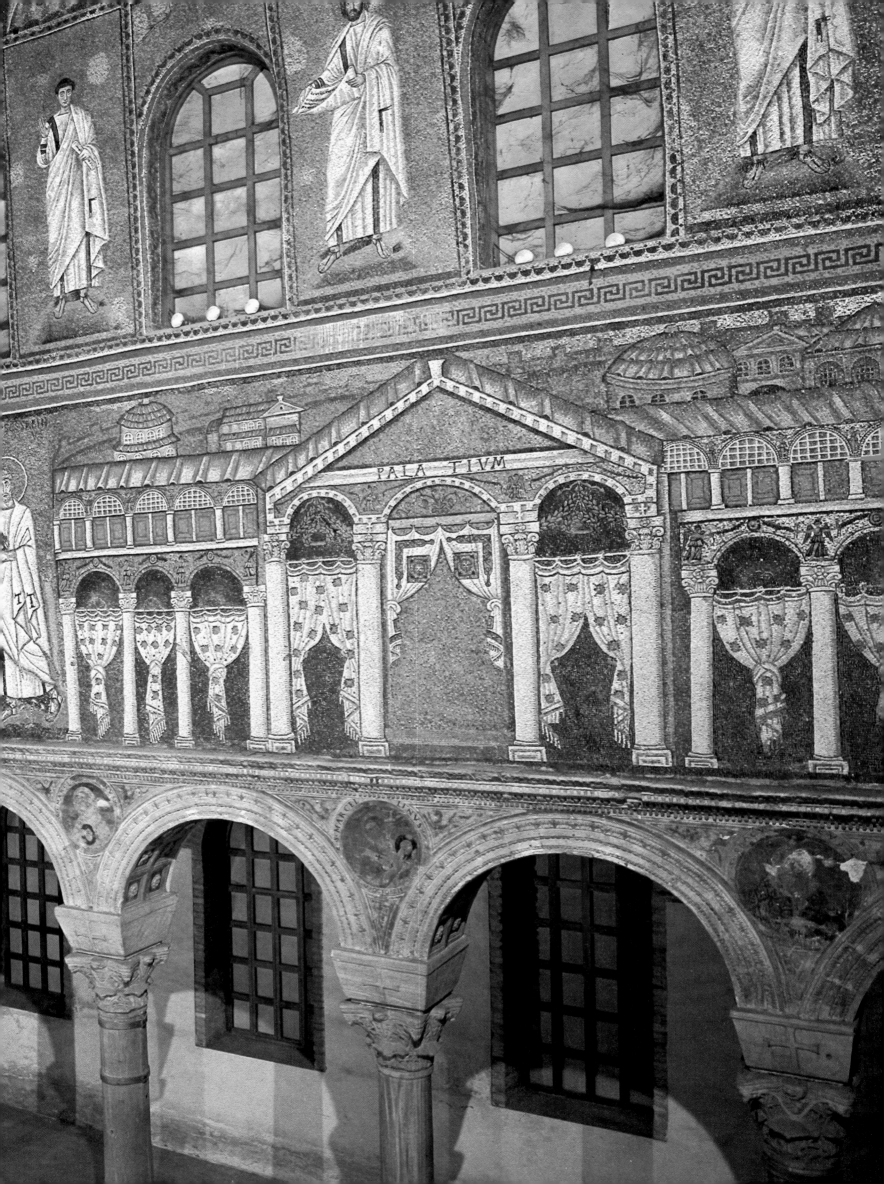

PALATIVM

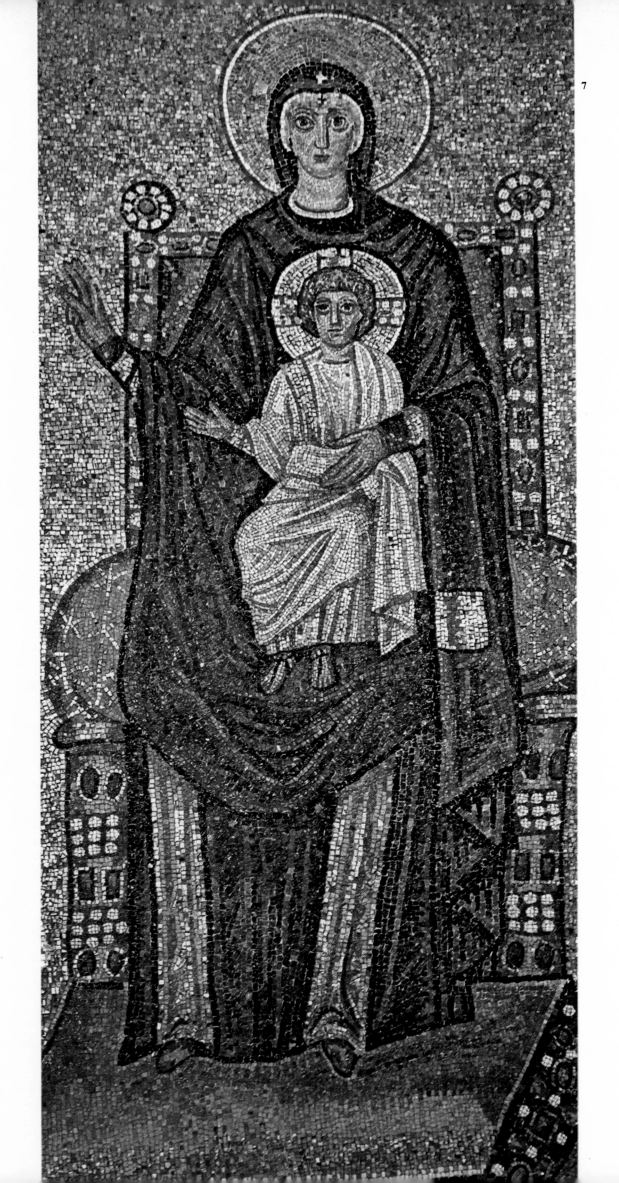

The History and Technique of Mosaic

'Aut lux hic nata est aut capta hic libera regnat' ('whether the light is born here or caught here, it reigns freely') says a poem in hexameters from the chapel in the Archbishop's Palace.

It was in the period between the 5th and 6th centuries, while it was still in a favourable geographical and political situation, that Ravenna developed its characteristic style of architecture. A vital component of this style are the mosaics which decorate the interiors of the churches, the symbols of a sacred, transcendental world which was the focus of Byzantine religion.

As the historian Procopius wrote when describing the buildings in the time of Justinian, 'it is as if . . . the interior of the church possesses a source of light . . .' Isolated from the external world, the interior of the church seemed to be transformed into a mystical world by the glittering mosaics.

These Byzantine mosaics, which have been described as 'the art of light', and which the Renaissance painters admired as *'pitture per l'eternità'* ('paintings for eternity'), are composed of ornaments and representations of saints. They were generally made from small cube-shaped pieces of coloured marble, brightly coloured opaque glass (smalti), or transparent glass enclosing gold and silver leaf. These pieces, known as tesserae, are about three to five millimeters long.

Using the term mosaic in its widest sense, we can find forerunners of this technique in the half columns excavated in Mesopotamia dating from around 4000 B.C., which are decorated with coloured slugs of clay, and in the mosaics dating from around 2500 B.C. discovered in the ruins of Ur on which figures are represented with unevenly set lapis lazuli and rubies. In the 6th century B.C., floors of coloured stone mosaic appeared in Greece. But the technique of tessera mosaic as we have described it originated in the Hellenistic world, whose centre was Greece, in the 3rd century B.C., and it was these Greek works which provided the basis for the mosaics of the Middle Ages. The technique spread rapidly through the Mediterranean lands of the ancient world, as the characteristic translucent glaze and the soft colours of the tesserae, which were lacking in wall paintings, and the durability of the materials from which they were made, rendered them particularly suitable for the decoration of buildings. As the technique became more and more precise, mosaic workers attempted increasingly to reproduce the effect of an existing painting. It is known that the famous mosaic of the Battle of Alexander from Pompei originated in the work of a Greek who had adopted the tradition of Hellenistic mosaic art, which aimed at the realistic representation of objects in an illusion of three-dimensional space. This mosaic technique was handed down to ancient Rome, where its development was given a special impetus by the extensive building activities of the Romans. Here it was used above all in the form of ornamental motifs decorating pavements, the pools in the public baths, basins at springs and garden niches.

Unlike the architecture of antiquity, which had given priority to the treatment of façades and the visual effect of an interior, medieval church architecture laid most emphasis on producing an aura of sanctity in an internal space surrounded by plain exterior walls. And gold-tinged mosaic, which would gleam in the light falling from the upper windows into the dimly lit interior of the church, was considered a particularly good material for this purpose. As a result, mosaic art developed a life of its own, which was based on a completely new concept of the world. As can be seen in one of the most notable examples, the 4th century Mausoleum of Santa Costanza in Rome, the mosaic is freed from its customary position on the floor and given a new place in the upper part of the church's interior. The surviving mosaic on the vaulting over the colonnade in the Mausoleum of Santa Costanza shows a vine as the symbol of Christ on an almost plain white background. The design is based on the traditional rendering of a vine branch, and the half-length portrait of Christ

7 Virgin with Child, Sant'Apollinare Nuovo, circa 504–526. The mosaic of the Virgin and Child in the interior of the church, with a row of female martyrs led by the three magi facing towards it, dates from the time of Theodoric. The figure of the Virgin, who is seated on a throne surrounded by four angels, creates a dignified and monumental impression and heralds the maturity which Byzantine art was to achieve in Ravenna.

31

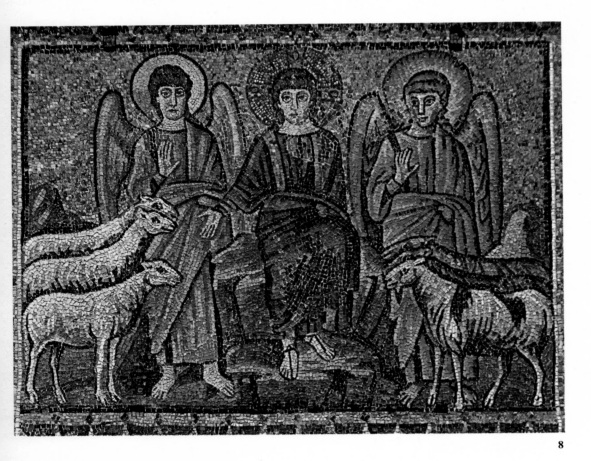

8

in the centre, as well as the wine harvest scenes in the four corners, is also done in the antique style.

Although the decorative motifs and other images in the Mausoleum are largely adopted from ancient styles of ornament, there is already clear evidence of an attempt to produce a symbolic, spiritual atmosphere in the interior. We can also see that early Christian mosaics in Italy made use of the familiar images of the past, that they attempted to create a new style while still acknowledging the old traditions. An interesting example of this traditional style is to be found in the mosaic on the apse of the Church of Santa Pudentiana in Rome; here the ancient, realistic manner of representation is most successfully blended with the rigorously symmetrical composition and mystical rendering of symbolic figures.

In the mosaics of Santa Maria Maggiore (4th to 5th centuries), the new, medieval character is clearer still. Here the last traces of the ancient manner of representing space exist side by side with the tendency to abolish space through a lavish and imposing use of colour, and the two techniques compete with rather than complement one another. But despite this rather unusual clash of effects, the spiritual character of the mosaic work can already be felt. The Milanese style, which is closely related to these early Roman mosaics, and at the same time provided the immediate source for the Ravenna mosaics, is represented by the mosaic work in the chapel of San Aquilino in San Lorenzo. The surface on which the figures are standing shows no trace of a realistic rendering of space, and Christ and the saints now seem to inhabit a golden, unreal world.

This symbolic, transcendental character, which gradually comes to dominate the early mosaics, can undoubtedly be seen as a product of the Oriental mind – a fact which makes the strongly Oriental mosaics from the early period of the Byzantine Empire particularly interesting. Unfortunately most of them have been lost, and today we must take the few surviving examples in Salonica, the second great city of the Byzantine Empire, as representative of a far greater whole. Here we find on the one hand a taste for the lavish use of gold as a means of achieving a transcendental, mystical atmosphere, and, almost in direct contradiction to this, the use of stylized composition and

9 The healing of a cripple, Sant'Apollinare Nuovo, circa 504–526. The eleventh mosaic on the north wall represents one of the miracles related in the New Testament. Its most notable features are the false perspective used in the representation of the buildings, and the extreme difference in the size of the figures. The style is somewhat different from that of the Virgin with Child from the same period which appears in the bottom zone.

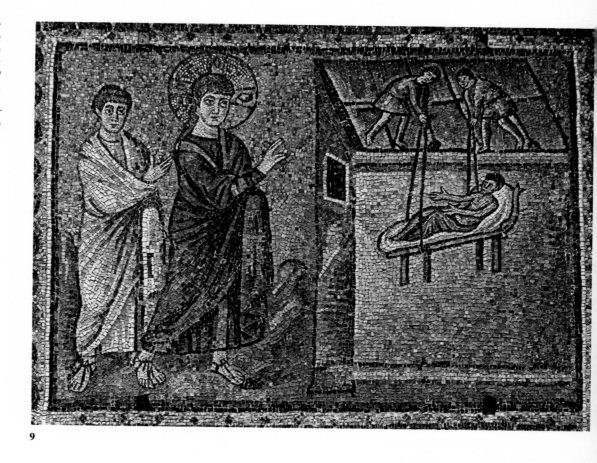

9

Pages 34–35:
10 The town of Ravenna and the harbour of Classe, Sant'Apollinare Nuovo, circa 504–526. The mosaic represents the harbour outside the town, and the walls of Ravenna itself, from which a procession of martyred saints is seen emerging. Here, as in the representation of Theodoric's palace found elsewhere, there are traces of the alterations which the building underwent in its conversion from a church of the Arians – the heretical sect of Theodoric's time – to an Orthodox place of worship. During recent restorations of the mosaic, traces were found of a number of figures which had originally been shown beneath the town walls at this point.

restrained colours in an effort to represent images of an austere spirituality. These features undoubtedly suggest a different sourse of inspiration than the Italian examples we have already mentioned. The Ravenna mosaics, poised in the middle of these two currents, the Oriental and the Western, partook of both to produce their own characteristic form of mosaic art.

We may take as the oldest example of this form the mosaics in the Mausoleum of Galla Placidia already mentioned, which were probably executed by artists brought from Milan. These mosaics cover the interior of the Mausoleum and dominate it entirely, producing a world of sacred symbolism which is entirely separated from the outside world. The influence of ancient figural art is still evident in the poses of the individual figures and the treatment of their clothing. The golden cross and stars which stand out against a dark blue background, suggesting a nocturnal image of the heavens, the symbolic figures from Biblical stories (such as deer and doves), and the rich ornamental motifs all impress the observer as deeply significant elements of an infinite mystical cosmos. This richness of colour, which is undoubtedly Roman in origin, becomes more refined in the Baptistery of the Orthodox attached to the Cathedral of Sant'Orso, where the mosaics also acquire a new luxuriance and splendour. Here the gold and dark blue form the basic tones of the whole composition, and they are effectively combined with vivid shades of cobalt, red, green, purple and phosphoric yellow, giving them an added brilliance. The figures are still strongly modelled, however, and even give an impression of movement.

In Theodoric's time, the use of strongly modelled figures began to wane and the more stylized composition which was to become characteristic of mosaic art in Ravenna slowly began to make its appearance. The stylized figures of saints, with their thick, dark outlines, seemed to turn away from the world of men, and their eyes, wide open in mystical fervour, announced the approach of the Byzantine transformation.

By the beginning of the era of Justinian, Ravenna had been completely integrated into the world of Byzantine art and the art of mosaic was in full flower. The particular characteristics of mosaics at this time are best demonstrated by the juxtaposition of examples from different periods which

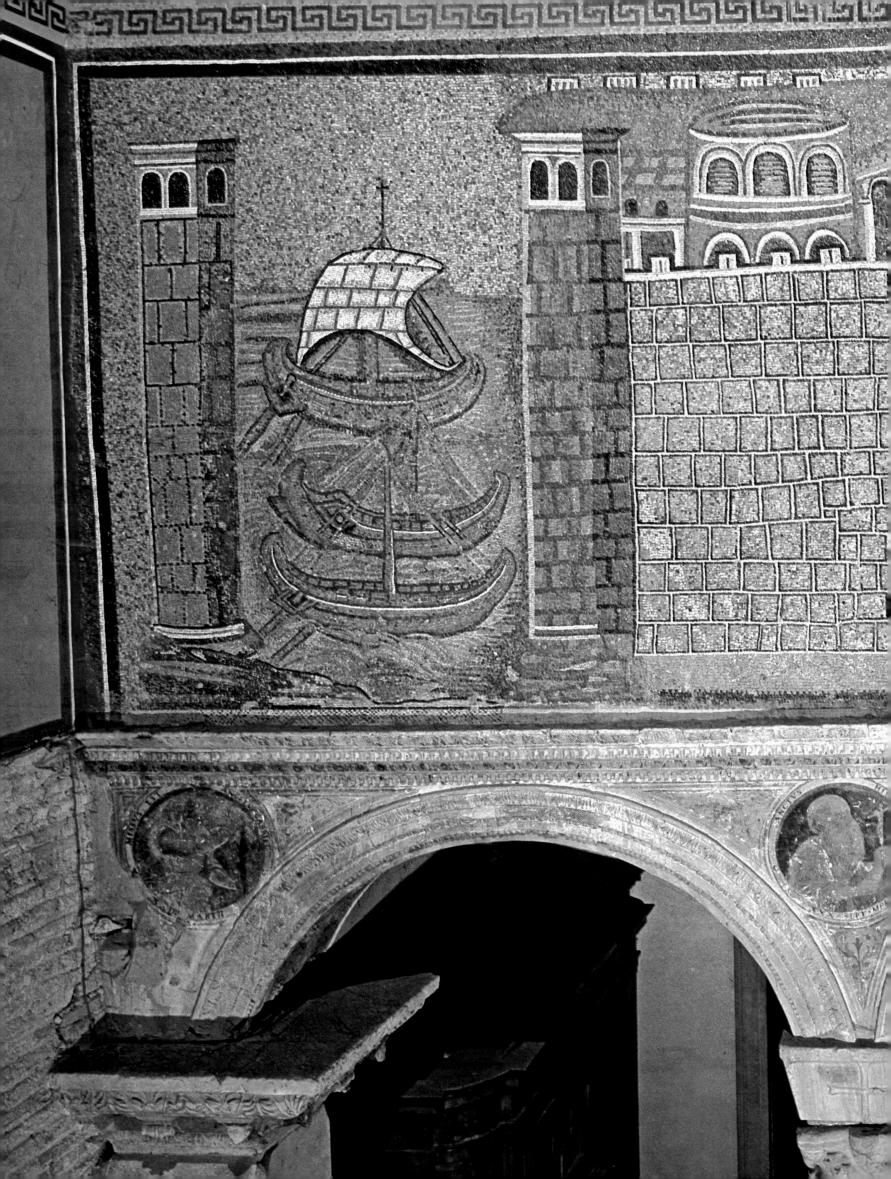

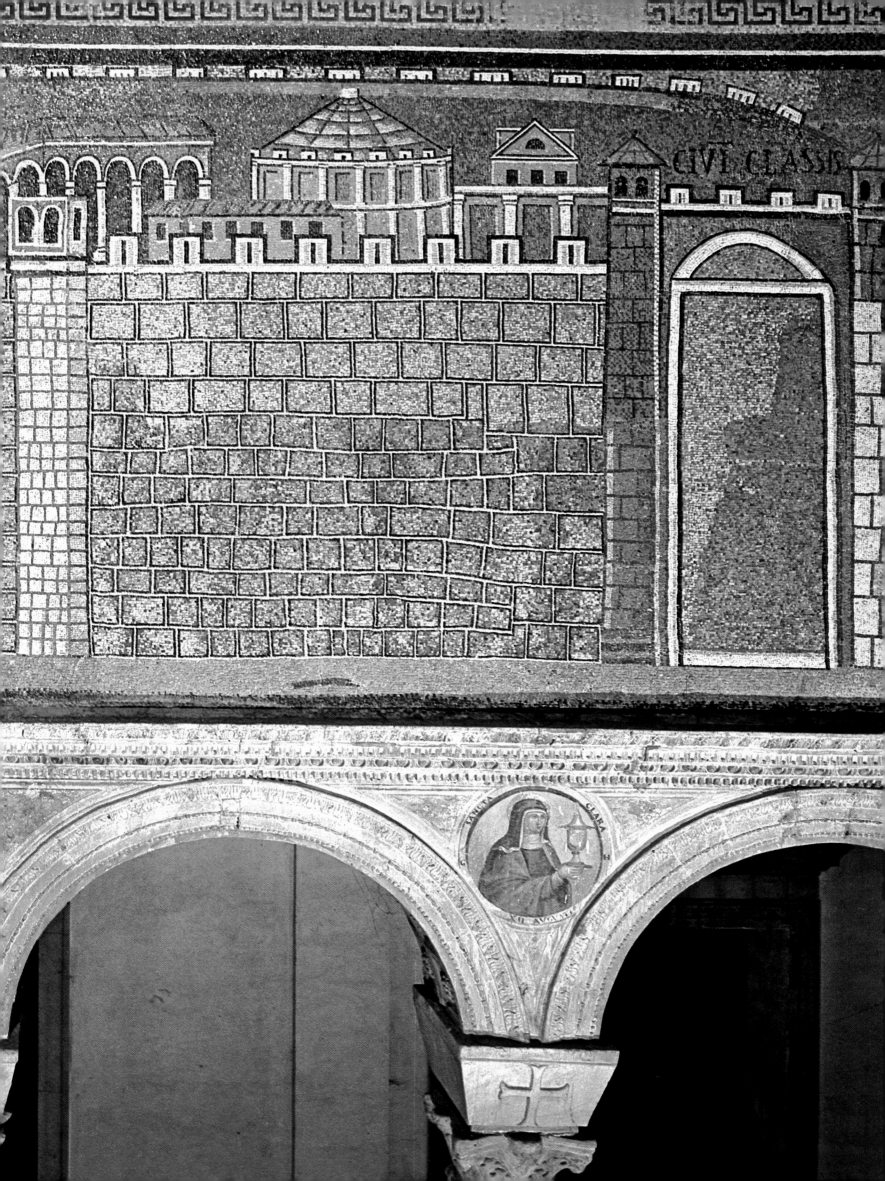

CIVI CLASSIS

can be found in the church of Sant'Apollinare Nuovo (plates 1, 5 to 10). In the procession of martyred saints in the lower area of decoration, we can see that the stylization of the figures has been taken a step further. At the same time the heaviness of the outlines has been completely lost, the figures being executed with thin, clear lines giving an almost rhythmic impression. The heavy, gleaming gold of Theodoric's time has been replaced by a lighter, more brilliant use of the material. The colour is more refined, and made more vivid by the use of lighter tones. The mosaics at San Vitale, and above all the portraits of the emperor Justinian and his wife (plates 14 and 15), are among the most characteristic examples of the splendid, imposing images produced by Byzantine art during the Golden Age of Justinian. All the figures are shown from the front, staring straight ahead, and with their clear, stylized treatment they seem to step across the bounds of time and space, bringing with them the echoes of an abstract, mystical world. Both tesserae and mother-of-pearl were generally used in these mosaics, and with their remarkably harmonious blending of colour tones and clear contrasts, they far outstrip the achievements of modern Pointillism or Neo-impressionism. Modern painters such as Renoir, Matisse and others, derived a wealth of inspiration from the Byzantine mosaic artists, but their names remain more or less unknown to us. In Ravenna, the only surviving trace of their identity is the Latin inscription *'magistrii imaginarii'* or *'magistrii musivarii'*, which means 'masters of the images' or 'masters of mosaic work'.

The art of Byzantine mosaic is an art of light, or more correctly of the reflection of light. The tesserae of the various different materials we have mentioned were slightly irregular. When preparing a wall for mosaic decoration the mosaic workers applied several layers of mortar, then drew a sketch of the design on the surface. Then, following the design, they pressed the tesserae onto the mortar one by one, deliberately setting them so that the surface was not entirely even. In this way the mosaic consisted of a multitude of different reflecting surfaces which gave a brilliant, kaleidoscopic impression as they were viewed from different angles. The tesserae containing silver and gold were often set at a particularly steep angle to reduce unwanted reflections. Despite the tonal richness of the mosaic, with few exceptions it used only a small number of colours; generally only five or six ground colours were used, with the addition of a few sparsely applied secondary colours. In fact the Byzantine mosaics proved that it is possible to create an unlimited palette through different combinations of a small number of colours. One often finds, for example, a piece of blue drapery which is sewn with flecks of cobalt or red, giving a deep, translucent blue which could not be achieved with a single colour. The Byzantine artists evidently possessed an outstanding gift for observation which enabled them to anticipate the colour theories of modern painting.

The radical stylization which is characteristic of the era of Justinian reaches its zenith in the apse mosaic of the church of Sant'Apollinare in Classe (plate 18), dating from the same period as San Vitale. In their later phase of development, Byzantine mosaics become more complex. The mosaic of the Virgin and Child in the Hagia Sophia in Istanbul, dating from the 10th century, displays a variety of colour tones which is not found in earlier examples. The green tones on the face of the Child, for example, are a distinct innovation. Further developments in the 11th and 12th centuries are exemplified by the mosaic preserved at Nea Moni on Chios, which displays an unusually powerful use of colour, with stark, bold contrasts of tone, by the mosaic of the Deesis in the Hagia Sophia with its rich colouring and finely shaded modelling of the bodies; and a few examples at Daphni and elsewhere. From this time on, the mosaics of Byzantium followed the Classical style. Among the last examples are the mosaics of the Kahriye Camii dating from around the 14th century. After this the role of the mosaic was taken over by fresco painting. Moreover, when exported to other areas, such as Venice, the technique of mosaic decoration could not but lose its individual character in the face of a wealth of new cultural influences.

11 Mosaic on the interior of the dome, Baptistery of the Orthodox, mid 5th century. The medallion in the centre shows the Baptism of Christ; surrounding it are the figures of the twelve apostles, and beneath them, in the outermost zone, a series of architectural motifs arranged in complex combinations. The contrast between the blue background and the extensively used gold gives the design a characteristic brilliance, but the drawing of the figures and other motifs still shows ties with the Hellenistic tradition. Light clay pipes were used in the construction of the domes.

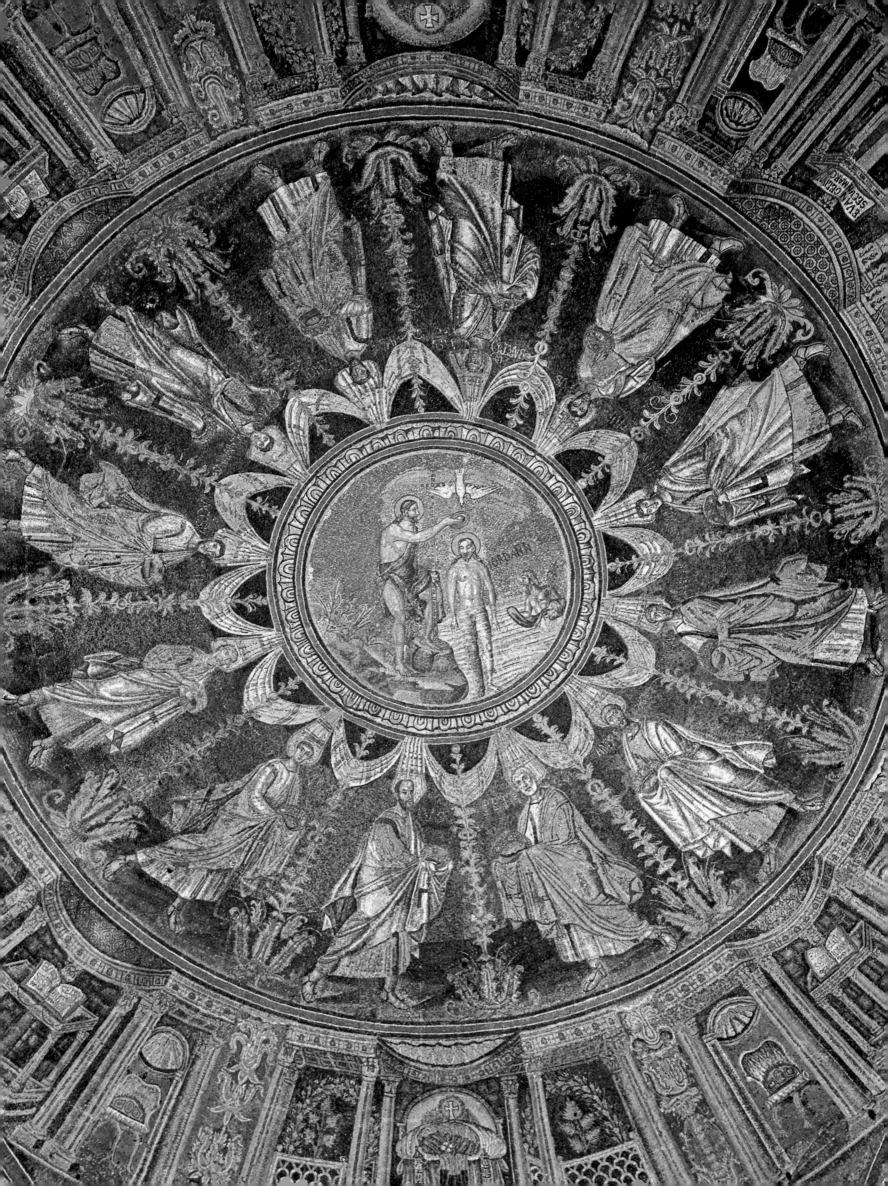

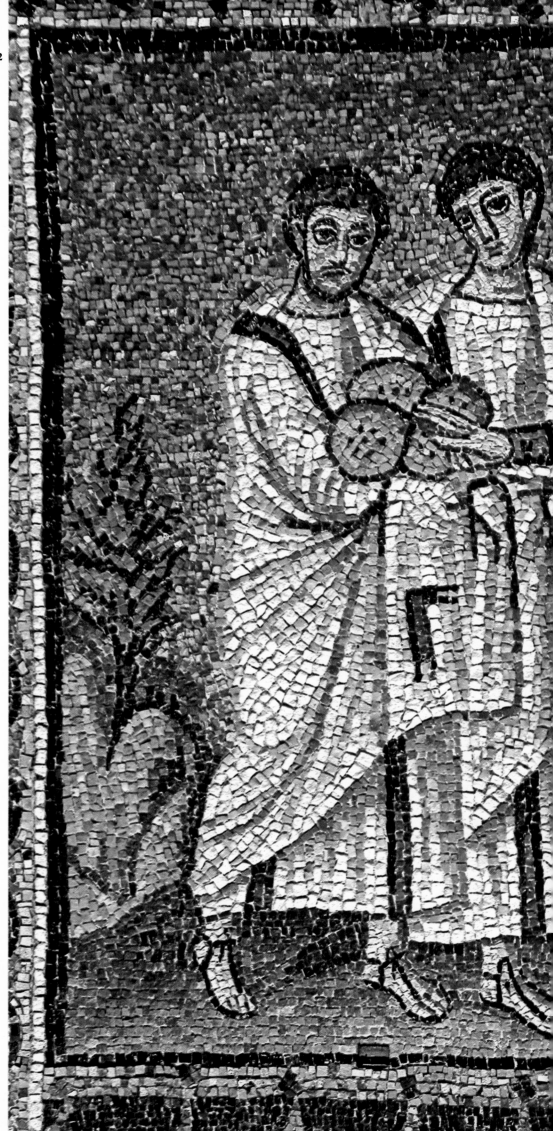

12 The miracle of the loaves and the fish, Sant'Apollinare Nuovo, circa 504–526. This second mosaic on the north wall depicts the miracle of the feeding of five thousand men with five loaves and two fish. Christ is shown somewhat larger than the apostles, and his clothing stands out against their white garments. This composition was probably influenced by Early Christian figural art.

38

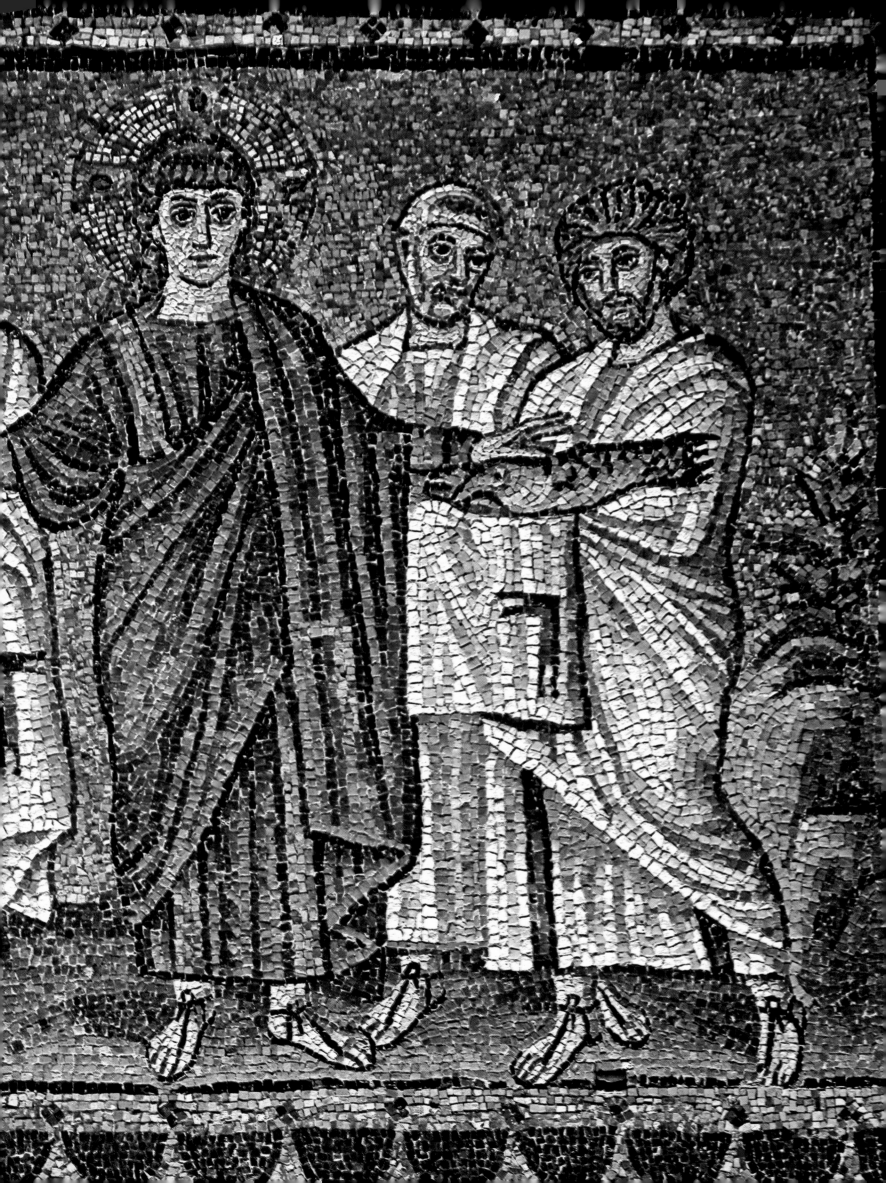

The Development of Byzantine Art

The triumph of Christianity and the elevation of Constantinople to the status of capital marked the beginning of the Byzantine Empire. It was as a result of these two historical events that the Roman Empire gradually took on a different character. Christianity provided the spiritual foundation for Byzantine culture, Constantinople offered it a geographical focus, and the reign of Constantine the Great was its point of departure. In the year 324, Constantine attempted to unite the Empire after his victory over Licinius. In 330 he abandoned Rome as his capital, since it was so hampered by the old traditions as to be unable to resist the steady advance of the Sassanid Persians and the attacks of the Germanic tribes of Europe. At the same time he was able to establish a new capital in Byzantium, a natural fortress situated in the East and well suited as the base for a military campaign. The separation of the Empire into its Eastern and Western components in the year 395 significantly increased the importance of this second capital of the Roman Empire. While the territories in the West fell under the influence of the Barbarians, Theodosius II was able to fend them off from his capital, which he then extended. He rebuilt the Hagia Sophia and erected the palace, as well as the gigantic city wall which still survives today. After the dissolution of the Western Roman Empire in 476, it was the Byzantines who maintained the ancient Graeco-Roman tradition in their capital, fusing it with Christianity and various Oriental elements, to produce the Graeco-Oriental Byzantine culture.

After its official recognition by Constantine the Great in 311, Christianity gradually moved into the foreground and came to play an important role in the Byzantine Empire. The main difference between the latter and the Roman Empire lay in the fact that now Christianity was linked with the Emperor as the state religion, and Emperor and Church together grew into a body of unnatural size. Theodosius I summoned the Ecumenical Council to Constantinople and extinguished the Arian heresy. In a series of edicts issued between 391 and 394, he raised Orthodox Christianity, already adopted by the Council of Nicaea in 325, to the status of the sole state religion and closed all the pagan temples and chrines. As a result of these reforms, the position of Christianity in the Empire became increasingly strong.

But the Graeco-Oriental world had always been stamped by a penchant for philosophical speculation on the mystical nature of belief such as was seldom found in Western society. This tendency resulted in the appearance of numerous sects, whose adherents were regularly branded as heretics. The Imperial Church condemned the Nestorians at the Council of Ephesus in 431, and the monophysites (who upheld the doctrine of the single nature of Christ) at the Council of Chalcedon in 451, and established the doctrine of the Trinity. This led to a deep rift in relations between the Imperial Church and the monks in Syria and Egypt who were adherents of monophytism, and the latter subsequently came into open conflict with the Roman papacy. At the same time, however, the power of the Byzantine Emperor and the clergy grew steadily, establishing a monolithic unity between the sacred and profane worlds, and forming the basis of a Christian absolute monarchy.

Constantine's efforts brought about a sudden upsurge of activity in Christian art, and his successors nurtured it and encouraged its expansion. Christian art, which was always closely linked to the Emperor, reached its first period of maturity under Justinian. The art of the 4th and 5th centuries displays a distinct unity despite the separation of the Eastern and Western Empires, and belongs to the category known as Early Christian art. In fact there is no clear distinction between Early Christian and Byzantine art, but the art of this

13 The Church of San Vitale, circa 526–
547. The construction of this church was
started by the archbishop Ecclesius after his
return to Ravenna from the eastern part of the
Empire, and completed in the time of arch-
bishop Maximianus. The internal structure of
the octagon is supported by eight pilasters,
above which is an octagonal drum pierced by
windows which supports the roof. In contrast
to the simplicity of the external structure, the
straight lines of the internal columns and the
two storeys arching outwards from them give
an impression of rhythmic complexity. The
ancillary structure on the right at the front is a
presbytery.

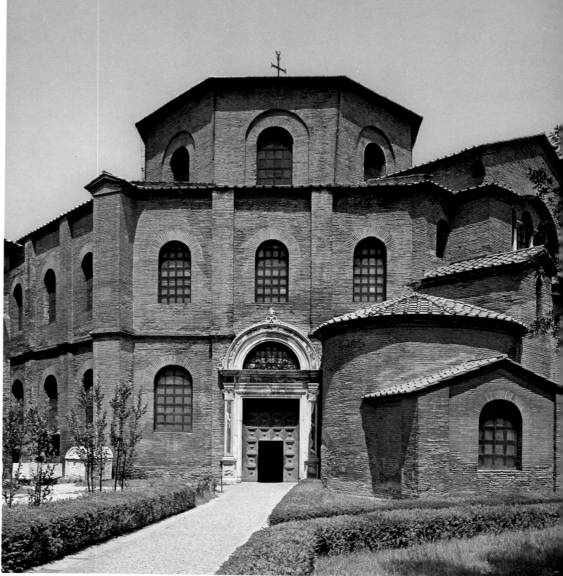

13

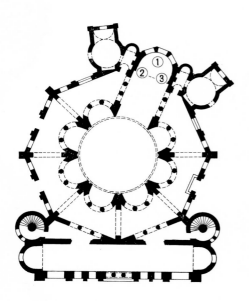

The Church of San Vitale
1 *Apse*
2 *Mosaic of the emperor Justinian*
3 *Mosaic of the empress Theodora*

Pages 42–43:
*14 The empress Theodora with her retinue,
mosaic in the apse of San Vitale, circa 547.
The two mosaics representing the emperor
Justinian and his wife which face one another
on opposite walls of the sanctuary are among
the masterpieces of Justinian's period. The
illustration shows the south wall, where the
empress is depicted entering the church
accompanied by officers and ladies of the
court. The rich colouring and the ceremonial
pose of the figures evoke the atmosphere of the
Byzantine court.*

period gained in stature as it absorbed, rather than rejected, the Graeco-
Roman tradition. At the same time works of art appeared which were more
closely related to the Oriental tradition, and this gradually achieved
precedence over the Graeco-Roman. However, we must first look at the
period in which these two traditions stood side by side, when Byzantine art
began. Geographically speaking, this took place in areas where Christian art
was already established, i.e. in Italy (particularly in Rome, where the
catacombs were created), in Palestine, Asia Minor, Constantinople, and the
Aegean littoral, but most especially in Salonica, the cross-roads of
communications between Constantinople and Italy, where some typical early
Byzantine mosaics have survived. The art produced in each of these areas
displayed the influence of local culture and made good use of local materials,
so that a regional tradition with its own specific characteristics was
established.

The public works of this period, such as theatres, baths and streets, usually
followed traditional Roman models, a notable example being the aqueduct
built by the Emperor Valens in Constantinople. At the same time certain
technical innovations are noticeable. Vaulting for example was now executed
in bricks and mortar or a kind of concrete, instead of marble or polished
granite. The marble capitals to columns were often taken from existing
buildings, or fabricated from local stone, with the result that buildings often
incorporated elements from a variety of different sources.

Christian architecture developed very quickly in the 4th century, to meet the demand for places of worship created by Constantine the Great's recognition of Christianity. The form of the divine service was established between the 4th and 6th centuries, and the central importance attached to communion and baptism had distinctive influence on architectural design. Few of these Christian buildings now survive. The types of church which developed in Rome, Constantinople, Antioch and Palestine can be divided into two basic categories – the basilica and the centralized building. These two architectural forms were combined to produce the domed basilica, which later became the characteristic form of Byzantine church architecture and as such forms a category of its own. Centralized buildings were used for memorial services and baptismal ceremonies, and to house the tombs or relics of martyrs. The characteristic form is a rotunda or octagon surmounted by a dome. A typical example of the circular form is the church of Santa Costanza, the mausoleum of Constantine's daughter Constantia in Rome, and of the octagonal form, the memorial church of St Philip at Pamukkale in Turkey.

The basilica was used for the baptismal service proper and the celebration of the Eucharist. Structurally, it is related to the former Roman basilica which was used for markets and court buildings. This was the basic architectural form considered suitable for the celebrations of Christian ritual, and it was developed continually over the course of the centuries. The main body of a basilical church was divided into a nave and two aisles by means of two parallel rows of pillars. Especially large churches had as many as four or six aisles, while a number of small churches lacked the pillars flanking the nave and consisted of a single hall. The nave was covered with a ridged roof, while a single pitched roof covered the aisles on either side. These roofs were laid over timber beams or a framework or trusses covered with boards. At the eastern end of the nave was the sanctuary which terminated in a semi-circular apse. This was soon flanked by antechambers on either side which were called the *diakonikon* (room for the deacon) and *prothesis* (room for the offerings), and which later developed into sacristies. The altar was positioned either in the sanctuary or in front of it, in the nave itself, according to the demands of local custom. The entrance was at the western end of the nave, and was reached by crossing an atrium surrounded by colonnades and the porch or narthex. The first major modification to the design of the basilica was made in 4th century Rome, with the introduction of a transept between the nave and the apse. This feature was soon found on churches elsewhere in Italy, in Greece and in Asia Minor, an example being the basilica of St Demetrius in Salonica.

Both Constantine the Great and his sons, and the high nobility of the period, built numerous basilicas in Constantinople, Rome and the Holy Land during the course of the 4th century. The type is known as the Constantinian basilica, and examples include the churches of San Giovanni Laterano (313–319), San Pietro, and San Paolo fuori le Mura in Rome, the Church of the Holy Sepulchre in Jerusalem (which combines the basilical and circular types of construction), the basilica on the Mount of Olives, and the Church of the Nativity at Bethlehem, which still retains something of its original form today. The oldest basilica in Constantinople itself was probably the original Hagia Sophia. This church no longer exists, but it is described in the *History of the Church*, written by the 4th century historian Eusebius of Caesarea. According to this work, the building had a nave and four aisles and was equipped with galleries like the basilicas in Jerusalem and Bethlehem.

An important 5th century example of this type is the basilica of the Monastery of Studies in Constantinople, which was consecrated to John the Baptist. It has the customary nave and two aisles, and the atrium has doorways on its western, southern and northern sides. The entrance door on the east side of the atrium leads into a colonnaded narthex with galleries like those in the aisles. The latter were occupied by women when they attended services, and were among the features common to basilicas in both Constantinople and Asia Minor. Other common features were the antechambers on either side of the apse which were to develop into sacristies, and the use of bricks, which

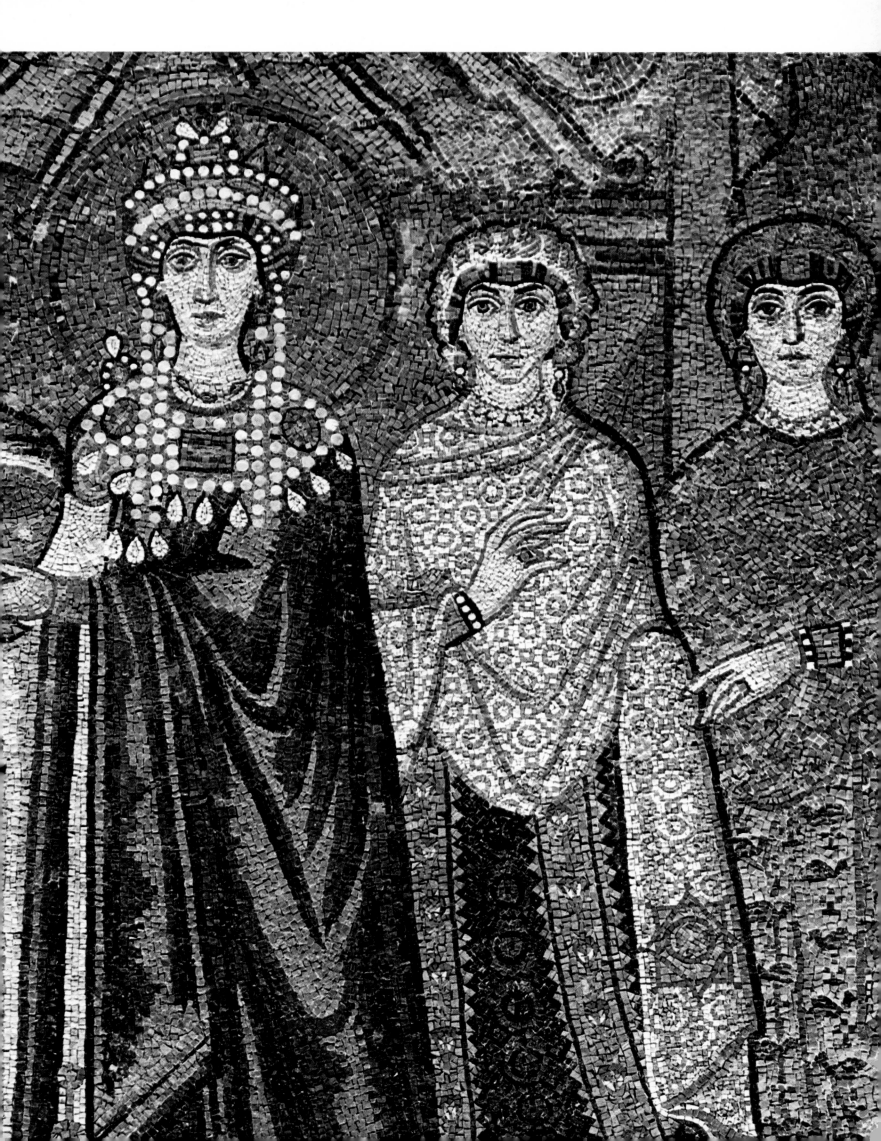

15 The emperor Justinian with his retinue, mosaic in the apse of San Vitale, circa 547. The portrait of the emperor is on the north wall, with that of his wife forming a pendent to it on the south wall. The emperor stands in the centre of the picture, flanked by bishops and officers. The mosaic consists mainly of tesserae of coloured glass and glass inset with gold leaf, but mother of pearl is also used. The gleaming gold contrasts with the vivid colours of the remaining tesserae to provide an atmosphere of religious solemnity. The two mosaics together are an outstanding example of Byzantine mosaic art.

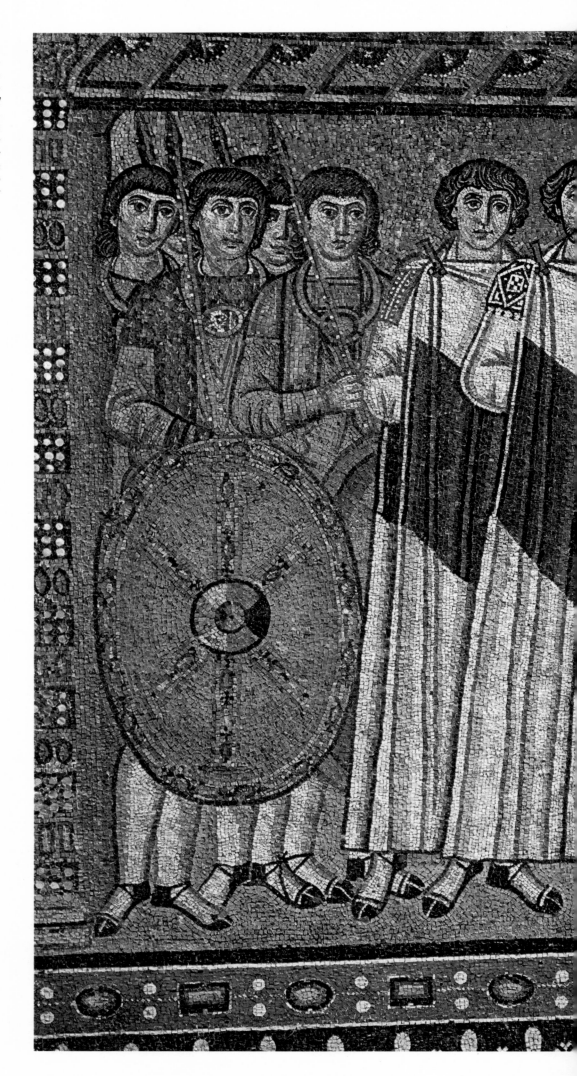

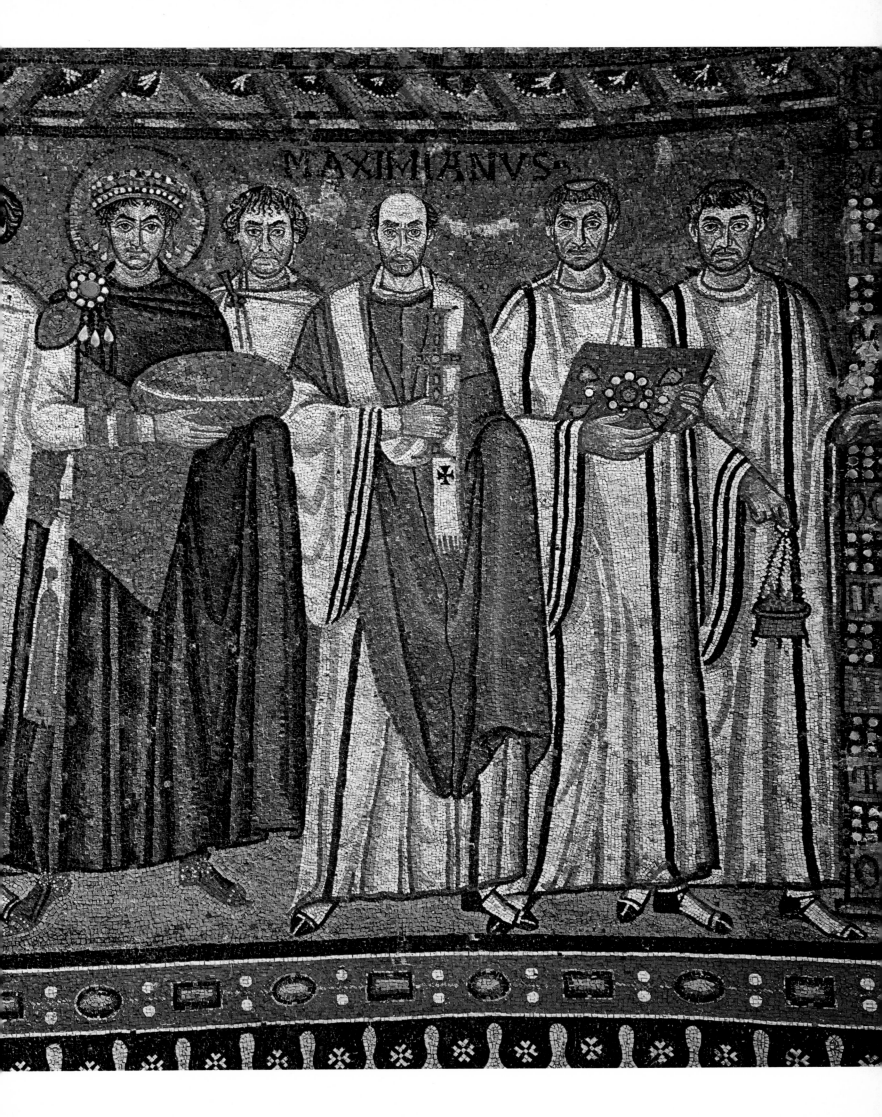

appeared for the first time during the 5th century. The Oriental character of these buildings emerges most clearly in the basilicas of Acheiropoietos and St Demetrius in Salonica.

Galla Placidia had travelled to Italy with the army assembled by her supporters, and had conquered Ravenna. From there she ruled Italy, visiting Milan and Rome from time to time. As a result, the influence of Byzantine art in Italy increased steadily from the 5th century. Nevertheless, Christian architecture in Italy during this period firmly retained its individuality, often expressing local tastes and customs. The influence of the Byzantine basilica on its products is revealed in the use of Oriental bricks, the rows of granite columns, and the long central limb incorporating the nave, with ante-chambers on either side; but the absence of galleries and the use of blind arcades as a means of decorating the outside walls are characteristically Italian. In Rome the basilicas of Santa Maria Maggiore and Santa Sabina still survive from this period. In Asia Minor and Northern Mesopotamia there are examples such as the church of Bin-bir-Kilisse, which differs from the timber-roofed basilica in having a vaulted ceiling. Owing to the lack of wood in these areas, brick vaulting was adopted at an early date, and its use greatly influenced the domed basilicas of the following period.

Of the painting of this period practically nothing remains. In order to learn something of its state at the time we must turn to the few surviving examples of mosaic work. Here we find images which are clearly rooted in the Graeco-Roman tradition while done in a style with strongly Oriental elements. The fine floor mosaic which once decorated the Great Palace in Constantinople now forms the basis of the Museum of Mosaics in Istanbul. It is one of the few profane examples from the reign of Theodosius II, including representations of figures, groups of animals and hunters, and symbols of the seasons. The movement of the figures, the manner of shading and the powerful sculptural quality of the images are all distinctly Classical in character. Floor mosaics such as this provide the only means of studying contemporary styles of decoration in architecture; numerous examples have also been preserved in the museum in Antioch.

Christian painting is represented by the mosaics used to decorate churches. The floor mosaic in the church of Aquileia in Italy contains ornaments and motifs from Bible stories, while still resembling the pagan mosaics of an earlier age. Similarly, the vine branches in the scenes of the wine harvest which are depicted on the ceiling of the basilica of Santa Costanza in Rome are reminiscent of the vine tendril motifs of antiquity. In fact the surviving examples of early mosaics in Italy all adhere to the Roman tradition. Among these are the scene of Christ and his apostles in the chapel of San Aquilino in the church of San Lorenzo in Milan, which adopted the style of the mosaic art of Ravenna, and the apse mosaic in the church of Santa Pudentiana in Rome, which is imbued with a calm Oriental atmosphere, while simultaneously showing remnants of Classical influence in its composition and the treatment of the figures.

Among the best known mosaics of this period are those which decorate the dome of the Church of St George and the small Church of Hosios David in Salonica. The mosaics in the rotunda of St George date from the period between the end of the 4th and the beginning of the 6th centuries. The mosaic from the apex of the dome, which was supported by four angels, has been lost. However, the part which lies beneath, bearing a representation of the martyrs of the Eastern Church on a gold ground, is still in good condition. These magnificent figures are full of Classical grace, but the manner of their treatment, with large eyes, slightly unequal bodies and an abstract representation of space, shows signs of the transition to the later period. The mosaic in Hosios David, dating from the end of the 5th century, depicts the Vision of Ezekiel: Christ is seated on a rainbow, surrounded by the figures of the four Evangelists. A bent figure stands in the lower left corner. Despite the biblical subject, the figure of Christ is done very much in the Hellenistic manner.

46

Neither frescoes, icons or manuscripts have survived from this period, but this does not mean to say that they were not produced. Indeed, they probably played an important role in the development of Christian art. Unlike painting, which took on a new lease of life and developed into an art of great beauty, sculpture, which had merely adopted the traditional conventions of Rome, went into a decline. From the 4th century, the Romans ceased depicting naked bodies and began to produce portraits of soldiers and emperors. This tendency also influenced Byzantine art, but here the traditional Oriental style gradually prevailed, and most of the works produced were closer to painting than to sculpture, being done in very low relief rather than sculpted in the round.

The Iconoclast Period

At the beginning of the 8th century, Leo III, a Syrian, mounted the imperial throne, having overthrown the Heraclean dynasty, which had become politically unstable. His accession marked the beginning of the Iconoclast movement, which was to shake the Empire to its foundations for more than a century.

The word iconoclasm is formed by the combination of two Greek words, *eikon* (picture) and *klae* (to break), and usually refers to the destruction of religious images. During the Iconoclast period, the people of the Byzantine Empire were split into two factions, the Iconodules, who venerated the images of saints, and the Iconoclasts, who favoured their destruction.

The question of whether or not it was right to venerate holy images had been a cause of strife since the beginning of Christianity, but it was not until the Byzantine period that the conflict came to affect the whole Empire. In a number of respects, the Byzantines' characteristic attitude towards art is expressed partcularly clearly in the Iconoclast period, and a knowledge of the direct causes of the coflict and the opinions expressed by the opposing factions will help us towards a better understanding of Byzantine art in general.

The two main philosophical currents underlying the intellectual world of the Greek peoples, including the medieval Byzantines, are those of Platonism and Aristotelianism. Platonic thought and its derivative, Neoplatonism, became mingled with the original teaching of Christ to provide a deep spiritual foundation for Byzantine life. According to certain of Plato's *Dialogues*, all figures and images created by the hand of man, including works of art, are a falsehood, which deceives man's weak senses by giving the appearance of being real. In Plato's later works such as the *Timaios*, however, a somewhat different opinion appears. Here he maintains that the cosmos, which is in a state of beautiful harmony, is not an incomplete copy of an original concept, but rather a reflection of the completeness of the supreme idea. This theory was adopted by Philo, the Alexandrian philosopher, who regarded the true logos of the cosmos as the image (*eikon*) of God. This tradition was adopted by Christianity. St Paul, for instances, says 'and as we have borne the image (*eikon*) of the earthly, we shall also bear the image of the heavenly' (I Corinthians 15, 49). Also according to St Paul, the believer is renewed in the image of his creator (I Colossians 3, 10). This positive attitude towards God and his image was taken up by larger Christian thinkers. The cosmology of the pseudonymous Dionysius the Areopagite in particular reflects this Platonic tradition, and he goes so far as to say that the earthly order which is visible to us is nothing but the reflection of the heavenly, invisible order governed by reason.

Another positive aspect of the Christian attitude towards images is its concept of the 'similarity' (*homoiosis*) between the image of God and that of man. In the book of Genesis, 1, 26, we find the words, 'And God said, Let us make man in our image, after our likeness . . .' This concept of the similarity between the image of God and that of man was soon extended to imply a similarity between God and his likeness, or icon, and this, together with the

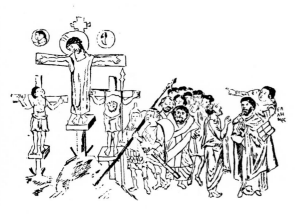

Illustrations from a manuscript of the Iconoclast period.

47

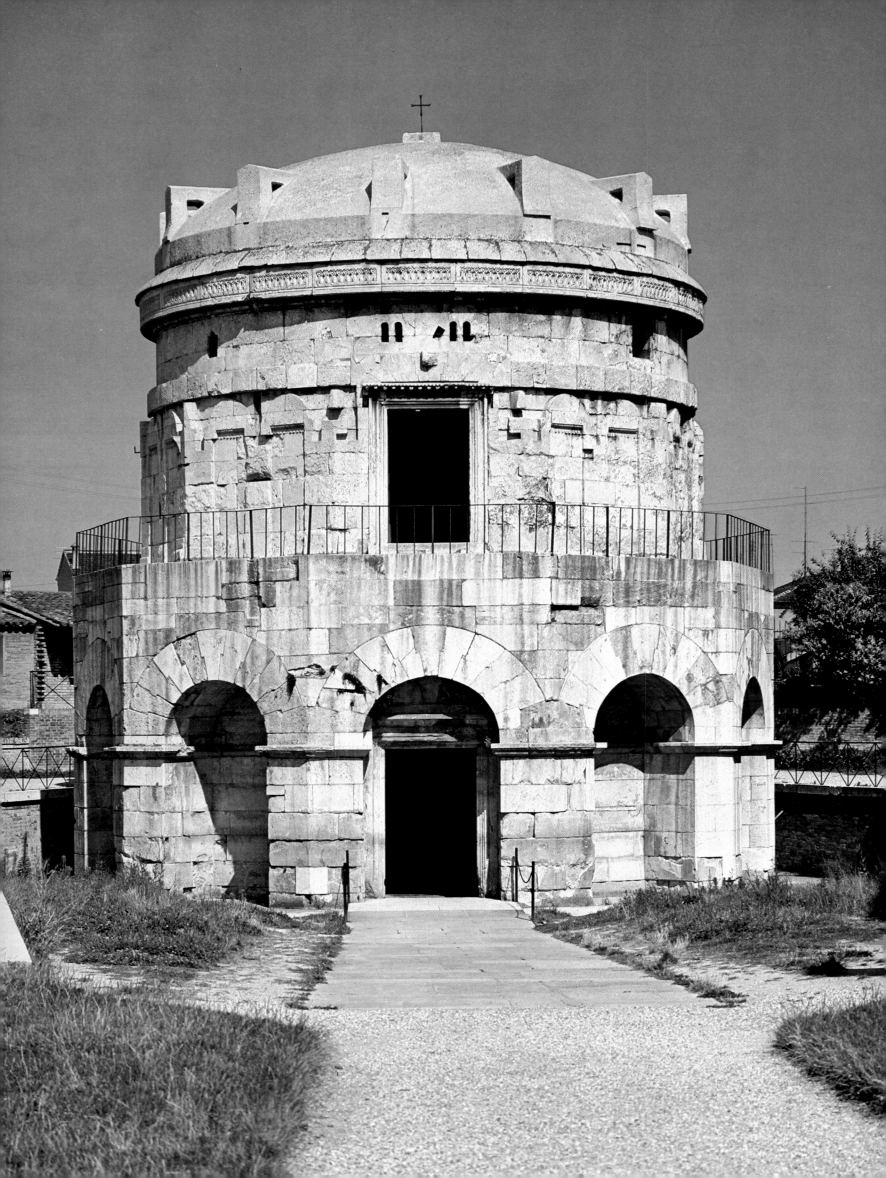

elements from the Platonic tradition already mentioned, was used to add weight to the arguments of the Iconoclasts.

With its origins in the Judaic faith, Christianity has always avoided pictorial representations of sacred subjects. The second Commandment says 'Thou shalt not make unto thee any graven image, or any likeness of any thing that is in heaven above, or that is in the earth beneath, or that is in the water under the earth: Thou shalt not bow down thyself to them, nor serve them.' (Exodus 20, 4–5). The earliest fathers of the Church, Tertullianus, Eusebius of Caesarea, Clement of Alexandria and others, clearly expressed their opposition to the use of images of God. But not all Jews and Christians observed this prohibition. Among those believers who came from the Graeco-Roman world with its long artistic tradition, there was an increasing desire to see Christ and the apostles represented in pictorial form, and to have the Bible stories brought to life by illustrations. In the year 313, Constantine the Great gave Christianity official recognition by the so-called Edict of Tolerance of Milan, and this was the signal for a flood of Christian art throughout the Mediterranean which combined the heritage of Judaeo-Christian thought with the creative power of the Hellenistic world.

Among the various forms of Christian art which subsequently appeared, the Iconclastic dispute was focussed on the works known as icons in the narrower sense, which were usually portable images of Christ and the Virgin Mary or the saints. There are varying opinions as to the origin of icons, and one traces them back to the imperial portraits of antiquity. Since the emperors of Ancient Rome were worshipped as gods, their likeness was also considered holy. And when Christ came to replace the earthly ruler in the minds of believers as the king of kings and ruler of all mankind, the image of Christ naturally received the same veneration as portraits of the emperor had previously. Another possible origin of icons is to be found in the veneration of holy relics, which spread very quickly through the Christian world from the 4th century onwards. The simple believers of the early Christian period, whatever their station in life, were particularly eager for anything which purported to be a part of the remains of a saint, or a piece of the Holy Cross. It is thought that holy relics of this kind were carried in reliquaries which bore the figure of the saint in question on the lid. Their owners may have believed that these reliquary caskets were imbued with a supernatural power, and this would soon have led to the belief that the saint's portrait on the casket was possessed of the same holy force.

This current of naive belief soon threw up legends about pictures which were 'not made by the hand of men' (*acheiropoietos*), and icons with particular legends attached to them appeared in large numbers. Soon a great wave of icon worship had engulfed the whole Byzantine Empire, and it is small wonder that many people regarded this new development as distasteful and reacted violently against it. Foremost among these were the Jews, who still observed their traditional commandments, and the Muslims, then beginning to settle on the borders of the kingdom, whose own doctrines forbade all pictorial representations of sacred subjects. Among the Christians, too, the movement was opposed by adherents of the radical and heretical Pauline school. Finally there were those who had no doctrinal objections to icons, but who detested the emperor and the ruling classes, who were beginning to insist on a cult of their own images under the pretext of iconoduly. And there were those among the rulers themselves who wished to restrict the power which the monasteries were rapidly appropriating for themselves as the chief representatives of icon worship. These rulers declared war on all icon-worshippers both within the Byzantine Empire and elsewhere. First of all the Muslim leader, Caliph Yazid II, ordered the destruction of all images, whereupon the emperor Leo III forbade icon worship, at first in a sermon in 726 and then more unequivocally in an edict of 730. These measure resulted in widespread uproar throughout the kingdom, in which religion, politics, local differences and various other factors were inextricably entangled.

The decision naturally had a far-reaching effect on Christian art. Firstly, all

16 Mausoleum of Theodoric, mid 6th century. This building, which follows the traditional mausoleum architecture of the late Classical period, is thought to be the mausoleum of the Ostrogoth king Theodoric, who died in 526. It has a ten-sided ground plan and is built in two storeys. The thick stone walls, which are of large, regularly laid blocks of masonry, are topped by a monolithic slab. The building's external appearance is suggestive of a sculpture, and the handle-like projections round the edge of the dome are unusual. The sarcophagus was housed in the lower storey, while the upper storey was used as a chapel.

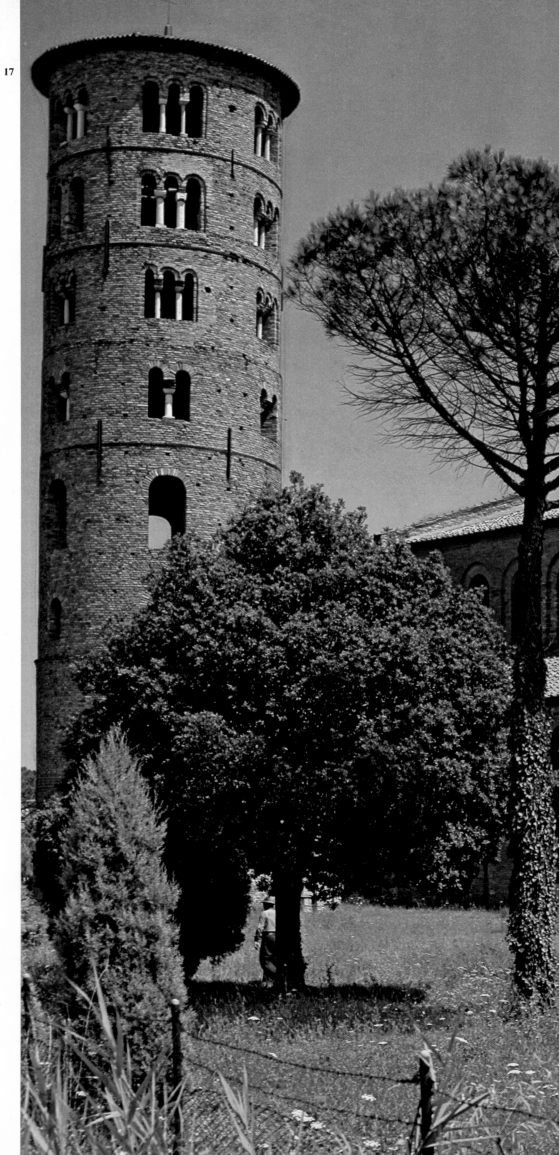

17 The church of Sant'Apollinare in Classe, circa 533–549. Erected by archbishop Maximianus near the ancient port of Classe, this basical structure is very similar to Sant 'Apollinare Nuovo. The lines of the exterior are cleanly drawn, and harmonize well with the campanile, which dates from around the 10th century. The long flat bricks used in the construction of the walls are characteristic of Ravenna.

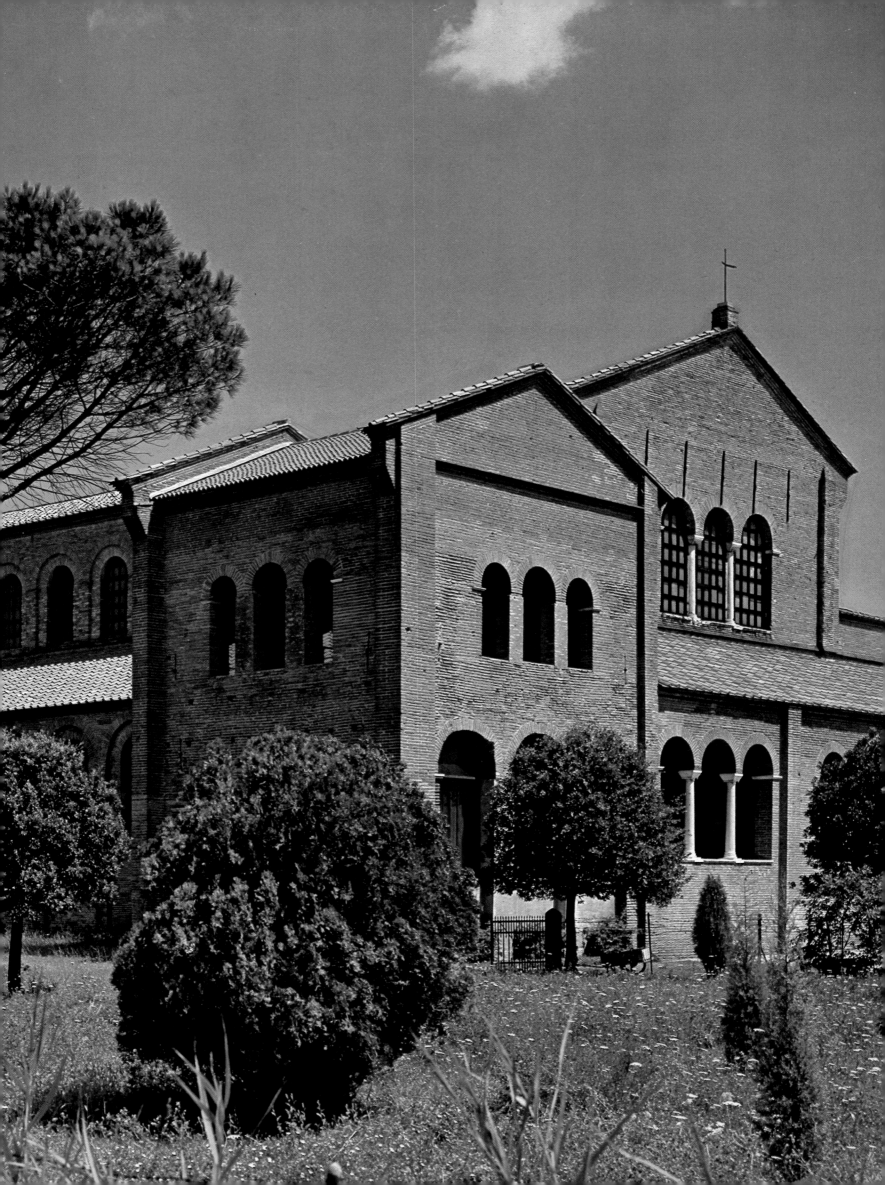

existing images of saints in the capital and elsewhere were destroyed and replaced by the Cross or other symbols and ornamental calligraphy, which were devoid of figural content. The results can be seen in the Hagia Eirene or Church of St Irene in Istanbul and some of the rock chapels in Cappadocia. Naturally the production of saints' portraits was now forbidden, and instead painters turned their hand to landscapes and other subjects which had nothing to do with religion. The icon worshippers and painters – most of whom were monks – were persecuted unmercifully and frequently put to death.

In this initial phase of the conflict, Germanos I and numerous others attempted to resist the tide of events, and defended the practice of icon-worship. In the theoretical struggle which developed at this time, the leading part was played by St John of Damascus, who based his arguments in favour of icons on the doctrine of the Incarnation. He claimed that just as God had become flesh in the figure of Christ, so the sacred power of God was present in an icon, which thus underwent a kind of transubstantiation. This idea is related on the one hand to Dionysius the Areopagite's doctrine of the similarity between the heavenly and earthly orders. On the other it is linked with the doctrines of St Basil of Caesarea, who stated that iconoduly is directed not at the icon itself, but at the original which it represents.

As a result of these efforts, the iconodulist faction won a temporary victory at the Ecumenical Council of Nicaea in 787. The edict issued by the Council came into the hands of Charlemagne, who at that time was trying to bring the whole Roman Catholic world of Western Europe under his rule. Whereas the Greeks had a natural penchant for abstract speculation, Charlemagne was a typically down-to-earth Western ruler, and he had no time for the hair-splitting arguments of the Byzantine Church father on the subject of icon-worship. He therefore issued the so-called *Libri carolini*, in which he himself took a firm stand on the subject, derived from the traditional Western doctrine on figural representation which had been founded by St Gregory the Great. Simultaneously with this development, Christian art in the West took a very different path from that of Christian art in Eastern Europe. For in the East, the victory of the iconodulist faction was short-lived. In 815, Leo V, of the Isaurian dynasty, expelled the icondulist patriarch Nicephorus from the patriarchate, and the ban on icons was re-established. In this second half of the conflict, the leading role, next to Nicephorus, was played by Theodore, a patriarch from the Monastery of Studios in Constantinople (cf. following chapter). Theodore reinforced the doctrine of the Incarnation put forward by his predecessor, St John of Damascus, and suggested that the observation (*antopsia*) of a holy image was equivalent to the contemplation (*theoria*) of the mystical in the Incarnation of Christ. Citing Dionysius the Areopagite as his source, he also asserted that God stood in a relationship of similarity with his image, and in essence was one with the latter, although the two were different in substance (*ousia*).

Shortly afterwards, on Christmas day 820, Michael II of Amorion murdered Leo V during the divine service, and it looked as though the situation would suddenly change. But the final solution of the conflict was not reached until the death of Theophilus, the last Iconoclast emperor, in 842. The council which met in the following year proclaimed a return to orthodoxy after more than a century of Iconoclastic conflict.

Byzantium after the End of the Iconoclast Period

In the year 867, Basil of Macedonia, who was then co-emperor, murdered the emperor Michael with his own hands while he was in a drunken stupor after a banquet, and seized his throne. This was the beginning of the Macedonian dynasty, which brought the Empire a period of renewed prosperity comparable to that which it had known under Justinian.

The period from Basil I's usurpation of power to 1081, the year in which Alexeios I Comnenos mounted the throne, is divided into two by the death of Basil II (1025). Between the second half of the 9th century and the beginning of the 11th, the Empire witnessed an era of unprecedented progress under a series of outstanding rulers. This was matched by a brilliant renaissance of the arts, which was centred on the imperial court at Constantinople. The cultural activities sponsored by the son of Basil the Great, Leo VI (886–912), and his son Constantine VII Porphyrogennetos (913–959) are particularly notable. They did not have the political and military skills of great rulers such as Basil the Great and Basil II, but instead they possessed an outstanding talent for literature and art which brought a breath of fresh air into the dull atmosphere left by the aftermath of the Iconoclastic struggles. Ancient literature, science and the arts all flourished at the court once more, and the artistic movement which marked this first half of the Macedonian dynasty is known as the Macedonian Renaissance.

During the first half of the 11th century, the spiritual element in the graphic arts became more and more pronounced. The main impetus for this development was probably given by the monasteries, and particularly by the Monastery of Studios in the Byzantine capital. And with it, the emphasis on spirituality which is the essential characteristic of Byzantine art found a new fullness of expression.

Architecture

The dome was one of the Byzantine architects' favourite devices, but it was by no means new. It was already to be found in the Roman architectural tradition, and had long been used in the lands on the far eastern boundaries of the Byzantine Empire. The dome had symbolized the infinity of the heavens since time immemorial, and in the Christian era it was a symbol of the mystical cosmos in the Neoplatonic sense. It was considered the holiest place in the church. The structure beneath the dome was sometimes cross-shaped or polygonal, but the ground plan most frequently used was that of a square, and a variety of methods were used in covering this structure with a hemispherical vault. One of these was the use of pendentives, the basic principle of which is as follows. A single arch is erected on each side of the square so that the foot of each touches that of its neighbour at the corner. In this way a curved triangular space is produced between the adjacent arches, and this is filled in with masonry, so that the apexes of the four arches are joined together. The spandrel produced in this manner is called a pendentive. Seen from above, it results in a circular figure joining the apexes of the arches, with the inner sides of the square lying at a tangent to this figure. The dome is then erected on top of this arrangement. The great dome of the Hagia Sophia in Constantinople is constructed in this way.

Another method is the use of squinches, whereby the corners of the square beneath the dome are bridged to form an octagon. The squinches are small arches or quarter-spherical vaults which are erected diagonally across the corners to provide a base for the dome.

The ground plan which was to become the norm for Byzantine architecture first appeared in the time of the Macedonian dynasty. Its form is that of a Greek cross, which is a figure with four arms of equal length extending from a

central square. The crossing in the centre is covered with a dome, supported in the manner already described. In the Catholicon of the Monastery of Hosios Lukas, which was built between Athens and the shrine of Delphi at the beginning of the 11th century, the central dome is supported on squinches, while the small dome between this and the apse can be said to use pendentives. The internal space is divided up by numerous pillars and walls, which together with the galleries and lofts give an overall impression of great complexity. There is an open space beneath the central dome, and the scattered light which reaches this creates a calm, twilit atmosphere. Slabs of dark green or deep red marble are set into the walls, and the figures of the Virgin and the saints depicted on the various domes, vaults and arcades appear against backgrounds of gleaming matt gold, from which their shining eyes seem to gaze directly at the observer. The central dome, as the highest point in the interior, probably bore a figure of Christ as Pantocrator gazing sternly down on those assembled at his feet, but this has now disappeared. Another feature of the cruciform buildings from the middle Byzantine period is the use of several domes grouped together on the roof. In the older churches there was only a large central dome, but in the middle period the four arms of the cross were also provided with domes, so that the roof now bore a total of five. Normally the central dome was the largest, while the other four were smaller. After the middle Byzantine period a circular or polygonal drum was used as a foundation for the dome, and this became gradually higher and higher, increasing the already exotic appearance of Byzantine churches. Brown bricks were used for the external walls. Blocks of white stone were laid between the courses, sometimes horizontally and sometimes at an angle, and the contrasting colours provided a rich decorative effect.

Mosaic Art

After the end of the Iconoclastic dispute, a number of major works were begun in the capital including the redecoration of the interior of the Hagia Sophia, and the renovation of the Church of the Holy Apostles. The latter has unfortunately been destroyed, but some idea of its impressiveness and size can be gained from St Mark's in Venice, which was probably modelled on the church in Constantinople. The magnificent decorations carried out in the Hagia Sophia after the Iconoclast period have only recently been revealed after a long eclipse, for the Muslims destroyed or plastered over many of the Christian images in the church when they turned it into a mosque after capturing the Byzantine capital. In the past few years American experts have been trying to restore the decorations to their pristine state, repairing the mutilated mosaics and removing the layers of plaster. The most magnificent of the mosaics now visible in the Hagia Sophia is possibly that of the Virgin and Child with two angels standing at her side, which was probably finished in 861. Its most notable feature is the Virgin's wide-eyed expression, which is not to be found in later mosaics. It seems imbued with a naive human warmth which indicates that the work has links with the traditional, Classical style of the pre-Macedonian period. There is a naive humanity also in the mosaic on the crescent-shaped wall which leads from the narthex to the nave. Here the figure of an emperor – thought to be Leo VI – is shown prostrating himself at the feet of the enthroned Christ Prokynesis.

By comparison with these works from the first half of the Macedonian period, one of the mosaics in the gallery of the Hagia Sophia is far more advanced and linear in character. In the group which shows Christ with Constantine IX Monomachos and his wife Zoe at his side (plates 24 to 26) the face of Christ and the folds of his robe in particular show a tendency towards abstraction which was unknown in the 9th century. They give an impression of spirituality which is characteristic of 11th century works and finds its clearest expression in the group of mosaics at Hosios Lukas which we have already mentioned.

18 Interior of the church of Sant'Apollinare in Classe. Of basilical form with a nave and two aisles, the interior of this church is remarkably spacious. The apse and the triumphal arch are decorated with mosaics dating from the time of its construction. The stylized rendering of the different motifs in the apse – the Cross, St Apollinaris and the sheep – gives the mosaic an effective simplicity and symbolic force. The marble which once covered the side walls was lost in the 15th century.

Structure of a wall mosaic
1 Brick
2 Coarse layer of mortar
3 Finer layer of mortar
4 Finest layer of mortar
5 Tesserae inset with a layer of gold leaf
6 Tesserae

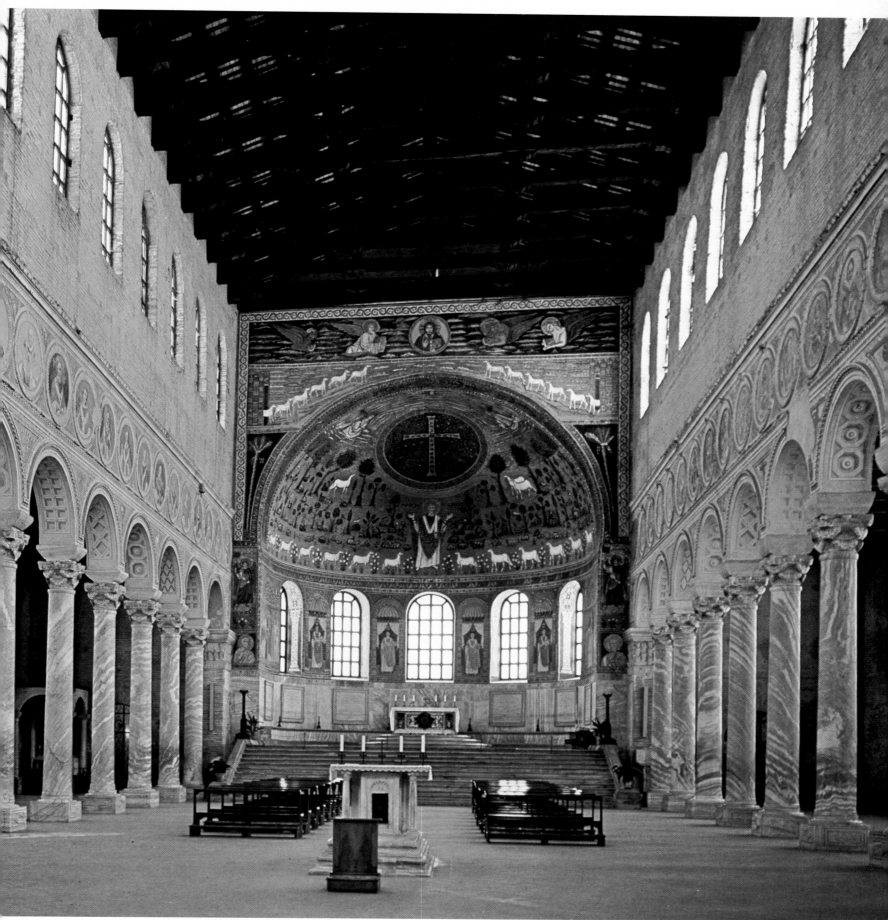

Wall paintings

Mosaics were the primary form of wall decoration in buildings in Constantinople at this time, and we must go outside the capital to find the most important examples of mural painting. There are frescoes probably dating from the 11th century in the underground chapel of Hosios Lukas, but they are of inferior quality, and better examples are to be found in the cathedral of St Sophia in Ohrid in Yugoslavian Macedonia and elsewhere. The large numbers of wall paintings preserved in the rock chapels of Cappadocia are of great historical significance, although they are works of an essentially local nature. The earliest groups among the frescoes here, which were first interpreted by Jerphanion, Thierry and others at the beginning of this century, date back to the time of the Iconoclastic conflict in the 8th century. One of the churches at Göreme, for example, is decorated in an entirely non-figural style, only the Cross and various ornamental motifs being used. In the old cave church of Tokale Kilisse in Göreme, dating from the 9th century, there are however numerous depictions of scenes from the life of Christ which are unexampled in the surviving paintings from the middle Byzantine period.

Illuminated Manuscripts

The change of style which took place in the transition from the Macedonian to the Comnene dynasties is probably best followed through the medium of illuminated manuscripts. The art of illuminated manuscripts has its origins in the ancient world, and occupies an important position in Byzantine art alongside the mosaics. Here the Classical element in the Macedonian dynasty came particularly to the fore, and the art of the so-called Macedonian Renaissance reached the height of its expression. The illuminations in the manuscript of the Homilies of Gregory of Nazianzus, probably commissioned by Basil I, are a good example of this, and have a particularly strong Classical flavour. In many of the illuminations of stories from the Old and New Testaments, the figures are dressed in Classical garments. Their facial expressions, the fantastic colouring and other characteristic features all echo the old tradition originating in the period before the Iconoclastic conflicts. But the Classical tendency in Byzantine art is shown even more clearly in the manuscripts known as the Aristocratic Psalters. The most famous of these is the Paris Psalter, which is in the Bibliothèque Nationale in Paris. Here the landscapes and buildings which form the background to the stories and figures from the Old Testament seem to have come directly from the wall paintings at Pompei, and Classical symbols are used everywhere, as if they had been directly copied from the sarcophagi of Ancient Rome. In fact it is obvious from the first glance that the psalter was designed to satisfy the taste of the nobles of the time, who were interested in a renaissance of the old traditions. In another group of manuscript psalters, known as the Monastic Psalters, there are on the other hand scarcely any Classical elements. The figures which cover the edges of the pages are so naively drawn as to appear almost crude, though they are full of vitality and movement. Among the Monastic Psalters, there are considerable stylistic differences between the works from the beginning of the Macedonian dynasty and those from the period after the middle of the 11th century. A psalter produced in Constantinople in 1066, which is now in the British Museum, contains figures depicted in a flat ornamental style similar to that of cloisonné enamel work, which serve to remind us that Classicism and realism were not the only major currents in Byzantine culture.

Constantinople

19 *The Hagia Sophia, Istanbul, 537. The
4th century church of the same name having
been burnt down in the Nika uprising of 532,
the Emperor Justinian completed the building
of this colossal basilica in six years. The cost
was enormous, equivalent to some £136
million or $243 million in present-day values.
Its overall height is 180 feetf and it was, when
built, the largest church in Europe. The nearby
minaret was built by the Muslims. The
illustration shows the basilica from the south-
west side.*

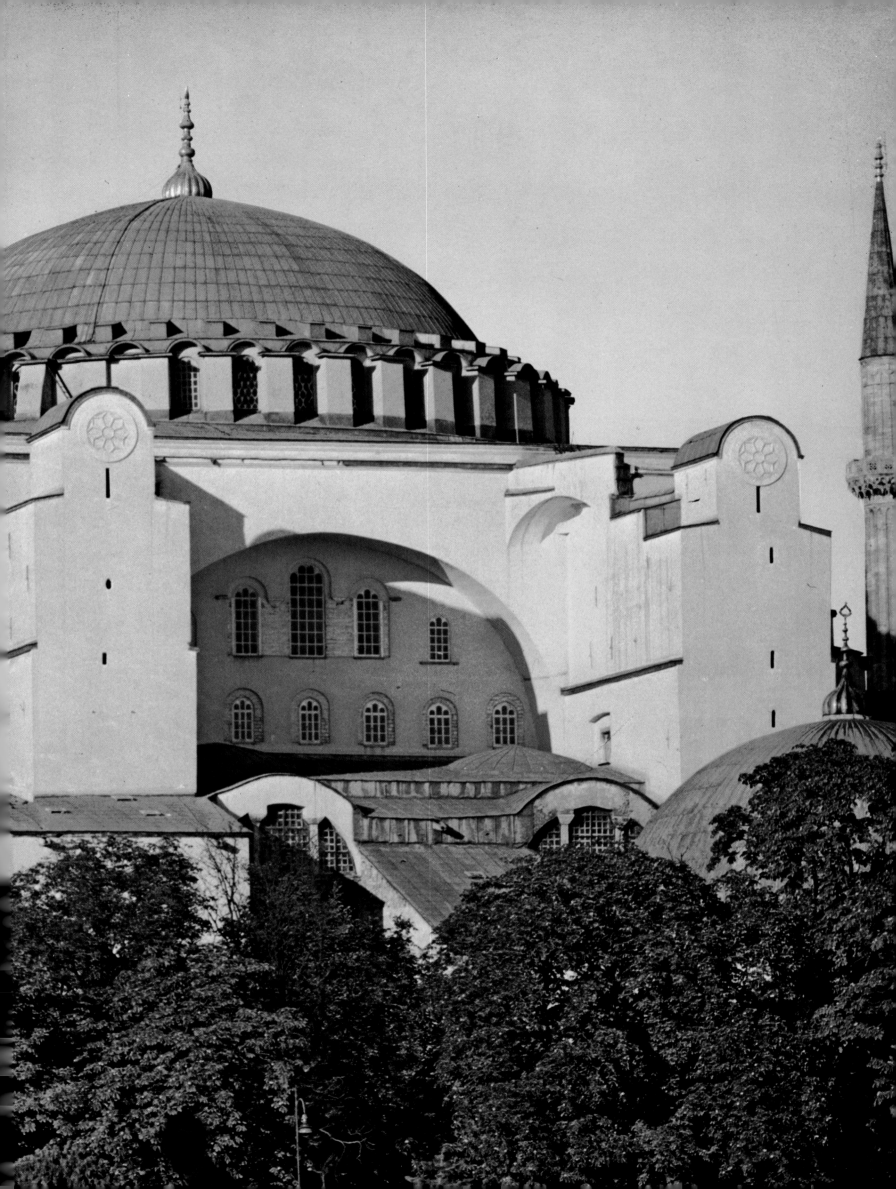

The Hagia Sophia

Between the 11th and 18th January 523 there was an uprising against Justinian and groups of rebels shouting '*Nika*' ('Victory') set fire to the Byzantine capital. After shutting itself in the stadium, the army of rebels was crushed by 3000 veterans of the Persian War, under the leadership of Belisarius. The Senate, the baths of Zeumius and the basilica of Hagia Eirene were among the buildings destroyed in the rebellion. The original basilica of Hagia Sophia, built by Constantine the Great in 325, had already been burnt down in the rebellion of 404 caused by the banishment of the patriarch Chrysostomos from Constantinople, but Theodosius II had rebuilt it. After it had been destroyed for the second time in the Nika uprising, Justinian the Great had plans drawn up for a greatly extended building. He wished to build a church 'such as there has never been since the time of Adam and will never be again', as a demonstration of his power and a means of suppressing the independent spirit of his subjects. This version of the Hagia Sophia is the one which we see today. The building was begun on 23 February 532 and finished nearly six years later on 27 December 537. On the day of consecration the emperor is said to have forgotten his imperial dignity and mounted the pulpit in an access of joy.

Some 100,000 workers were engaged in the building of this monumental church, which is 253 feet long and 234 feet wide. The dome rises 180 feet above the floor and has a diameter of 107 feet. It is a worthy monument to the achievements of the emperor Justinian and the first golden age of the Byzantine Empire. Justinian dreamed of reestablishing the old Roman Empire. In 533 his army had defeated the Vandals in North Africa, and in 536 he had entered Rome. Almost the whole of the Mediterranean coast was under his control; his dreams of world unity had brought him possession of Italy and North Africa in the west and contributed to the prosperity of the Empire as a whole. But the fact that the previous emperors had already embarked on the creation of an eastern nation meant that his plans undermined the strength of his empire. After his death, Heraclius succeeded temporarily in halting the decline of Byzantium, but by the beginning of the 8th century its territory consisted only of Anatolia, the coastal province of the Balkan peninsula and Southern Italy, and in 717 the Muslims laid siege to the capital, Constantinople.

20 Gallery of the Hagia Sophia, 537. The four corners of the nave of the Hagia Sophia, beneath the great dome, are concave and semi-circular in form. The illustration shows a view across the nave from one of the galleries, to the pillars of the gallery on the opposite side. The columns of different coloured marble emphasize the spaciousness of the interior. The capitals bear the initials of the emperor and his wife, surrounded by beautifully carved acanthus leaves.

Pages 62–63:
21 The central dome of the Hagia Sophia, 537–538. The structure is supported by four arches; it has a diameter of 107 feet and is lit by forty windows round the base. The building was originally fitted with an even shallower dome, but its precarious method of construction soon resulted in its collapse and it had to be rebuilt. The apex of the dome was probably decorated with a mosaic of the Cross or the name of Christ, but the Muslims replaced this with an inscription from the Koran.

Below: cross-section of the Hagia Sophia.

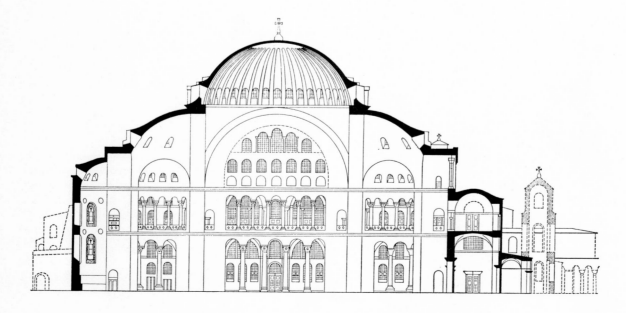

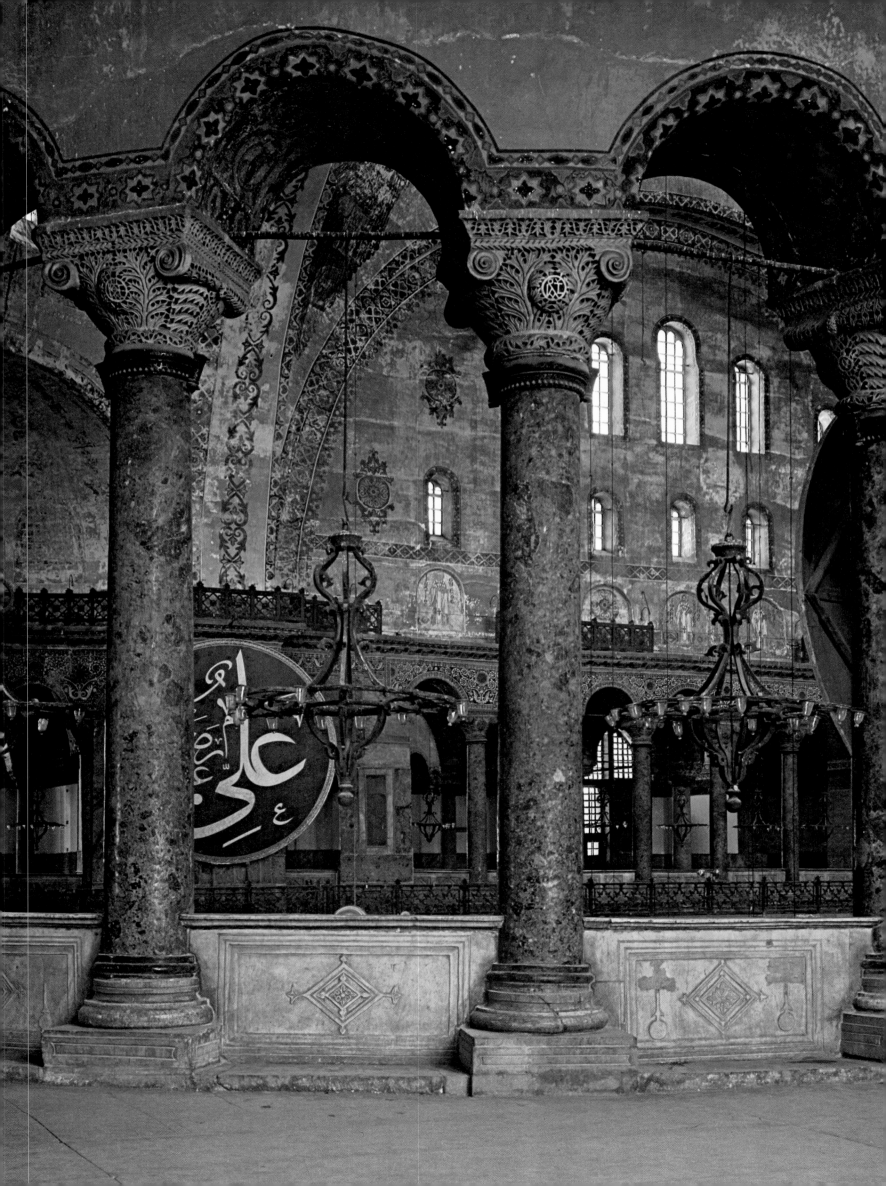

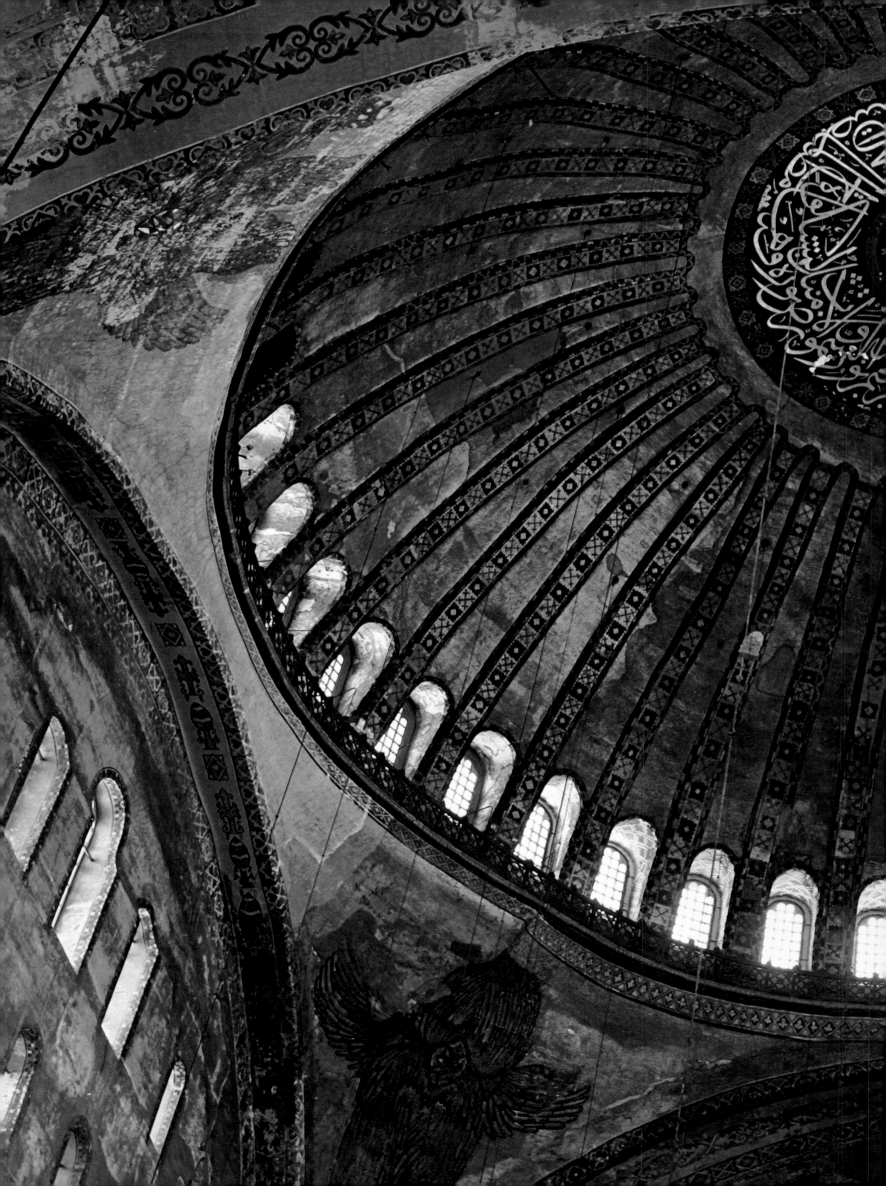

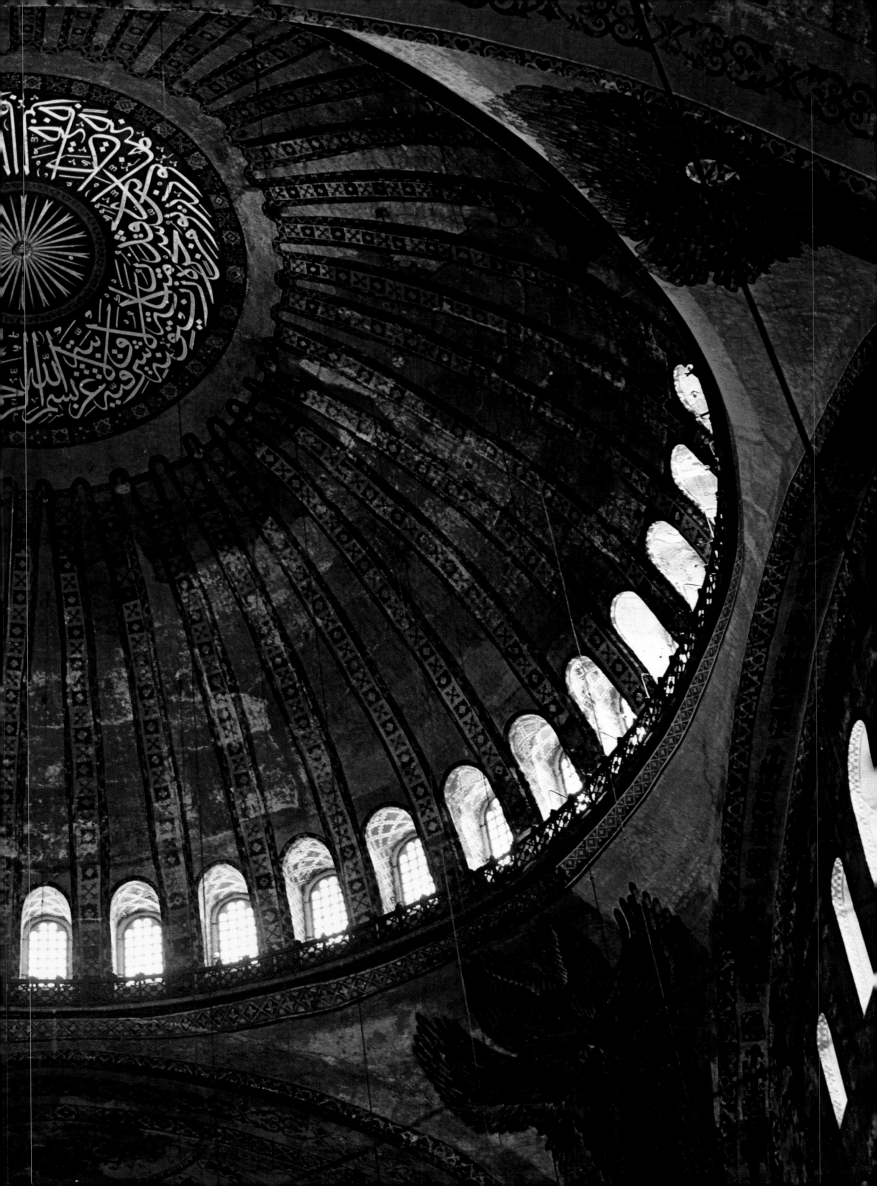

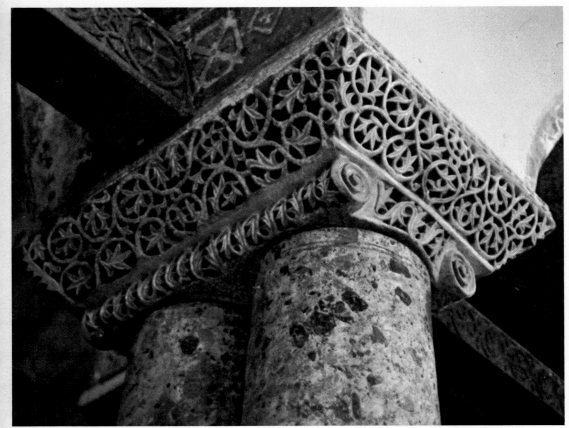

22, 23 Capitals and wall decoration, Hagia Sophia, 537. The individual architectural features in the interior of the Hagia Sophia are richly decorated. The area above the arcades at the four corners of the nave, for example, is faced with black marble inlaid with decorative motifs in white marble, producing an effect of Oriental splendour. The capitals are treated with a form of pierced decoration which creates a subtle play of light and shadow. The use of these lace-like motifs reflects the influence of the city's Eastern Mediterranean cultural tradition.

Justinian the Great can be considered the last of the Roman emperors and the first ruler of the Byzantine empire. Together with his wife Theodora, he brought prosperity to the capital and the provincial towns. The military installations which he built reflected his inclination towards despotism and his taste for luxury, and his court was renowned for its splendour. As emperor, he concerned himself not only with the extension of his territory but also with governmental reforms. He also codified Roman law and had the *Corpus juris civilis Justinianus* compiled in 527. In reorganizing the government he brought the church under his control and used it to strengthen his imperial power.

The Byzantine Empire before the 6th century was to some extent raw and disunited, and it was Justinian's efforts which brought it to full maturity. The Hagia Sophia was an expression of the complete realization of the Byzantine spirit. Highly developed techniques were available for its construction, and the finest materials were used. In the mosaics in the capital and those in Salinoca and Italy from the same period, we see Byzantine art at the height of its perfection.

From the beginning of the 6th century, many of the stone buildings erected in Constantinople had domes. The church of SS Sergius and Bacchus, built by Justinian in 527, has an octagonal central structure enclosed by external walls constructed on a nearly square ground plan. An atrium originally surrounded the entrance. The design is a deliberate combination of the centralized form of building normally found in Syria and Palestine and the basilica which was the traditional form of Christian church architecture. The idiosyncratic structure which results can be described as a domed basilica, a term which we shall use later in referring to the churches of Hagia Eirene and Hagia Sophia.

The Hagia Sophia has a number of peculiarities which are not to be found in other buildings, and is generally considered the greatest masterpiece in the history of Byzantine architecture.

When Justinian rebuilt the church after its destruction in the Nika uprising, he clearly intended it to be an expression of his authority and imperial power which would help to stifle any future rebellion at birth. He commissioned the

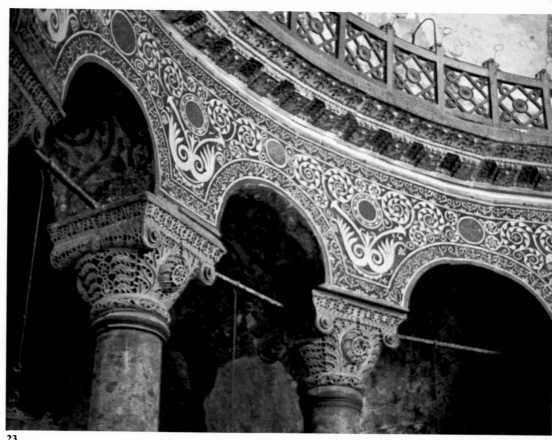

23

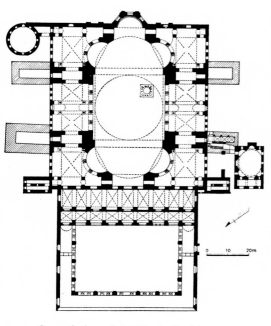

Ground plan of the Hagia Sophia.

design for the new structure from two architects, Anthemius of Tralles and Isodorus of Miletus. Both of them were natives of Anatolia, where they had already built a domed structure, and were well known both as architects and mathematicians. They were outstandingly gifted as architects, builders and painters, and were also well schooled in geometry and astromy.

From the outside, the church gives a somewhat heavy impression. The ribbed decoration on the interior of the dome and the forty windows surrounding its base make it appear lower than it is. The substantial piers which provide the main support for the dome on the north and south sides of the building help to strengthen this impression. The interior is arranged in the familiar tripartite form, but the nave is very large compared with the galleried aisles on either side. As a result the colossal central dome dominates the whole building, giving a sense of unity normally found only in centralized buildings. The main dome is supported on vast pendentives and large semi-domes extending to the east and west; at the eastern end, there are three niches with small semi-domes, the central one of which forms the apse. At the western end there are two more niches, one on either side of the entrance. On the south and north sides the main arches are filled in above the galleries by walls pierced with windows, which help to stiffen the structure of the main dome and support its weight. The building is designed so that the vaulting which forms the ceiling of the galleries and aisles distributes the weight of the main dome evenly throughout the structure. This technique is one of the main characteristics which differentiates Byzantine church architecture from that of the West. It was later developed by Byzantine architects to produce the five-domed type of construction consisting of a large main dome and four smaller ones, erected on a square or cruciform plan. Among the churches of this type are the church of St Sophia in Salonica and the Church of the Assumption at Nicaea.

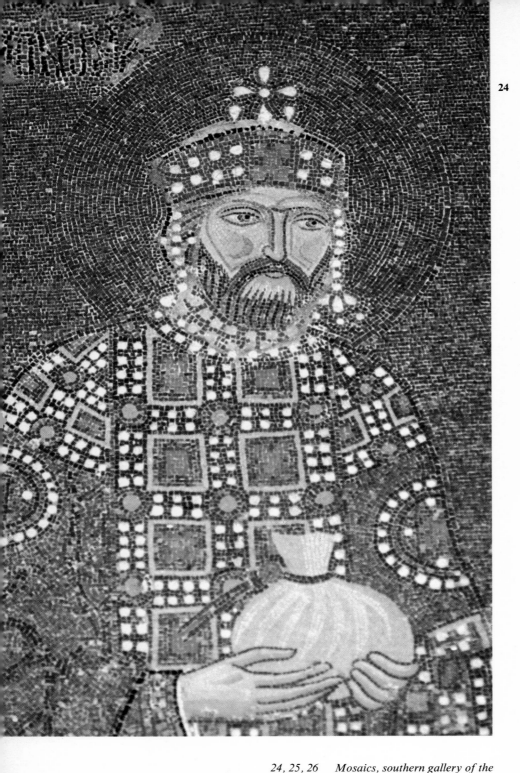

24, 25, 26　Mosaics, southern gallery of the Hagia Sophia, 11th century. The gallery of the Hagia Sophia is decorated with mosaics mostly created by successive emperors after the Iconoclast period. The result is a miniature museum of outstanding works of Byzantine art. The mosaics shown here decorate the area at the gallery's south-eastern corner, which once served as the emperor's waiting room. The figure of Christ as Pantocrator is enthroned in the middle of the design, and flanked by the emperor and empress, standing in attitudes of reverence with offerings in their hands. Above their heads are various inscriptions, including one which reads 'Constantine, true believer in God as Christ, the absolute ruler, the emperor of the Romans, Monomachos', and 'Zoe, the most pious empress'. Zoe was directly descended from the Macedonian emperor Basil, who was responsible for the empire's prosperity in the middle period. The preservation of the Mace-

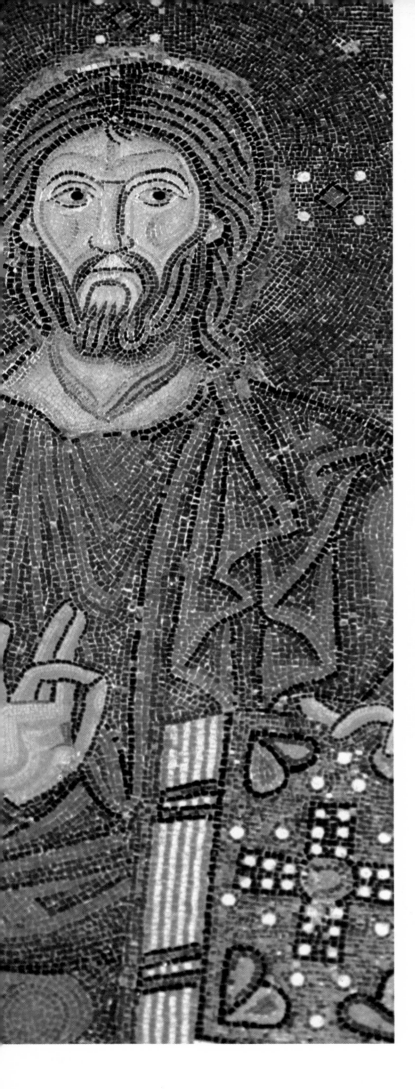

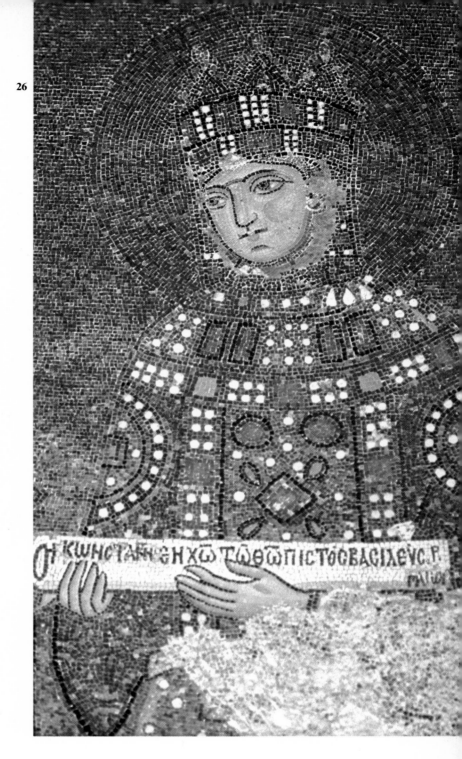

donian dynasty was a matter of state policy, and partly for this reason she married three different emperors in succession and ruled jointly with her younger sister, during the first half of the 11th century. She is one of the most dramatic figures in the history of the Byzantine empire. Constantine Monomachos was her third husband, and by the time she married him she was already sixty-two years old. In the mosaic she looks distinctly younger, and in fact the emperor shown with her was originally one of her previous husbands, whom she had married in middle age. After her third marriage, his name and face were apparently replaced by that of her new husband. The portraits are imbued with a sense of benevolent humanity, overlaid with the idealizing, abstract tendency characteristic of Byzantine art of the middle period. The latter contributes an element of spirituality and sophistication which is characteristically Oriental.

The Geographical Situation and Layout of the City

Constantinople lies on the hills on both sides of the southern exit of the Bosphosus, overlooking the Sea of Marmora at the narrowest point of the straits leading from the Black Sea to the Mediterranean. More than 2000 years before Christ it was already a vital link on the route from Eastern Europe to Asia Minor, providing a half-way house between the great cultures of Europe and the Orient. A good natural harbour, the Golden Horn, provided an ideal base for naval and commercial shipping. There was in fact a combination of circumstances which favoured its development into an important city.

The modern Turkish name for Constantinople is Istanbul. The city is spread across three separate peninsular areas, and each sector is entirely different from the others. The area on the eastern side of the Bosphorus, beyond which the Anatolian plateau stretches away towards Asia, is now called Üsküdar. The western side, adjoining the European continent, is divided into two parts by the Golden Horn. The northern part of this was formerly called Pera, but is now Beyoglu, while on the southern side is the old city of Konstantinopolis with all its historical associations, now known as Stamboul. These two districts are linked by the Aratürk and Galata bridges, which span the Golden Horn. The harbour is said to be so named because it is shaped like an ox horn, and the water shines gold in the evening sun. During the Byzantine period, riches poured into the city from all directions. From China and India in the east came silk, ivory and spices; food for the substantial population came from Anatolia and Egypt in the south, while in the north, skins and furs from Russia were brought down the Danube and across the Black Sea. All roads led to Constantinople, and its waterways formed a gigantic harbour well suited to the capital of an empire.

On a hill in Üsküdar stands the barracks in which Florence Nightingale stayed during the Crimean War (1853–1856); it is now an army medical school. Üsküdar was formerly Chrysopolis, the historical site where Constantine the Great defeated his imperial rival Licinius for the second time. Licinius begged for mercy through his wife, who was Constantine's sister, and was taken to Salonica, but finally put to death in 324. It was from this time that Constantine nursed the hope of uniting the Roman world under a single emperor. He established his capital in the old city of Byzantion, realising the advantages of its situation and appreciating all that its natural beauty and the proximity of the East with all its riches would add to the splendour of his court. The fact that the city was an important centre of communications by land and sea must have weighed heavily in his decision.

Beyoglu contains the newer parts of the town, with Taksim Square in the centre, surrounded by modern buildings; the old business quarter is centred on the Tower of Galata. During the reign of Theodosius II the district was incorporated into the city of Constantinople and surrounded with walls. It was a particularly prosperous sector, most notable for its flourishing business quarter run by the Genoese; later a Venetian colony was also started there. After the collapse of the Byzantine Empire, the Genoese were governed by their own feudal lords, and the district became independent. Today the walls are gone, but the Tower of Galata is still an impressive sight. Originally built in the time of Anastasius I (491–510), it was destroyed in 1261 and rebuilt by the Genoese in 1349.

Istanbul had once been a colony of Ancient Greece. Constantine realised his dream of making it a new Rome, and laid plans for a great wall enclosing the seven hills on which the city was built. The site was naturally an important cultural centre, and today it is an area full of history. One has only to enter it to feel the presence of an ancient culture, and the relics of successive ages can be everywhere observed. In the time of Ancient Greece, the tip of the old city, projecting into the Bosphorus, was the site of the Acropolis of Byzantion. **27**

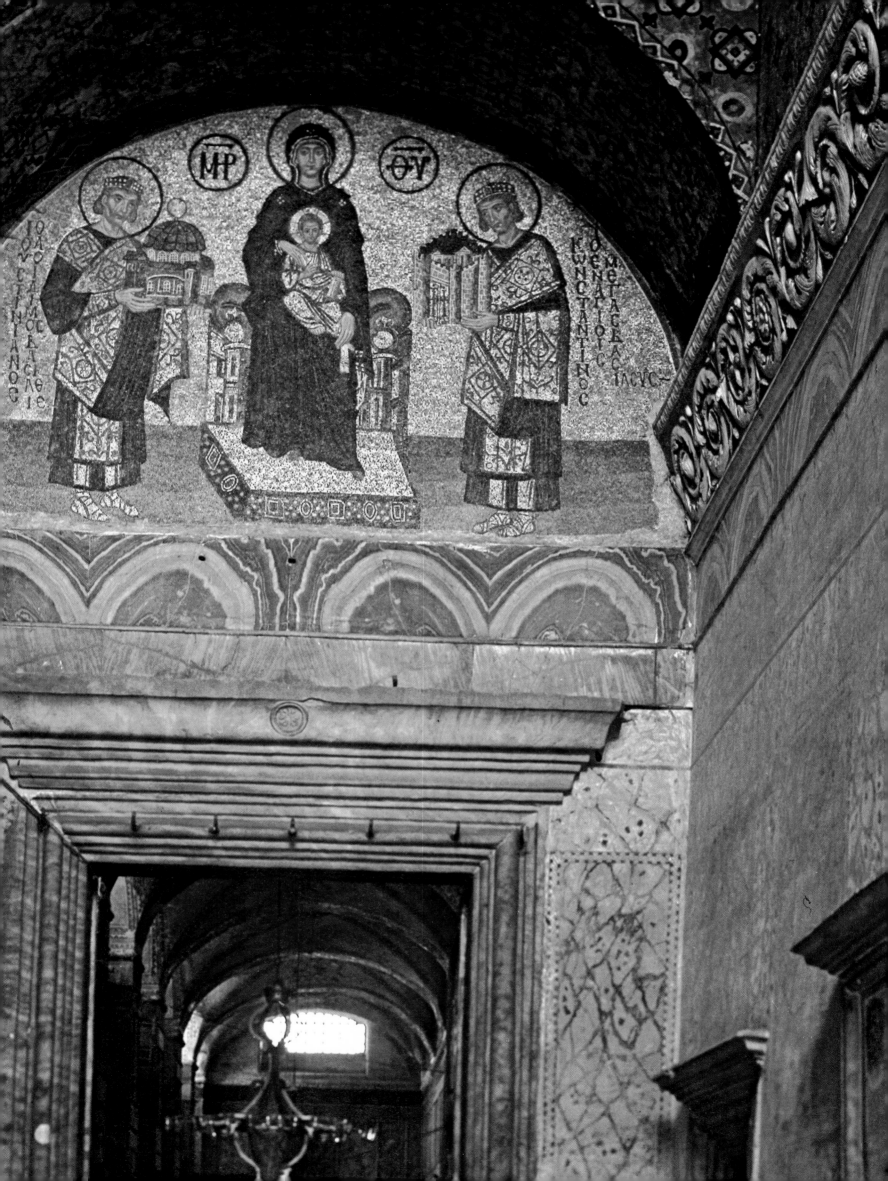

28 *Mosaic, south gallery of the Hagia Sophia, 13th century. The mosaic shows Christ in Judgment in the centre, flanked by the Virgin Mary and John the Baptist begging for forgiveness on behalf of mankind. It is considered the finest of the gallery mosaics in the Hagia Sophia and was probably executed in the periods before and after the conquest of the city by the Crusaders. Here we can see the complex, delicate treatment of the human form which the mosaic shares with the figure of Christ dating from the early 14th century in the Kahriye Camii.*

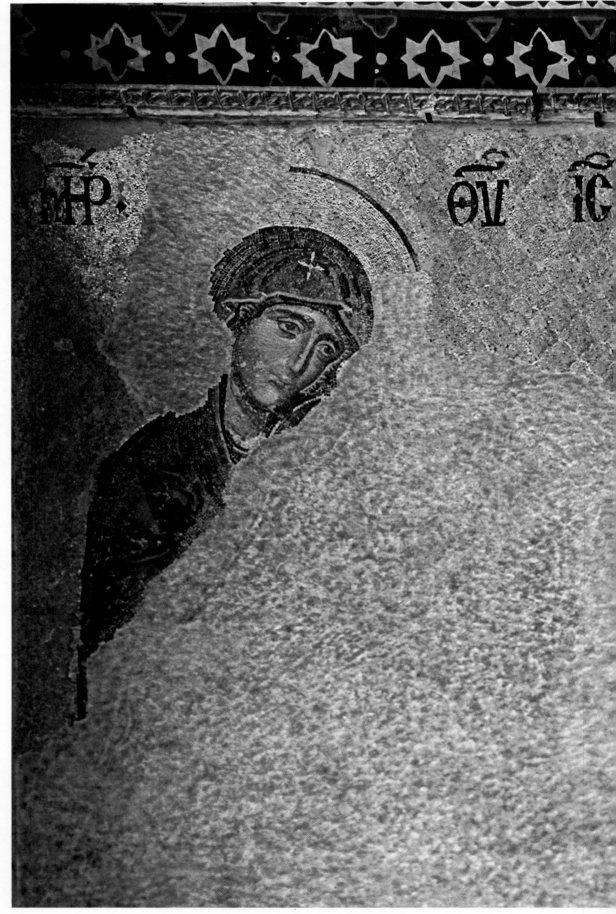

28

Pages 68-69:
27 *South-west entrance of the Hagia Sophia, 6th to 10th centuries. The Hagia Sophia, which is now a public museum, can be entered from the west front, at the southern end of the narthex. This arrangement can be traced back to the beginning of the 6th century. The mosaic over the entrance probably dates from the end of the 10th century; it shows the Virgin and Child in the centre, flanked by Constantine on the right and Justinian on the left. The two emperors are holding models of Constantinople and the Hagia Sophia.*

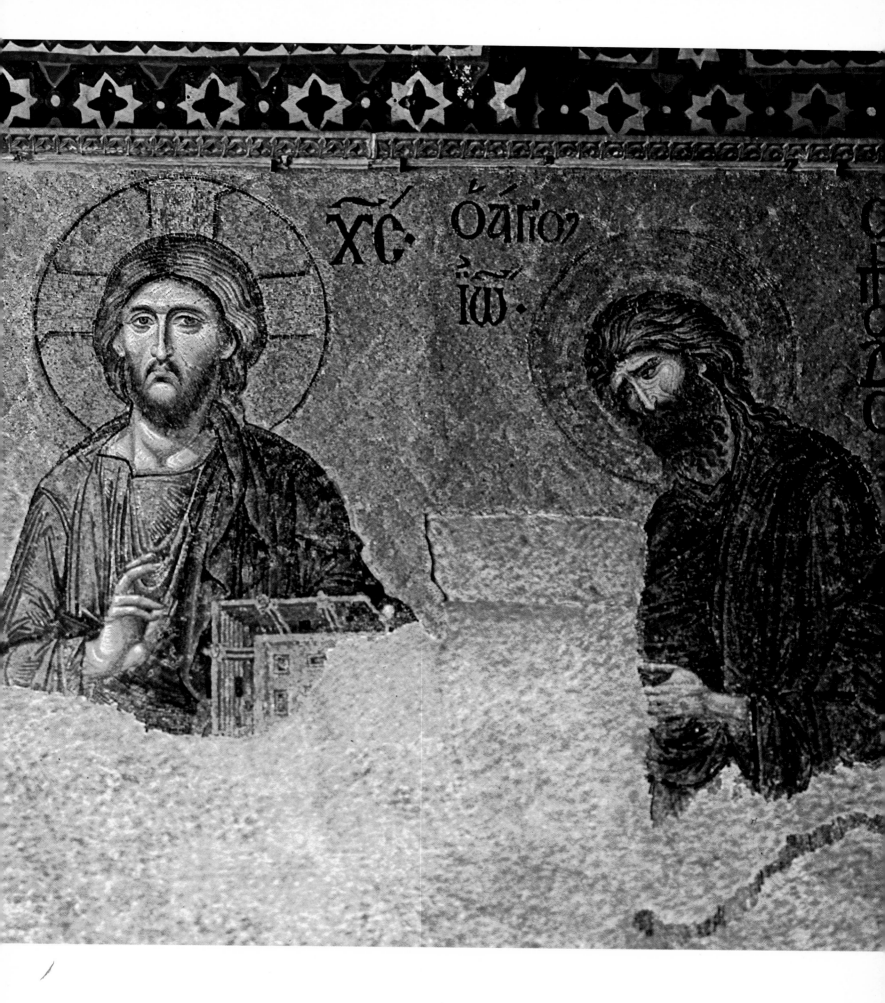

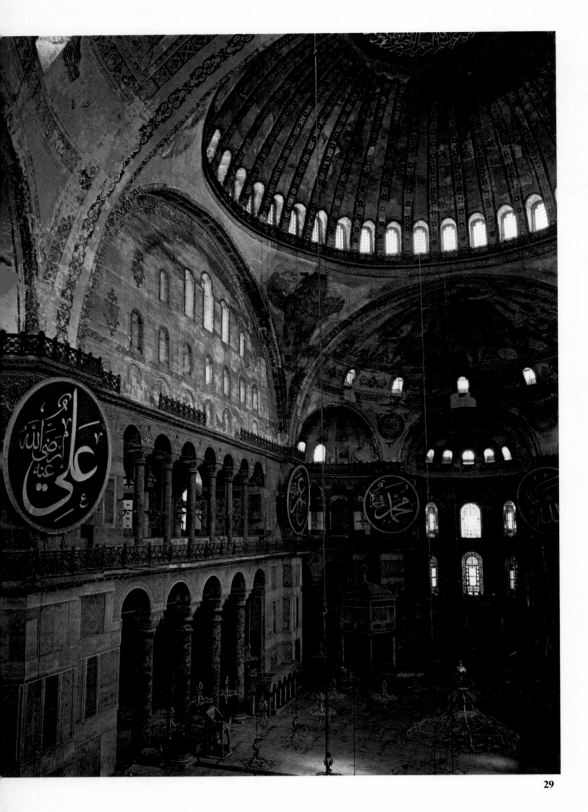

29 Interior of the Hagia Sophia, 537. In this view we are looking left from the north-west end of the church at the two rows of columns which separate the aisle and gallery on the north-east side from the nave. Three of the gigantic arches which support the dome by means of pendentives can be clearly seen. The mosaic in the central apse at the end of the church dates from the 9th century. The large medallions bearing Islamic calligraphy were of course added by the Muslims. This view from the level of the galleries gives some idea of the enormous space enclosed by the nave and the dome.

30 Hagia Eirene or Church of St Irene, Istanbul, Turkey, 532 to circa 740. On 11th May 330 A.D., the former Greek colony of Byzantion acquired a new name and entered a new and brilliant phase of its history as Constantinople, the capital of the Roman Empire. The Emperor Constantine built three large churches in his new city, intended as vehicles for decoration and named after the three venerable attributes of Christ – wisdom (sophia), peace (eirene), and strength (dynamis). The two churches of Sophia and Eirene were rebuilt by Justinian after they had been burned down in the Nika rebellion of 532, and have survived to the present day.

Now it is occupied by the Topkapi Palace, built under the Ottoman Empire, which is a public museum. The palace also houses the Museum of Antiquities, which contains the famous sarcophagus of Alexander the Great (4th century B.C.), discovered in Sidon in the Lebanon. On its south side, the church of Hagia Eirene, or St Irene, stands by itself in a small wood. But this part of the promontory is dominated by the colossal shape of the Hagia Sophia, the Church of Divine Wisdom which stands as a symbol of Istanbul.

Near the Hagia Sophia and the Palace is the Hippodrome, which can be considered the third symbol of the city of Constantinople. These three buildings formed the centre of life in the capital in the time of the Byzantine emperors, who thought of themselves as the representatives of God's will on earth. The Hagia Sophia was the religious centre, the Palace the seat of

political power and the Hippodrome the focus of public life. The Byzantine palace was destroyed long ago, and the only clue to what life there was like is a note on ceremonial written by Constantine VII Porphyrogennetos. The building stretched as far as the present-day Museum of Mosaics on the southern side of the Sultan Ahmet Mosque (the Blue Mosque). Between the Blue Mosque and the Hagia Sophia lies an extensive park, which was once the Augusteon or Forum of Augustus, the public meeting place of the Byzantine capital. On the north side it adjoined the front of the Hagia Sophia; it was bounded by the Palace to the south, and reached as far as the underground cistern of the Palace in the west. Known as the Basilica Cistern, the latter was installed by Constantine the Great and rebuilt in the time of Justinian. To the west of this cistern is a second, known as the Cistern of Binbirdirek or the Thousand and One Columns, which was completed in the 6th century. At least 224 columns were used to support the barrel-vaulted roof of this enormous structure.

The Hippodrome, which was particularly famous in the time of the Byzantine Empire, stood on the site now occupied by the At Meydani Square on the west

31 *Exonarthex and domes, Kahriye Camii, early 14th century. 'Kahriye Camii' is an Islamic name meaning the 'Mosaic Mosque'; the building was originally known as the Church of the Chora, after the inscription on the mosaic of Christ inside the church, which reads 'Chora ton zonton' ('the kingdom of life'). At the beginning of the 14th century, the old domes were renewed under the current prime minister, Metokites, and an exonarthex and a chapel were added.*

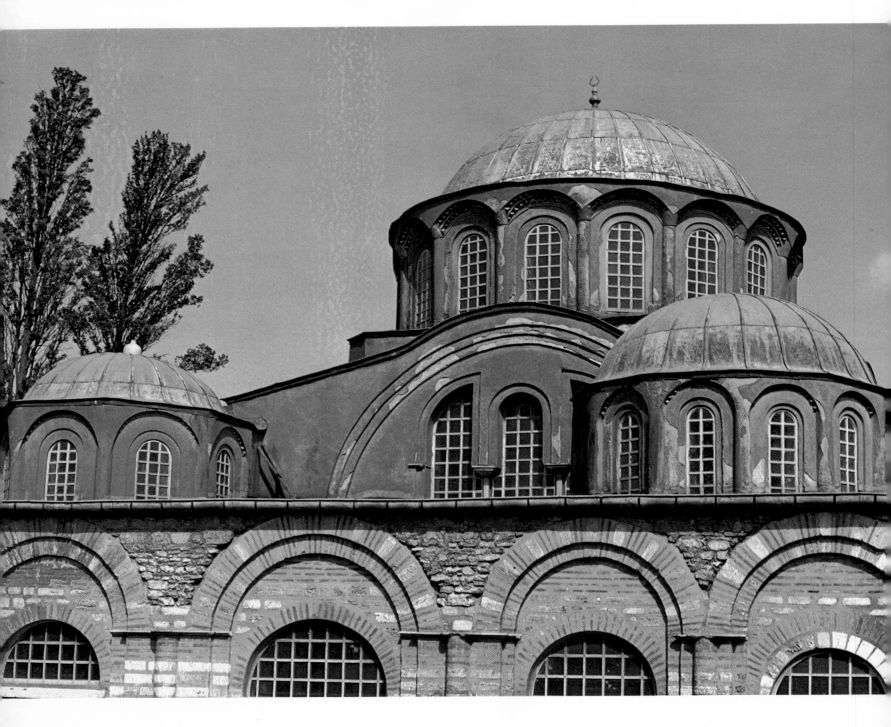

32 Hagia Eirene, Istanbul. This church, which stands opposite the Hagia Sophia, was rebuilt as a domed basilica after its destruction in the Nika uprising. In 740 it was rebuilt once again and the construction of the dome was altered. The present-day church also shows evidence of alterations carried out by the Turks. The large mosaic cross in the apse was added after the Iconoclast period.

side of the Blue Mosque. The first hippodrome was built by the Roman emperor Severus in 203 A.D., and this was enlarged under Constantine the Great into a colossal area measuring some 1,300 by 490 feet. The central area surrounded by the main racecourse was known as the Spina. A long, narrow terrace paved with stone, which was strewn with sand during races, it was formerly the site of many monuments, only three of which still remain in their original positions. These now stand in a row towards the southern end of the At Meydani Square. The first is the Obelisk of Theodosius, which was made for Thutmosis III (1504–1450 B.C.) and originally stood in the temple at Karnak in Egypt. Theodosius I had it set up in the middle of the Spina in 390 A.D. The plinth is decorated with examples of early Byzantine relief sculpture showing Theodosius crowning the victor in a horse race and other scenes also involving the Emperor. Next to this obelisk is another relic, badly damaged, which is known as the Serpentine Column. Originally erected by the Greeks outside the temple of Apollo at Delphi, in memory of their victory over the Persian army led by Xerzes I at Plataea, it was brought to the Byzantine capital by Constantine the Great. Finally there is the Walled Obelisk, which

32

Below: Telanissus (Qal'at Sem'an), Syria. Ground plan of the monastery and Memorial Church of St Simeon.

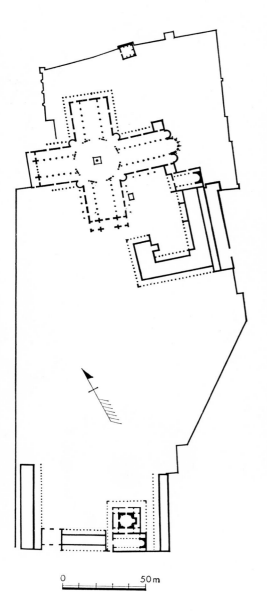

0 50m

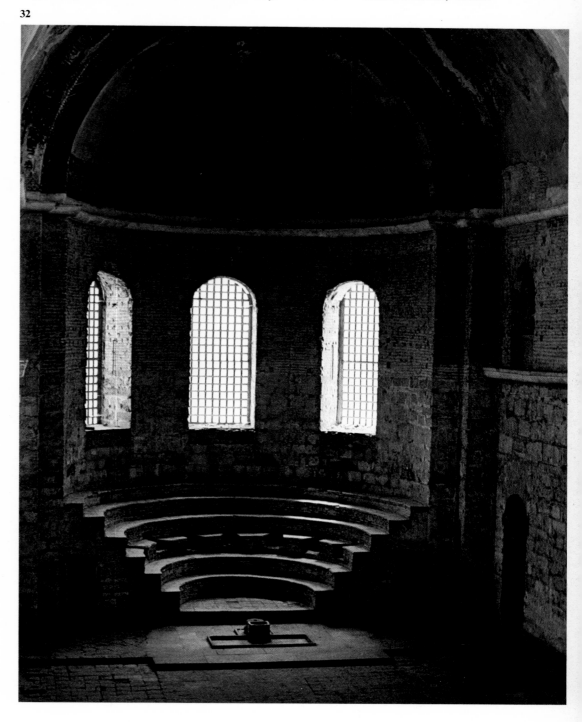

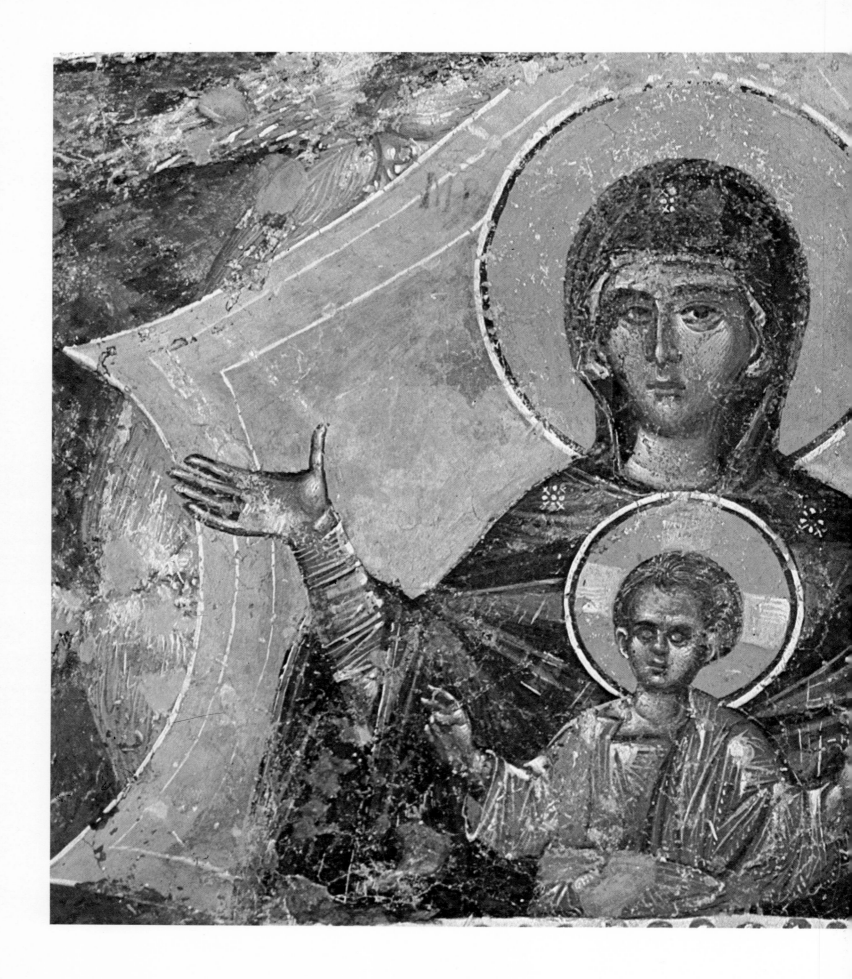

33

33 *Virgin and Child, Kahriye Camii, 14th century. This typical example of late Byzantine wall painting is set in the middle of the arch of an* arcosolium *(a niche containing a tomb set into the wall), to the south of the west side of the inner narthex. The Virgin Mary and Christ are shown praying with outstretched hands, while angels look out from behind the curiously shaped halo.*

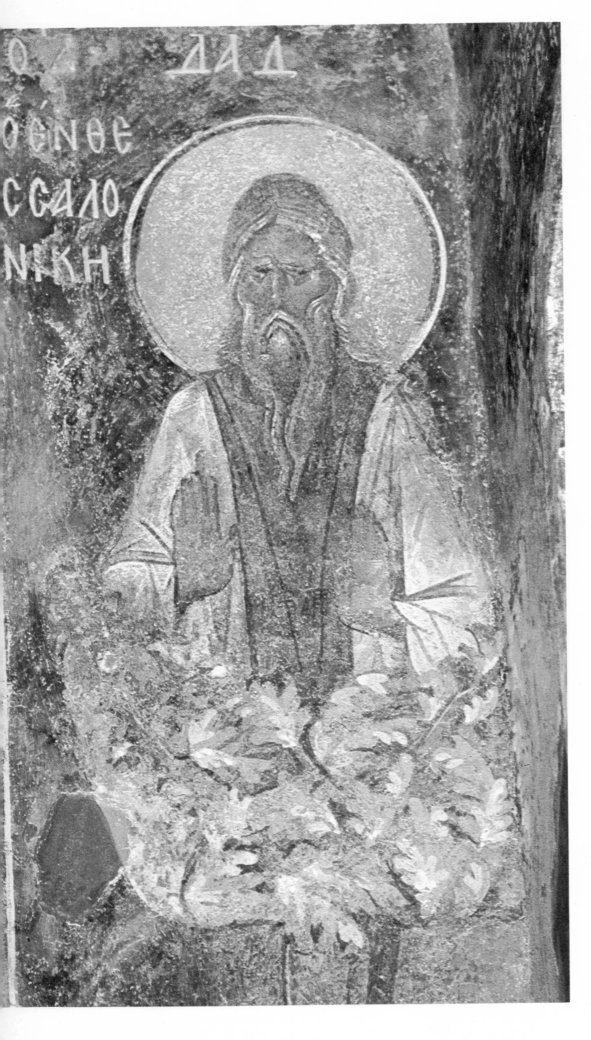

ΟΑΓΙ ΔΑΔ
Ὁ ΘΝΘΕ
ϹϹΑΛΟ
ΝΙΚΗ

34 St David of Salonica, Kahriye Camii,
circa 1320. This painting is on the left-hand
wall at the entrance of the southern ante-
chamber. St David was a hermit at Salonica in
the time of Justinian, who is reputed to have
sat in an apricot tree for three years and
acquired miraculous powers through the
practice of certain exercises. The delicacy and
expressiveness of the painting bring out the
saint's austere character.

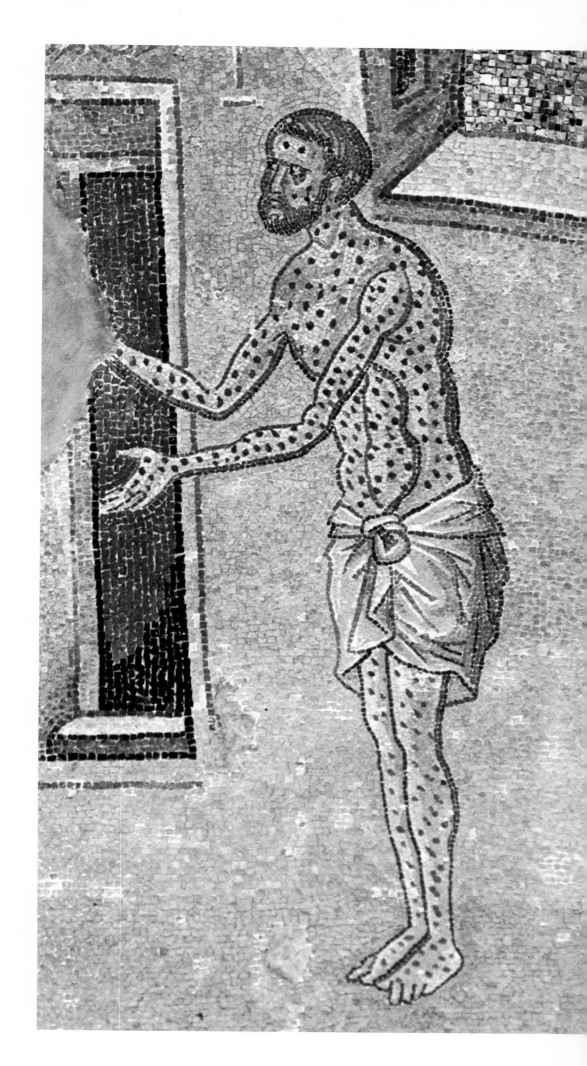

35 The healing of a leper, Kahriye Camii, 1315–1320. The illustration shows the right-hand section of this scene, which is on the west side of the south arch in the outer narthex of the Kahriye Camii. The left-hand side, which represents Christ with his apostles, has been almost completely destroyed. The scene is that described in the gospels, in St Matthew 8, 1–4, St Mark 1, 40–44, and St Luke 5, 12–14. The disease is shown discreetly by means of spots covering the whole body, so that the figure retains a sense of dignity also found in other scenes.

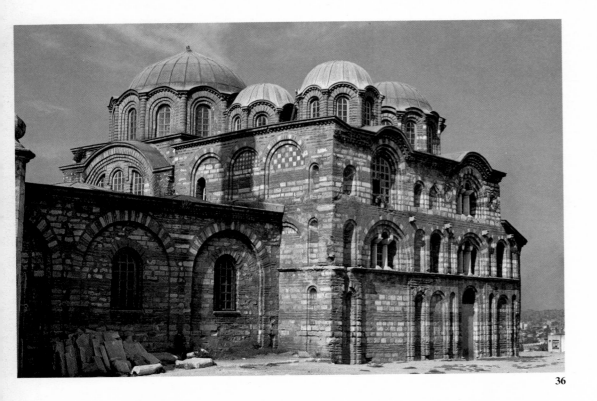

36 Fethiye Camii, Istanbul, Turkey, early 14th century. In the part of the old city which lies next to the Golden Horn, there had been a church since the very earliest times, and in the 14th century a chapel was erected on the south side of the building. The interior is decorated with mosaics dating from the Paleologue era. At that time the building was a convent, and it was called the Church of 'the most blessed, holy Mary'. At the end of the 16th century, however, it was turned into a mosque, and is known today by its Islamic name.

was erected at an unknown date and restored by the emperor Constantine Porphyrogennetos, for which reason it is also known as the Column of Constantine.

A main thoroughfare ran west from the Hippodrome, linking together the Forum of Constantine, the quarter of Amastrianon, the Forum Bovis and the Forum of Arcadius. Nothing remains of these public buildings today, except for the columns of the Forum of Constantine and the plinth of the Column of Arcadius, which once stood in the Forum of Arcadius.

When one crosses the Atatürk bridge from Beyoglu, the Aqueduct of the Emperor Valens (364–378) lies directly ahead of one. An adequate water supply was vital for this enormous city, and many excellent aqueducts and cisterns were built. The aqueduct built by the Emperor Valens stands in the middle of the present-day quarter of Stamboul, linking the third and the fourth hills of the old city. It is one of the few examples of early Byzantine architecture in Constantinople which has survived almost complete in its original state. It is some 650 yards long and 88 feet high, and consists of a double row of arches. It is a substantial structure, similar to the Pont du Gard in France and the aqueduct at Segovia in Spain, and a reminder that Constantinople was originally a city of the Roman Empire. To the south of the aqueduct are the University of Istanbul and the Grand Bazaar, which is a labyrinth of small alleys. Fruit is still sold on its streets today, as well as valuable goods such as icons, precious stones and carpets.

The wall which surrounds the Stamboul district has also survived. It was this wall which enabled the Byzantines to withstand the attacks of the barbarians and to preserve the Empire until 1453, even though most of the territories they once ruled had been conquered by the Muslims, and only the Balkan peninsula remained in their possession. Solid and robust, it is moulded to the contours of the city, a visible reminder of the shape of medieval Constantinople. The original wall was renewed and altered more than once, and the present structure was built by Theodosius II, who also established the course which it now follows. At the time of the Greek settlement of Byzantion there was already a wall surrounding an area in which the Topkapi Palace then stood. Severus destroyed the town in 196, then built a new one which he enclosed with walls. Constantine the Great extended them to enclose an area five times larger, but the capital of the Empire was constantly growing, and a fourth structure was needed. In 413 Theodosius embarked on its con-

37 The Last Judgment, Kahriye Camii, circa 1320. The illustration shows the major part of the scene of the Last Judgment painted on the vaulting of the southern side-chapel. The lower part represents the so-called Deesis, with Christ enthroned in the middle and the Virgin Mary and John the Baptist on either side of him, acting as mediators between God and mankind. A throng of angels fills the background; above them an angel is rolling up the scroll of the heavens referred to in Revelation 6, 14.

struction, enclosing an area spreading far to the west, and this is the one which we see today.

Proceeding along the shore of the Sea of Marmara to the west, one reaches the remains of a walled citadel in the shape of a pentagon, known as the Yedikule or Seven Towers Castle. Here stands the Golden Gate of Constantinople, erected by Theodosius I. At this point the city wall turns north, cutting across the peninsula to the Golden Horn. The palace of Constantine Porphyrogennetos, the Tekfursarayi, stands next to the wall a short distance before it reaches the Golden Horn. One of the few surviving palace buildings, it has a three storied front with an entrance faced in red brick and multicoloured marble which is an important example of Byzantine architectural decoration.

Architecture

Most of the surviving Christian churches in Constantinople were converted into mosques by the Muslims. Near the sea shore, to the west of the Blue Mosque, is the church of SS Sergius and Bacchus, which is now called the Küçük Aya Sofya Camii. It was built in the same period as the Hagia Sophia, and was converted into a mosque in the reign of Bayazid II (1481–1512). Going towards the centre of the city from here, one soon comes upon the Bodrum Camii, which was once the church of the Myrelaion Monastery. This is a Byzantine building dating from the 10th century, which was converted into a mosque in 1574. On the coast further to the west are the ruins of the monastery church of St John of Studios (now the Imrahor Camii). The walls are no longer standing but the basilical ground plan is still recognizable. It is a church with a long history, which was begun in 463, and was the centre of the monastic movement during the Byzantine period. To the west of the city centre stands the Koca Mustafa Paşa Camii, formerly the church of St Andrew in Crisi, which was founded by the younger sister of Theodosius II at the beginning of the 5th century. It was restored under Basil I (867–886), and extended by Theodora, the niece of Michael VII of the Paleologue dynasty; it too was turned into a mosque in the time of the Ottoman emperor Selim I. Going north along the Golden Horn from the Atatürk Bridge, one encounters the Gül Camii, the former church of St Theodosia. Its original 10th century Byzantine architecture is still recognizable, but the building was considerably altered when it was converted into a mosque in the time of Ahmet I (1603–1617). There were three Byzantine churches near the Aqueduct of Valens, all of which have been turned into mosques. The Mollazeyrek Camii, formerly the monastery church of Christ Pantocrator, has a fine original marble floor. The Kilise Camii, in which a fine mosaic was discovered under the plaster during renovation works in 1937, is the former church of St Theodore, which was turned into a mosque immediately after the fall of Constantinople. The Kalenderhane Camii, originally the church of the monastery of Christ Akataleptos, was also turned into a mosque at that time, but some marble wall decorations and sculptures have survived.

There are two Byzantine churches near the city wall at the north-west corner of Stamboul which possess fine mosaics dating from the 14th century. Both of them are now used as museums. One of them is the Kayriye Camii, the former church of St Saviour in Chora. The mosaics in this church, dating from the time of the Paleologue dynasty, were restored by the American Byzantine Institute between 1948 and 1958, and are the finest in Istanbul. The building has a long history, having been founded in the 5th century. It received its current form when it was partially rebuilt in the 13th century. The other church is now called the Fethiye Camii and was originally the church of St Mary Pammakaristos or the Blessed Virgin. Its magnificent mosaics, like those of the Kahriye Camii, were only recently discovered during the course of restoration.

38 Angel with the scroll of the heavens, Kahriye Camii, circa 1320. Detail from the left-hand side of the vault. The angel is holding a long white scroll which is partially rolled up, the remainder having formed a kind of vortex in the form of a shell, on which are painted the sun, moon and stars (cf. St Matthew 24, 29). The angel floating in the void makes an unusually elegant figure, and the folds in his filmy blue and brown garments are rendered with masterly realism.

Page 84:
39 Marble relief on the plinth of the Obelisk of Theodosius, Istanbul, late 4th century. The eastern hill of the old city of Constantinople was once the centre of courtly and political life. Here stood the original church of Hagia Sophia and numerous other churches and palaces, but today only a handful of ruins remains as a reminder of past glories. The Hippodrome in particular, built by Septimius Severus in the early 3rd century and extended by Constantine the Great, was a building of great political and social importance, where citizens and rulers could gather together in a common pursuit. Successive emperors decorated it with their acquisitions, and the emperor Theodosius had the obelisk brought from the temple of Karnak in Egypt. The reliefs decorating the plinth represent members of the imperial court attending the races and foreign rulers with their retinue paying tribute to the emperor. The strong horizontal accent in the composition suggests an Oriental influence. The figures are badly weathered, but still show the grace which is characteristic of the period.

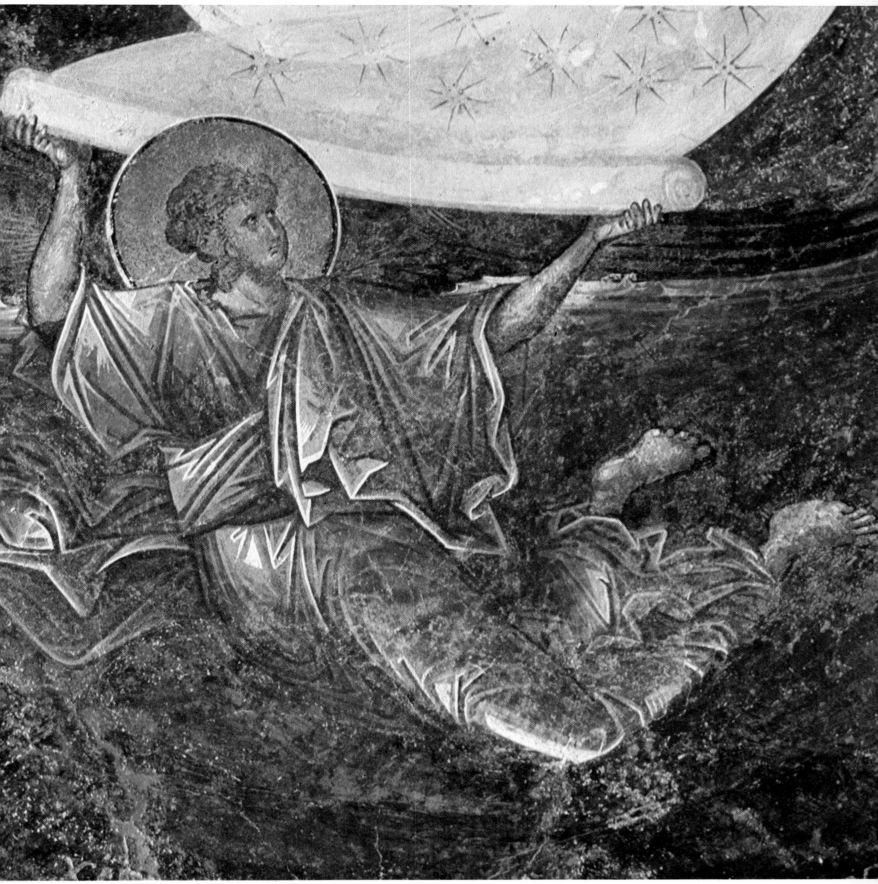

38

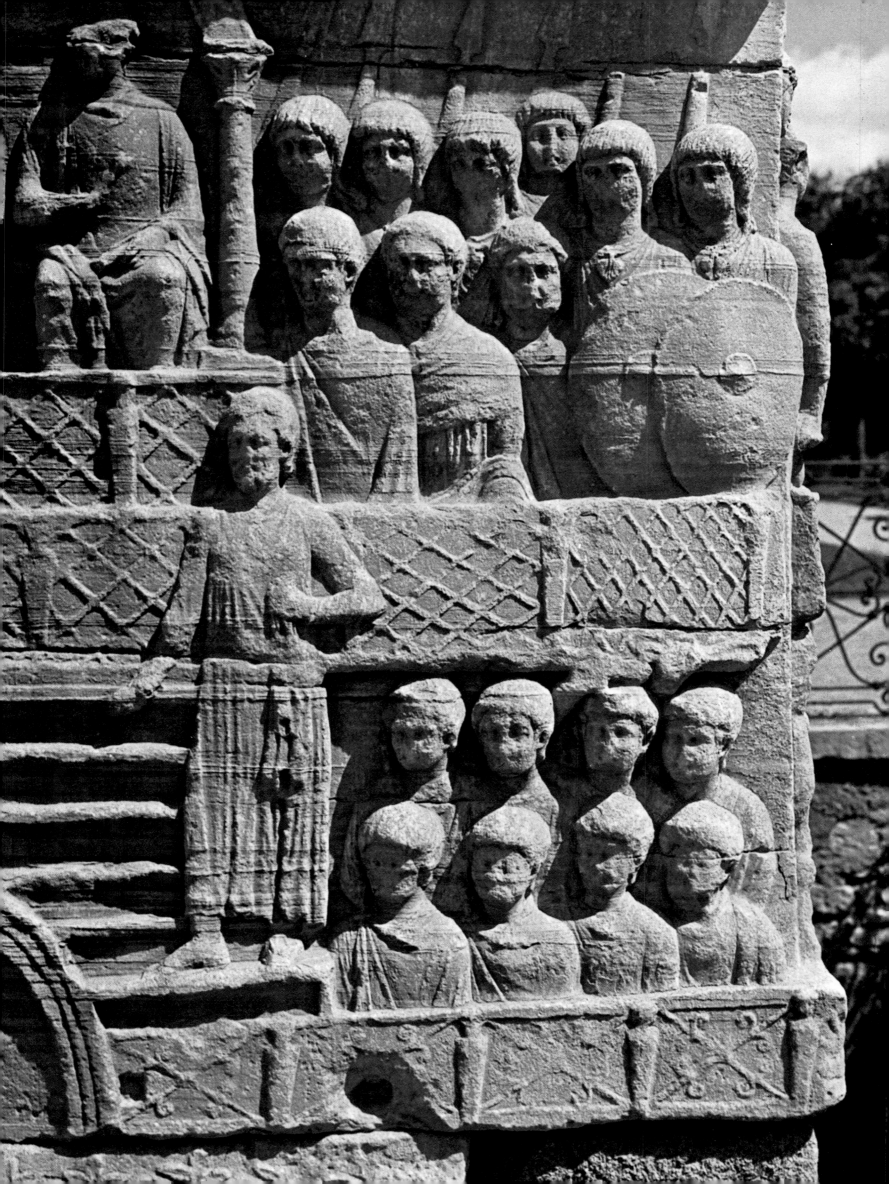

The Holy Mountain

Monasticism in the Eastern Church I

Intellectual background and beginnings

The words 'monk' and 'monastery' are both derived from the Greek word *monachós*, which means 'alone', 'to be on one's own'. Thus the original intention of the monastic life was to withdraw from the world and lead a solitary existence. The reasons for this related to a long-standing religious tradition. Even in primitive societies, men who served God or possessed a divine charisma remained outside the life of the community and had nothing to do with worldly matters. They aspired to sanctity and attempted to live according to the will of God. In this broader sense, monasticism has existed in almost every age and among all peoples. There were monastic communities in Indian Brahmism, and with the rise of Buddhism and its different schools the monastic way of life spread throughout Eastern Asia as far as Tibet. But there were also a few Jews who lived as monks in pre-Christian Palestine. The best known examples are the Qumran sect and the Essenic community on the Dead Sea, whose existence only came to light fairly recently with the discovery of the Dead Sea Scrolls. These people left the towns as a matter of religious principle and led a communal life governed by strict rules; their way of life bore strong similarities to that of the monastic communities of Christianity.

Christian monasticism, which reached the height of its development in the 4th century A.D., had many things in common with the monastic life of Buddhism and Judaism, but at the same time, it had its own entirely original philosophical background. The intellectual world of the monks of the Byzantine Empire was rooted in other traditions than those of the earlier religions. They took their inspiration from the Western philosophical tradition which had been founded in Ancient Greece, and they were proud of it. The original source of their ideas lies with Plato in the 5th and 4th centuries B.C., and the tradition descends through the Neoplatonism of Plotinus, who developed his philosophy in the Roman world of the 3rd century A.D.

Central to Plato's philosophy was the concept of true Being, a state which transcends all worldly things and is accessible through the medium of the true Idea. Thus it was the philosopher's goal to encounter the true Idea within himself in order to triumph over the material world, which he held to be only a shadow of true Being.

This attitude, in which the contemplation (*theoria*) of the true Idea is considered the highest goal of reason, appears very clearly in Neoplatonism as it was systematized by Plotinus. Plato compared the highest Idea with the sun, and Plotinus also described the meeting with the divine as the experience of 'light'. 'This light,' he says, 'comes from the Highest Being, and it is the Highest Being himself . . . God comes with the light, that is to say that the light is the proof of the coming of God.' He also says, 'without the contemplation (*theoria*) of the light, our soul remains in darkness'. For those who were influenced by this idea, the one true life worth striving for was the 'contemplative life' (*bios theoretikos*, or *vita contemplativa*).

But how is this 'life of contemplation' to be achieved? In the words of Plotinus: 'How many stages of passion (*pathos*) must the soul be freed from – anger, covetousness, sadness and similar feelings – to become similar or near to God, and how far can the soul be separated from this body?' This freeing (*apatheia*) of the soul from the body and the human passions was for the men of the 3rd century nothing less than the real object of life. Even before the Neoplatonists, the Stoic philosophers maintained that this same 'freeing' was an indispensable condition for the achievement of 'true knowledge'. It was a state which required the mastery of sexual appetites, gluttony, desire for fame and various other human passions, in a word the practice of 'asceticism'

40 Catholicon, Monastery of St Panteleimon, Mount Athos, Greece, founded in the 12th century. From a very early date, monks of different nationalities had established their own indigenous monasteries on Mount Athos. The Russian monastery in particular continued to exercise a great influence until the beginning of the 20th century. With the exception of this institution, all the monasteries on Mount Athos are now under Greek control. The globular mountings of the crosses on the cupolas are particularly Slavonic in style.

Pages 88–89:
41 Monastery of Pantokratoros, Mount Athos, founded in the 14th century. Most of the numerous monasteries on Mount Athos, like this one, are built on the sea shore and have a small quay. The only form of land transport is the donkey, and many of the institutions must be approached by sea even today; supplies are also frequently brought by ship. The monastery is surrounded by walls as a defence against pirates and other aggressors. The upper storeys contain individual cells with verandah-like arcades built out in front of them. A watchtower is set into the exterior wall. A monastery such as this usually has only one, solidly built door, which is locked at sundown. Within the walls there is a central atrium, a catholicon, other chapels, a refectory and various other buildings.

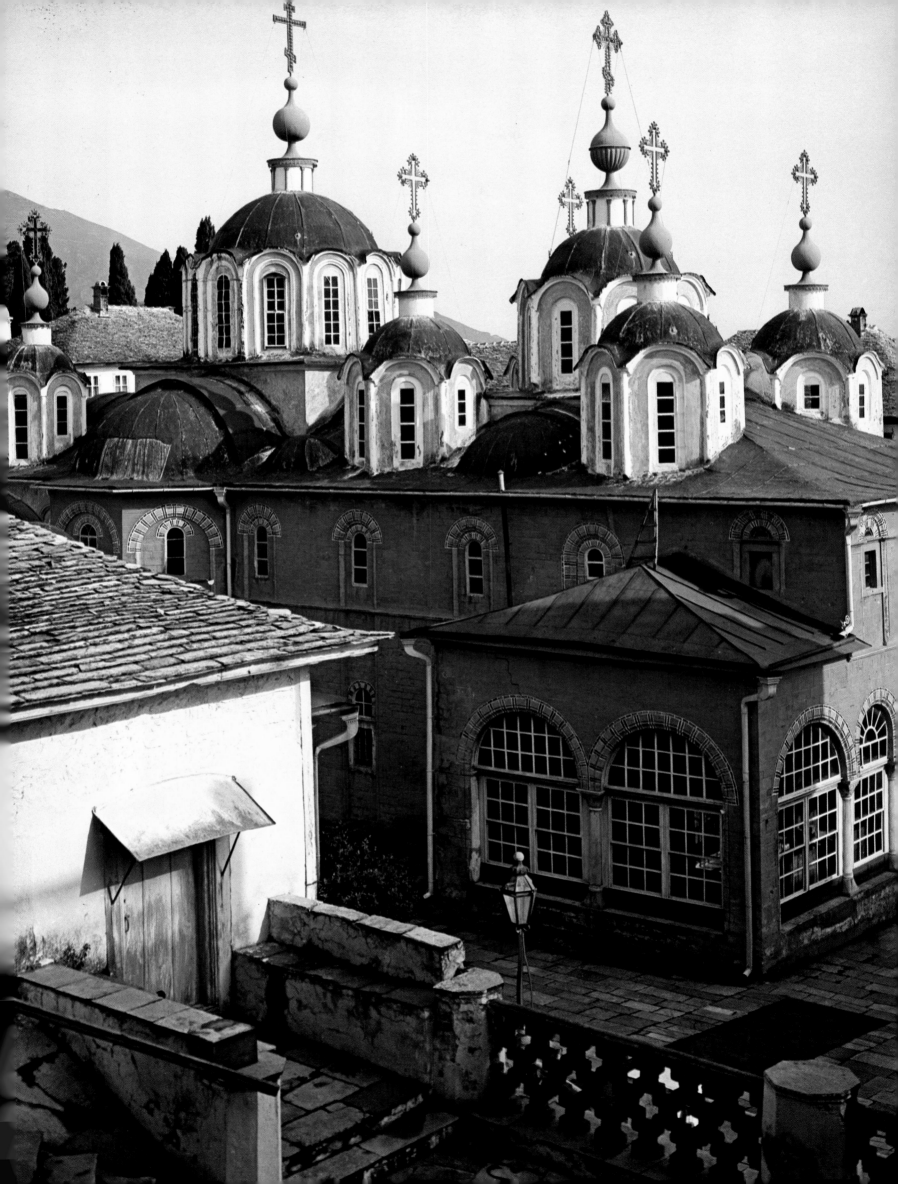

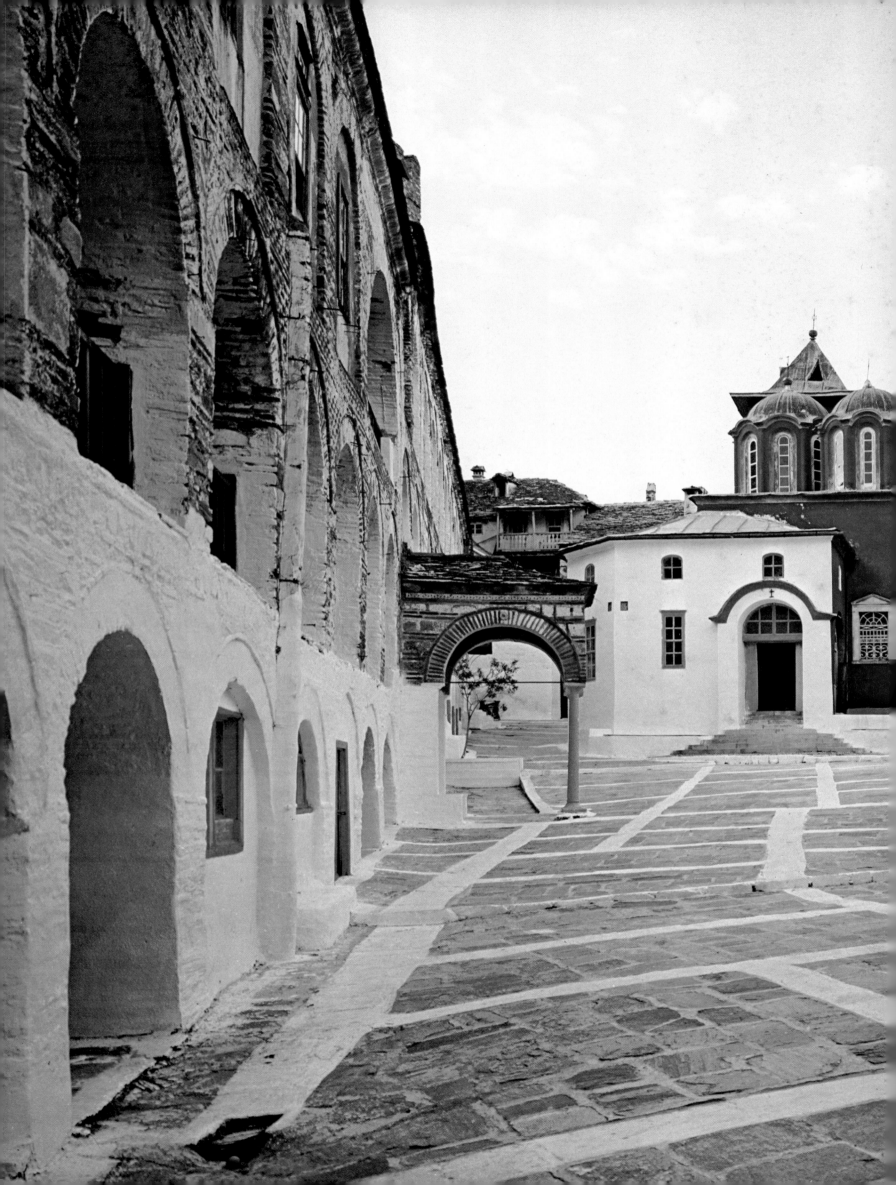

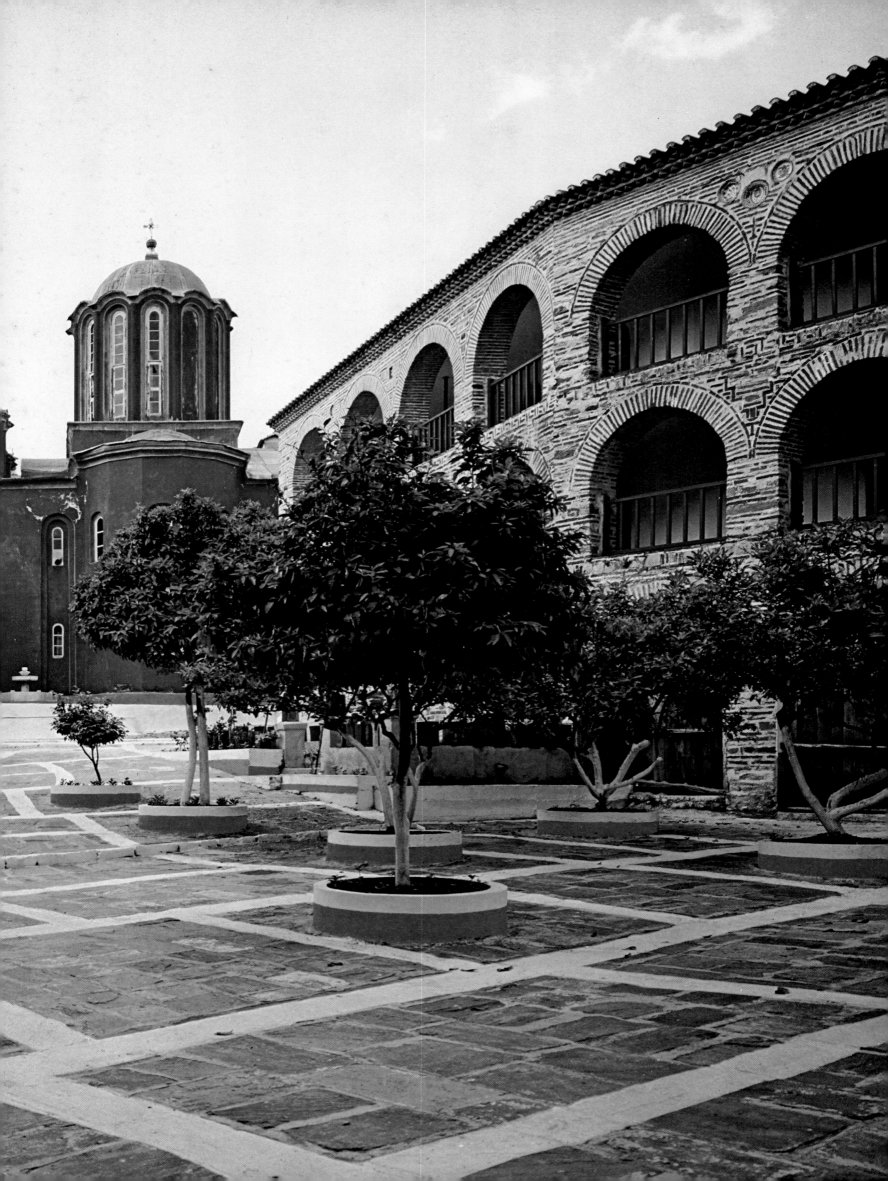

(*askesis*). Thus the ancient philosophy which formed one of the foundations of monasticism required the practice of three main disciplines – the contemplation (*theoria*) of God as the highest goal of reason, the freeing (*apatheia*) of the self from human passions which was required for this, and the practice of asceticism (*askesis*).

Not all the monks of the Byzantine Empire were trained philosophers, however. The people who were inspired by the Christian gospel preached by the missionaries to give up their possessions and embark on a monastic existence in the desert were not thinkers. They were moved chiefly by the teaching of Christ and the stories of his life which they heard.

Asceticism and the renunciation of the world are frequent themes in the life and teaching of Christ. His predecessor John the Baptist may well have belonged to one of the Jewish desert communities already mentioned, and Jesus himself is said to have gone into the desert after his baptism by John and spent forty days and nights without food or water, resisting the temptations of the devil. On the other hand, both in his words and actions, Jesus ignored many of the precepts which the Jews of the time zealously followed. The gospels relate that the Jews accused him and his disciples of not fasting like other Jews, of feasting with prostitutes and sinners, and of drinking wine. We may deduce from this that it was Jesus' intention to free the old ascetic tradition of Judaism from the shackles of established precept and make it a universal requirement for all those who aspired to the contemplation of God, regardless of their race. The asceticism preached by Christianity thus became a universal virtue which his disciples and the early apologists of Christianity spread throughout the Mediterranean countries.

Then, in the 4th century, Christian culture and thought fused with the ancient Greek and Roman traditions in a new and remarkable development. The Judaeo-Christian doctrine of universal love was combined with a form of logical speculation which the Greeks had been developing for centuries. In the 3rd and early 4th centuries the Alexandrian church fathers, who included Clement, Origen and others, combined the concept of asceticism taught by Jesus with the traditions of Neoplatonism and Stoic philosophy, and in the middle of the 4th century the new monastic movement of Christianity was finally born. The father of this movement is generally held to be the Egyptian hermit St Anthony, who was born into a rich Christian family in 251 or 252 A.D. When he was about twenty years old he heard of Jesus' saying: 'If you would be perfect, go and sell all that you have and follow me', and deciding that he had found the true path of Christianity went and took up the existence of a hermit in the Libyan desert. According to legend he too was subject to the temptations of the devil there. Soon after this, he moved to a mountain on the other side of the Nile and numerous followers collected around him to embark on an ascetic and contemplative existence. His fame reached as far as Constantinople, and a correspondence was established between him and the Emperor Constantine. Athanasius of Alexandria, the great 4th century father of the church, was among his pupils, and wrote a life of his teacher which has been handed down to us. Athanasius also journeyed to Rome with two Egyptian monks, and this event is generally recognised as the starting point of the monasticism in the Roman Catholic Church.

From its beginnings in Egypt, Christian monasticism soon spread to neighbouring countries such as Syria and Palestine, and then throughout the Mediterranean. Before considering the development of the movement, and the culture which it produced in different areas, we must take a look at the characteristic modes of existence which it created.

The Institution of Monasticism

The Christian monks and monasteries can be divided roughly into three categories according to their way of life. The first is that of the anchorite or hermit, who had no communal existence and lived a life of complete solitude.

42 *Mural paintings, Catholicon of the Iviron Monastery, Mount Athos, founded in the late 10th century. In the second half of the 10th century St Athanasius the Athonite founded the monastery known as the Great Lavra, which was the beginning of the settlement on Mount Athos. Athanasius himself came from Asia Minor, but maintained a benevolent attitude towards the monks from other countries and helped them in building their own monasteries. St John the Iberian, who as his name indicates probably came from the present-day region of Georgia, entered a monastery on Mount Athos and became the teacher of St Athanasius. He then founded another monastery which was called Iviron (= Iberian). Iviron rapidly grew into one of the biggest institutions on Mount Athos, and it is still in existence today. Both the narthex of the Catholicon and a major part of the dome over the chapel are covered with mural paintings. They seem to have been painted at a fairly late date, but the figures are executed in the traditional Byzantine style.*

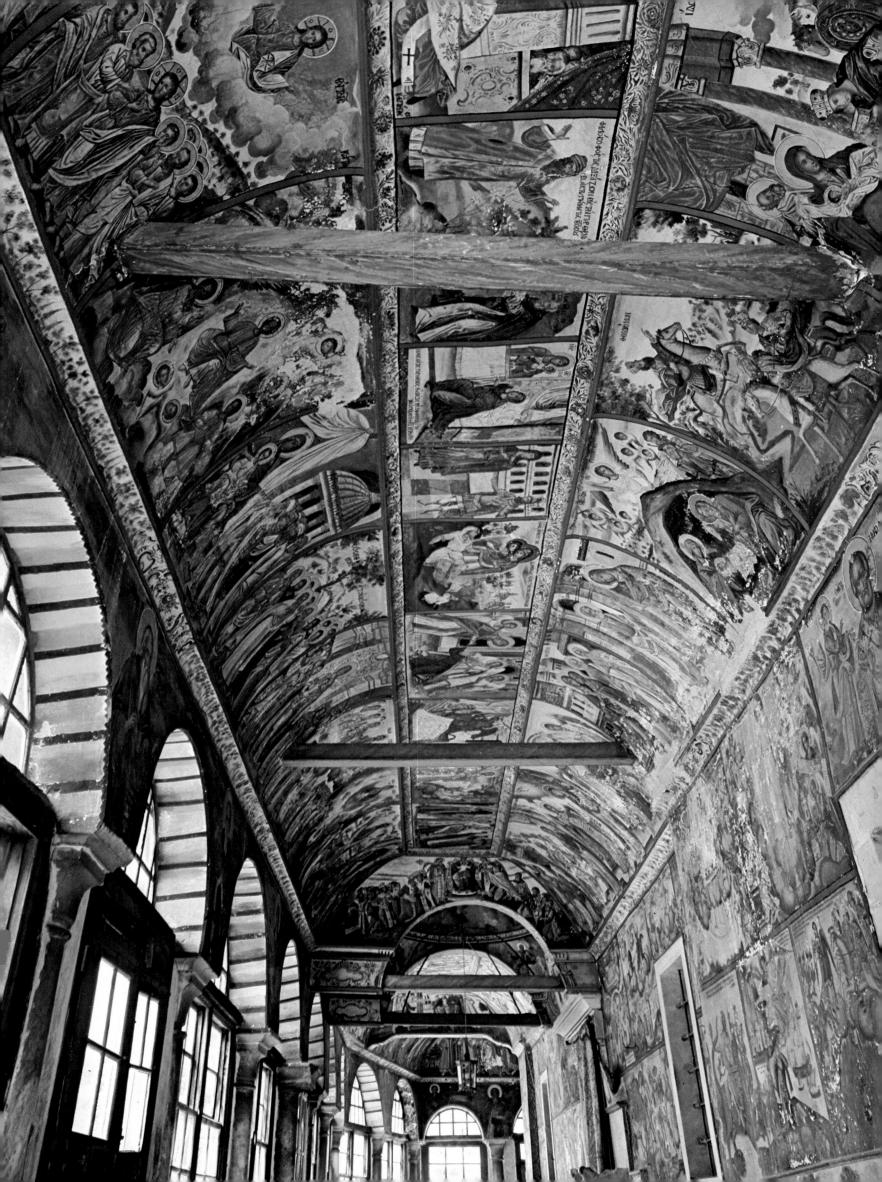

Hermits also practised certain self-imposed exercises or conditions of existence; a hermit who mainly practised meditation is known as a hesychast or quietist hermit, while a stylite was one who spent his life on top of a pillar. The second form of monasticism is the eremitic community known as a *lavra*. Its members lived in individual cells in a communal settlement, but usually led an independent existence, preoccupied with their own practices and only coming together occasionally for services under an abbot. The third form of monasticism is what is generally understood by the monastic life. It is known more precisely as coenobitism, from the Greek *koinobion* (communal living), to highlight the difference between this and the other two forms already mentioned. The monks who belonged to a coenobium had to share their living quarters, as well as holding services and taking meals together.

At the end of the 14th century, when quietism was flourishing on Mount Athos, the organic consciousness of the community became fragmented and the coenobium split into small groups of hermits, who had their own liturgy and established some form of economic organization. This type of monasticism is known as *idiorrythmos* ('living in one's own way'). The progression from anchoritism to the *lavra*, then to the coenobium and finally *idiorrythmos* can be seen in terms of the origin, growth and dissolution of the coenobium. Until the stage of the *lavra* had been reached there were no particular problems, but when monasticism became coenobitic in character it was necessary to establish a set of written rules governing the life, dogma and liturgy which the community was to follow. The collection of these rules is known as the *typikon*.

St Anthony himself and his followers were anchorites in the strict sense of the word, leading a solitary life and undertaking ascetic practices on their own; but it was in Egypt where their movement began that the coenobitic monasticism also developed. St Pachomius, who came from the region of the Upper Nile, founded a substantial monastery in the village of Tabennisi and himself became its abbot. During his lifetime nine monasteries and two convents came into being and the number of monks and nuns rose to 9000. The *typikon* drawn up by Pachomius is generally considered to have been the first of its kind.

Most of the monasteries were under the leadership of an abbot (the *hegumenos* or leader). The abbot had to observe the rules and precepts of the monastery as strictly as anyone else, since he normally had a large number of monks under his control to whom he must set a good example and generally act as spiritual adviser.

A man had to fulfil certain conditions in order to enter a monastery, but there was no enquiry into the kind of life he had led in the past so long as it was clear that he was really ready to become a monk. Adolescents and eunuchs were not admitted; however, former slaves were not refused entry in principle, though it was more difficult for them than for others. A person who wanted to enter the monastic life could exceptionally obtain an official divorce. Under the regulations prevailing in the 6th century, the monastic life began with a novitiate of three years. On entering the monastery the novice was given the tonsure and put on the garb of his status. At the end of the three-year period he had to make a full confession and take a vow of chastity, obedience and poverty before he could become a fully-fledged monk. Unlike its equivalent in Western monasticism, the form of obedience demanded was not necessarily that of following the principal's orders or obeying the precepts of the monastery, and poverty did not necessarily mean giving up one's entire wealth. The object of exercising these three virtues was, rather, to experience 'the sadness and misery of the solitary life' as fully as possible within one's soul. An unusual form of monasticism was the *dipla monasteria* (the double monastery), in which monks and nuns of both sexes spent their novitiate in the same institution, although this was strictly forbidden by the state at the time. There were also different groups of hermits who occupied an intermediate position between those who could be properly termed monks and the laity. Among these were the *spoudaioi* (rigorists), who collected at famous holy

43 Monastery of Grigoriou, Mount Athos, founded in the 14th century. The monastery stands on a cliff overlooking the sea and with its thick walls looks almost like a small fortress. It is constructed of stones, bricks and mortar, and this mixture of materials, together with the variegated tiling on the roof, gives it a distinctly unusual appearance. In this view the dome of the Catholicon and the cypress tree in the atrium can be seen over the rooftops in the centre.

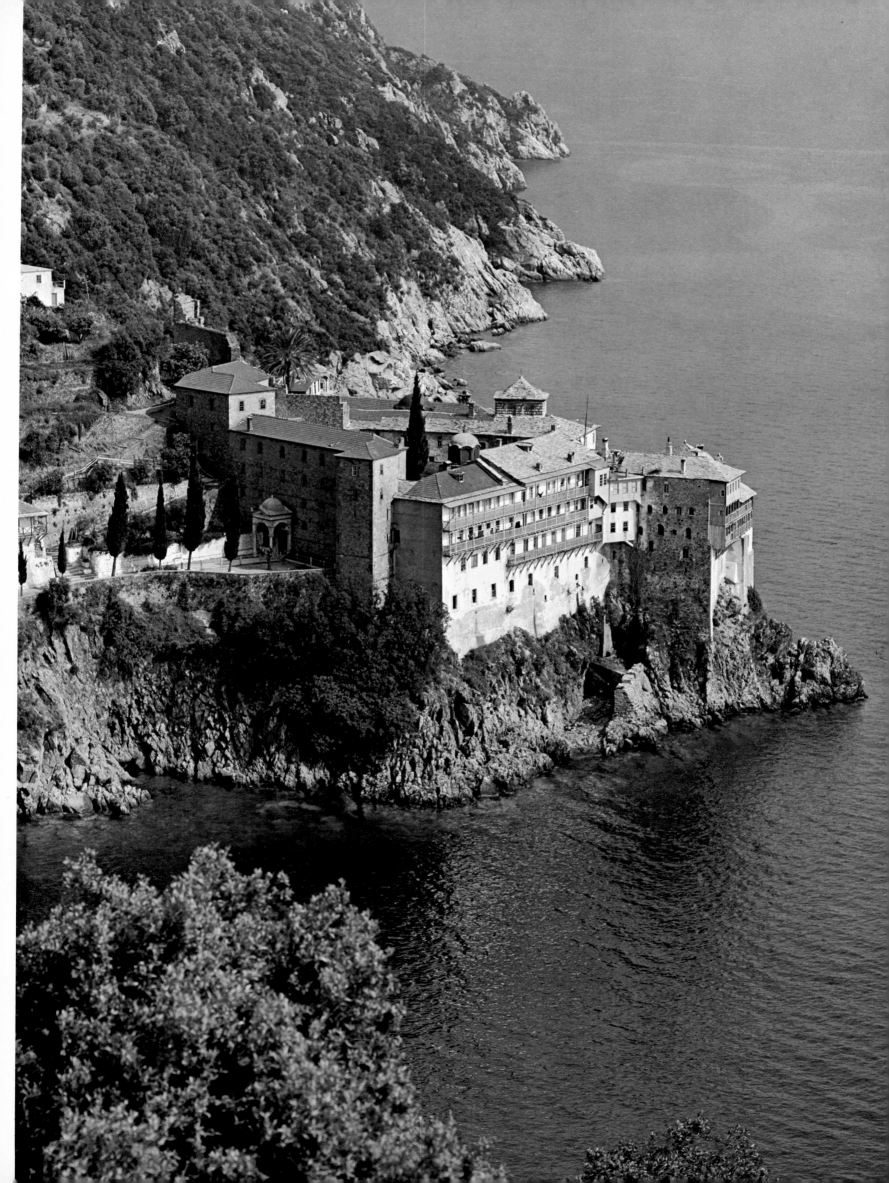

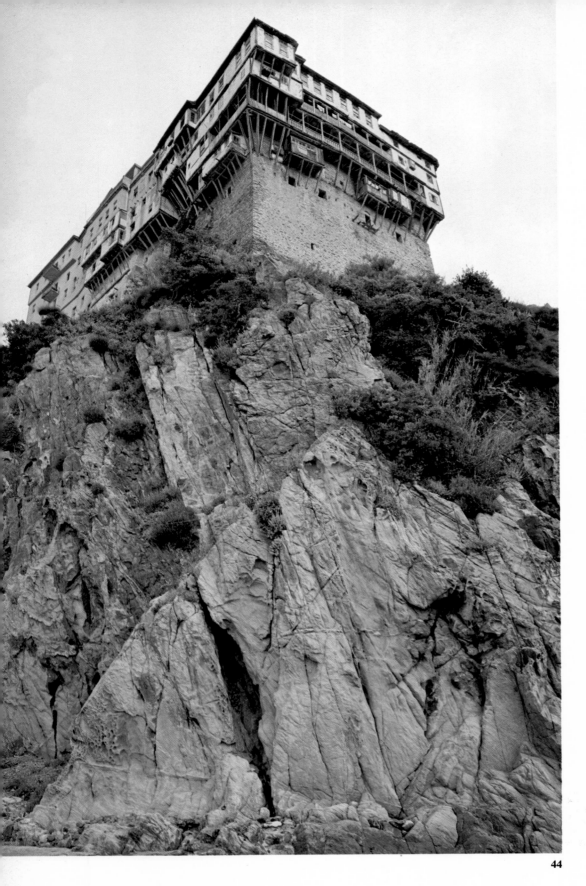

44 Monastery of Dionysiou, Mount Athos, founded circa 1366. This monastery is thought to have been built by Hosios Dionysios; like the monastery of Simonos Petra, it is sited in an impregnable position on top of a steep cliff.

places and at ruins frequented by pilgrims, where they preached the gospel, practised an ascetic way of life and held religious services. Another group were called the 'Fools (*saroi*) in Christ', a collection of beggars, street musicians and often genuine madmen. It should be remembered that all these different forms of monasticism and monasteries were independent of the church and state. In the 6th century, under the emperor Justinian, an effort was made to bring a large number of monks and monasteries of different kinds under the strict control of these two institutions, and this was gradually successful.

Yet the monasteries of the Eastern Church were founded on a strong will to independence from all external authority which never entirely left them, and it

45 Monastery of Simonos Petra, Mount Athos, founded in the 14th century. Said to have been built by Hosios Simonos, this monastery is one of the best known on Mount Athos, and like the Monastery of Dionysiou makes use of the steep cliffs in its construction. For a long time, this and many other monasteries were under the protection of the Serbian princes.

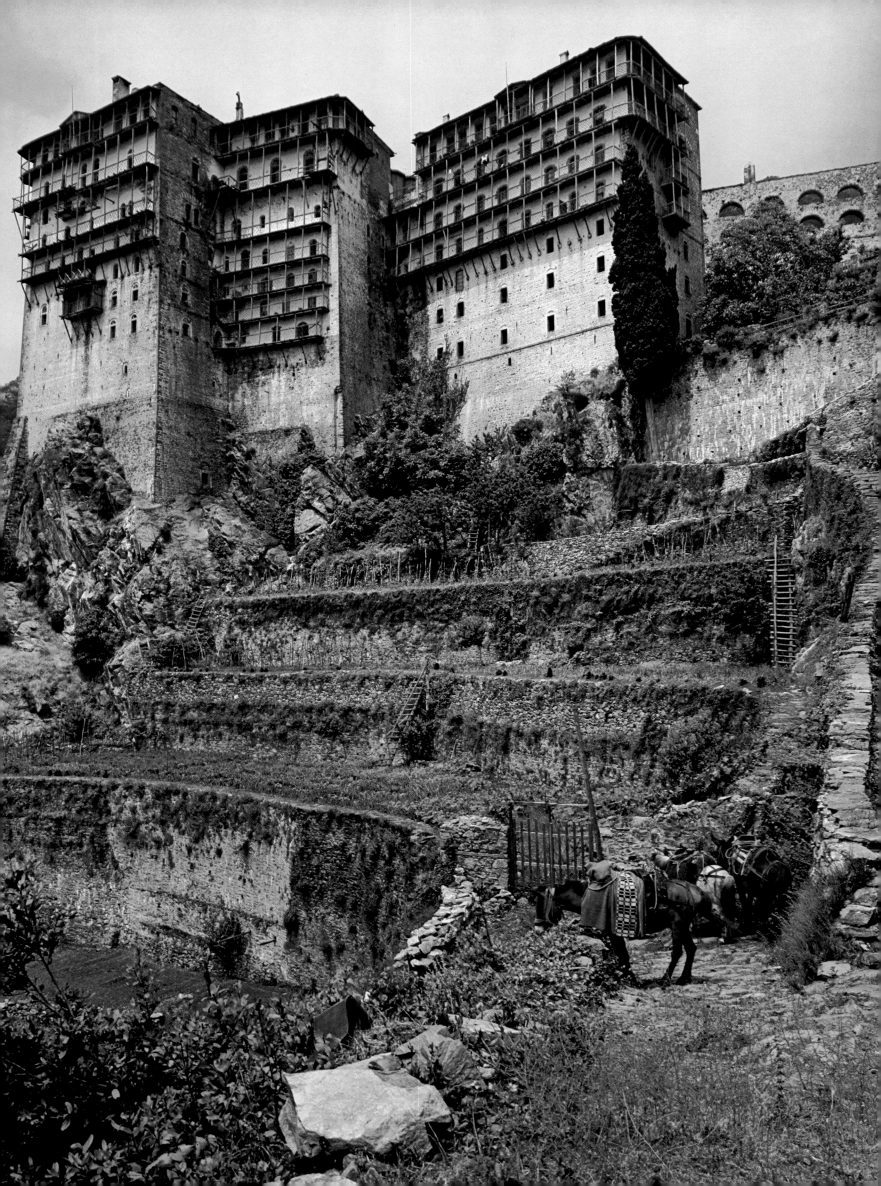

is undoubtedly because of this that they have preserved their characteristic form and culture until the present day, 1500 years after their foundation.

The History and Culture of the Monasteries in the Eastern Mediterranean: Egypt

Christian monasticism, as we have seen, began in 4th century Egypt. When St Anthony became a hermit there were already many others leading an ascetic existence in the region around the Nile, and a few groups of coenobitic monks are known to have existed in the Upper Nile before the Pachomians became active. Once St Pachomius had founded his coenobium with its own particular rules, Egyptian monasticism developed rapidly and spread to all points of the compass.

The Egyptian monks had a considerable impact on the cultural life of the Byzantine Empire, chiefly as a result of their belief in the 'single nature' of Christ. It was the influence of the powerful Egyptian monasteries which resulted in the condemnation of the Nestorian doctrine of the dual nature of Christ at the ecumenical Council of Ephesus in 431. The leader of the movement against the Nestorians was Cyril of Alexandria, and amongst his supporters was Schenoudi, the head of the White Monastery on the Upper Nile. Subsequently, the situation changed, and at the Council of Chalcedon in 451 it was the Monophytism of the Egyptian monks and the Alexandrian church which was condemned as heretical. As a result of this strong opposition, the Alexandrian and Egyptian church eventually broke off relations with the Orthodox Church at Constantinople, which still adhered to the moderate doctrine of the two natures of Christ. The schism was an event of profound political and cultural significance in the history of the Byzantine Empire. It resulted in the establishment of the autonomous Coptic Church in Egypt, which has retained its independence from the Eastern Orthodox Church to this day.

One of the best known Coptic monasteries was the White Monastery, which was built in the first half of the 5th century on the western bank of the Nile. Today its extensive buildings lie in ruins, but they still reflect the influence of ancient Eastern traditions which is characteristic of the area. The numerous works of Coptic art produced in the Nile region since the 4th century display a wealth of provincial features, and are a reminder of the cultural activity of the Egyptian monks in the area.

A notable example of artistic activity in the Coptic monasteries are the wall paintings in the Monastery of Apollo, also in the Nile region. This institution was founded by St Apollo, a pupil of Pachomius, at Baouit near Hermopolis in the second half of the 4th century. It grew rapidly until it was inhabited by some five hundred monks, but after the Arabs penetrated the area it was gradually abandoned and fell into ruin. The discovery of the site by European archaeologists at the beginning of this century caused great surprise among scholars of early Christian monasticism.

The complex of buildings was surrounded by high walls on all sides. On the north side there were two monasteries and on the south side a convent. In addition there was ample accommodation for pilgrims and some fifty small chapels, monks cells, crypts and other rooms. Some of the many wall paintings which decorate them show Christ on the day of the Last Judgment, and the small figures of the Virgin Mary, the apostles and saints standing in rows at his feet are done in a provincial style.

The Sinai Peninsula

The Sinai peninsula bordering on Egypt was also occupied at an early date by groups of hermits living on the edge of the desert. This is one of the most important holy places of the Judaeo-Christian tradition, having close links

46 Monastery of Dionysiou, Mount Athos. Mount Athos had been a centre of artistic activity in the Byzantine Empire from an early date, and the mural paintings known as frescoes, which were executed on fresh lime plaster, suddenly became extremely popular there in the 14th century. The fresco painters, who are often described as members of the Cretan School, were active throughout the peninsula and left numerous examples of their art. This section of a mural of the Last Judgment is in the refectory of the Dionysiou Monastery. Christ appears as the ruler of the cosmos, sitting in judgment and surrounded by the heavenly host and the apostles. On his right hand we see the souls of the righteous gaining salvation, while on his left hand the sinners are driven into the eternal fire. The mural probably dates from 1547, but both the style and treatment of the figures follow the medieval tradition.

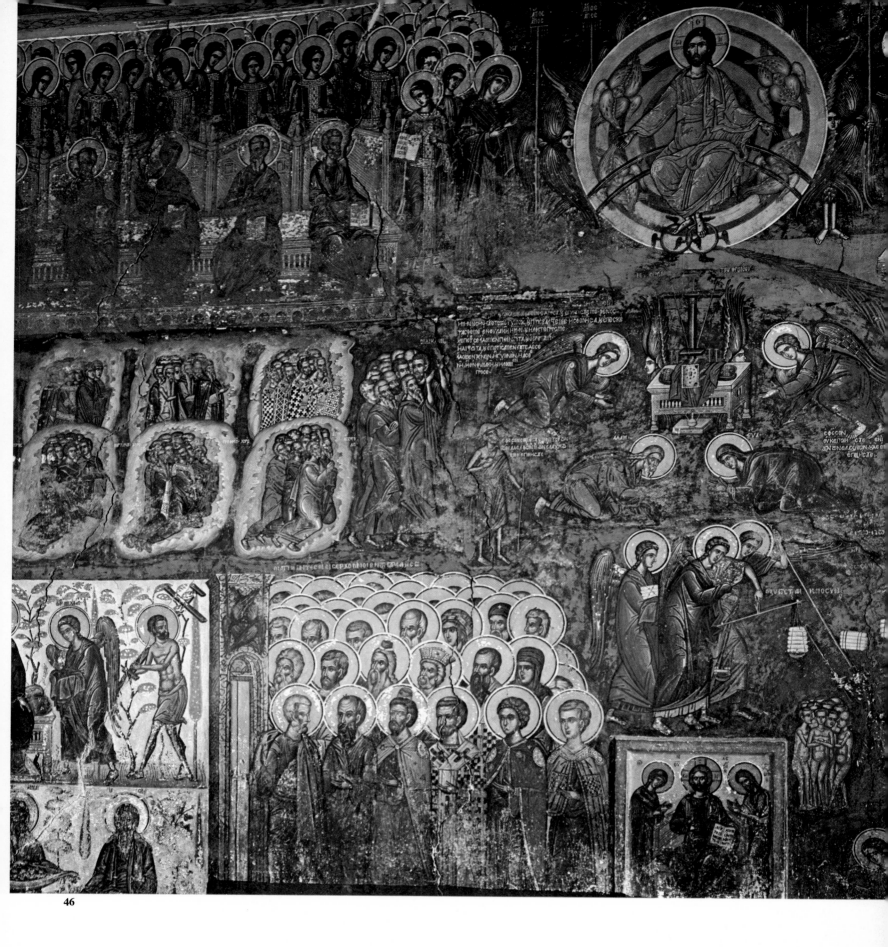

46

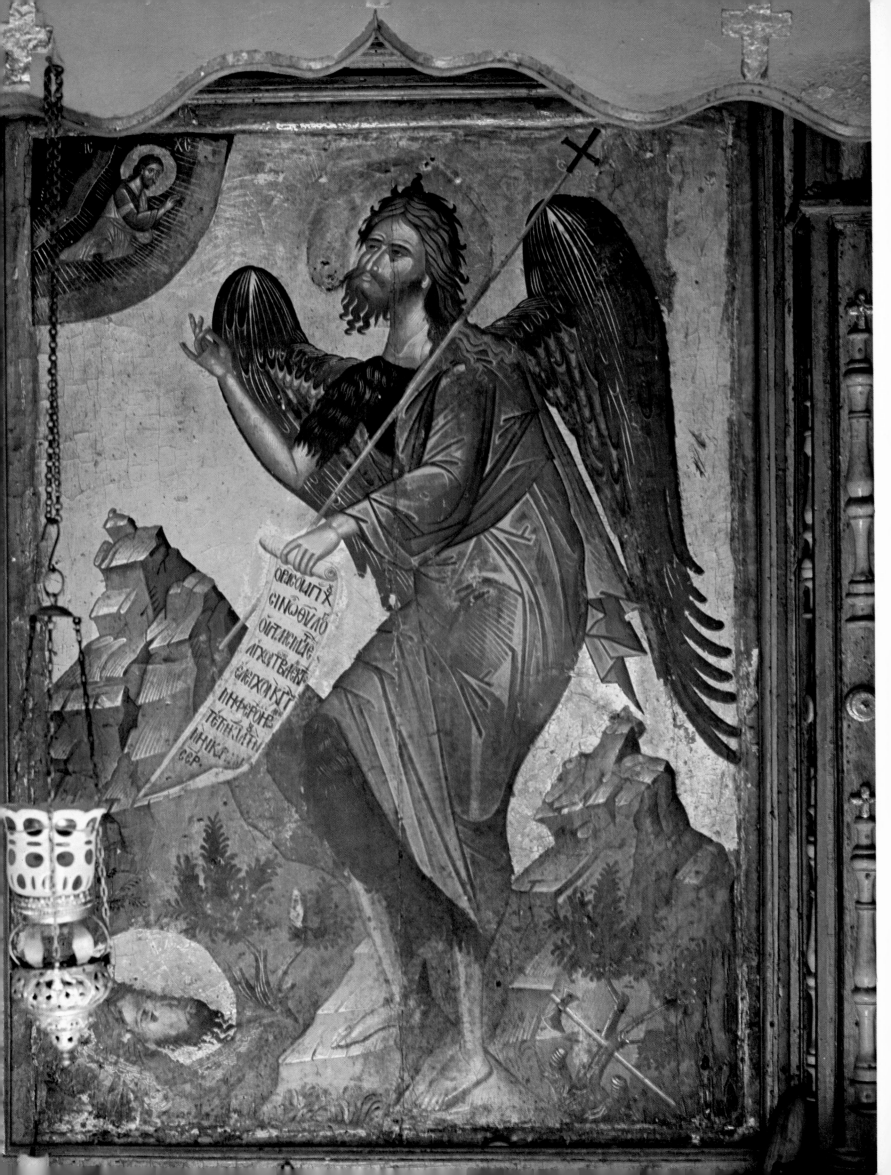

with the Old Testament. It was across the Sinai desert that Moses led the people of Israel on their exodus from Egypt. It was on Mount Sinai that God spoke to Moses, and a church was erected on the spot at an early date. Another church appeared lower down the mountain at Horeb, and a monastery called Batos was built at its foot (the name means thorn bush, and is a reference to the burning bush from which Moses first heard the voice of God). The Monastery of Batos contains a remarkable chapel founded by the Emperor Justinian and decorated with a fine mosaic of the transfiguration of Christ. After the legend of St Katharine of Alexandria made its appearance in the 7th to 8th centuries, the Monastery of Batos adopted her as its patron saint, and today it is known as the Monastery of St Katharine. In spite of the repeated wars which have torn the area, including the Arab-Israeli conflict in the contemporary period, the Monastery of St Katharine was considered a holy place not only by Christians of the Eastern and Western Churches but also by the adherents of Judaism and Islam. Today it is a site of major historical importance, ranking as one of the oldest monasteries still active since their foundation in the time of the Byzantine Empire. Inside the monastery, a flame has burned continuously for centuries, marking the sacred spot where Moses saw the burning bush.

Lying in an isolated valley on the barren Sinai peninsula, the Monastery of St Katharine is a veritable treasure house of Byzantine art. In addition to the mosaic mentioned above it contains two thousand icons and three thousand manuscripts in various languages dating from the 4th century onwards. Among these is the manuscript known as the *Codex Sinaiticus*, which is one of the oldest surviving manuscripts of the New Testament and one of the foundations of our present-day Bible.

One of the abbots of the monastery at Mount Sinai during the 7th century was St John Klimax or Climacus. In his book called *The Ladder to Paradise* he describes thirty different kinds of ascetic practices, and likens these to a ladder of thirty steps which will enable monks leading the contemplative life to achieve a vision of the supreme light. The manuscript was repeatedly copied and richly illustrated by the monks at Mount Sinai and other places, and its influence on mysticism in the Byzantine monasteries was immeasurable.

Palestine and Syria

Palestine needs no introduction as the Holy Land of Christianity, the place where Christ was born, where he proclaimed the Gospel and finally died on the Cross. A monastery is thought to have existed in a north-eastern suburb of Jerusalem as early as the 4th century A.D.. In the 5th century a whole succession of monasteries were built under the direction of St Euchisios, and at the end of the century the Monastery of the Tower of David was also built in Jerusalem. Probably the most important of these Palestinian monasteries was the *lavra* founded by St Sabas, in which the last of the Eastern church fathers, St John of Damascus, spent the latter part of his life. It was from here that John emerged in the 8th century to defend the practice of icon worship in the Iconoclast conflict which shook the foundations of the Byzantine Empire. The centre of monastic activity in Syria was Antioch, where Hellenistic culture had flourished since ancient times. In the 4th century Diodore of Tarsus founded an *asketerion* or ascetic school there, in which he taught the techniques of inner contemplation and instructed the youth of the city in philosophy and theology. Antioch rapidly became one of the most important centres of Christian art and learning after Alexandria in the time of the early church fathers. Among the latter, John Chrysostom and Theodore of Mopsuestia were pupils of Diodore, and Nestorius, the leader of the heretical movement condemned by Cyril of Alexandria, had also been trained in his school.

The most famous of the Syrian monks, however, is undoubtedly Simeon the Stylite, who lived in the 5th century. Simeon embarked on the monastic life at

47 Icon of St John the Baptist, Monastery of Dionysiou, Mount Athos. Following the artistic traditions of antiquity, icons in the Eastern Church were not considered merely as pictures of saints, but were thought to be endowed with mystical force, and were greatly revered for this reason. This picture of John the Baptist with wings is rather curious, and seems to have been painted in the modern era after a medieval model.

a very early age, and when he was thirty-three he began to live on a pillar at Telanissus (now Qal'at Sem'an) in order to prevent visitors from disturbing his contemplations. At first the pillar was only about nine feet high, but it was gradually increased until it was a substantial structure about sixty feet high with a balustrade around the top. There he remained for the rest of his life, exposed to wind, rain and scorching heat, and this rigorously ascetic mode of existence attracted streams of visitors, including Theodore of Mopsuestia. He would deliver sermons and freely dispense advice to the crowds, who venerated him as a saint, and though he seldom descended from his perch, it is thought that he did allow himself to be persuaded to attend the ecumenical Council of Chalcedon in 451.

Simeon's ascetic way of life made a great impression on the people of the Byzantine Empire, and after his death in 459 a great monastery was built at Telanissus. Next to the monastery building itself was the martyry or memorial church of St Simeon. The ground plan of this building was in the form of a cross, with unusually long arms measuring 230 and 260 feet. At the crossing stood the pillar of St Simeon, covered by a large octagonal roof. This great church was endowed by the emperor himself and is an important landmark in the history of Byzantine architecture; its monumental proportions are an eloquent testimony to the veneration which Simeon inspired in his lifetime.

Monasticism in the Eastern Church II

Constantinople

A number of monasteries are traditionally supposed to have existed in the region of Constantinople before Constantine built his capital there. No concrete evidence of this exists, however, and the oldest institution of its kind in the capital, historically speaking, is the Monastery of Dalmatos. This was founded in 382 A.D. by the monk Isaac, who had come to Constantinople from Syria; the building was financed by an influential officer of the imperial guard named Dalmatos, and for this reason it is known by his name.

The monastery which had the greatest impact on Byzantine history in both the political and artistic fields was, however, the Monastery of Studios, which was founded in 463. This institution was named after its founder, who was governor of the district in 454, and was dedicated to John the Baptist. For the first three hundred years of its existence the monastery does not seem to have distinguished itself in any way. In the 8th century, however, it produced two famous abbots in succession – Plato and his nephew Theodore – and suddenly began to play an important role in the political and cultural life of the city. The impact of Theodore's defence of icon worship has already been mentioned, and here we will merely give a short account of his life.

In the second half of the 8th century there lived an official of noble family whose wife was called Theokiste (the name means 'created by God'). Although they were both of distinguished origins, they were evidently pious practitioners of icon worship, and had a deep respect for the monastic way of life. In 759 they had a son, whom they named Theodore. Somewhere around 780, when the prohibition against icons had temporarily lost some of its force, the family were visited in the capital by Theokiste's brother. This man, whose name was Plato, was the abbot of the Symbola Monastery, and he evidently spoke to them persuasively of the virtues of the monastic way of life, for they all decided to enter a monastery. As the family owned a piece of land in Sachydon, in the region of Bithynia in north-western Asia Minor, they went there and founded a monastery of their own. The country was soon invaded by the Arabs, however, and their establishment was threatened, so they returned to the capital and entered the Monastery of Studios, which at that time was almost abandoned. Only a few years later the number of monks in residence had risen to some seven hundred.

48 Icon, Monastery of St Paul, Mount Athos. Mount Athos survived the collapse of the Byzantine Empire and remained one of the major spiritual centres of the Eastern Church. Many of the icons which have survived there were probably brought as offerings from different parts of Eastern and Western Europe. This example with enamelled figures seems to have been used as a cover for a Bible, and was probably presented to the monastery by an eastern visitor.

Pages 102–103:
49 Ruins of the medieval town of Mistra, Greece, 13th to 15th centuries. The town of Mistra flourished in the time of the Paleologue dynasty, a few miles from Sparta in the Peloponnese. The ruins of the dwelling houses, the citadel and the monasteries give some idea of the town's prosperity at that time. Some of the churches escaped restoration at a later date and are badly dilapidated as a result, but they contain mural paintings which are an important documentary source of Paleologue art.

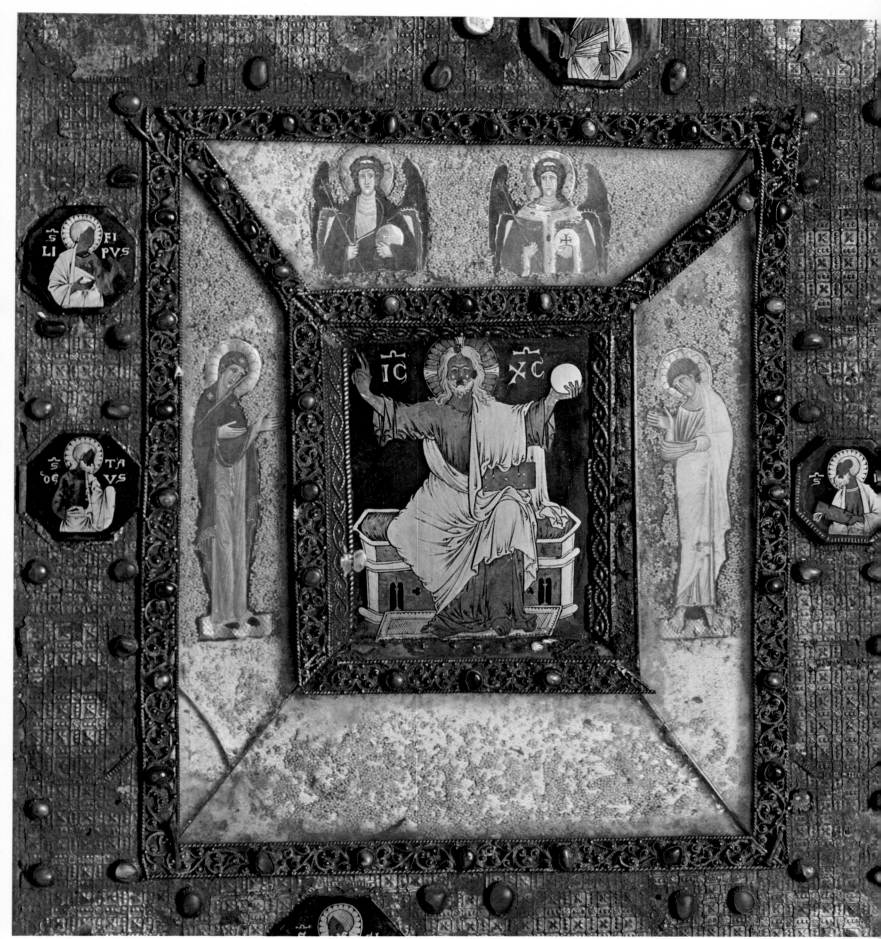

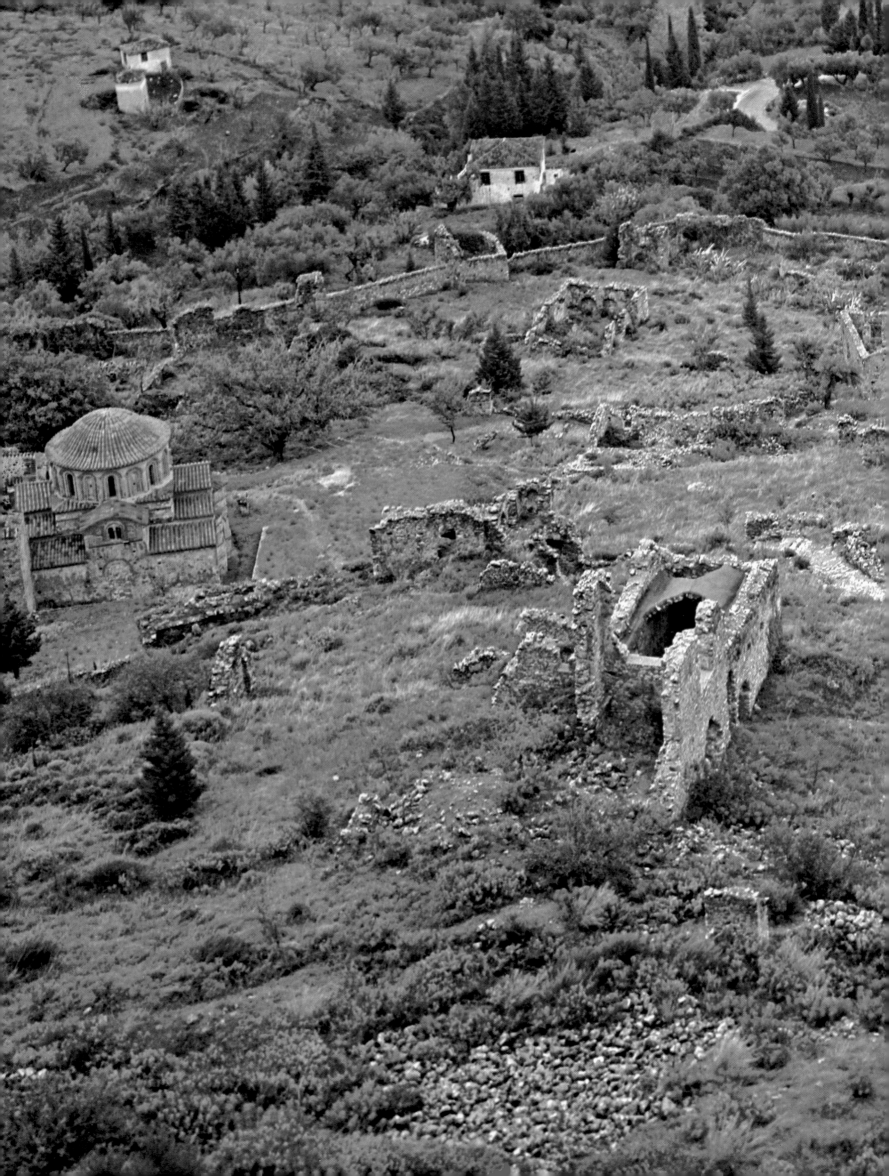

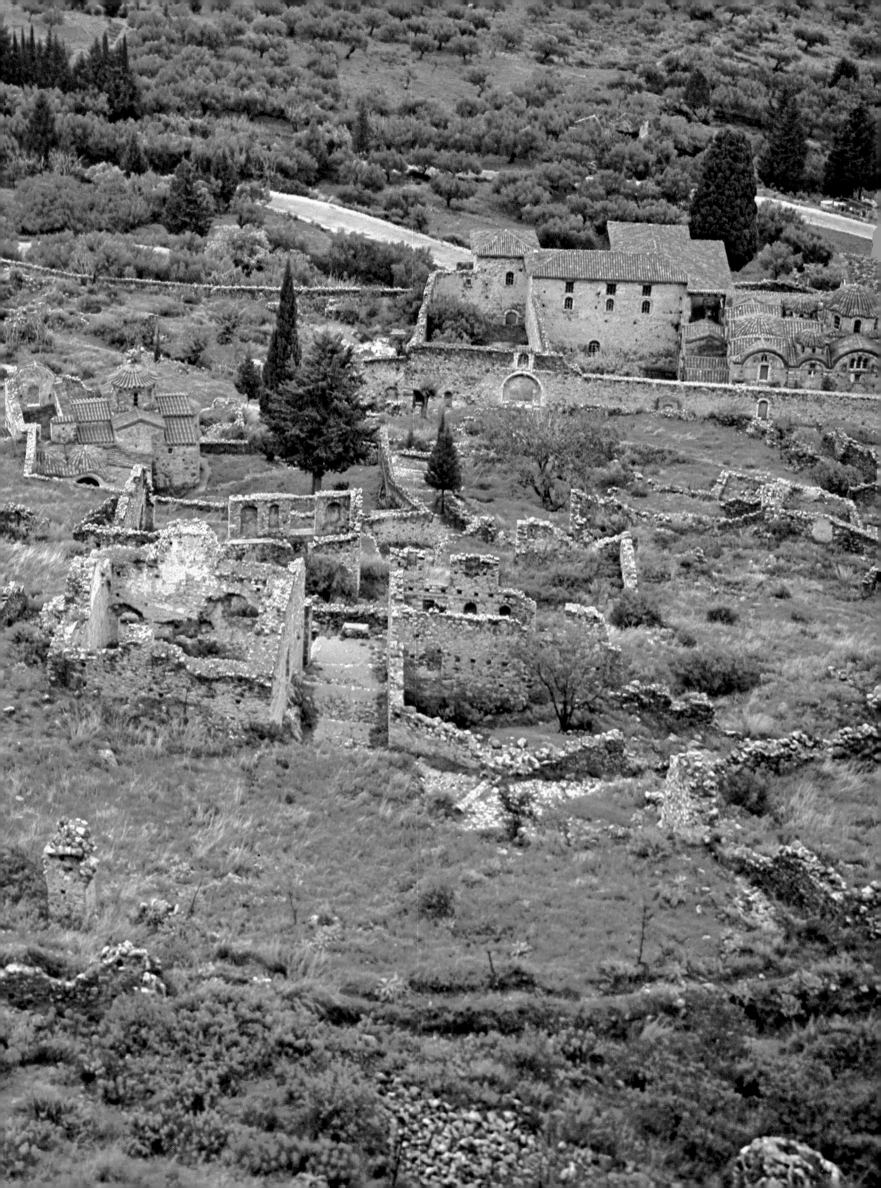

Meanwhile the dispute with the Iconoclasts, which had been quiescent for some time, flared up again, and both Theodore and his uncle and brothers were banished from the capital. Theodore refused to give up the struggle, writing letters and bringing political pressure to bear on his opponents from his place of exile. Unfortunately he died while still in exile in the year 826, before he could witness the final victory of the iconodules. His brothers and collaborators, however, were called back to the city.

Theodore was not the only person to suffer in the struggle against the Iconoclasts. In November of the year 767 Stephen, the abbot of the monastery of St Auxentios in Bithynia, was horribly done to death in the streets of Constantinople by a crowd incited by his opponents. Innumerable other monks were exiled, killed, blinded or mutilated by the Iconoclasts, and many monasteries were closed and converted into public buildings. The Iconoclastic conflict was a time of great persecution for the Byzantine monasteries, and the victory of the iconodules in the year 863 was above all the victory of the monks, who had fought a long hard battle for their beliefs. The violence of monastic feeling against the Iconoclasts is well illustrated by the illuminated psalters produced in the period after the conflict, of which the Khludov Psalter in the Historical Museum in Moscow is perhaps the best example. Although these books were intended for liturgical use, the monks used the illustrations accompanying the Biblical texts to depict their sufferings at the hands of the Iconoclasts in the most graphic fashion. The men who obliterated icons of Christ, for example, are compared with those who tortured Jesus on the Cross; and the figure of Simon Magus being trampled by the feet of the Apostle Peter is another symbol of the Iconoclasts. At least one of these psalters is known to have been produced at the Monastery of Studios in 1066.

The Monastery of Studios was later to become famous for its scholarly activities, which included the publication of liturgical books and the production of illuminated manuscripts. Today it lies in ruins, and anyone who visits the site in the southern quarter of Istanbul near the Sea of Marmara cannot but reflect on the changes wrought by history. The monastery chapel, which is almost the only surviving example of 5th century architecture in Constantinople, was a substantial basilica with a broad central nave and an aisle on each side. As is normally the case with Oriental basilicas, there were galleries on both sides and at the end opposite the apse, supported on columns some twelve feet high. The capitals were decorated with acanthus leaves, while the marble architrave above was carved with a similar design. Every chisel-stroke of this ornamental motif, with its subtle effects of light and shade, seems imbued with the Classical tradition which was a part of the city's heritage. But Constantinople was under Muslim rule for more than five hundred years and the roof and the beams of this memorable church have long since collapsed. Even the magnificent marble columns have only partially survived. One wonders what happened to Theodore and the monks who were prepared to risk their lives to preserve the cultural traditions of the Byzantine Empire. Did they really see the light of their eternal salvation in the icons which they defended? In the ruins of the Monastery of Studios, a wire barricade now fences off an area which the local children use as a playground. Grass grows luxuriantly in the cracks in the coloured marble which once paved a splendid interior, and there is little to remind one of the capital's era of glory, which lasted more than a thousand years.

Cappadocia

Christianity spread at an early date to Cappadocia, the hinterland of Asia Minor which lies between Constantinople in the west and Syria and Armenia in the east. The first epistle of Peter was addressed to 'the strangers scattered throughout Pontus, Galatia, Cappadocia, Asia and Bithynia'. Cappadocia sent seven bishops to the first ecumenical council, which Constantine called at

50 Church of Aphendico, Mistra, early 14th century. The scene shows a group of martyrs on the west wall of the northern wing of the church, which is dedicated to the Virgin of the Monastery of Brontocheion. The figures are done in the elegant style of Constantinople, and are unusual for their light colours and delicate brushwork. The influence of mosaic art can be seen in the white spots accentuating the edges of the garments and the row of feet which seem suspended above the ground.

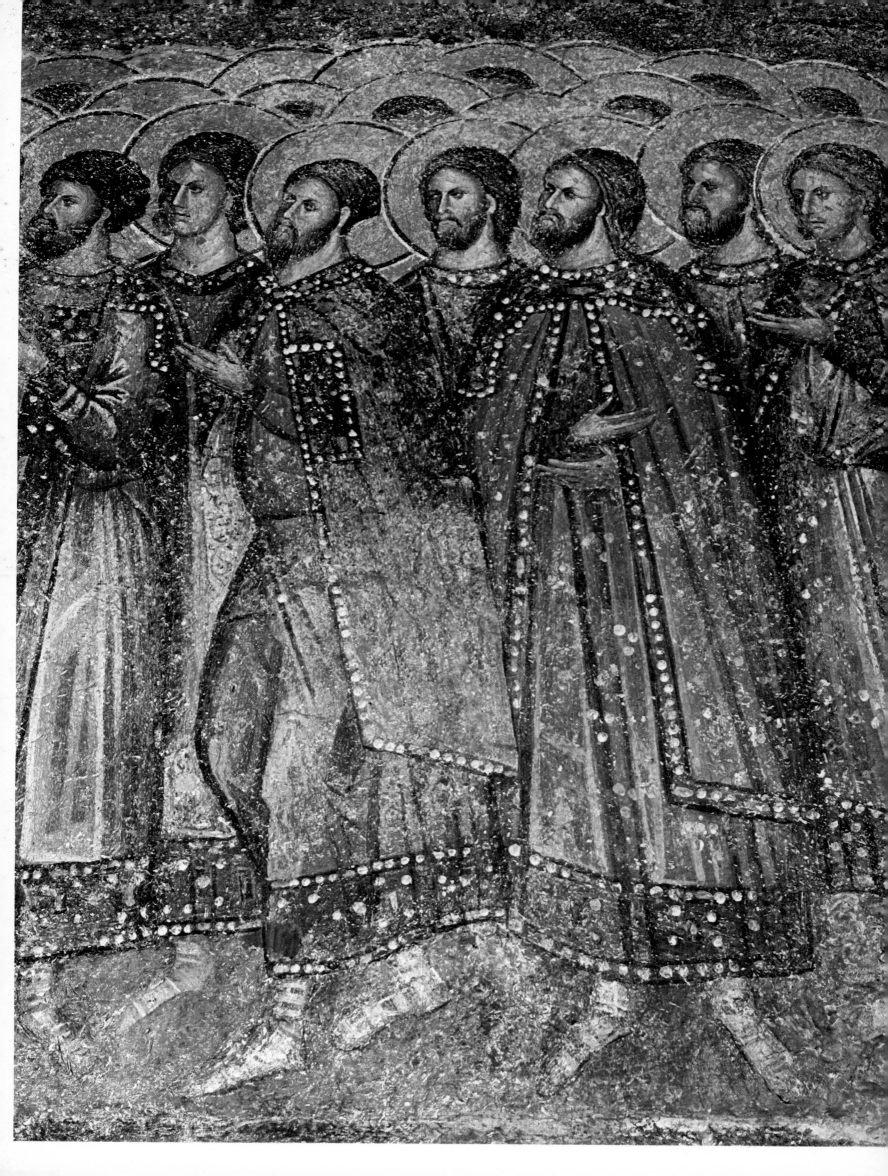

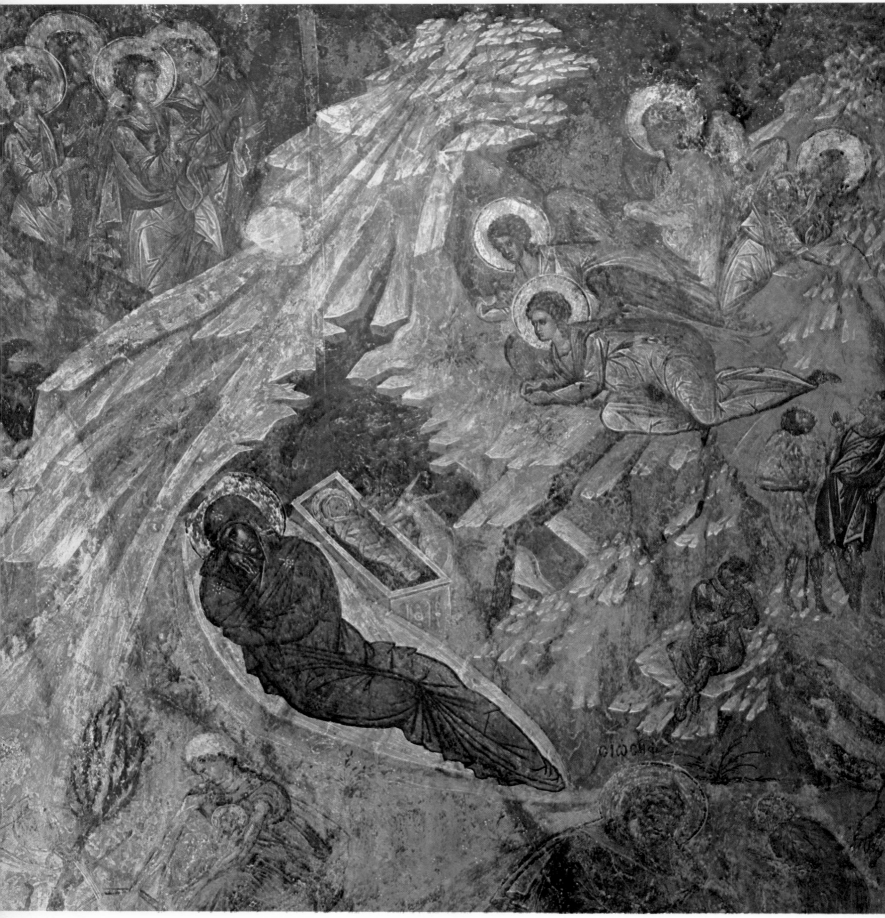

51 Church of Peribleptos, Mistra, late 14th century. The wall paintings to be found in this church are the crowning glory of the last period of Byzantine art. They are stylistically related to the elegant productions of the court in Constantinople. In this depiction of the Birth of Christ, the light which seems to stream from within the very substance of the picture endows it with a profound and poetic sense of mysticism. The formalized drawing of the rocks and the realistic figures indicate that the artist has drawn inspiration from the techniques of icon painting and manuscript illumination.

Nicaea in 325 – an indication that the area was already an influential centre of Christian belief at this early date.

St Basil the Great, who was a native of Cappadocia, made an important contribution to the development of monasticism, following in the footsteps of St Anthony and St Pachomius.

Basil was born around 330 into a rich Christian family in Caesarea, the capital of Cappadocia. He studied the normal disciplines of the Classical world, first in Caesarea and Constantinople and later in Athens itself. At the school in Athens he formed a close friendship with Gregory of Nazianzus. After completing his studies Basil returned to his homeland and came under the influence of the famous monk Eustathius, a native of Sebaste, near the border of present-day Armenia, whose austere way of life he greatly admired. Encouraged by his pious elder sister, Basil became a Christian at the age of about twenty-six, and decided to adopt the monastic way of life. To indicate the sincerity of his intentions, he journeyed to Egypt, Syria and Palestine, where monasticism was considered to have originated. After studying the different forms of monastic existence in these places, he returned home and together with Gregory of Nazianzus founded a monastery in Pontus, where he codified the basic rules of monasticism in two volumes.

Basil's choice of the monastic life, like that of Theodore, was undoubtedly influenced by his family circumstances. His grandparents were probably martyrs, and his sister, having lost the man she was betrothed to, committed herself to lifelong celibacy. It was she above all who persuaded Basil to become a monk, as she did his younger brother, Gregory of Nyssa. Basil's mother Emelia also came to Pontus after the death of her husband, and led the life of a hermit together with her daughter. At the age of about forty, Basil became bishop of Caesarea, succeeding Eusebius, who had written a *History of the Church* and the *Vita Constantini*. Basil now became an important ecclesiastical and political figure, founding charitable institutions and generally exercising the Christian virtues. He died when he was not yet fifty. The monastic rules which Basil compiled were to have a profound influence on later generations of monks, and on the church in general. They were based on the rules of Pachomius, which Basil had studied in Egypt, but he evidently took into consideration the difference in climate between Egypt and Asia Minor, for their strictures are milder and more humane than the originals. It would not be an exaggeration to say that the rules compiled by St Pachomius and St Basil the Great were the foundation stone of Byzantine monasticism as it subsequently developed.

Among Basil's collaborators was his friend Gregory of Nazianzus, who was a gifted speaker and helped to spread the orthodox principles originally established at the Council of Nicaea. Gregory played a major part in the attemps to unify religious opinion in the Byzantine Empire. Basil's younger brother, Gregory of Nyssa, is considered a better theoretician than either of these two. He adopted the concepts of Neoplatonism and Stoicism, bringing to them a profound mystical sense which enabled him to take the fusion of Christianity and ancient philosophy a stage further than hitherto. Without Gregory of Nyssa, the mystical concepts of the pseudonymous Dionysius the Areopagite, or the mysticism of St John Climacus could never have come to life. While his elder brother Basil laid the institutional and practical foundations of Byzantine monasticism, it was Gregory who brought it to completion in a mystical sense. These three great monks are generally known as the Cappadocian Fathers, and the monasteries of Cappadocia are justly famous as the repositories of the spiritual world which they helped to establish. But they are perhaps equally well known for the unusual works of art which they contain. In the region of Ürgüpp there are gigantic rocks produced by erosion which have numerous cave monasteries carved into their sides. The interiors of these monasteries are decorated with frescoes dating from the beginning of the Iconoclast period up to the 11th century. Some of these reflect the artistic traditions of Egypt, Syria and Palestine, while others show clearly that the style of painting of the Byzantine capital had also

reached this remote region. Since few works of art from this period now survive outside the capital, the paintings in these monasteries are important documents of Byzantine cultural history.

Greece

The frescoes in the rock-chapels of Cappadocia are historically significant, chiefly because they retain clear elements of the traditional Byzantine style, combined with a wealth of local stylistic features. In order to examine the mainstream of Byzantine art in the middle period and the splendour of its development after the defeat of the Iconoclasts, we must however turn our attention to two monasteries in Greece. These are the Monastery of Daphni, which lies just outside Athens, and the Monastery of Hosios Lukas (St Luke) at Phokis, on the road to Delphi. The connection between the works of art in these monasteries and others in mainland Greece has already been mentioned in the introduction, and before proceeding any further we must examine the origins of the larger monasteries on Mount Athos in particular and their place in the history of Byzantine art.

The monastic movement which developed between the end of the Iconoclast period and the 10th century was mainly confined to Egypt, Palestine, Syria and Asia Minor. After the 10th century, however, these areas gradually came under Arab and Turkish domination, and Mount Athos became the most important bastion of monastic life. The name 'Mount Athos' is given to the whole of the narrow tongue of land which juts into the Aegean at the eastern end of the Khalkidhiki peninsula, east of Salonica. More specifically, however, it is the name of the mountain which stands at the tip of this extension. The sides of the mountain are steep and difficult of access, with cliffs falling sheer into the sea. The top is bare and rocky, and can only be reached on foot or on donkey-back even today.

This steep, remote place was originally colonized by anchorites, who found it an ideal retreat in which to pursue their ascetic way of life. The first monks settled there around the beginning of the 9th century, and around the middle of the same century they built a *lavra*. In the 10th century they chose the oldest monk amongst them as the leader of their community and designated Kariés, in the middle of the peninsula, as his seat. The hermits scattered across the mountain top gradually collected around this spot, as the opportunity to move presented itself. There was even a move to form a proper coenobium at this time, since the shores of the Aegean were being threatened by Saracen pirates and the monks were inadequately organized for self-defence. The high stone walls which now give the monasteries of Mount Athos their fortress-like appearance were in fact built as a defence against invasion.

In the middle of the 10th century a monk named Athanasius came to Mount Athos. A native of Trebizond, on the Black Sea coast of Asia Minor, Athanasius studied in Constantinople before joining a monastery in Bithynia led by St Michael Maleinos. The latter was the uncle of the reigning Byzantine emperor, Nikephoros Phokas, and as a result of this connection Athanasius was appointed spiritual adviser to the emperor when he was already living as a hermit on Mount Athos. With money from the emperor, who was a devout supporter of monasticism, he began building the first coenobitic monastery on Mount Athos in the year 961. It was known simply as the Megista Lavra or Great Monastery. At about the same period Athanasius compiled a set of monastic rules based on those which Basil the Great and Theodore had produced at the Monastery of Studios, and also incorporating some elements of the Western Benedictine tradition. The emperor issued a special 'golden edict' (*chrysobullon*) granting the Lavra exterritorial status and exemption from taxes. Then in the 11th century, in the time of Constantine IX Monomachos, Mount Athos received the official title of Hagion Horos, the Holy Mountain. The event signalled the beginning of its first period of efflorescence.

Right:
52 Monastery of the Theotokos or Mother of God, the Great Meteoron, Greece, founded in the 14th century. The monasteries of the Meteora are built on a group of great rocks which tower above the plain of Thessaly. The most important of them, the Great Meteoron, was founded by a monk named Athanasios, who had been driven from Mount Athos by the Turks and established himself on the Greek mainland. In this view of the Monastery of the Theotokos, perched on the side of a rock near the Great Meteoron itself, the meaning of the word meteora – *'floating in the air' – is graphically illustrated. Today the unusual site attracts more tourists than monks.*

Pages 110–111:
53 South side of the Catholicon of Hosios Lukas, Phokis, circa 1020. *With the adoption of the Greek cross as a ground plan, the development of Byzantine church architecture can be said to have reached its completion. Byzantine architecture in the middle period found a new method of suspending the dome over the square base, providing more space in the interior than hitherto. This church was formerly assumed to have been built by Romanos II (959–963), but it is now thought that his son Basil II (996–1025) may have visited Athens on the way home from his victory in Bulgaria and carried out his father's wish to build a church. The building follows the traditional style of Constantinople, with galleries and a narthex, but the combination of stones and bricks is typically Greek.*

Monastery of Hosios Lukas, ground plan and decorations.
1 *Virgin and Child*
2 *Pentecost*
3 *Christ*
4 *Pantocrator*
5 *Annunciation*
6 *Birth of Christ*
7 *Baptism of Christ*
8 *Consecration of the temple*
9 *Pantocrator*
10 *Crucifixion*
11 *Baptism of Christ*
12 *Doubting Thomas*

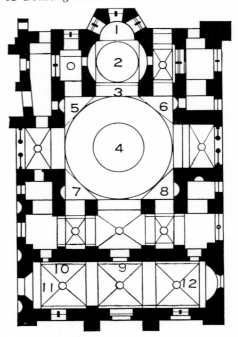

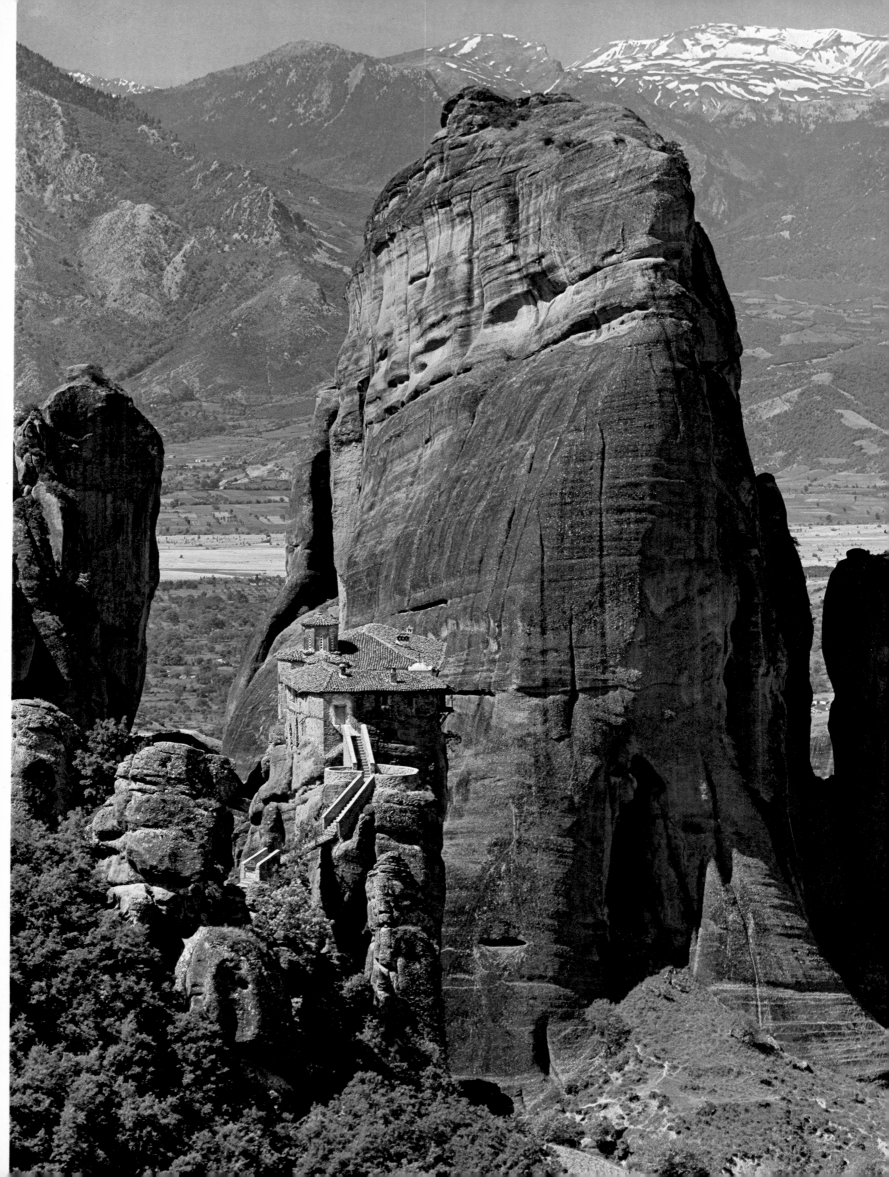

The Catholicon or main chapel which now stands in the inner garden of the Lavra is the oldest of the numerous buildings on Mount Athos, going back to the time of Athanasius. In the 12th century, the Holy Mountain was beset by internal strife and threatened with attack from outside. In 1204, however, it received an infusion of new blood when the Fourth Crusade passed by, leaving behind it a host of monks from countries outside the Byzantine Empire, who had decided to settle on Mount Athos. St John the Iberian, who had come to Mount Athos from Georgia (Iberia), became a pupil of Athanasius and shortly after built the Iviron Monastery (the name means Iberian, i.e. Georgian). Some Slavonic monks founded the Xylourgou ('woodworker's') Monastery in the mid 12th century, but soon moved to the present-day Monastery of St Pantaleimon. At the end of the 12th century, the present-day Monastery of Chilandari was occupied by the Serbs, and some Bulgarian monks occupied the Zographou ('painter's') Monastery, which also survives. The Monastery of Koutlmousiou was probably founded by a Seljuk Turk who had been converted to Christianity.

The Byzantine emperors, and the Turks who destroyed their empire and ruled after them, made intermittent efforts to bring the monks on Mount Athos under the control of the state, or at least to subject them to the influence of the imperial church, which was closely linked to the state. But the monks' will to independence resisted all external pressures, and theirs is an autonomous organisation even today, although Mount Athos is now subject to Greek law. One needs a special visa to visit this bastion of Eastern monasticism, which is still independent of the official church.

The monks who have lived on Mount Athos have often had colourful histories, and few were more colourful than that of the monk known as Joasaph. His story begins at Easter in the year 1321, when Andronikos III, the self-willed Paleologue prince who ruled the Byzantine Empire as it then existed, accidentally killed his elder brother over a love affair. In the aftermath, his sick father died of grief, and Andronikos III had to leave the palace to escape the anger of his grandfather Andronikos II. Fortunately the prince had a few staunch friends, who stood by his side and left the capital with him. Among them was a very rich young man, the future emperor John VI Cantacuzene, who had not only inherited immense wealth, but was also a naturally gifted politician and military leader; he was probably also the most pious ruler ever to sit on the imperial throne. When he was later forced to abdicate this throne, John Cantacuzene became a monk, adopting the name of Joasaph, and wrote his memoirs in which he relates his flight from the capital.

Another interesting story is that of the monk Gregory, who slightly before these events took place had left the island of Cyprus to study in a monastery on Mount Sinai. There he seems to have been mainly concerned with the ideas contained in the *Ladder to Paradise* of St John Climacus, and because of this stay he is known today as St Gregory of Sinai. Later, Gregory left Sinai and went across the Holy Land to Crete, where he met a monk named Arsenios who introduced him to the idea of the *vita contemplativa*. After learning various spiritual and mental disciplines from Arsenios, he moved to Mount Athos to pursue a life of quiet contemplation which brought him new mystical experiences.

The ecstatic mystical practices known as Hesychasm had a strong influence on the monks at Mount Athos towards the end of the Byzantine Empire. Attemps to experience the divine light by means of inner perception were by no means new, but the novelty of 14th century Hesychasm lay in the technique of contemplation used. Historians have described the procedure as follows. First the monk shut himself in his cell, locked the door, and sat down quietly. He emptied his mind of all extraneous thoughts and let his chin and beard sink onto his chest. He fixed his gaze on his navel, and concentrated his thoughts on the same spot, then began to repeat over and over again, 'Lord Jesus, Son of God, have mercy on us'. At first he would see nothing but darkness, but if he repeated the prayer day and night, simultaneously breathing

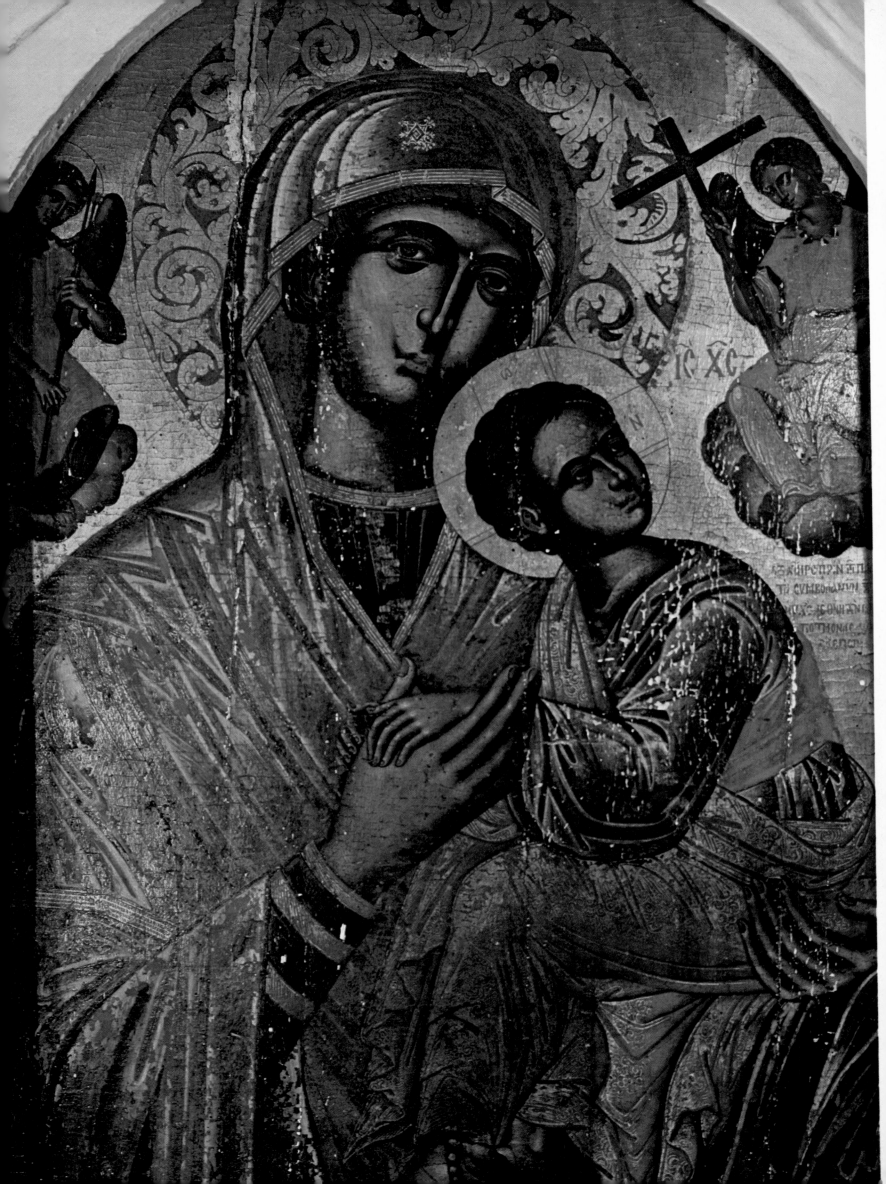

Ὁ ΠΑΝΤΟ ΚΡΑΤΩΡ

ΔΕΥΤΕ ΠΡΌΜΕ
ΠΆΝΤΕC ΟΙ ΚΟ
ΠΙῶΝΤΕC ΚΑΙ
ΠΕΦΟΡΤΙCΜΕ
ΝΟΙ ΚἈΓῶ ΑΝΑ
Cῶ ΥΜΑC ᾶΡΑ ΤΕ
ΤῸΝ ΖΥΓΌΜΟΥ

ΕΦ ΥΜΑC ΚἉ ΜΑ
ΘΕΤΕ ἈΠ ΕΜΟΥ
ΟΤΙ ΠΡΑΟC ΕΙΜΙ
ΚἉ ΤΑΠΕΙΝΟC Τῆ
ΚΑΡΔΙΑ ΚΕΥΡΗ
CΕΤΕ ΑΝΑΠΑΥΣῖ
ΤΑC ΨΥΧΑΙC ΥΜῶ

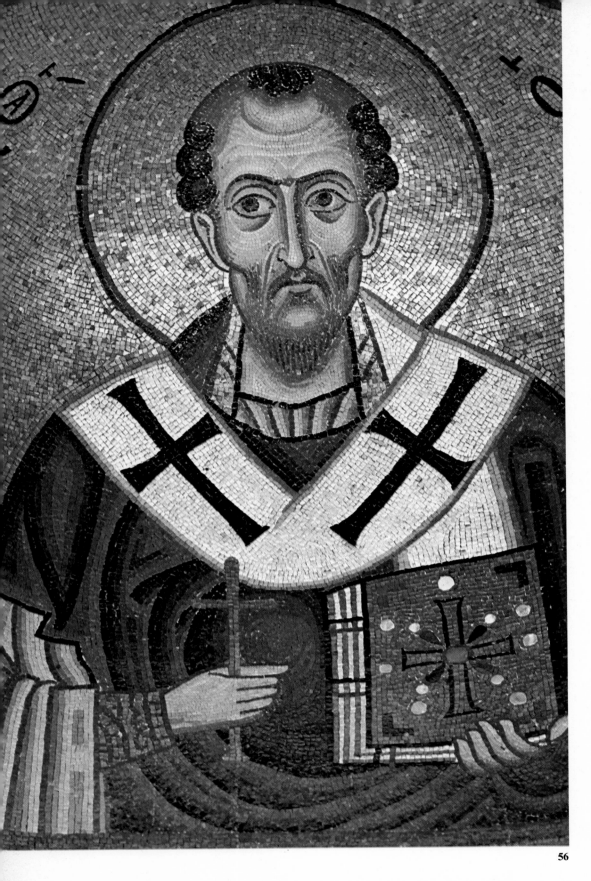

56

according to a certain pattern, he would be gradually filled with a sense of unearthly joy. Then he would inwardly perceive the light which comes directly from God, the same light which Jesus radiated at his Transfiguration on Mount Tabor. Finally the monk's whole form would be clothed in light.
The concept of the experience of this divine light as synonymous with the contemplation of the highest Being had already been adopted by the early Church Fathers. We mentioned earlier in this chapter that the idea was transmitted via the writings of Dionysius the Areopagite amongst others and reached St John Climacus at the monastery on Mount Sinai. Thus it is not surprising that Gregory, who studied at Mount Sinai, learned this method of contemplation and introduced it to Mount Athos. This illuminative form of mysticism appears as early as the 11th century in the work of mystical

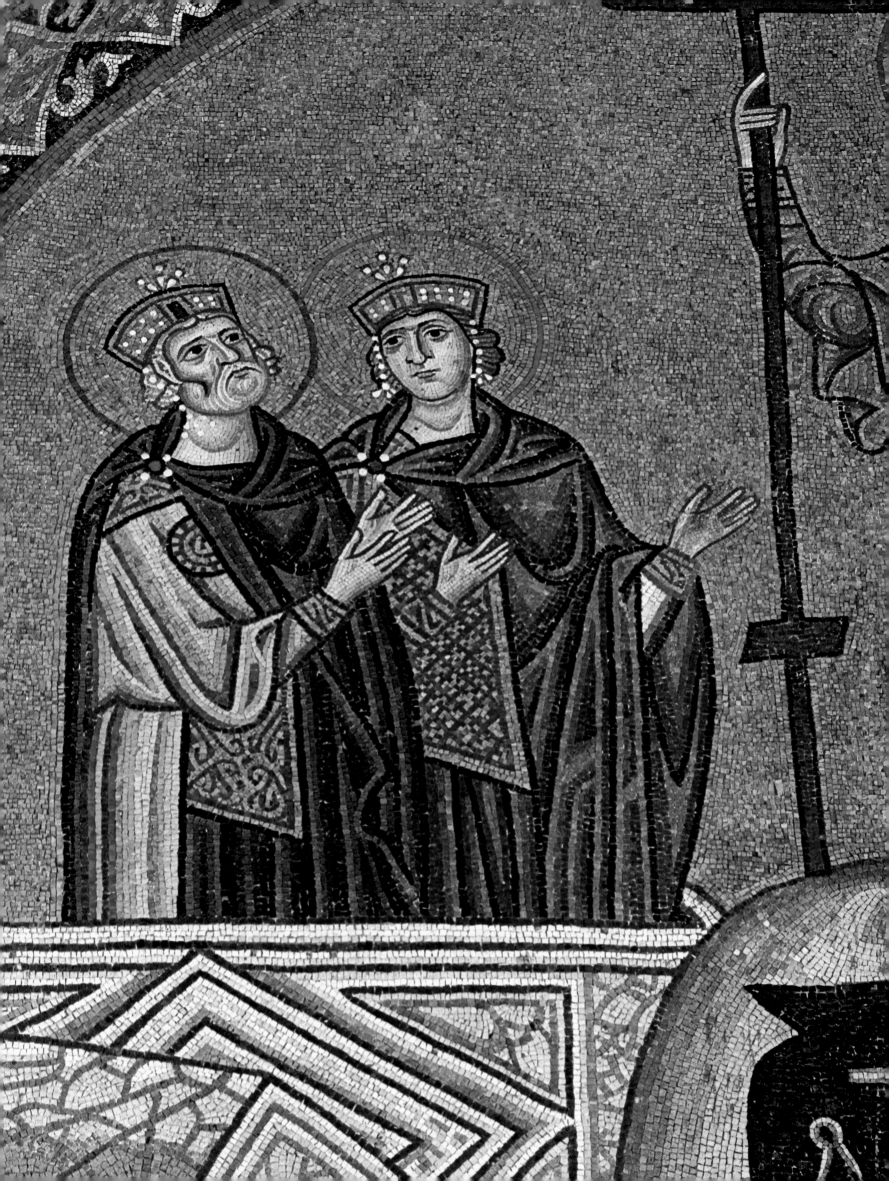

58

thinkers such as Simeon the New Theologian, who died in Constantinople. In the 14th century an indigenous technique of contemplation and perception was developed on Mount Athos, which can almost be described as Oriental. The monks of Mount Athos rapidly adopted Hesychasm, and rumours of their extraordinary experiences of illumination spread throughout the Empire.

This kind of mysticism had always found opponents, and it did so in the Middle Ages. The most outspoken critic of Hesychasm was the monk Barlaam, who had come to the Byzantine Empire from Calabria. Having trained in the sophisticated ways of thought of Western scholasticism, Barlaam regarded the possibility of an illuminative perception of God as foolish superstition. But more than this he considered any belief in such a possibility as dangerous heresy from the standpoint of Christian doctrine, which held that the essential being of God must transcend our sensory perceptions. Thus Barlaam's Western training brought him into theological conflict with the simple Eastern monks amongst whom he found himself, and in 1332 he wrote a tract attacking Hesychasm.

At this time few of the monks on Mount Athos were capable of rising to this challenge, and they therefore appealed for help to Gregory Palamas, who had at one point spent five years in the study and practice of Hesychasm in the Monastery of Vatopédi on Mount Athos. Gregory's ripost to Batlaam's tract marked the beginning of the Hesychastic dispute which is the climax of Byzantine theological history.

The conflict was not confined to the theologians. The politicians and educated classes of the Byzantine Empire both split into two factions and fuel was added to the dispute by the fact that John Cantacuzene, the future emperor, was himself an ardent supporter of Hesychasm. Cantacuzene had not ceased to support Andronikos III with whom he had fled from the capital many years previously. He had helped to restore him to his throne, and was now commander of the Empire's land and naval forces, and hence its *de facto* ruler. When Andronikos died in 1341 leaving his nine-year-old son John Palaiologos to succeed him, the child's mother assumed the regency, but Cantacuzene disputed this claim and the Empire was plunged into civil war. While Andronikos, with the backing of Cantacuzene, had supported Gregory Palamas, Barlaam now gained the upper hand with the support of the Paleologue faction. The Bulgarians, Serbs and Turks had meanwhile involved themselves in the Empire's internal disorders and were seeking to gain whatever territorial advantage they could from the affair. In addition both Genoa and Venice in the West were looking for an opportunity to seize the capital, Constantinople. In fact this dispute may be said to have led to political and military conflict between Eastern and Western Europe. The struggle lasted until 1351, when Barlaam suffered a final defeat at a Council presided over by Cantacuzene, who had by this time won a provisional victory over the Paleologue faction and had himself crowned emperor as John VI. The Hesychast doctrine was officially recognized by the Byzantine Church and the monks of Mount Athos were vindicated. The triumph of John Cantacuzene was short-lived, however. In 1354 he was forced to abdicate by his rival John V Palaiologos and eventually retired to Mount Athos, where as the monk Joasaph he spent his last years in writing and quiet contemplation. The ideas which fuelled the Hesychastic conflict were a compound of everything which had been thought and believed in the Byzantine Empire since ancient times. The result was a magnificent historical drama which spelled the end of an already collapsing despotic state. Its chief protagonists, Cantacuzene and the monks of Mount Athos who supported him, were the last representatives of a way of thought which belonged to a previous era. They drew their spiritual strength from Byzantine monasticism, which had scaled the heights of mystical experience.

A number of manuscripts from this period, produced between 1370 and 1375, are now preserved in the Bibliothèque Nationale in Paris. One of these contains an illumination representing the Council of 1351, which brought

victory to the Hesychasts. Cantacuzene sits on a raised throne surrounded by bishops, soldiers and a host of monks clad in black. Another manuscript shows the Transfiguration of Christ on Mount Tabor, and is clearly inspired by the beliefs of Hesychasm. Christ is surrounded by a mighty halo of elaborate form, and the light from it bathes the three apostles at his feet, who have thrown themselves down as if struck by lightning. The illustration demonstrates the kind of art which was produced by Hesychasm – the light which surrounds the figure of Christ is nothing less than the divine *energeia* of which Gregory of Palamas spoke so often.

59 The Baptism of Christ, Daphni, late 11th century. The use of scenes from the early life of Christ to decorate the squinches linking the square nave to the dome above is a common feature of Byzantine church architecture. In this scene of the Baptism of Christ, which decorates the south-west corner of the nave, the groups of figures are symmetrically arranged so as to fit in with the architectural form. Many details of the scene are reminiscent of Ancient Greek sculpture – the submissive attitude of Christ, the skilful rendering of his naked body, the rounded cheeks of the angels and the beard and hair of Christ and John the Baptist. The Classical sense of ideal beauty is combined with a religious sensibility and the overall effect is very agreeable. The mosaic artists may well have learned Classical techniques from manuscripts, or from the ancient carved reliefs in Athens, but their place of origin is uncertain; they are generally thought to have come from Constantinople. The mosaics at Daphni show great variety and are generally more painterly in execution than the examples at Hosios Lukas. They embody all the features of a new style which was to find its chief expression in Byzantine painting of the early 12th century. Historically, they occupy an important place in the period at which the characteristic features of art under the Comnene dynasty were taking shape.

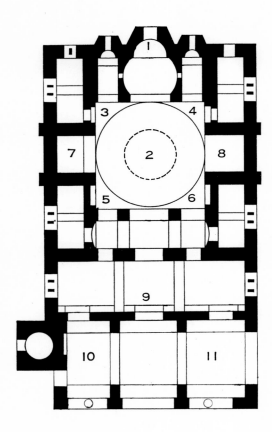

Church of the Monastery at Daphni, ground plan
 1 Virgin and Child enthroned
 2 Christ as Pantocrator
 3 The Annunciation
 4 Birth of Christ
 5 The Transfiguration
 6 Baptism of Christ
 7 Birth of the Virgin Mary
 The Crucifixion
 Entry into Jerusalem
 Awakening of Lazarus
 8 Adoration of the Magi
 Journey to the underworld
 Doubting Thomas
 Consecration of the temple
 9 Koimesis
 10 The Last Supper
 Washing of the disciples' feet
 Judas's betrayal of Christ
 11 Mary's visit to the temple
 Simeon's blessing
 The prayer of Joachim and Anna

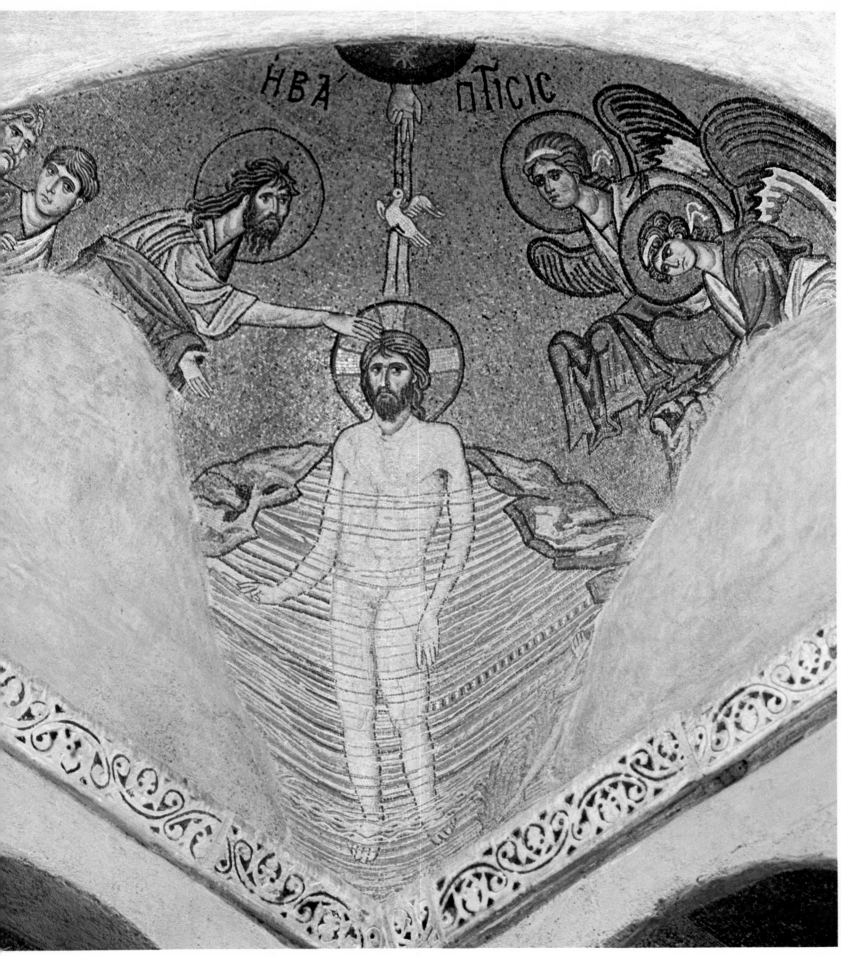

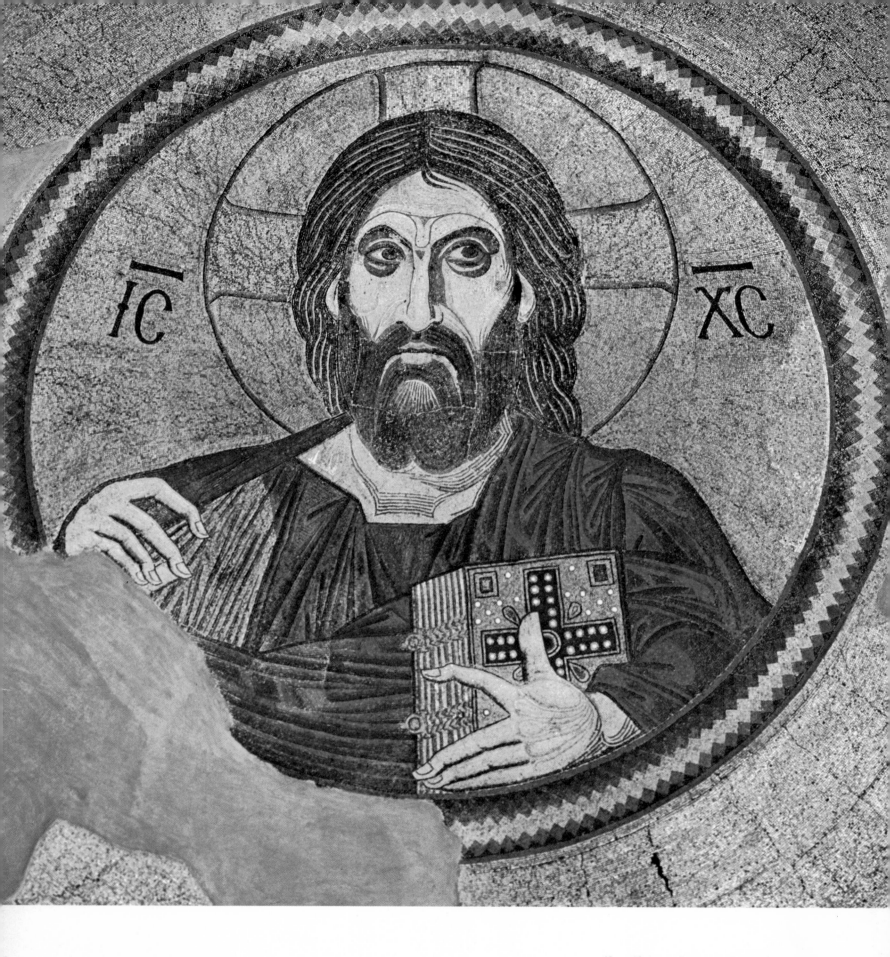

60 Christ as Pantocrator, Daphni, Greece, late 11th century. The figure of Christ as Pantocrator appears traditionally inside the central dome of the Byzantine church. The stern, majestic figure which looks down on visitors at Daphni owes more to traditional styles than the other mosaics in the church. The Oriental depiction of Christ as a stern, majestic figure is quite different from the more humane figure of Western interpretations.

Venice and Sicily

*61 St Mark's Cathedral, circa 1063–1094.
The church which originally stood on this site
was damaged by fire in the 10th century and
the present vast structure is the result of
rebuilding and successive extensions in later
centuries. The cruciform building has five
large domes, a narthex and several chapels
and annexes. The extensions built after the
main structure was finished added to the
ornamental richness of the whole complex,
and the multitude of different styles used
between the Middle Ages and the Renaissance
reflect Venice's position as an international
centre. The illustration shows the western
façade of the building which overlooks St
Mark's Square.*

122

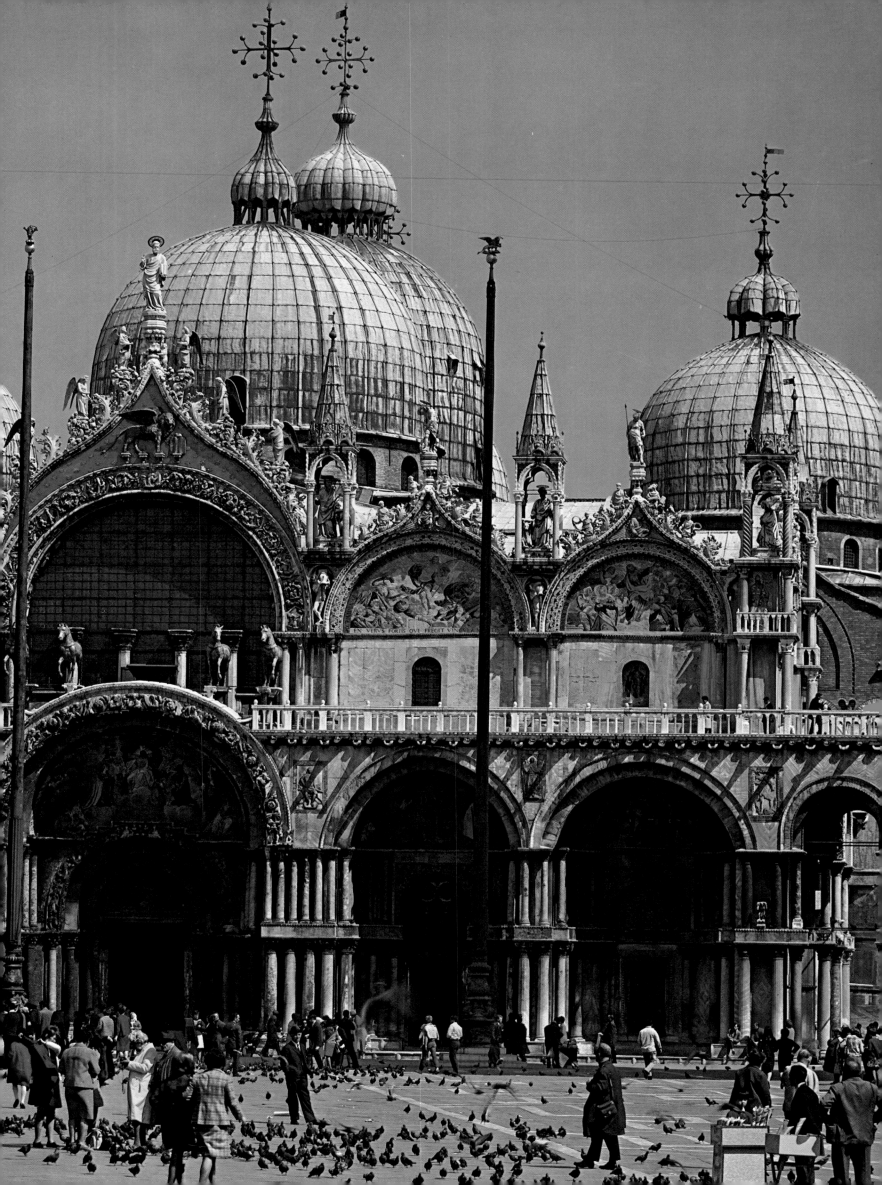

Venice and St Mark's

At the beginning of the 5th century A.D., the emperor Honorius moved the capital of the Western Roman Empire from Milan to Ravenna, to escape the threat of the barbarian tribes advancing from the north. Many former inhabitants of the regions round Milan moved with it, and settled in the lagoons on the Adriatic coast north of Ravenna. These lagoons had long been the homes of fishermen, and though geographically similar to Ravenna were in fact even more securely isolated from the mainland. It was here that Venice was born, in the 5th and 6th centuries, and developed rapidly under the domination of Ravenna. According to one of the emperor Theodoric's subjects, a Greek named Casiodoros, the inhabitants reinforced the top soil of the islands by weaving the water plants together. They ate mostly fish, and made a living through the extraction of salt and maritime trade. Even at low tide little of the land was visible, and at high tide it would often disappear altogether; the life of the inhabitants, as they moved about on the sea with their water plants, was reminiscent of that of aquatic birds.

Ravenna at this time was very much a fashionable city, but at the end of the Golden Age of Justinian it went out in a blaze of glory and fell rapidly into decay. Venice now became the centre of trade on the Adriatic; with the help of its salt-extracting and ship-building industries it rapidly developed into the most important commercial city in Italy. Its most important trading partner, and the one to which the city owed its prosperity, was of course Byzantium. Venice already had a long history of trade relations with the Byzantine Empire; in Theodoric's time the city was already buying the products of Istria (now the western part of Yugoslavia), under the direction of Ravenna. The stone used to strengthen the marshy foundations of Venice includes a great deal of Istrian limestone as well as the more familiar reddish stone from Verona. The network of sea routes which Venice developed was also of economic importance for the Byzantine Empire. After the 7th century, when the prosperous lands of Egypt and Syria fell to the advancing Muslims, the Empire became particularly dependent on its Western European neighbours, and placed a great deal of reliance on the Venetian merchants. This situation led to the signing of a commercial treaty in the year 992, which contained a number of conditions favourable to the Venetians. By the time the treaty was renewed in 1082, Byzantine sea power was near to collapse, and the Empire had to make further concessions to Venice.

In the cultural rather than the practical sphere, it was naturally Byzantium which held sway over Venice. The Venetians were unconsciously bewitched by the splendour of Byzantine art, and as their commercial footing gradually became sounder, they began to dream of a renaissance of Byzantine art in their own city. The supreme expression of this dream is of course St Mark's Cathedral.

The building of St Mark's is linked with a legend, according to which the evangelist St Mark was shipwrecked on the Adriatic at a place corresponding to present-day Venice. As he came to land an angel appeared to him and told him that his body would one day be interred on that spot. The Venetians took this prediction to heart and in 828 they brought St Mark's body from Alexandria and began building a church which was to bear his name. A wide variety of materials were used for its construction, including white limestone from the quarries of Istria, which is reminiscent of marble, reddish stone from Verona, and stones already used in buildings of the Classical and Early Christian periods. Designed by a Greek architect, the original church took fifty-one years to build and probably had the cruciform construction characteristic of Byzantine church architecture.

In the year 976 there was a rebellion against the ruling Doge, Candiano IV, who fled from his burning palace to St Mark's, and was there taken prisoner and murdered, together with his son. The Doge's palace and the town centre

62

124

62　　Marble slabs on the outside wall of the
treasury of St Mark's, 9th to 10th centuries.
These relief panels sculpted with typical
Byzantine designs are set into the treasury
wall on the south side of the cathedral. Panels
of this type were originally used to decorate
the iconostasis in Byzantine churches, but
were also employed as external ornamentation
in later sculptures. The examples shown are
probably part of the original church of St
Mark's, or may have been brought across the
sea from the East.

was destroyed, and the cathedral was badly damaged. The city immediately began work on its restoration, incorporating the surviving sections of the old church in a new structure which was completed in 978. Many of the decorative features which show a strong connection with Byzantine art, such as marble capitals and relief panels, are thought to have survived from the earlier building.

Other Italian towns such as Pisa, Genoa, Aquileia and Verona, which had grown into rivals of Venice, also began to build cathedrals one after the other. As a result of this, in 1063 Venice made plans to extend the church of its patron saint. After some deliberation as to whether the available funds should be used for the building or for military purposes, a third stage of building was embarked upon. The cathedral was finally completed in 1071, and its consecration took place in 1094.

This 'third' cathedral, which is the building we see today, is a large cruciform structure with five domes, one over the crossing and one on each arm of the cross. The great main piers are each formed by a group of four columns linked by arches and covered with a small dome inside. The piers themselves are joined by broad transverse arches which give the effect of barrel-vaulting and contribute to the massively powerful impression of the interior. All these details suggest a relationship between St Mark's and Justinian's Church of the Holy Apostles in Constantinople. Originally mentioned in a report by a Byzantine historian dating from the time of its construction in the 6th century, this church was eventually destroyed by the Muslims in the 15th century. It too was substantially altered in the 11th century, and the builders of St Mark's probably based their design on the 10th century structure which still retained the original form. At all events there can be no doubt that the Venetians deliberately modelled the church of their patron saint on a Byzantine original. The name of its Greek architect is unknown, but according to legend, instead of receiving his fee he was fined by the Doge Domenico Contarini for saying 'If I had wanted to, I could have made this building even more beautiful.' The relief of an old man with his finger in his mouth, which can still be seen inside the main entrance on the west façade of the church, is said to be his portrait, but this is as unverifiable as the legend itself.

The size of the new cathedral was in conspicuous contrast to the churches then being built in Byzantium itself, where a tendency towards smaller structures had slowly been developing. Its scale is another indication of the Venetians' mood at a time when their city was steadily increasing in power and influence, and beginning to rival Greece. In this period, Venice stood practically on a level with the Byzantine Empire, and a further proof of its status is the fact that Domenico Servo, who was Doge at the time when the cathedral was finished, received the title of Protproedoros from the Byzantine court and married the younger sister of the emperor Michael VII Dukas.

The enthusiasm of the Venetian citizens for their cathedral may be measured by the fact that the completed building continued to receive further decoration over the course of the centuries. In the 12th century an entrance was built in the Roman style on the long western façade, and in the 13th century the original domes of Greek design were crowned with a wooden superstructure. After the taking of Constantinople by the Crusaders in 1204, numerous works of art were brought to Venice, many of them sculptures, and among them were the four gilded horses which now decorate the west façade of the cathedral. The influence of the Islamic world, with which Venice had frequent commercial contact, also made itself felt, and the Italian Gothic style is also represented in the sculptures and architectural features which decorate the roof. The work of decoration continued until the 19th century. St Mark's combines all these disparate elements and unites them in an extraordinary monument to Venetian history, a treasure house to which the city's merchants brought the riches they accumulated on their travels to both East and West. The splendid mosaics which decorate the cathedral both inside and out are perhaps the clearest demonstration of how much Venice owed to the

Byzantine cultural tradition. The history of these is well documented, and the oldest mosaics now surviving would seem to have been produced in the time of Doge Servo, between 1071 and 1084. The mosaics in Torcello Cathedral on the Venetian lagoon are almost as old, dating from the late 11th to early 12th centuries. These early mosaics were produced by Greeks and are to be found mainly in the apse and part of the narthex of St Mark's; others from the same period were lost in a fire at the beginning of the 12th century. A second phase of mosaic decoration began in 1156, and among the surviving examples from this period are the mosaics on two of the four secondary domes representing Pentecost and St John the Evangelist, and the mosaic on the arch beneath the south side of the main dome.

The most active period of mosaic decoration in St Mark's was however the 13th century. The first work to be produced was the scene of the Ascension in the main dome, and then came the major part of the mosaics in the interior including those on the vaulting and the small domes over the narthex. The only external mosaic to have survived the alterations made during the Renaissance, which shows St Mark's body being carried into the cathedral, the representation of the story of Genesis over the door of St Alipio and the mosaics in the chapel of Cardinal Zeno, were all created in the second half of this century. Then in the 14th century work began on the task of decorating the walls and the vaulting on the right-hand side of the interior and in the baptistery.

St Mark's Cathedral, ground plan
 1 Dome of the Ascension
 2 Dome of St John
 3 Dome of St Leonard
 4 Eastern dome
 5 Pentecost dome
 6 Treasury
 7 Baptistery
 8 Marble relief panels
 9 The Tetrarchs
10 Columns of Acri
11 Entrance on western façade
12 Mosaic of the Transportation of St Mark's body
13 Dome of the Creation
14 St Clement's Chapel

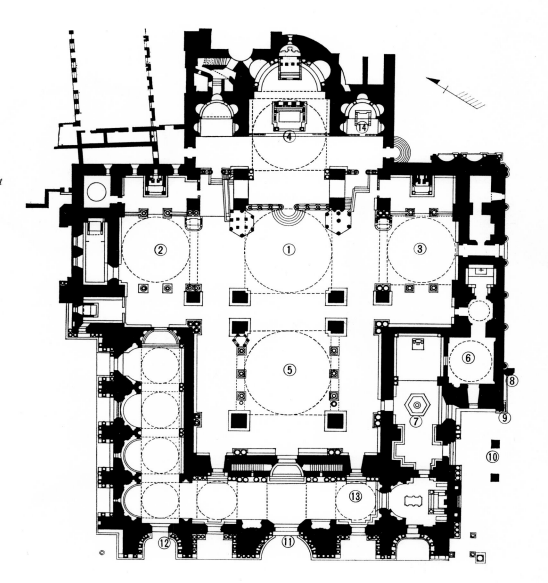

Most of the mosaics in St Mark's were produced over the course of 300 years by Greeks brought from the Byzantine capital who worked with Venetian craftsmen and gradually taught them their skills. As time went by the native workers gained confidence and slowly but surely the creative initiative passed to the Venetians. Inevitably the artistic traditions of the Greeks, who had originally been solely responsible for this aspect of the work, tended to dominate the entire series. Nevertheless, from about the 13th century, local stylistic features began to appear which contrasted strongly with the pronouncedly Oriental character of most of the mosaics and were often related to Roman painting. Most typically Oriental is the almost excessive use of gold, which covers the entire surface of the internal walls and vaulting with an unearthly sheen. Yet the narrative scenes from St Mark's Gospel and the story of the Creation show an unmistakably Western concept of the subject matter. They are done in a naive, graphic style which gives the scenes a characteristic solidity and is most obvious in features such as the proportions of the figures, the surrounding scenery, the facial expressions and the treatment of water and waves.

After so wholeheartedly adopting this characteristic Eastern Mediterranean art form in the 14th century, the Venetians allowed it to decline rapidly in the 15th century, and soon became dependent on the talents of artists from other parts of Italy. The year 1425, in which the famous Renaissance painter Paolo Ucello was called to Venice, was a significant date in this respect, for it signalled the end of the traditions of mosaic and Byzantine art in the city of canals.

Sicily

Sicily, the southernmost part of Italy, is also not far from North Africa, and forms a natural mid-point between the Eastern and Western Mediterranean. From ancient times, the island was considered a valuable vantage point by the different peoples who sought to dominate the Mediterranean. The Phoenicians, the Greeks, the Carthaginians and Romans all occupied Sicily in succession and developed commercial bases there. After they had left, traces of their civilizations remained deeply imprinted on the island, until it began to resemble a melting-pot of different races and cultures.

At the beginning of the 6th century, when Italy was ruled by the Ostrogoth king Theodoric from his capital at Ravenna, the Byzantine Empire established a base on Sicily in its turn, in order to achieve more direct control of the Italian peninsula. This link between Sicily and the Byzantine Empire lasted only until the latter's much feared enemies, the Saracens, landed on the island. By this time, however, the language and religions of the Greeks had become established among the inhabitants. In the second half of the 9th century, the Saracens, who already had control of most of the coastal areas, embarked upon the conquest of the whole of Sicily. After a number of local battles with the Greek army, they at first conquered the major part of the western side and soon after extended their control to the whole of the island. Saracen warships filled the harbour of Palermo in north-west Sicily, which the Muslims used as a base for their attacks on the coastal towns of southern Italy. As can be observed from the example of the Iberian peninsula, the Muslims went to extraordinary lengths to establish their culture in the lands which they conquered, and this was no less the case in Sicily. Traces of the Muslim occupation remained imprinted in the island's culture long after the Saracens had retreated to North Africa.

The Saracen domination of Sicily lasted some two hundred years, and during this time there was no major counter-attack by the Byzantine Empire. However, it is clear from surviving Greek documents that some attempts were made to regain a footing on the island, even if these were unsuccessful.

Around the middle of the 11th century, Sicily was invaded by the Normans, who exploited the Saracens' internal dissensions and after a number of battles took possession of the island. Initially acting as part of the Byzantine armed

63 The Creation, southern dome of the narthex, 13th century. This is one of the six small domes which cover the narthex. It is situated above the door which leads to St Clement's Chapel at the southern corner of the cathedral and dates from the third stage of construction in the 13th century. The story of the Creation is told in twenty-four scenes grouped in three concentric circles, and the figures are noticeably similar to those in the 6th century illuminated manuscript known as the Cotton Bible.

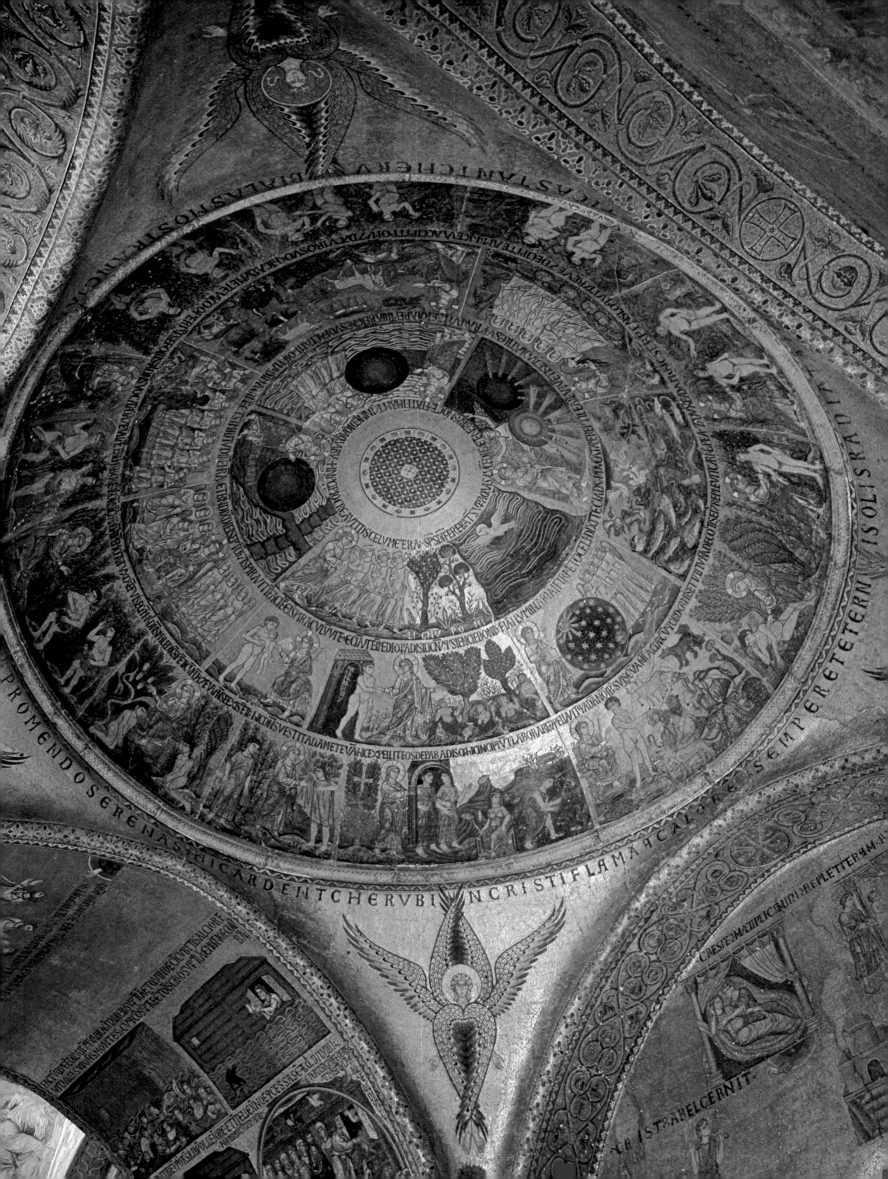

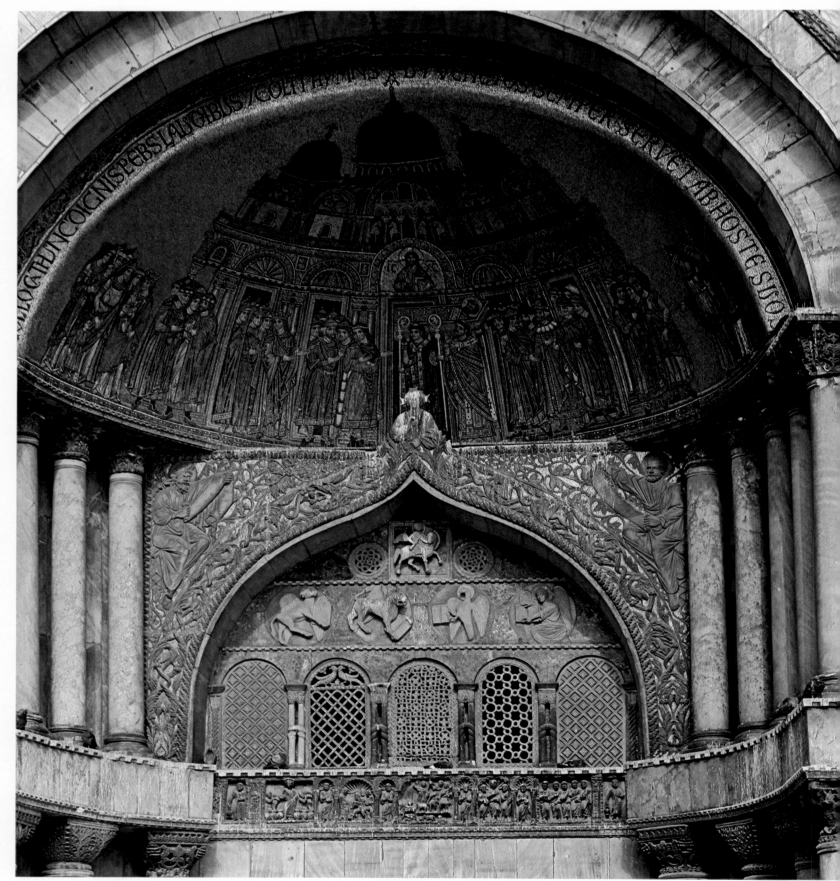

64 Transportation of St Mark's body, north doorway of the west front, 13th century. Venetian mosaics produced under the direction of Byzantine master artists appear in St Mark's from about the 13th century. The mosaic shown here is one of these, and depicts the body of St Mark being carried into the church. The scene has a certain informal warmth which distinguishes it from the works of the early Byzantine painters.

forces, the Normans soon settled on the territory which they had conquered, and in the year 1130 Sicily became a Norman kingdom under Roger II (1130 to 1154). It was the start of a new era for this southern island, set in the blue of the Mediterranean and strewn with cacti and coconut palms. The culture of the Normans was of course mainly influenced by France, but in building their fortresses and palaces in Sicily, they accepted the heritage of Saracen culture and this was combined with the local characteristics of the time to produce an interesting and idiosyncratic mixture of styles. It is very much what one might expect of an island which as we have said was a melting-pot of different cultures. The clearest demonstration of this stylistic mixture is to be found in the religious buildings which appeared in Palermo and Cefalù and the mosaics which were used to decorate them. The mosaics in particular show that Sicily remained under the influence of the old Byzantine Empire long after its relations with it were severed.

It is thought that there were Saracen mosaic artists in Palermo when the Normans invaded Sicily, and these soon returned to their craft under Roger II. The works produced by the Saracens were purely ornamental, however, and the artists responsible for the figurative mosaics in the churches were undoubtedly brought from Greece. These Greek mosaic artists worked with Sicilian assistants in the idiosyncratic Sicilian churches, and since the churches themselves were a new development, the work represented something of an adventure for both parties. One of these buildings was the Cathedral at Cefalù, which was commissioned by Roger II as his court church in 1131, and finished, according to an inscription, in 1148. It is of basilical form with a nave and two aisles. Its present appearance dates from the 13th and 15th centuries, when the western façade and narthex were added. The structure is basically Norman in style, but the decoration is Saracen, giving the building the appearance of a typical Sicilian church. There are two areas of mosaic decoration, both created in 1148, in the apse and the sanctuary in front of it. The two mosaics would seem to have been done by different artists. In Greek churches the figure of Christ as Pantocrator appears on the main dome of the building, but here it appears on the semi-dome over the apse. Beneath it stand the Virgin Mary and angels, with the twelve apostles beneath these again. On the walls to right and left are four series of saints and bishops or prophets. The whole composition is skilfully related to the architectonic space of the church, and the figure of Christ as Pantocrator, the omnipotent ruler of the cosmos, is possibly the finest surviving mosaic in any Sicilian church. It is notable for the deep humanity and benevolence suggested by its facial expression, and when compared with other works from the Byzantine mainland already shows the beginnings of the characteristic Sicilian style. Palermo, some seventy-five kilometers to the west of Cefalù, was favoured by an excellent harbour. In the course of a century and a half the Norman rulers who succeeded the Saracens turned this town into a prestigious European metropolis. Italian artists and others came from far and wide to the Norman city, attracted by the fame of its court or summoned by its rulers. These were the interpreters of the Romanesque, Gothic and Byzantine styles of the time. Under the initiative of the Norman kings, Sicily, and especially Palermo, now truly developed into a melting-pot of Eastern and Western cultures. The Capella Palatina or court chapel of Roger II, built between 1132 and 1140, combined all these disparate elements in what at first seems an almost chaotic profusion. Its interior is like a treasure chest, a dream world of decorative riches, and this was precisely the atmosphere which Norman rulers sought to create. The chapel itself is small, but the presbytery has a Byzantine dome set on squinches, and the surprising combination of pillars apparently taken from a Classical building and pointed Saracen arches mirrors the development of Sicilian history in that period. Some of the original mosaics with Greek inscriptions can still be seen in the presbytery, the sanctuary and part of the nave. On the right-hand wall of the sanctuary is a series of scenes from the life of Christ, from the Nativity to the entry into Jerusalem, and these are considered among the finest Byzantine mosaics of their period. In

their overall concept, they are reminiscent of the mosaics on a similar theme at
Daphni. However, by contrast with the more austere and formal style of the
Greek versions, the Sicilian mosaics show an anecdotal tendency, revealed in
a degree of humanity which is absent from the others. The Pantocrator
appears in a medallion in the centre of the dome, with eight archangels
occupying the lower part. In the recesses of the squinches beneath are figures
of the four evangelists. The composition, if not the technique, remains
unmistakably true to the traditions of the Byzantine homeland.

The traces of Byzantine culture in Palermo can be seen most clearly in the
Church of La Martorana, also known as Santa Maria dell'Ammiraglio. This
church was originally built in 1143 on a cruciform plan, but its external
appearance has been substantially altered over the centuries. The original
mosaics are still to be found in the interior, however, and both their technique
and the arrangement of the figures round the Pantocrator in the main dome
indicate that they are the work of skilled mosaic artists who were
contemporary with those of Daphni. The church was endowed by the
commander of Roger II's navy, Georgios, who was a native of Antioch in
Syria.

The cathedral of Santa Maria la Nuova rises above the plateau of Monreale
south west of Palermo. The building was started in 1174 under William II
with the aim of checking the influence of the archbishop of Palermo, and
completed in 1182. It is a building of substantial proportions and the style of
the exterior bears some Romanesque features, together with a wealth of local
characteristics. The use of the pointed arch, and the decoration of the ceiling
and other structural components, indicate an Islamic influence in the interior,
but the overall structure and manipulation of space is clearly Romanesque.
The well-lit cloister on the south side of the cathedral contains an Islamic pool
and breathes the almost tropical atmosphere which is unique to Sicilian
churches. The mosaics in this building are undoubtedly the most magnificent
of all Sicilian church mosaics, though from a technical point of view they
leave something to be desired. By comparison with the examples we have
mentioned so far they are somewhat lacking in charm, and are notable for
their cold colours and stiff drawing. The figures of the Pantocrator and the
Virgin in the apse follow the same arrangement as those at Cefalù and are still
clearly rooted in traditional styles. Some development is noticeable, however,
in the scenes from the New Testament on the walls on either side of the nave.
By comparison with the well-balanced figures characteristic of previous
Byzantine mosaics, those here are notable for their somewhat homely
appearance and the mechanical treatment of the bodies. Some scholars
believe that this is due to the rapidity with which they were produced, but
their treatment cannot be attributed simply to lack of skill on the part of the
artists. More probably it is due to the fact that the task of design and
conception had now been transferred from the Greeks to the native workers.
This is suggested by the inscriptions accompanying the mosaics, which are
written in Latin, whereas that in the apse is in Greek. Also, the unusual
treatment of the waves shows some similarity to that in the scenes from St
Mark's gospel in Venice, and this again would suggest that Latin mosaic
artists had replaced their Greek masters. Mosaics continued to be produced
in Sicily after these examples at Monreale, but most of them had increasingly
little connection with the world of Byzantine art, and the influence of Italy
became stronger with every year that passed.

65 *Noah's Ark, mosaic in the narthex, 13th
century. The barrel vaulting next to the small
dome bearing the scene of the Creation is
decorated with various scenes from the Old
Testament story of Noah. The illustration
shows the return of the dove announcing the*

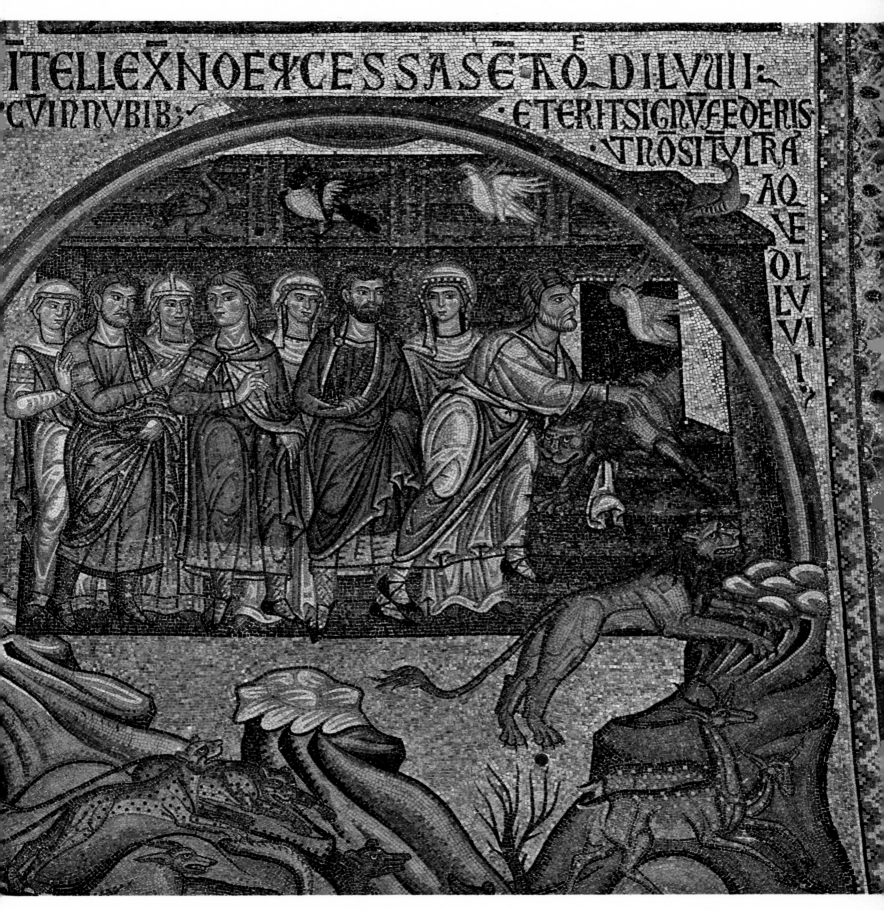

ITELLEXNOEXCESSASGTO DILVIII
CVINNVBIB· ·ETERITSIGNVFEDERIS
·TNOSITVLTRA
AQEOLVVI·

end of the flood and Noah's family leaving the ark with the animals after the waters have receded. The treatment of the figures shows the influence of Romanesque painting, which began to appear in the mosaics in the interior from about the 13th century.

Pages 134–135:

66 *Arrival of St Mark's body in Venice, St Clement's Chapel,* circa *12th century. This chapel contains various scenes from St Mark's Gospel, and the vaulting on the south side is covered with a series of mosaics showing the transportation of St Mark's body from Alex-*

andria to Venice. These are characterized by a naive graphic style well suited to the legendary nature of the subject matter, but there are signs of development towards a more sophisticated mode of representation in the treatment of the faces and the waves.

133

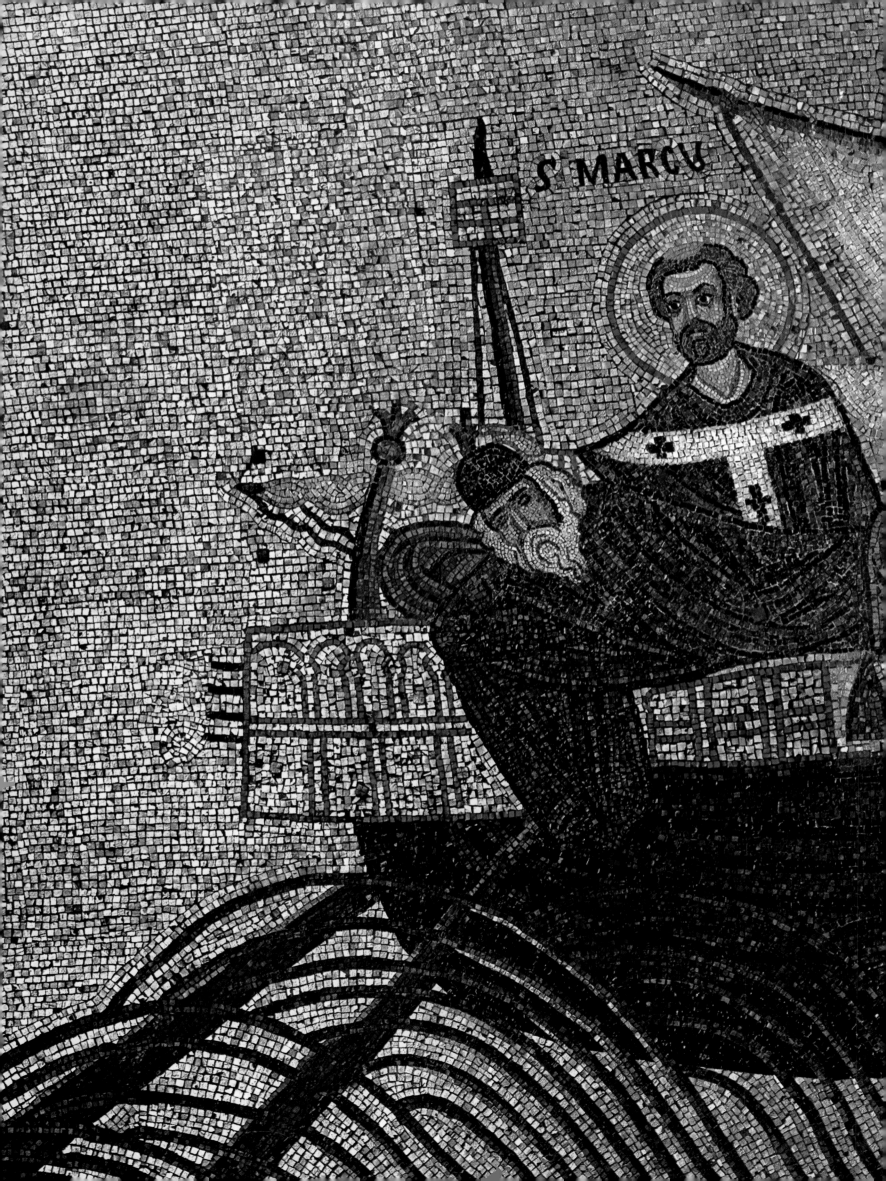

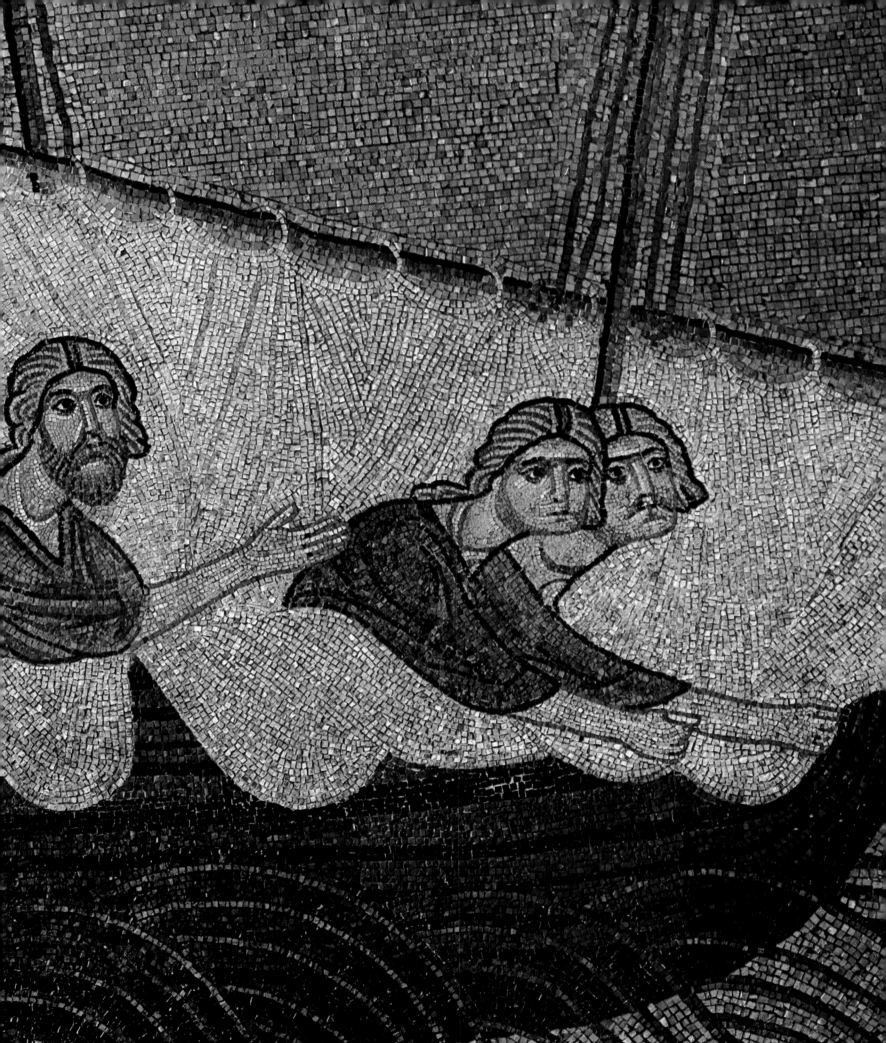

Byzantine Culture and the West

The relationship between the Byzantine Empire and Western Europe is complex and difficult to grasp. Although the Empire underwent a number of changes over the course of the centuries, it retained a certain political and cultural homogeneity for more than a thousand years. The situation in the Western world, however, was quite the opposite. During the same period the northern peoples descended on what was left of the Roman Empire; the old order collapsed, and new states and political groupings were formed; alliances were made and broken and a state of constant flux prevailed. Inevitably, attitudes towards the relatively more advanced Eastern Empire varied enormously during this period, according to the national, historical and religious standpoint of those involved. The church of the Eastern Roman Empire, even before its separation from the Roman Church, was regarded by the Roman pope as an apostatic institution, even a dangerous rival. Yet for the Carolingian and Ottonian rulers, who had the task of establishing the Holy Roman Empire in the name of the pope, the Byzantine world was the very ideal and prototype of their conception. The sheer size of the Byzantine Empire naturally aroused mixed feelings amongst the Western countries at different times during their development. This is not the place to dwell at length on the Empire's role in the formation of Western Europe during the Middle Ages. Suffice it to say that the connection between East and West was always complex, and that political intentions and economic interests were ever changeable and changing. But in the cultural sphere the traffic between the Byzantine world and the West was almost always one-sided; it was Byzantium which provided the inspiration for the West and not vice-versa. The influence of Byzantine culture on the West was especially great in the areas such as Ravenna, Venice or Norman Sicily which we have already discussed. At the same time, the distribution of Byzantine coins from the 4th to 7th centuries indicates that from the earliest period of the Empire's existence Byzantine merchants visited not only Italy but also the central ports of Western Europe. Pilgrims from Western Europe visiting Palestine in the 6th century had to make a stopover in Constantinople, then at the height of its prosperity under Constantine, before continuing their arduous journey. A document from this period mentions a party of nuns from Poitiers who visited the capital.

The Byzantine court maintained diplomatic relations with the Western rulers from the 8th century, and an embassy from the Eastern Empire visited the Frankish kingdom on several occasions. Charlemagne, as the first ruler of the whole of Western Europe, received a diplomatic mission from the Byzantine emperor Michael I at his court at Aix-la-Chapelle. These ambassadors brought refined and magnificent gifts from their homeland, which must have confirmed the rumours of Byzantine splendour and filled the Western rulers with a longing for the riches of the East. Charlemagne himself filled his court at Aix-la-Chapelle with Oriental furniture and his palace chapel was modelled on the church of San Vitale in Ravenna. Objects wrought in precious metals and the highly-prized silk tapestries and fabrics of which Byzantium had a virtual monopoly played an important part in spreading the legend of the power and riches of Constantinople. Large quantities of these goods are preserved in many Western monasteries today. But they were not only bought to be cherished and admired; they also had an important influence on Western arts and crafts, contributing to the development of metalworking in the monasteries on the Rhine, and providing the basis for enamel technique in France.

The Iconoclastic conflict which shook the Byzantine empire to its foundations contributed greatly to the dissemination of Byzantine art in Western Europe. Supporters of icon-worship, monks and craftsmen who

67 Gregory of Nazianzus, mosaic in St Clement's Chapel, late 12th century (includes some later restoration work). Like the structure of the building, the mosaics in St Mark's include sections from earlier periods. These earlier mosaics were produced by Greek artists up to the time of the Renaissance. Some examples also show evidence of restoration at a later date, and the lower part of this portrait of Gregory of Nazianzus, in particular the plinth on which he stands, dates from the Renaissance period.

Pages 138–139:
68 Cefalù and the Cathedral of St Peter, Sicily. Numerous churches were built in Sicily in the 12th century, under the Norman kings. Among them is the cathedral which rises above the town of Cefalù, overlooking the Mediterranean. It was begun in 1131 for the court of Roger II, but was not finally completed until the 15th century. The structure shows the heterogeneous Romanesque style characteristic of Sicilian architecture of the period, but the interior contains some magnificent Byzantine mosaics which are the oldest in Sicily.

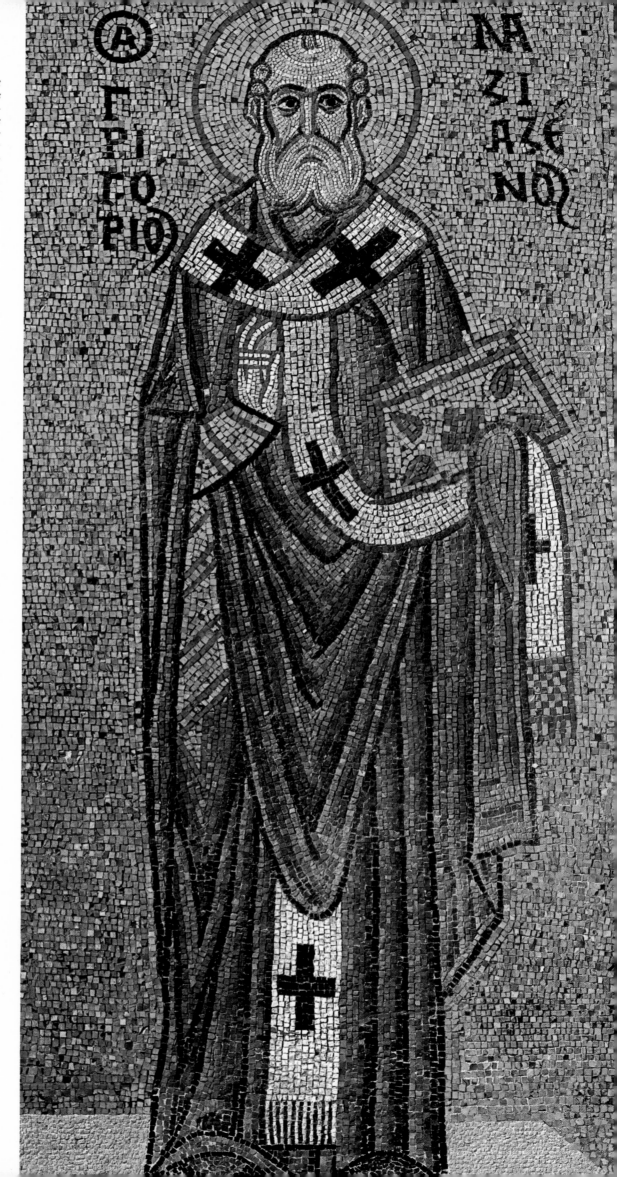

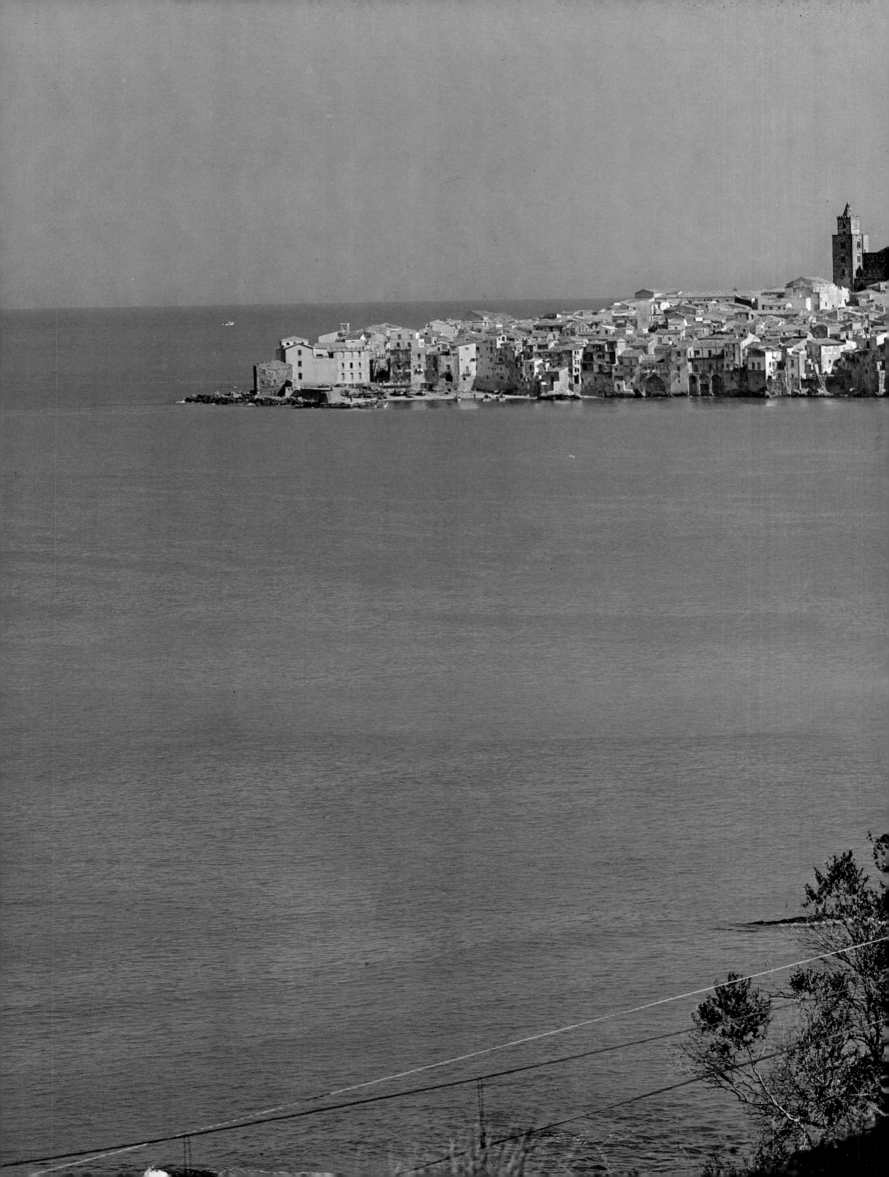

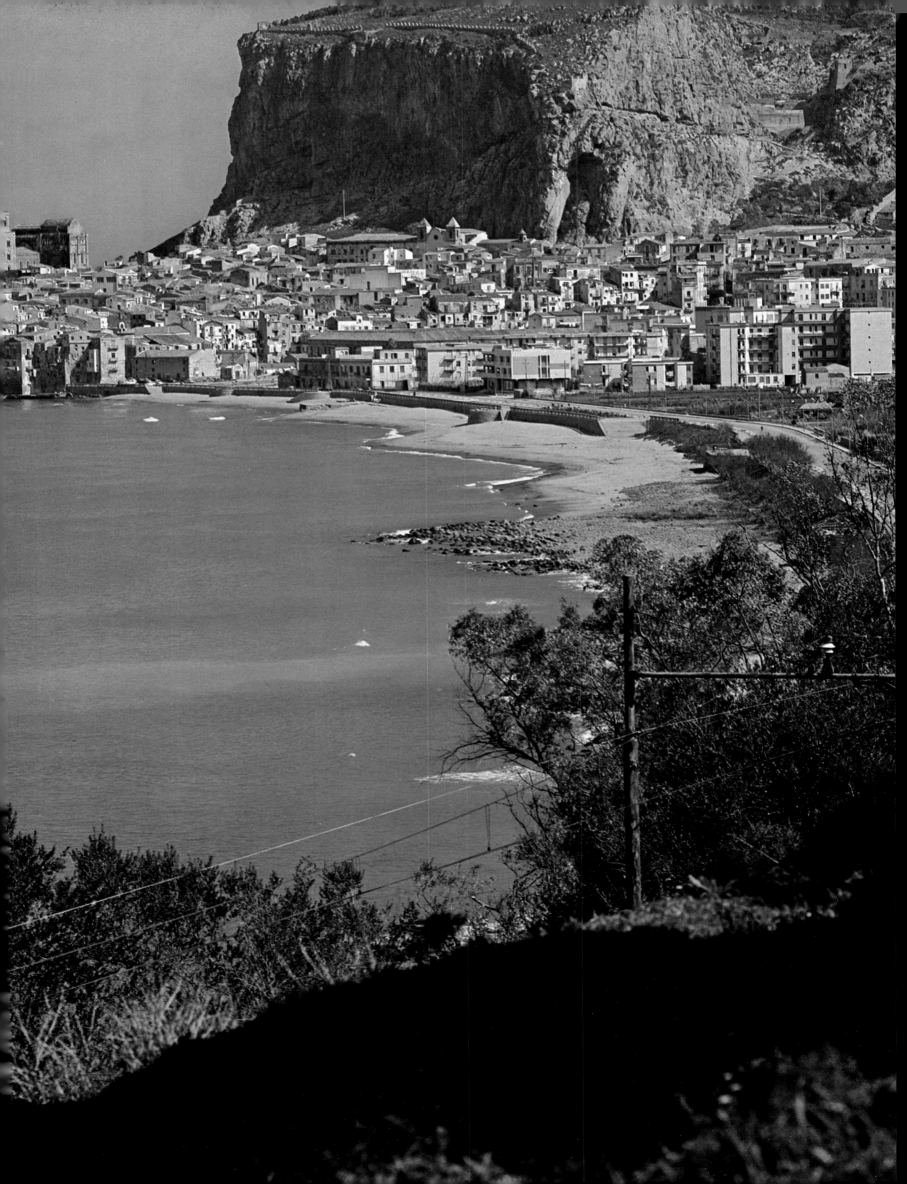

wanted to be free to paint icons as they pleased, left their native land in droves and settled chiefly in Italy.

Italy was already closely linked by tradition to the Byzantine Empire. From the age of Justinian in the 6th century to the 8th century, when Ravenna was lost to the Lombards, the major part of Italy was in the Empire's hands. The Byzantine influences which had taken root in various places during this period persisted, and as late as the 9th century a series of mosaics of marked Byzantine character was produced in Rome. This persistence of Byzantine culture largely explains the preference of the expatriate Byzantine monks for Italy.

In the second half of the 9th century, the Byzantine monks settled chiefly in the southern part of the Italian peninsula, occupying the area which had once been a colony of the Ancient Greeks. This medieval Greek colonization received political support from the Macedonian dynasty, who saw it as a means of establishing a foothold in Italy and regaining control of the country. The process continued for some two hundred years, during which churches were built in a number of different places. These combined the traditions of Byzantine church architecture with local stylistic features, and some interesting examples are still to be found in Calabria and elsewhere.

While Southern Italy returned into the hands of the Italians, the Byzantine Empire did not relinquish its ambitions to extend its power in Western Europe. Now, however, its expansionist policies took the form of economic activity rather than colonization. Trading began with Venice and other important Italian towns, governed by the traditionally astute policies of the Byzantine government. In the 11th century Byzantine culture was enthusiastically adopted both in Venice and other parts of Italy. The high quality of Italian craftsmanship in the Middle Ages was initially due to the inspiration provided by the numerous magnificent metal objects received from Constantinople at this time. It was during this period that the magnificent enamels of the Pala d'Oro came to Venice, together with some equally splendid silk tapestries. The abbot of Monte Cassino ordered large quantities of church ornaments and decorative objects for his monastery from a workshop in Constantinople. A large number of Greek craftsmen were brought to the monastery during this period, which also saw the beginnings of mosaic art in Sicily.

Compared with its impact on Italy, the influence of Byzantine culture on the rest of Western Europe was less tangible and is therefore less easily recognized. There is evidence of constant and widespread Byzantine influence in the field of the decorative arts, but in other areas such as painting, sculpture and architecture, the situation is more complex. One may suppose it to have been strong in Germany, where Otto II married a Byzantine princess, Theophano, in the year 927. Certainly the miniatures of Rechenau and Trèves contain elements which can be attributed to the influence of Byzantine painting. In France, there is a series of domed Romanesque churches which many authorities have thought similar to Byzantine buildings. The church of St Front in Périgeux has been compared to St Mark's in Venice, while Angoulême Cathedral seems inspired by the churches of the Eastern Mediterranean around Cyprus. Recently, however, a number of scholars, most of them French, have refuted the importance of this connection in view of the substantial difference between the French and Byzantine methods of mounting the dome. Generally speaking Byzantine art seems to have appeared nowhere in such an unaltered form as in Italy. There are nevertheless very many examples of the influence of Byzantine art on Western Europe, ranging from the eagles and mythical beasts carved on the capitals of Romanesque buildings in the 11th and 12th centuries to the figures and whole compositions which were adopted in murals and miniature painting. The contribution of Byzantine art to Western European culture was unique in that it was not adopted in its entirety but instead fertilized the graphic arts with a wealth of Oriental motifs and a highly systematized iconography. It also introduced a greater level of technical sophistication and the concept of

Right:
69 Christ as Pantocrator, Cathedral of St Peter, Cefalù, circa 1148. The apse mosaic at Cefalù, with its colossal half-length portrait of Christ as the ruler of the cosmos, may be assumed to have been produced under Greek direction. However, the facial expression of Christ, the emphatic outlines and the arrangement of the figures are all typically Sicilian.

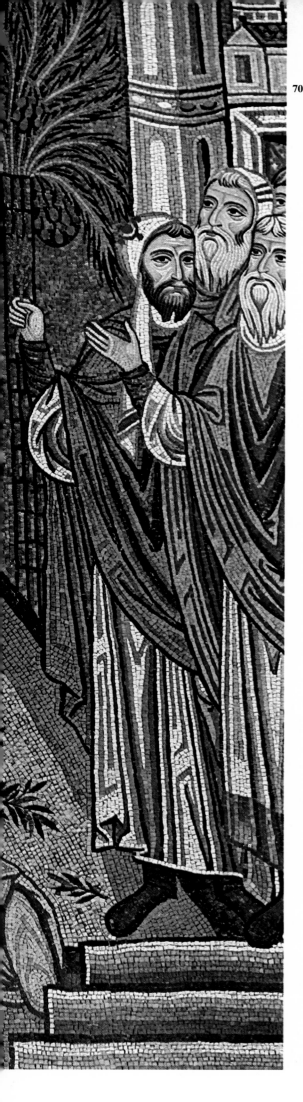

70 regular, stylized forms. These elements, which help to give Romanesque art its essential character, can be found in the frescoes in the church of Berzé la Ville near the Benedictine monastery at Cluny in France. Some scholars consider these paintings to be the work of the Greek artists who were brought to Italy by the monks of Monte Cassino.

Another opportunity for contact between the cultures of Western Europe and Byzantium was provided by the Crusades which began at the end of the 11th century, and particularly the Fourth Crusade, a century later, in which the Christian armies became diverted from their original goal and took the city of Constantinople. By this time, apart from Italy, where Venice had taken on the

70 *The Entry into Jerusalem, Capella Palatina,* circa *1143. This depiction of a favourite theme in Christian art is one of the finest surviving mosaics from the time of Roger II, characterized by its fresh colours and subtle harmonies of tone, and the rigorous organization of the composition. It is situated over the entrance to the sacristy, and may be considered a superior example of the Byzantine mosaic style of this period.*

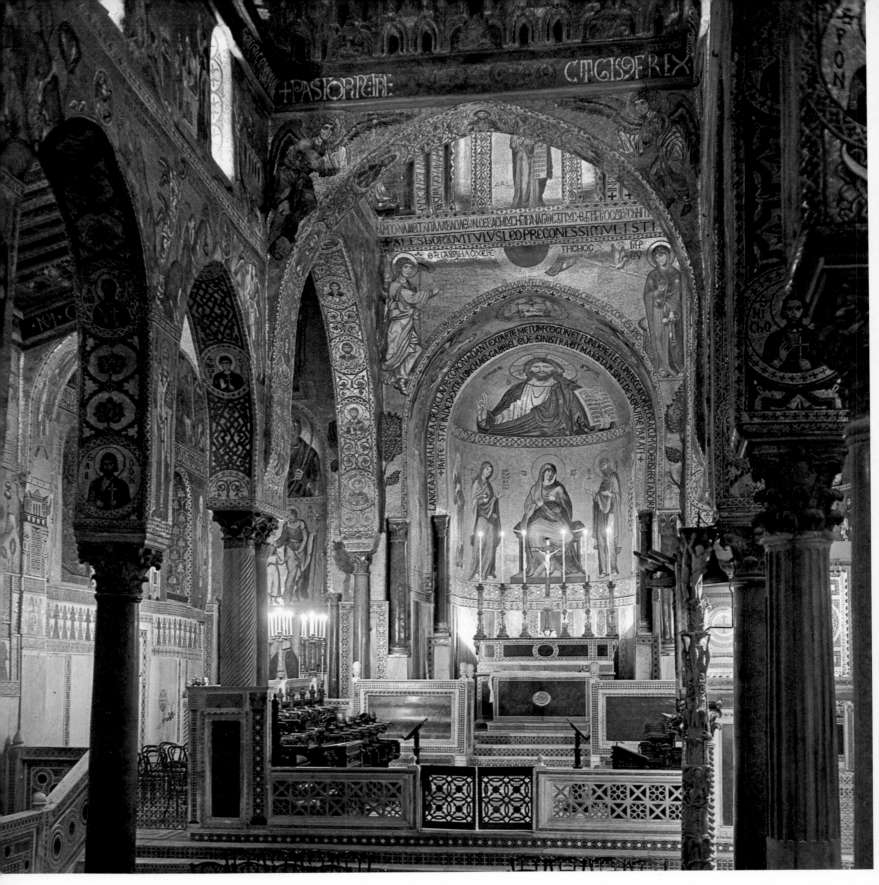

71 Capella Palatina, Palermo, 1129–1143. This was the court chapel of Roger II. Its form is that of a domed basilica, but the construction uses a variety of different styles. The interior, with its Classical pillars, Islamic decoration and mosaic figures, creates a sumptuous, yet alien effect, which clearly illustrates the mixture of cultures which prevailed in the Norman kingdom. Some Greek mosaics from the time of the church's construction are preserved in part of the presbytery, and by comparison with these the mosaics in the nave, produced some twenty years later, have already assumed a more local character.

appearance of an artistic colony by Byzantium, the countries of Western Europe had their own established cultural forms. As a result, the Crusaders' encounter with the Byzantine world, and the numerous examples of Byzantine art and craft which they brought back as the spoils of war could not have any profound effect on European art. Instead the Byzantine world's

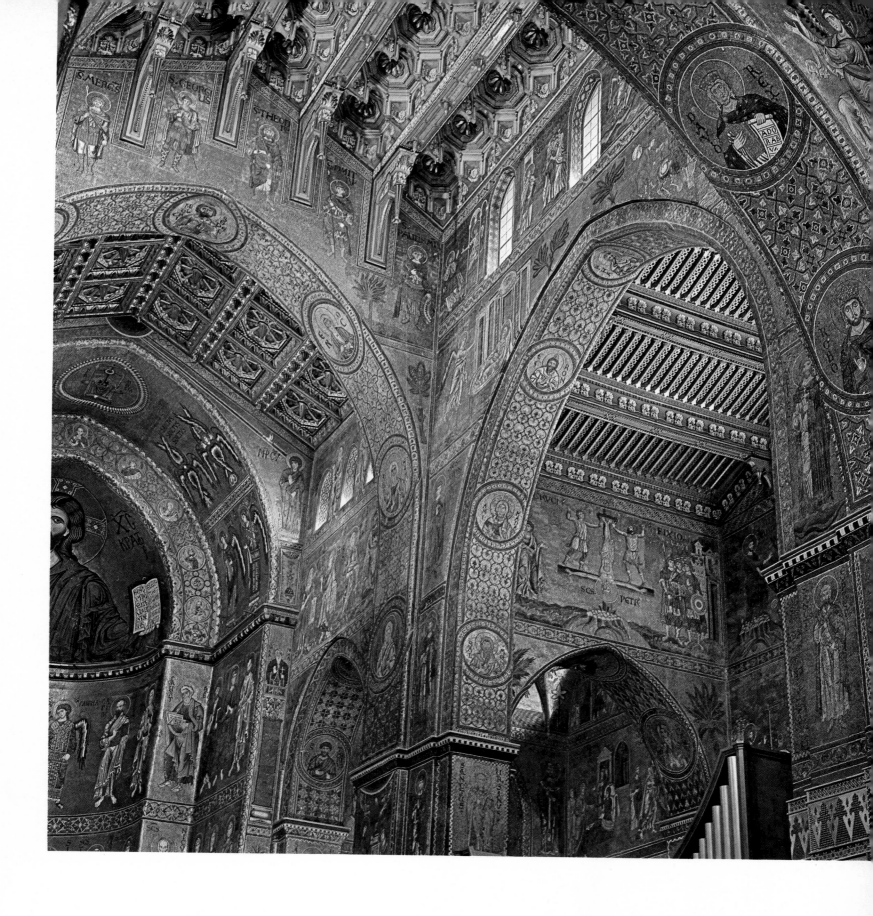

72 *Apse and transept, Cathedral of Monreale, 1174–1182. The sumptuous decoration of this church is here seen at its most magnificent. Part of the main apse is visible on the left. In the Cappella Palatina the Islamic element was confined to the nave, but here it extends throughout the interior. The apse contains the customary mosaic of the Pantocrator, together with other figures. The pitched wooden ceiling over the crossing is decorated with applied motifs characteristic of Islamic plaster-work.*

heritage of ideas derived from the ancient philosophy enabled it to contribute much to the formation of Western thought at this time, particularly in the field of academic philosophy. In Italy, Byzantine artistic influence persisted until the 13th and 14th centuries, and in the field of painting inspired such artists as Cimabue, Duccio and Cavallini. Their successor Giotto

145

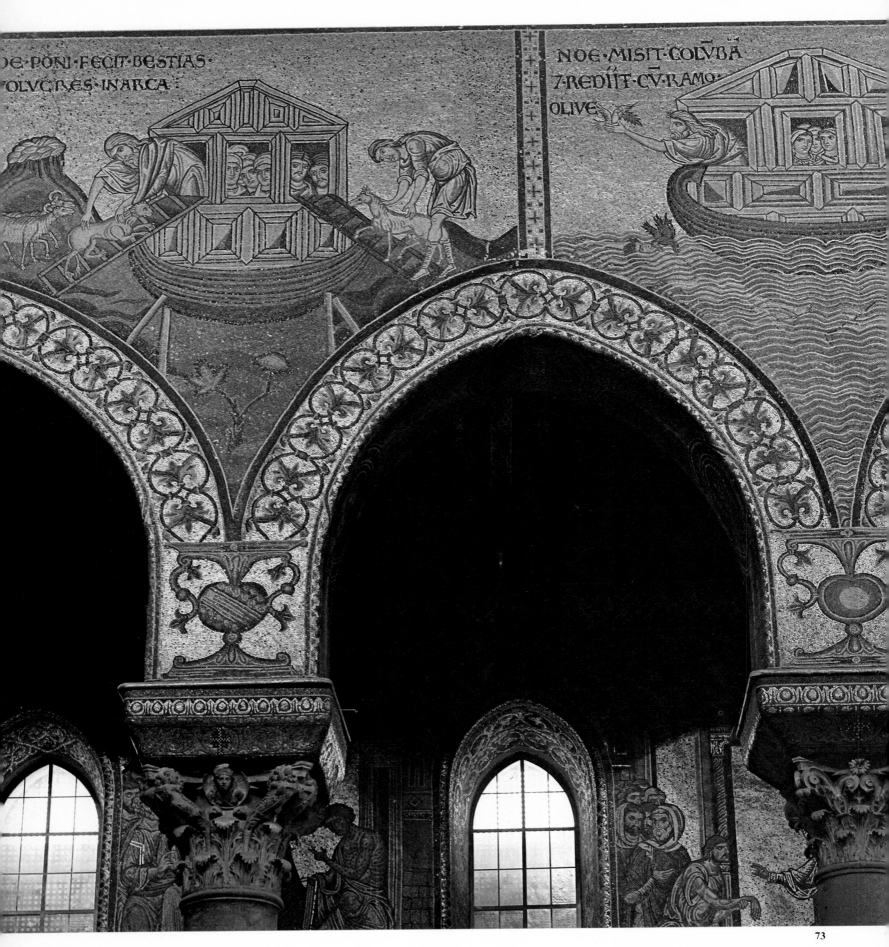

146

73 *Noah's Ark, mosaic on the side wall of the nave, Cathedral of Monreale, 1174–1182. The mosaics in this cathedral, including the Pantocrator in the apse which is probably modelled on the one at Cefalù, are conceived on a grand scale and make a sumptuous impression. At the same time their composition is noticeably stiff and formal, an indication that the end of mosaic art in Sicily was near.*

74 *Roger II being crowned by Christ, mosaic in the narthex, La Martorana, Palermo,* circa *1143. Also known as Santa Maria dell'Ammiraglio, this church was originally a Byzantine structure of cruciform design, but its appearance has been changed greatly by successive additions and alterations. Among all the Sicilian mosaics, this scene of the king receiving his crown from Christ is probably the most Greek in style.*

Page 148:
75 *Exterior of the apse, Cathedral of Monreale, 1174–1182. While many Sicilian churches from the time of the Norman kingdom have been altered in varying degrees, the Cathedral of Monreale has survived in more or less original condition both inside and out. The exterior of the apse nevertheless has the blind arcades typical of Romanesque architecture, though these have been transformed by the use of the Islamic pointed arch and decorative tile motifs.*

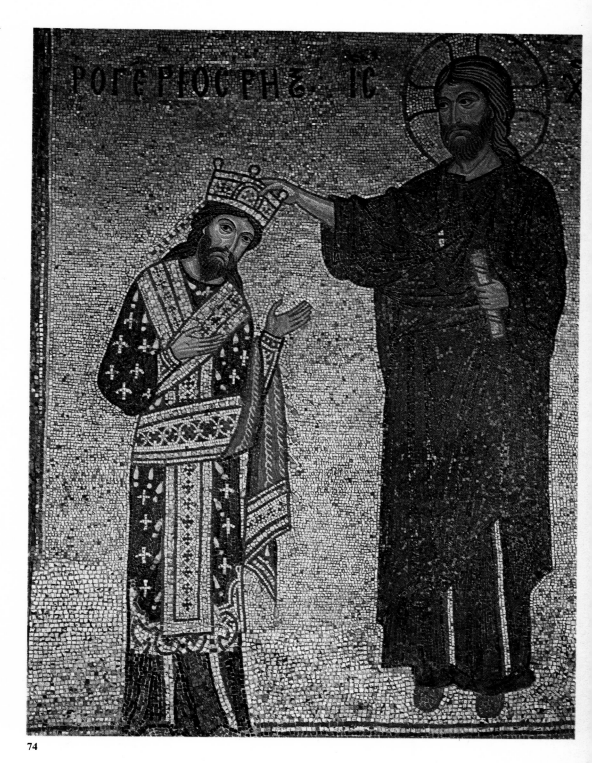

74

(1276–1337) inherited the same creative tradition, but digested it entirely in developing his own individual style. While the heritage of Byzantine art remained alive in Italian painting after Giotto, it soon sank unnoticed in the mainstream of the Italian Renaissance.

A few examples of the Byzantine style in painting survived even this development. Icons, for example, continued to be produced in Venice until the 17th century, but the germ of new invention was by now extinguished. Possibly its last fruit is to be found in the work of the Greek painter Domenicos Theotokoplos, better known as El Greco. A native of Greece, El Greco went to Venice to study under Tintoretto and other Italian painters, but soon moved to Toledo in Spain, where he developed his own highly idiosyncratic style. His work to some extent revived the Byzantine tradition at the beginning of the modern period, and it is imbued with the artist's nostalgia for his native Crete, which was the centre of late Byzantine painting.

147

The Balkans and Russia

The Post-Iconoclast Period

The Art of the Comnene and Angelid Dynasties

The Macedonian dynasty ruled Byzantium for three centuries, but was brought to an end in 1081 by a rebellion of feudal nobles and officers. It was succeeded by the Comnene and Angelid dynasties, who though they could not match the splendour of the golden age under Basil I, succeeded in preserving the empire from collapse until 1204, when Constantinople was sacked in the Fourth Crusade. During the early period of the Comnene dynasty in particular, the graphic arts gradually overcame the abstract tendencies which had characterized the last period of the Macedonian dynasty and developed a rich ornamental style in what is known as the Comnene Renaissance. Little architecture of note was produced during this period and its characteristics are found more in painting and the decorative arts.

From about the mid 11th century, the decorations in the Hagia Sophia in Constantinople show an even greater tendency towards abstraction. A mosaic commissioned by John II Comneos and his wife Eirene in about 1118 has as its centrepiece a figure of the Virgin Mary which is similar to that commissioned by Constantine Monomachos. However, the representation of the human body has become even flatter and all suggestion of three-dimensional realism has been virtually abandoned. It is rather the decorative patterns of the clothing which stand out from the gold background, clearly demonstrating the ornamental taste of the period.

A direct contrast to this abstract style which dominated the last years of the Macedonian dynasty is provided by the mosaics in the Church of the Assumption in the monastery at Daphni. The construction of the church itself was formerly dated to the beginning of the 11th century, but it is now thought to have been built around 1080. It is of the usual cruciform plan. The mosaics which decorate the interior show the customary arrangement of figures to be found in Byzantine churches, although their style is less familiar. The central dome carries the image of Christ as Pantocrator, the ruler of the cosmos, and the four squinches supporting the dome are decorated with scenes of four important historical events from the life of Christ. Figures of the prophets stand between the windows which encircle the base of the dome. The mosaic in the upper part of the apse, which like the dome is one of the holiest parts of the church, originally depicted the Virgin and Child. The transepts and narthex contained mosaics depicting the childhood of the Virgin Mary and other events preceding the Birth of Christ. This arrangement of New Testament figures is based on the important liturgical text known as the Menologion which was a record of the exploits of the saints in the order of the ecclesiastical calendar. It provides a useful illustration of the development of Neoplatonic cosmology at the end of the Classical era. The style of the mosaics, however, is in conspicuous contrast to the spirituality of similar works in other 11th century monasteries such as Hosios Lukas, or Nea Moni on the island of Chios.

The depiction of the naked body of Christ at his baptism is soft and graceful, like the work of a Classical Greek sculptor such as Praxiteles. The threatening Pantocrator of Hosios Lukas here becomes a mild-eyed Christ, full of humanity. The treatment of clothing and natural forms and the rich colours clearly show the influence of the Classical tradition. Many of the scenes may be considered the finest and most typical of Byzantine mosaics.

Such outstanding examples of Byzantine Classicism are few and far between,

with the exception of a few manuscripts which we shall return to shortly. For this reason, the dating of these mosaics at Dalphni has long been the subject of controversy. Fortunately, another masterpiece of the Comnene Renaissance has been preserved in the form of the frescoes of the church at Nerezi in Yugoslavia. The murals in this church, which is dedicated to St Panteleimon, were probably painted around 1167 by an artist from the Byzantine capital, under the patronage of a member of the Comnene dynasty. The highly convincing modelling of the human form and graceful facial expressions, reminiscent of Classical portrait art, are to some extent shared by the mosaics at Daphni. But the frescoes at Nerezi are also characterized by an unexpected impression of gentleness and human warmth, and it is this extra nuance of humanity which distinguishes the productions of this period from those of the Macedonian era.

Towards the end of the Macedonian dynasty and during the Comnene period, an entirely new type of stylized miniature began to appear in manuscript illumination. Numerous manuscripts of the Gospels, liturgical books and hagiographies were illuminated in this style, and their abstract character indicates that they are related to the 11th century Macedonian art of the monasteries. Examples such as the Gospels dedicated to John II Comnenos and others and a number of manuscripts of the Octateuch, probably produced in the early 12th century, undoubtedly rank with the art of Daphni and Nerezi, displaying the same richness, the same decorative yet firmly delineated forms, and the same lively depiction of human feelings. Among the best known illuminations are those in the collection of Homilies of the Virgin Mary by the monk James of Kokkinobaphos in Asia Minor. Two almost identical copies have survived, one of which is now in the Vatican, the other in the Bibliothèque Nationale in Paris. The copy in the Vatican contains scenes from the Old Testament as well as episodes from the life of the Virgin Mary covering her birth, childhood, Annunciation and visit to Elisabeth. The brilliance of the illustrations, and the general attitude and feelings which they express, make this the most characteristic of surviving Byzantine manuscripts.

In recent years a large number of icons have been discovered on Mount Sinai, and the process of their classification has gradually brought to light a hitherto unknown facet of icon art from the middle Byzantine period. A comprehensive interpretation of their history has not yet been undertaken, but it is now known that in the period covering the end of the Macedonian dynasty and the beginning of the Comnene, the production of icons was closely connected with that of manuscripts, in particular the group of small, stylized miniatures mentioned above. This was especially true of the icons relating to the Menologion and Synaxarion, which often incorporated full-sized church ornaments reduced to a microscopic scale. These icons served the requirements of a highly formalized liturgy, designed to inculcate a set of dogmatic principles. At the same time, the world of icon painting saw a movement towards the expression of human feelings and sensibility and an even greater emphasis on the direct decorative impact of the picture. A good example of these new preoccupations is the so-called Virgin of Vladimir (illustrated in the frontispiece), which was produced in Constantinople around 1125 and subsequently taken to Russia. This depiction of the Virgin and Child, with their cheeks joined in a touching embrace and Christ's arm outstretched towards his mother's breast, shows a deep understanding of human sensibility.

The most notable product of the decorative arts in this period is the Pala d'Oro in St Mark's in Venice, which has already been mentioned in a previous chapter. A massive altar screen with eighty-six enamel panels, it was originally made for Doge Orseoli in 976 and subsequently restored at the beginning of the 12th century. We might also mention that many of the bronze doors used on Italian buildings in the 11th and 12th centuries were cast and engraved in Constantinople, and these were then used as patterns for the casting of other doors in Italy itself.

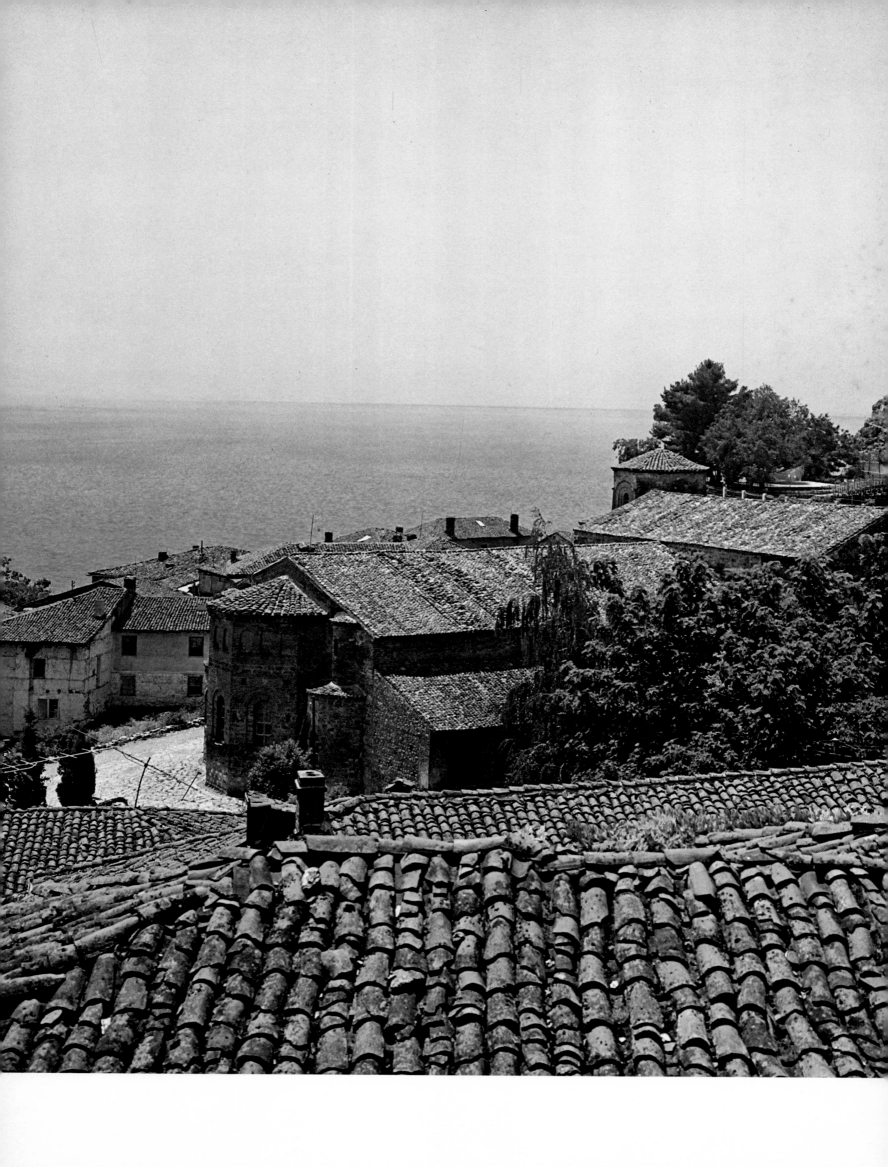

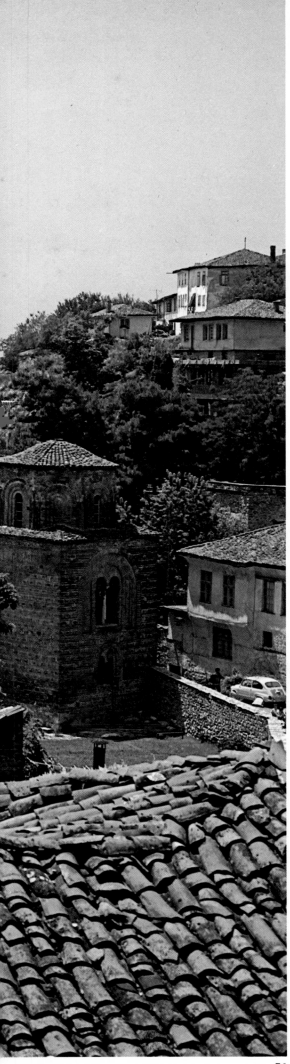

The Art of the Paleologue Dynasty

From the point of view of the Byzantines, who prided themselves on their Classical heritage, the army of the Fourth Crusade which invaded their Empire under the pretext of a holy war was an army of cultural barbarians. The conquerors were at first bewitched by the splendours of the Eastern Roman capital, but soon gave way to an ungovernable lust for plunder. They sacked the holy places of Constantinople and their sacred ornaments, deliberately plundering and destroying the most magnificent of them. And fifty-seven years later, the historic Empire was arbitrarily split up by these uncultured Europeans. In order to destroy the invaders, the reigning emperor, Michael VIII Palaiologos, needed help, and he was fortunate to obtain the powerful naval support of Genoa, which at that time was in conflict with Venice. The moment he had longed for finally came when in 1261 he re-entered Constantinople. According to legend he hurried straight to the Monastery of Studios without stopping to take off his armour, then went to the Hagia Sophia to report his victory to God. The Paleologue dynasty ruled for the next two hundred years, until the end of the Empire, and this period saw the last flowering of Byzantine culture. Art, philosophy and science reached new creative heights, but no amount of cultural activity could conceal the critical situation which was becoming every day more apparent. The Empire's neighbours and the nations of Europe were seeking any opportunity to appropriate the splendours of Byzantium for themselves. Meanwhile the imperial government was severely weakened in its functions and rapidly heading for collapse. The Empire itself now yielded to foreign influence, hoping to check the decline by establishing a balance of power. But the foreign powers treated the Byzantine territory as if it were their own, and the government was powerless to stop them. The culture of the Paleologue era is a culture of overripeness and decay. It concealed an unspeakable anxiety, a pressing fear of the fall of the Empire and its culture. And this anxiety gave the arts of the period a unique and passionate character, simultaneously spurring men on to extremes of contemplative thought.

This new artistic style – the style of the Paleologue dynasty – emerges clearly at the beginning of the 14th century in the mosaics of the Church of St Saviour in Chora (the Kahriye Camii) in Constantinople. How this style first came into being is the subject of much controversy among present-day scholars. We cannot deal with the question at length here, but it can be established that it had many forerunners prior to the 14th century. Often counted among these is the magnificent mosaic of the Deesis (the figure of Christ flanked by the Virgin and John the Baptist) in the gallery of the Hagia Sophia in Constantinople (plate 28). The mosaic is badly damaged, but is notable for the refined but highly realistic treatment of the figure of Christ in the centre and the depth of suffering expressed in the face of John the Baptist. These features give it a certain similarity to the mosaics in the Kahriye Camii, which were endowed by Theodores Metochites (the son of Michael III and minister of Andronikos II), and especially to the portrait of Christ on the upper part of the narthex doorway. The mosaics of the Kahriye Camii also contain numerous figures from the story of the Virgin Mary. These scenes, which are partially based on the apocryphal gospels, are characterized by a naturalism and sense of reality which contrasts with the sumptuous style of the mosaics at Daphni.

Metochites also endowed a chapel on the south side of the Kahriye Camii. The interior of this chapel is covered with frescoes, and the scenes of the Last Judgment and Christ's descent into Hell are widely known. Other groups of frescoes, representing the last masterpieces of Byzantine mural painting, still survive today in various parts of Greece. The most important of these are the murals at Mistra. This town, not far from the region of ancient Sparta, was the scene of much building activity after Michael VIII had brought the ruling families of the Peloponnese under his influence and established a member of the imperial house as its ruler. Many of the buildings produced were

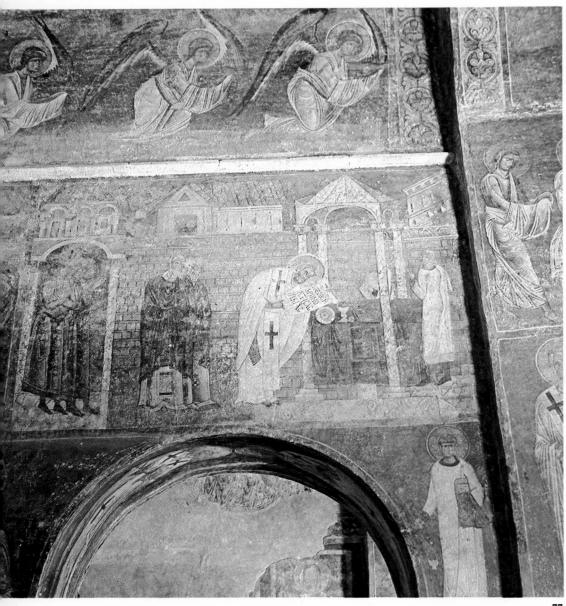

decorated with frescoes, and the church of Peribleptos, for example, is filled with strange and unreal scenes.

The style developed by this last 'renaissance' of Byzantine art under the Paleologue dynasty was highly influential throughout the Balkans as well as in Italy and the countries of Western Europe.

The Balkans

The adaptability of Byzantine culture was no less great in a time of national weakness than it had been during its former glory. Its sphere of influence was extraordinarily wide, and its traces can be found in architecture as far afield as Armenia and Georgia, east of the Black Sea. Indeed, the Slavonic world as a whole – the Balkans stretching north of the Byzantine Empire and Russia itself – adopted Byzantine culture as their own, and preserved and developed its traditions long after the collapse of Byzantium.

Christianity spread to the Balkans at a fairly early date. A church probably dating from the 4th century and murals depicting a host of angels have survived in the former town of Serdica, now Sofiya, the capital of Bulgaria. This is only an isolated instance, however, and the definitive contact between the Byzantine Empire and Bulgaria did not take place until the 9th century. The relations between the two countries before this period had been largely

Page 154
76 St Sophia, Ohrid, Yugoslavian Macedonia, 11th to 12th centuries. The cathedral at Ohrid, the centre of Byzantine culture in the northern Balkans, is a basilica with a nave and two aisles; the nave was once surmounted by a large dome; a campanile originally stood at the western end, but this was destroyed in the 15th century when the Muslims converted it into a mosque. The west front, to the right of the picture, is formed by a two-storied narthex with twin towers, which was built in the 14th century.

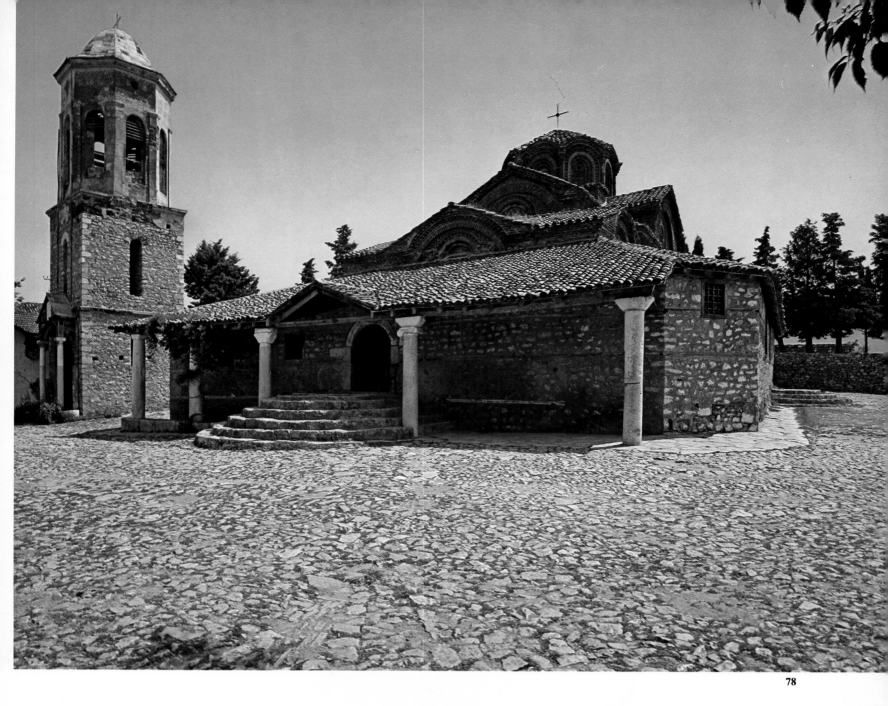

78

Left:
77 Mass of St Basil, wall painting on the north wall of the apse, St Sophia, 11th century. The apse at the east end of the church and the adjoining sanctuary contain the oldest murals in the church, a section of which is illustrated here. The unusual softness of the style and the reticent colours, with brown and ochre predominating on a blue background, illustrate the new direction taken by Byzantine art in the Balkans.

Above:
78 Church of St Clement, Ohrid, Yugoslavian Macedonia, 1295. Standing on a hill in the town, this church shows externally the general features of late Byzantine architecture. Internally it shows the cruiform plan characteristic of Balkan church architecture, combined with a narthex. The chapels on the north and south sides were built in the 14th century, while the 19th century saw the addition of the outer narthex which now forms the west front.

meetings of enemies with a common frontier. In the 8th century the emperor Constantine V marched north to attack the Bulgarians, while in 813 the Bulgarian army under Krum Khan reached the walls of Constantinople. After the death of Krum Khan, two monks from Salonica, the brothers Methodios and Kyrillos, visited various places in the Balkans and energetically set about converting the inhabitants to Christianity. They also introduced the Cyrillic script, which they had invented for the purpose of translating the Bible into the Slavonic language. Finally Boris I, the tsar of Bulgaria, visited Constantinople and was christened there in 864.

Although the two states were subsequently to find themselves in conflict more than once, their common religious basis ensured that Byzantine culture remained predominant in Bulgaria. After his return from Constantinople, Boris I built seven large churches in different parts of his country. During the reign of his son, King Simeon (893–927), magnificent palaces and churches were built, chiefly in the capital, and the studios and workshops of the monasteries were active on an unprecedented scale. The buildings in the capital are particularly noteworthy for their idiosyncratic character, combining as they do the unusual forms of dome and architectural ornament which already existed in the country with the additional features of the Byzantine style. The famous clay icon, which was discovered in the ruins of the Monastery of Patleina near Preslav and originally adorned the wall of the

building, is a striking confirmation of the high level which Bulgarian art had already reached at this time.

Simeon brought the whole of the Balkans under his dominion; his reign was a golden age for Bulgaria in both the political and cultural spheres, and he was granted the title of emperor (*basileios*) by the Byzantine Empire. After his death the country's power and influence declined and it was split into east and west. King Samuel, the ruler of Western Bulgaria, regained control of the whole nation and established his capital at Pliska, and then at Ohrid. He opposed the Byzantine emperor Basil II, who was nicknamed 'the Bulgar killer' (*bulgaroktnos*). After his death in 1018 Bulgaria finally came under Byzantine rule together with Serbia, and the church, which had freed itself from the control of the Patriarch of Constantinople in Simeon's time, also had to return to its former dependent status.

The fact that few buildings have survived from this time lends special interest to the frescoes preserved in the Monastery of Pacikovo, dating from the 11th to 12th centuries, for they reflect the period of Greek domination of the area and the brilliant style of the Comnene dynasty. In the year 1185, Bulgarian resistance against Greece came to a head, and the country finally won its independence. The fortress of Turnovo in the gorge of the River Yantra was chosen as the capital, and an attempt was made to reunite the two kingdoms under one ruler. This was achieved under Tsar Ivan Asen (1218–1241) and an empire arose which for a period even included Byzantine territory around Constantinople. Skilled craftsmen were brought to the capital of Turnovo and numerous churches and monasteries began to appear. The seventeen ruined churches discovered on the hill of Trapesiza and the castle on the hill of Zaravez are in themselves evidence enough of the prosperity of the town.

After the death of Ivan Asen, the country was divided up once again. In the 13th century it was incorporated into the Byzantine Empire under the Paleologue dynasty, and in the 14th century it came under the rule of the Serbian emperor Stephen Dušan. During this period more churches were built in various places and decorated with murals and icons which combine the traditions of Byzantine painting with local stylistic features. The group of wall paintings in the church at Boiana, near Sofia, is well known as being typical of this period. These works demonstrate the high level achieved by Bulgarian painting at this period, displaying a close relationship with the Byzantine style of the 13th century but preserving their own individual conceptual form. A large number of important churches were built at this time, including the Church of the Forty Martyrs, the Church of SS Peter and Paul, the Church of St John Aleiturgetos and the Church of the Archangel Gavriel Mizhail at Nessepar on the Black Sea coast, or the church in Asen Castle at Asenovgrad. In the field of painting, many typically Bulgarian works were produced, not only murals but also icons and illuminated manuscripts. Icon painting, which had originally developed during the first golden age under Simeon, perpetuated an artistic tradition which was rooted in the national character and preserved it even after Bulgaria had succumbed to Turkish domination in 1393.

The territories of Macedonia and Serbia, which are now a part of Yugoslavia, were brought within the sphere of Byzantine cultural influence in the 9th century, when they were ruled by Bulgaria. Macedonia, which had long been an important avenue of communications between East and West, was already closely linked with the culture of neighbouring Greece, and as the ruins in the town of Stobi indicate, its relations with that country had lasted from the Hellenistic period until the time of Justinian. But it was not until after the 9th century that the Serbs, a southern Slavonic ethnic group, came under Byzantine political domination and adopted the doctrines of the Greek Orthodox Church and the Byzantine culture which was associated with it. The two missionary monks Methodios and Kyrillos probably contributed to this transformation.

The place in which Byzantine culture first took root was Ohrid in central Macedonia, where the Bulgarians established their patriarchate. After they

79 Koimesis, wall painting on the west wall of the presbytery, Church of St Clement, 1295. Most of the murals inside the church were painted by the Greek artists Michael and Eutychios. The dynamic structure of the composition, achieved through bold contrasts of light and shadow and powerfully drawn figures, nevertheless indicates that they were moving in a different direction from contemporary works on the Greek mainland. The quality of this painting is on a level with that of the murals in St Sophia.

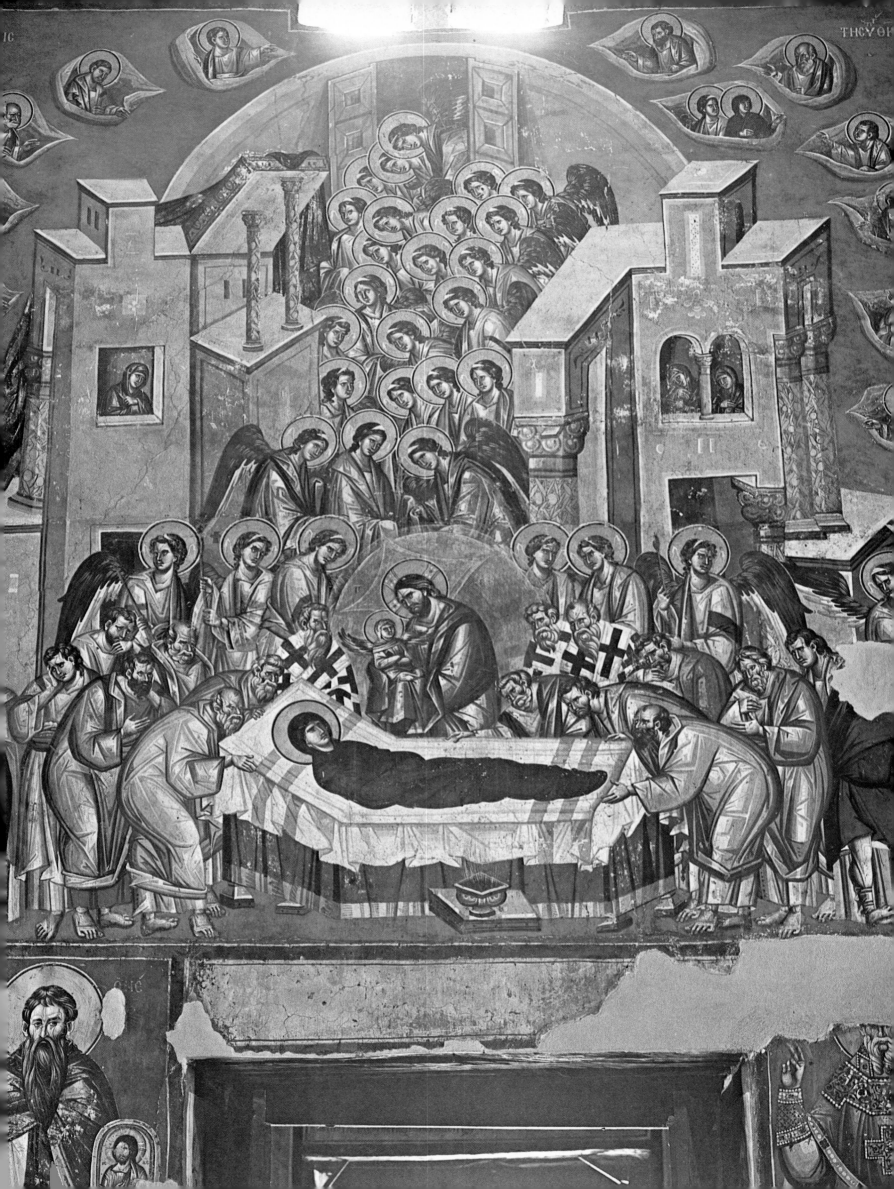

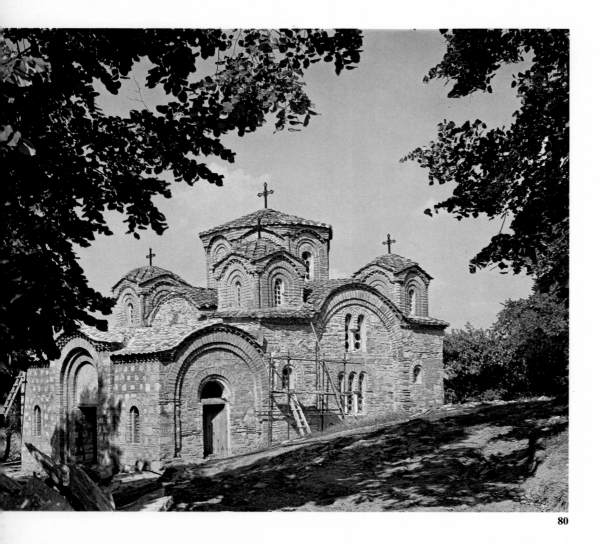

had left, the town and the shores of Lake Ohrid retained their status as the birthplace of the Orthodox Church for the Serbs and a centre of Byzantine culture. The cathedral of St Sophia was probably built as early as the 9th century, but its present form dates from the 11th century, when it was rebuilt. Originally a domed basilica, it received various additions in the 14th century and partially collapsed after the 15th century, so that little of its former appearance remains. However, the surviving frescoes in the inner apse are highly prized as examples of Byzantine mural art from the Macedonian period. Most of the churches in Ohrid are built on the familiar plan of a Greek cross, the most typical being the church of St Clement, built in 1295. Again, its external appearance has been changed by additions made by later generations, but the frescoes adorning the interior, painted by the Greek artists Eutychios and Michael, are important works of the Paleologue period and more advanced in concept than their counterparts in St Sophia.

In the 11th and 12th centuries, in the period in which Bulgaria lost control of Macedonia, a second centre of Byzantine culture existed in the area, and one which had close links with the Byzantine Empire. This was the region of Skopje, which lay within the authority of the patriarch of Ohrid. The Church of St Panteleimon, which was built in 1164 in a monastery at Nerezi in the mountains outside Skopje, is a famous example of the local peculiarities of architectural style. The building contains a number of excellent murals, done in the style of the Comnene dynasty, with some outstanding figural subjects, full of humanity and warmth; the paintings are enlivened with delicately rendered grasses and flowers, which serve to distinguish them from similar works in Greece.

A rebellion in 1042 won the Serbs temporary independence from the Byzantine Empire. Soon they were to be freed once and for all from Byzantine domination when Stephen Nemanya created the kingdom of Serbia in 1169

and a new capital was founded at Raska. King Stephen II Porovyencani (1196–1228) established the independence of the Serbian orthodox church and appointed his younger brother Sava the first patriarch. The Nemanya dynasty, having thus created the basis for the political and ecclesiastical independence of Serbia, produced several generations of able kings and gradually asserted itself throughout the Balkans. King Milutin drove the Eastern Roman army back behind its own frontiers. Stephen Dušan (1308–1355) took possession of Salonica, the second largest city in Greece, and his army pursued the aggressors to the Gulf of Corinth. As a result, in 1340 the Byzantine Emperor recognized his dominion over the whole of Macedonia, excluding Salonica. Five years later Dušan achieved a long-standing ambition when he created the Serbian Empire and had himself crowned 'Tsar of the Serbs and Greeks'.

The Serbia church, which was founded by St Sava, became increasingly solidly established as the Nemanya dynasty grew in power, and a succession of monasteries were built in various different places. It was these buildings which created the characteristic style of Serbian church architecture. The school of Raška, which formed the main stream of this style, is characterized by a mixture of the Romanesque style derived from churches on the Adriatic coast and the late Byzantine style of church architecture which predominated in Macedonia. It ingeniously combines the advantages of the long Romanesque nave with those of the Byzantine centralized structure with a dome. Most of the buildings of this type have an aisle-less nave, often covered with barrel vaulting, part of which serves as a narthex. The central space of the interior is crowned by a dome, regardless of the effect this has on the external aspect, and the walls are decorated with murals containing groups of figures done in the Byzantine manner. The churches of St Mary at Dečani, Sopočani and Studenica are typical examples of this style. They are all built of

81

Pages 160–161:

82 Church of the Monastery of St Naum, southern shore of Lake Ohrid, 16th century. This church was founded by a Slavonic monk, St Naum, in the year 900. Only the foundations remain of the original building, which was constructed on a trefoil ground plan, and these were used as the basis for the present structure. The oldest part of the building is the cruciform presbytery, followed by the central chapel and the narthex. The façade dates from the 19th century.

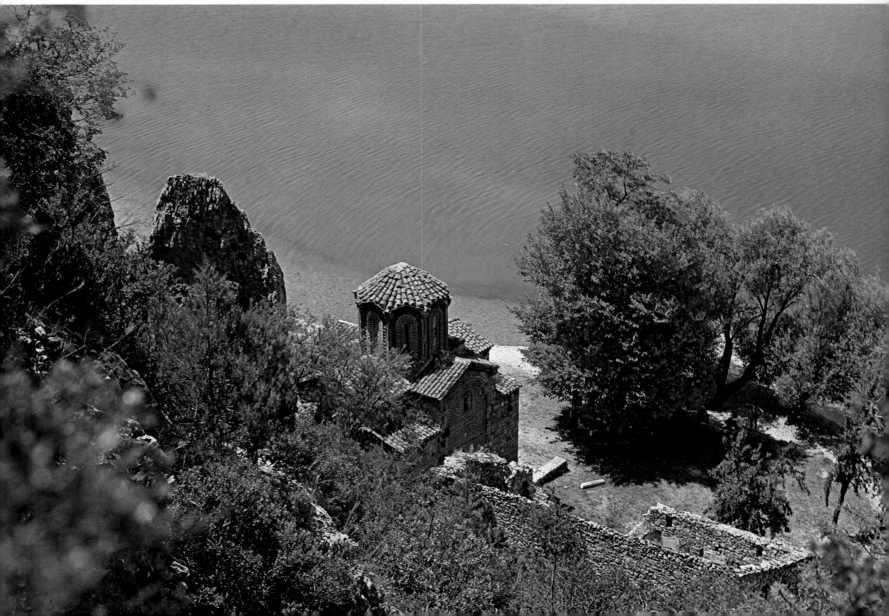

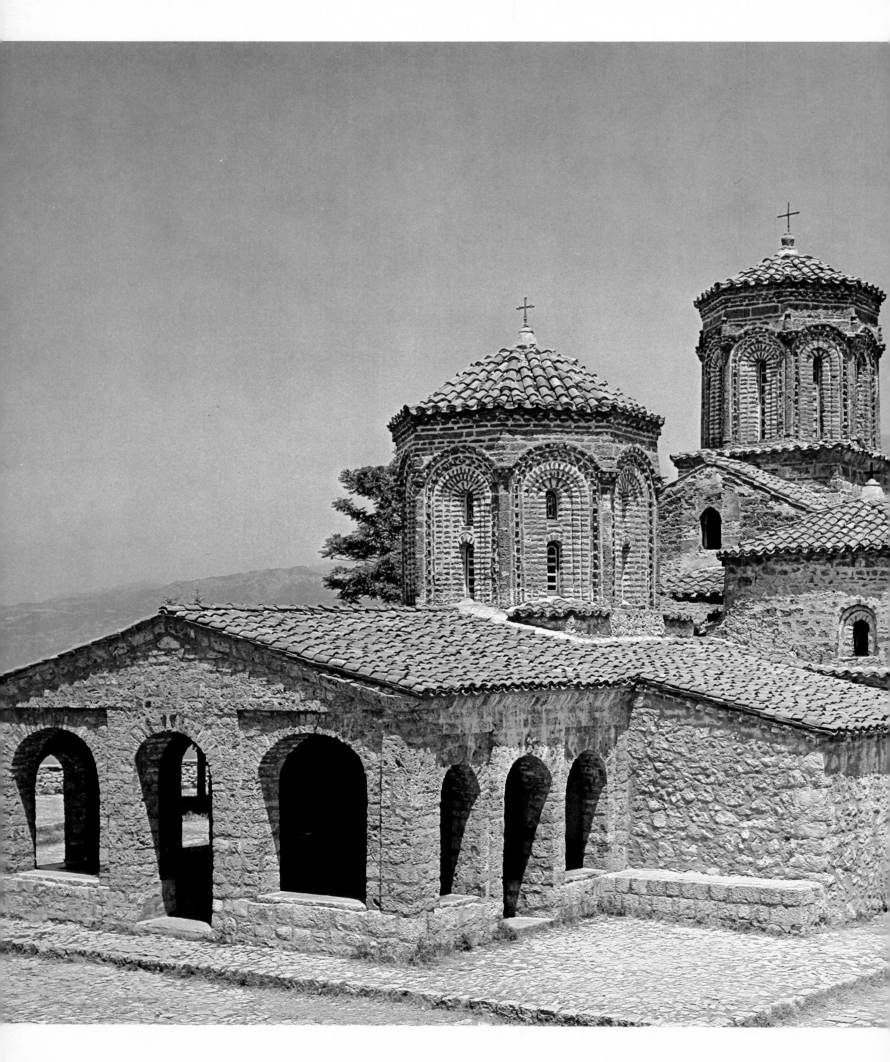

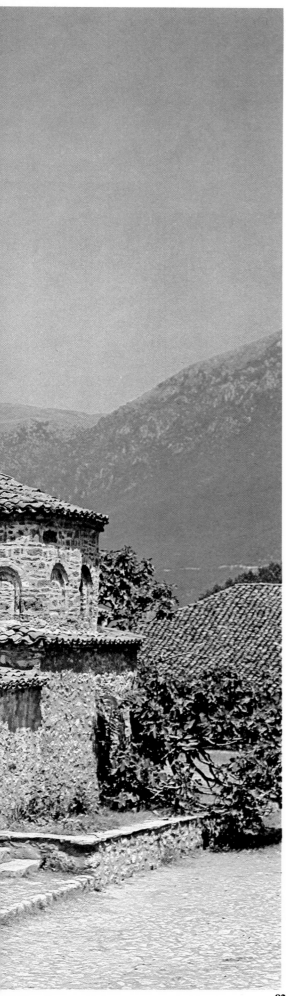

stone, and the exteriors of those at Dečani and Studeniča even include sculptures which bring to mind the Lombard architecture of Northern Italy and provide an interesting contrast to the Byzantine murals of the interior. These buildings in the eclectic style of the school of Raška are full of unpretentious charm, blending harmoniously with the landscape of mountains and deep valleys which surrounds them. Their balanced design and the way in which they harmonize with their setting are a tribute to the creative force of Serbian architecture. By contrast, the buildings of the so-called Serbo-Byzantine school have a much more dominant character, exemplified by the monastery church of Gračanica. The ground plan is that of a cross in a square, the upper part of the building being constructed so that the substructure of the dome is surrounded by four pairs of barrel vaults on four sides. This design is found in other churches of the same period, but the church at Gračanica represents its most convincing and successful application.

Whereas there are frequent local differences in the architecture of the Serbian churches, due to variations in climate and techniques of construction, the murals in their interiors are more consistent. Here there are quite a large number of works which appear directly related to Byzantine painting, both in their subject matter and their style. Greek artists did in fact work on many of the most significant paintings. As in the case of Sopočani and Gračanica, it quite often happens that a work which could be classed in the first rank of Byzantine wall painting appears side by side with a more modest work probably produced by a local artist.

The tradition of Byzantine painting in Macedonia and Serbia continued until the 15th century, when it was lost as a result of the Turkish domination of the area.

The last area of the Balkans to be touched by Byzantine culture was that corresponding to present-day Romania. Here the influence of Byzantine architecture began to make itself felt in the 14th century via Bulgaria and Serbia. It is to be found most notably in the Church of St Nicholas in Curtea de Argeş, which was built on the Byzantine cruciform plan. Also of Byzantine inspiration is the Church of Voronet, a typically Romanian building whose exterior is entirely covered with wall paintings.

The Old Cities of Russia

It was in the unending expanses of Russia that the Byzantine culture which had grown up outside Greece survived the longest. Here the traditions of Byzantine church architecture became deeply rooted, and they are often to be found in churches built long after the Byzantine era, albeit frequently masked by differences of form and design. In their eager search for the sources of the Byzantine tradition of church architecture in Russia, scholars are often apt to overlook many of the characteristic features which have been moulded by the history and topography of the country, not to say the creative spirit of its people. While in many parts of the country the orthodox liturgy is still celebrated in churches filled with candles and the smell of incense, the links between this historical survival and the sources of Byzantine culture in Russia are by no means as direct as they might at first appear.

The Greek Orthodox Church was introduced into Russia in the 9th century, at the same time as it was becoming established in the Balkans. At the end of the 10th century the province of Kiev was ruled by Prince Vladimir, one of the earliest Russian saints. Vladimir's support for the Orthodox Church and strenuous efforts to unite the Russian nation around him made Kiev the political and religious centre of Russia, and it was here that Byzantine culture developed. According to the historical records, there were churches in Kiev even before the official recognition of Christianity at the end of the 9th century, and a Byzantine cathedral of some description was built before its formal adoption as the state religion. The hilly provincial capital overlooking the River Dnepr was the site of the first stone church, the Cathedral of the Assumption, which was given the nickname Desyatinaya (tenth) after the tithes paid by Prince Vladimir. Completed in 996 and consecrated in 1039, the cathedral was destroyed and rebuilt at frequent intervals in later centuries, and today the foundations are the only clue to its original form. The style of the building is unusual, and at the time it had no predecessors either in Greece or in Russia. Indeed, its origin is still the subject of debate today.

The presence of Byzantine culture in Kiev, Russia's oldest city, is exemplified by the Cathedral of St Sophia. According to the Chronicle of Novgorod, its construction was begun in 1018, a year after Prince Vladimir's son, Yaroslav the Wise, had become ruler of the province. The main body of the church was built in five sections, with two aisles on either side of the nave. The latter was particularly broad and probably covered with a large dome in the middle, while the four ends of the side-aisles were covered with a total of twelve smaller domes. The west front and the ambulatory on the north-south axis were surrounded by open galleries with arcades. The style was new even for Greece, the homeland of Byzantine art. The cathedral is generally identified as Byzantine, but in fact it is considerably influenced by the church architecture of Armenia and Georgia. At the period in which it was built,

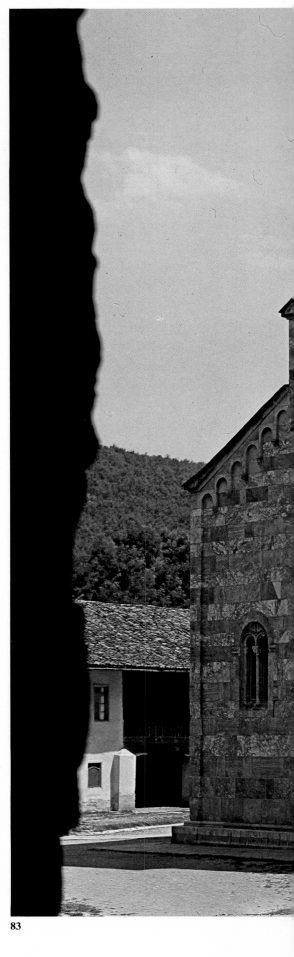

83

83　*Church of the Monastery of Dečani, Serbia, 1327–1335. The building is in the style of the school of Raška, which was active in the mountain areas of Serbia. It was built by King Milutin's grandson Stephen Dušan, who for a time ruled both Serbia and Greece, in memory of his father Stephen Dečanskyi. The exterior of the building is Romanesque, particularly in the use of ornamental sculptures, but the interior is more closely related to the Byzantine style. The church's murals are particularly well known.*

Pages 164–165:
84　*Church of the Monastery of Gračanica, Serbia, 1321. This masterpiece of Serbo-Byzantine architecture is highly unusual in form. Its rising roof line, which progresses from the outer walls to the pinnacle of the main dome, is a tour de force of architectural individuality. The building is constructed on a cross-in-square plan with the addition of a narthex. The interior is decorated with a portrait of the church's founder, King Milutin, and other figures. The exonarthex facing us in the illustration was added at a later date.*

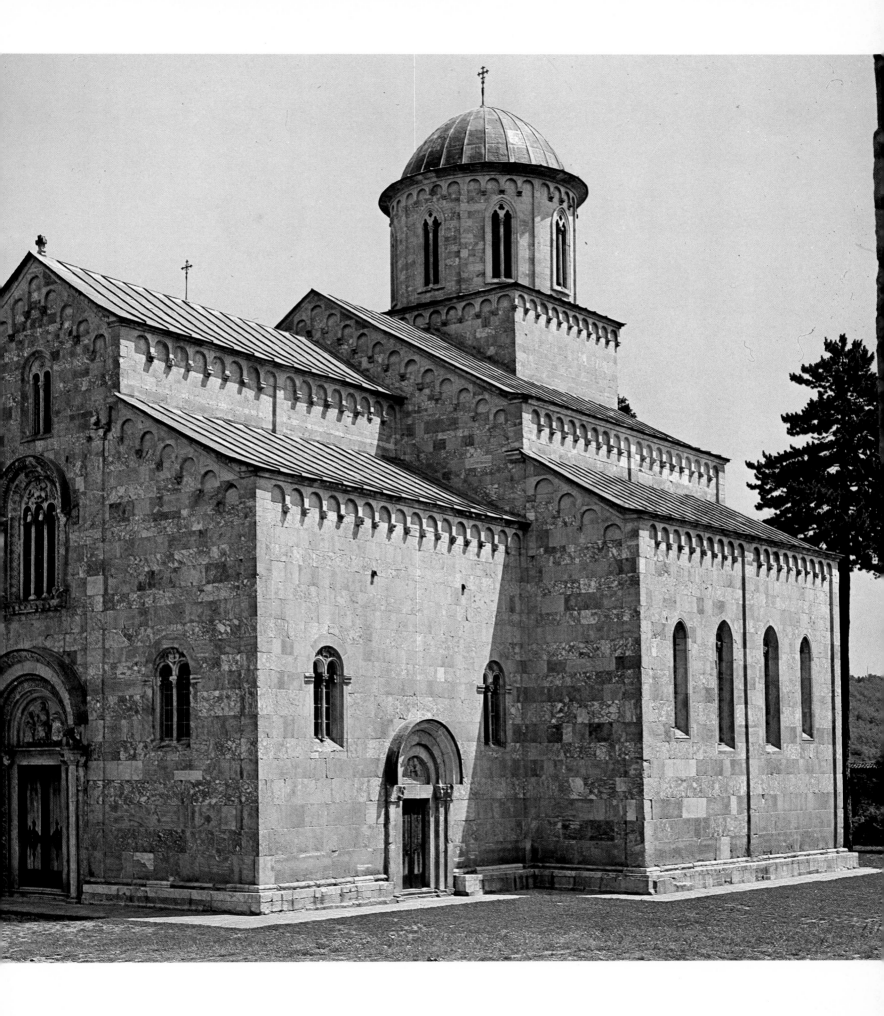

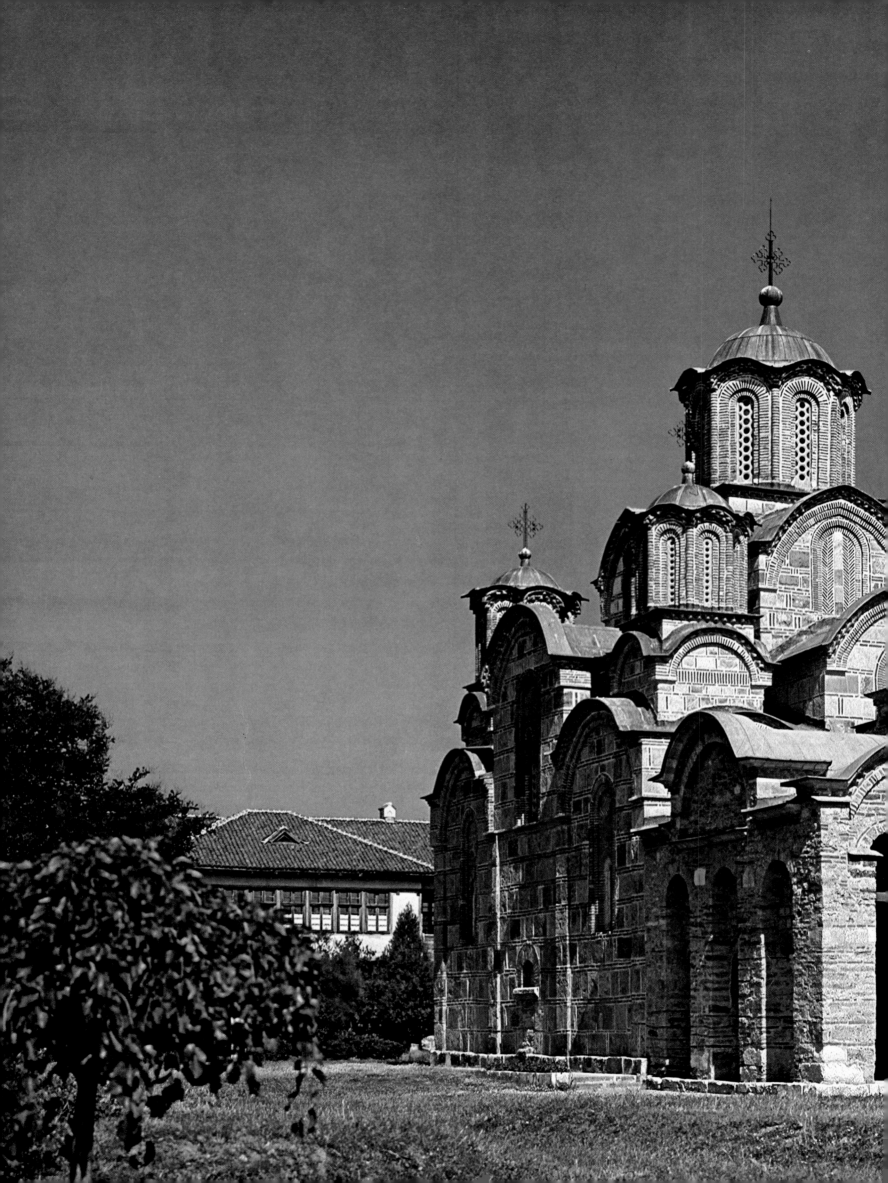

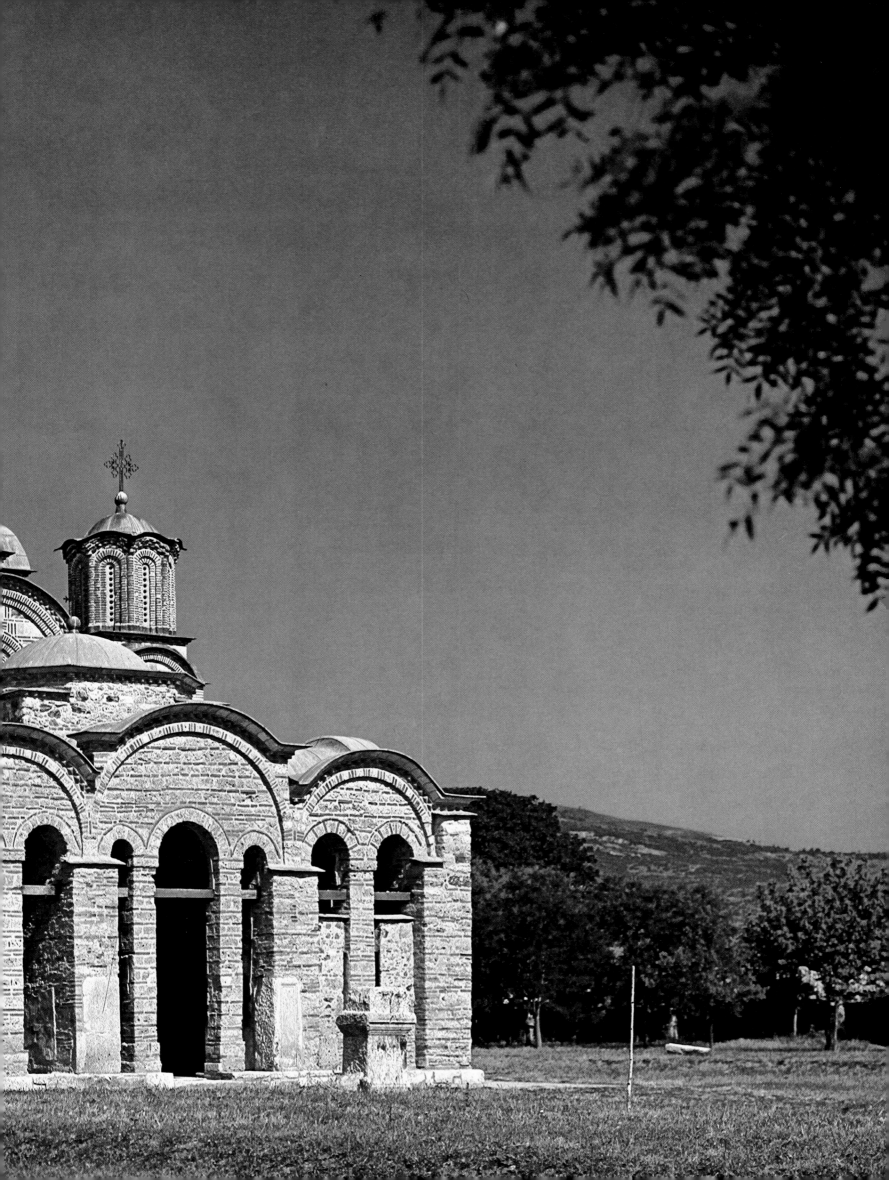

Kherson, on the northern shore of the Black Sea, was the main port of Kiev and as such played an intermediary role between Russia and the Byzantine Empire, and it seems quite possible that the architectural style used came from Armenia via Kherson. In the absence of historical proof, the cathedral remains a subtle cultural and architectural puzzle, but we do not need documentary evidence to tell us that the mosaics in and around the apse are the work of an outstanding Greek artist. Their atmosphere of Classical dignity, the powerful, heavy drawing of the figures and the schematic nature of the composition are all tendencies apparent in Byzantine mosaics of exactly the same period. In addition to the cathedral, an astonishing number of churches and monasteries were built in Kiev in rapid succession, including the Monastery of St Michael, which is well known for its early 12th century mosaics. After the death of Jaroslav the Wise, however, this early centre of Russian culture fell a victim to its own internal conflicts, and in the second half of the 12th century it was finally laid waste by invading hordes from southern Russia. The earliest account of these events makes repeated references to the frightful devastation of the city and the tragic situation of those inhabitants who still sought to maintain a Christian way of life. Not even the cathedral escaped destruction, but between the 16th and 18th centuries an entirely new structure arose from the ruins, built of stone and composed of a nave and eight side-aisles, and it is this structure which survives today.

In the 11th century, when Kiev stood at the height of its prosperity, the commercial town of Novgorod in northern Russia began to compete with it as an important cultural centre. Novgorod had originally been settled by the Varangians in their progress across Russian from Scandinavia. It was in the 9th century that they first established themselves at the point where the River Volkhov flows out of Lake Ilmen. Soon they founded a town which spread out on either side of the river and in the 10th century they began to use the waterway to trade with the surrounding districts. By the 12th century their sphere of activity reached as far as Germany in the north and Constantinople in the south. The contact between Novgorod and Byzantine culture came about as a result of Prince Vladimir's conversion to the Orthodox religion. Vladimir sent the Greek bishop Joachim to Novgorod to spread the new doctrine and supervise the building of a church. In fact the Church of St Sophia, built of the oak which was the customary construction material in northern Russia, was finished at the end of the 10th century, earlier than its namesake in Kiev.

We do not know what the Church of St Sophia in Novgorod looked like, but, named as it was after the Hagia Sophia in Istanbul, we can assume that it was built in a style which suited the spirit and the liturgy of the Byzantine church. At the time of its construction it was famous as the largest building in northern Russia; it was destroyed by fire in 1045, but work was immediately started on a replacement. As high quality stone was scarce in the area, the new church was built of rough stone blocks joined with thick mortar and covered with plaster. Completed in 1062, it was of a similar but simpler design to the cathedral of the same name which was started somewhat earlier in Kiev, and

85 *Church of the Monastery of Sopočani.*
Although at first sight it looks like a basilica, architecturally this church belongs to the school of Raška. The core of the building is the cruciform presbytery, covered by a dome, to which a narthex has been added. The parts corresponding to the aisles are divided into separate compartments, each serving as an independent chapel. The ruined exonarthex and the campanile date from the 14th century.

Pages 168–169:
86 *Koimesis, Church of St Mary, Studenica, 1569. Each of the three churches in the monastery of Studenica contains some excellent wall paintings. The illustration shows one of the paintings in the largest, the Church of St Mary. These works are interesting, despite their late date, as they still follow the traditional Byzantine style. The white flecks covering the whole picture are the result of defacement by the Muslims.*

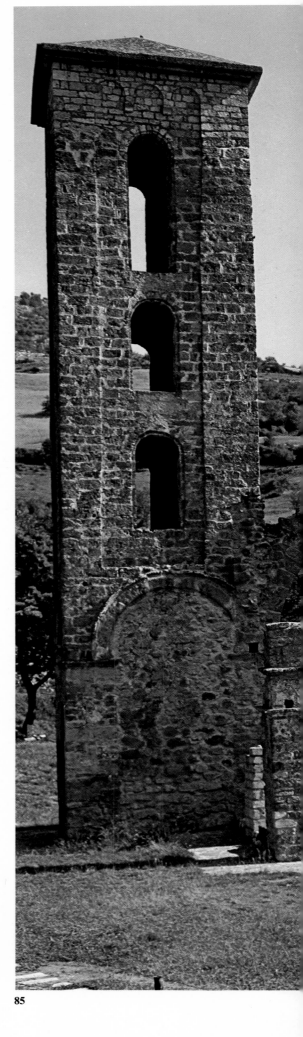

85

166

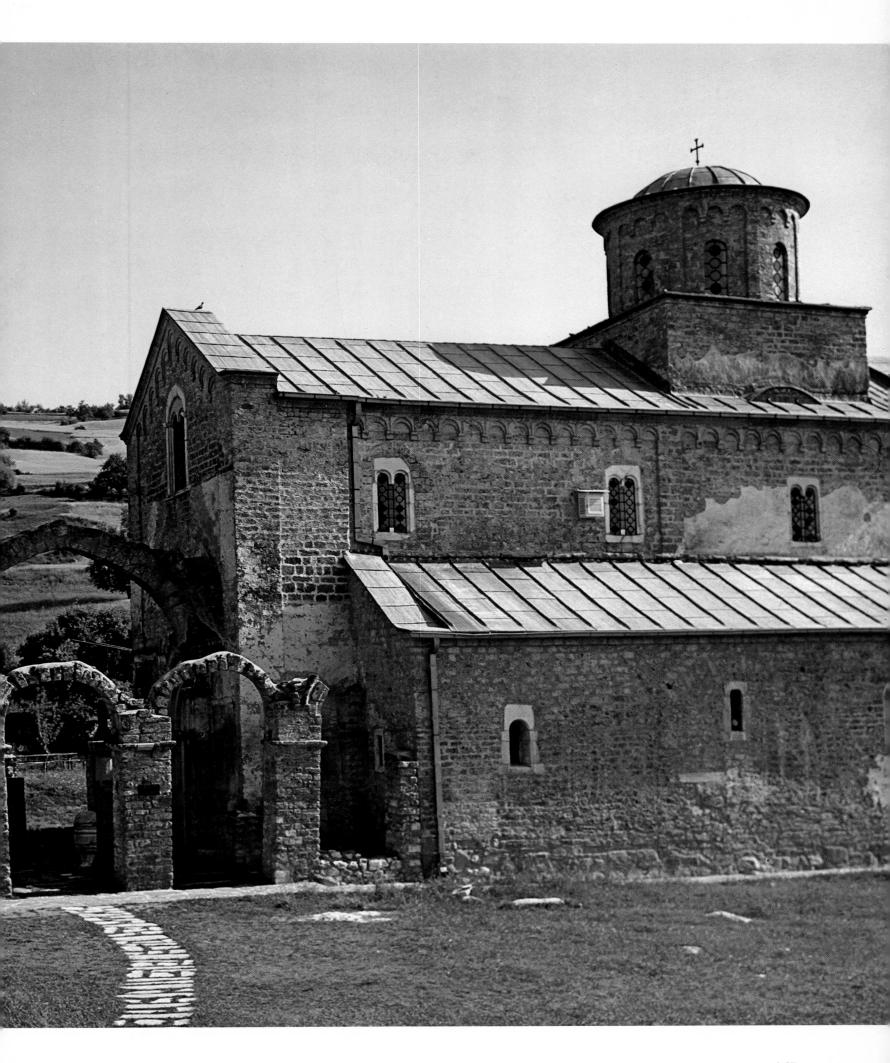

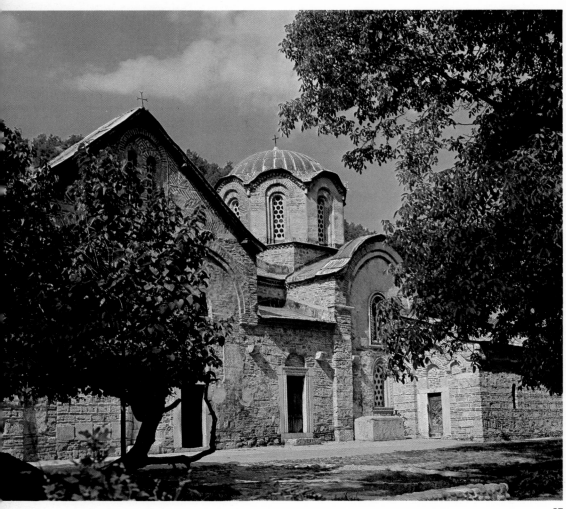

87

the same architects may well have been responsible for both structures. The internal arrangement owes much to Byzantine architecture; flanked by two aisles on either side, the nave is much wider than at Kiev, and the spatial configuration of a Greek cross emerges rather more clearly. But its external aspect in particular serves to demonstrate the different ways in which the elements of Byzantine art and culture were assimilated in Kiev and Novgorod. As the seat of the principality, the city of Kiev took the Byzantine state system as its model and adopted both Byzantine culture and the Orthodox religion primarily for political reasons. The commercial city of Novgorod, on the other hand, seems to have served as an intermediary for the dissemination of Byzantine culture in the West. We might say that while Kiev sought to transplant Byzantine culture in its entirety, Novgorod was more selective in adopting those aspects of it which served its specific needs.

The commercial character of Novgorod is revealed in some unexpected ways. The Chronicle of Novgorod mentions some seventy churches built in the 12th century, and records the names of the founders of twenty-one of these. No less than fifteen of these endowments came from rich townspeople and groups of merchants, an unusually high proportion compared with the capitals of Kiev and Vladimir, where most of the churches were controlled by the ruling princes. And more than half of the remaining churches were founded by monks. This unusual set of circumstances inevitably changed the character of Byzantine architecture in the area, and as we have suggested, the exterior of St Sophia's Cathedral is an important example. Here the outside walls of the aisles were brought up to the same height as the nave and the domes were of an unfamiliar helmet shape. In the 12th century an external gallery was added on the south side and covered with a kind of Romanesque vaulting, and at the same time the helmet-shaped domes, with the exception of one in the middle,

88

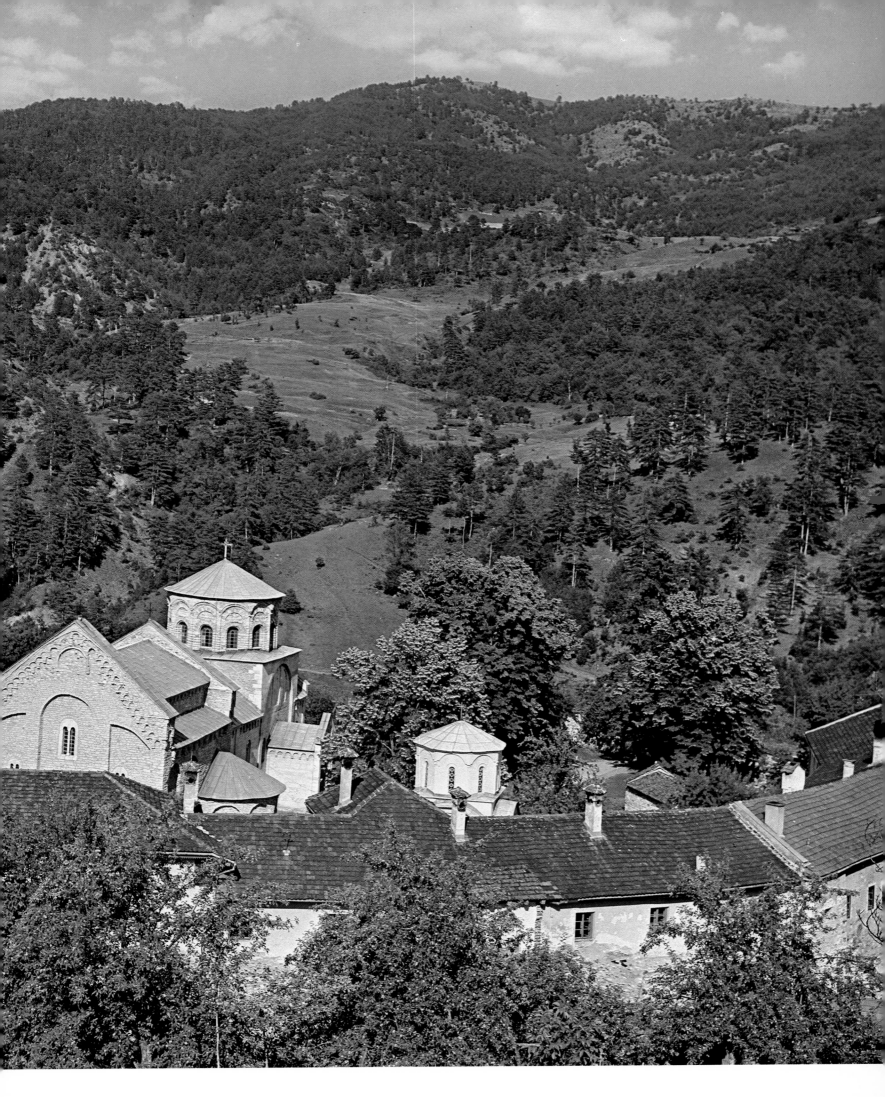

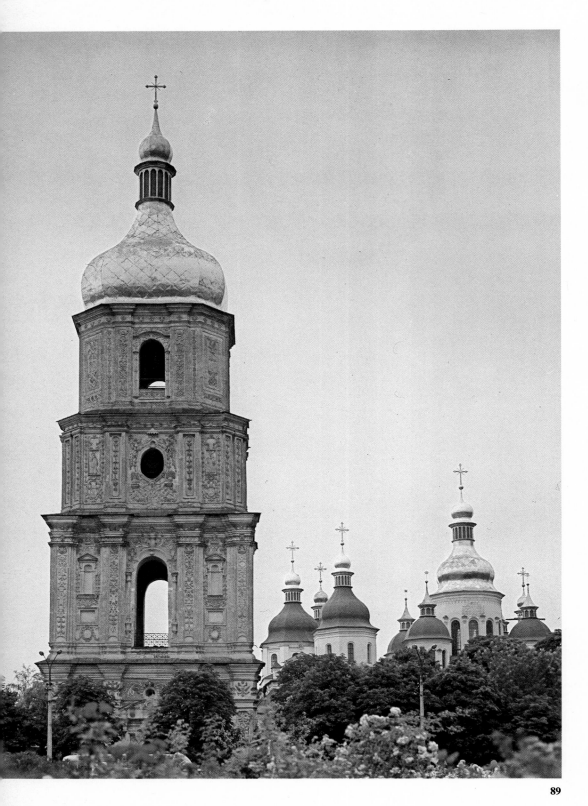

89

Page 170:
87 *Patriarchal church, Peč, Serbia, 14th century. This is an unusual composite building, consisting of a group of churches united by a common narthex. The oldest is the Church of the Apostles in the middle, part of which dates from the 12th century. Each of the churches contains murals from its own period, which enable one to follow the development of Serbian painting from the 13th to 17th centuries.*

Pages 170–171:
88 *Monastery of Studeniča, Serbia, 12th century. Shown here is the Church of St Mary founded by Stephen Nemanya, the first of the kings who ruled Serbia for two hundred years. The monastery was the centre of the Serbian church in the Middle Ages. Peacefully situated in a wood at the foot of a mountain, it consists of three churches, the Church of St Mary (12th century), the Royal Church (14th century) and the Church of St Nichola (12th century), together with a tower and the monks' living quarters.*

Right and left:

89, 90 *Cathedral of St Sophia, Kiev, USSR, 11th to 18th centuries. Kiev was the first Russian city to be influenced by Byzantine culture, and the cathedral provides a historical record of this influence. The original structure, which was built under the supervision of Greek architects, fell into ruin when Kiev was invaded in the late 12th century. The more extensive building which replaced it between the 16th and 18th centuries was done in the Ukrainian Baroque style. The original cruciform plan with a nave and four aisles was extended to create a total of eight aisles, thereby considerably altering the cathedral's appearance. However, part of the original wall, with its attractive alternate courses of stone and brick, is still visible at the east end, and some of the original mosaics are preserved in the apse and other parts of the building. Produced by Greek masters in the 11th century, they provide historical evidence of Kiev's close relationship with the Eastern Roman court.*

were changed to the more familiar onion shape. These departures from the Byzantine tradition were a reflection of the individuality of Novgorod, of a character moulded by its northern climate and the influence of international trade.

In the 12th century, other churches appeared in the commercial quarter and the suburbs of Novgorod which seemed inspired by the indigenous builders' search for a style of church architecture suited to the character of their northern homeland. A typical example is the church of the Monastery of Yuryev, near the Cathedral of St Sophia, which is famous for its Byzantine wall paintings. Here the cruciform plan which formed the heart of St Sophia is somewhat simplified, and the external aspect, with the exception of the extension carrying three pairs of domes and the apse, is reduced to a less

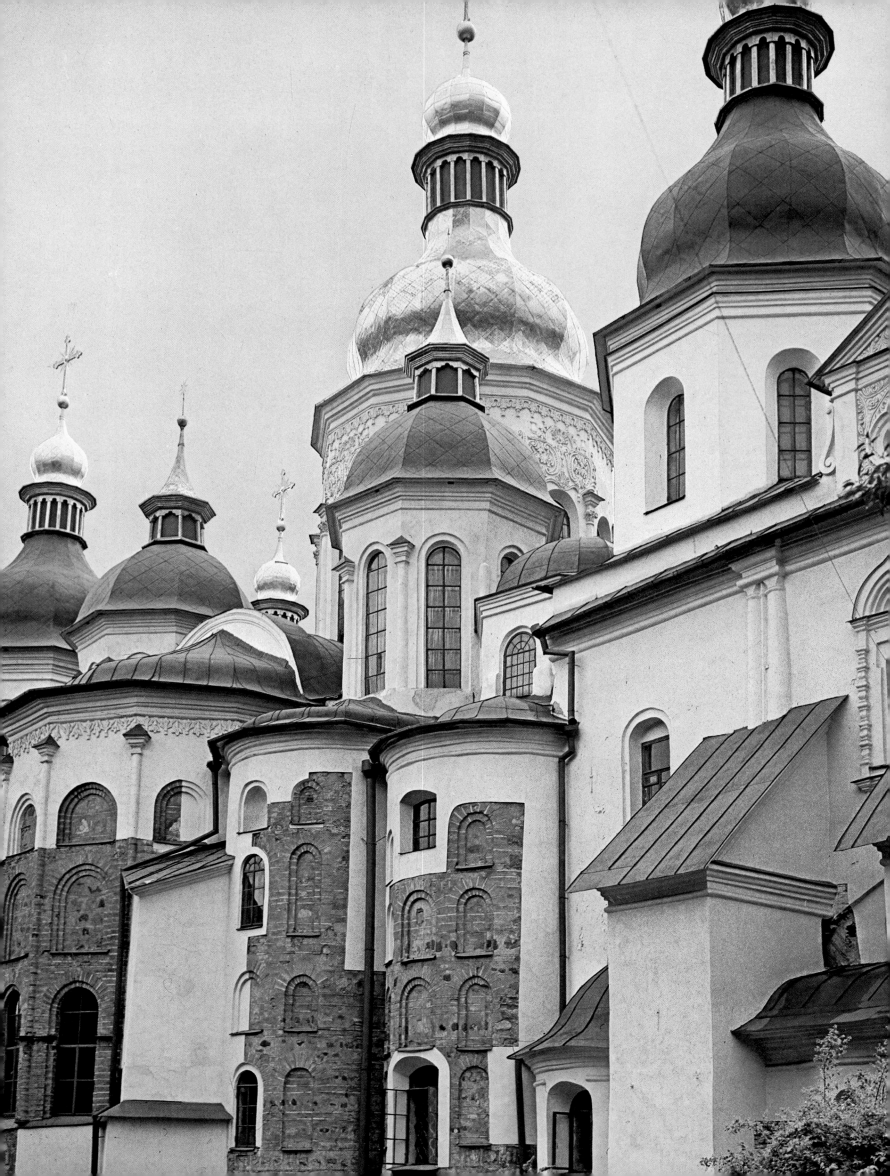

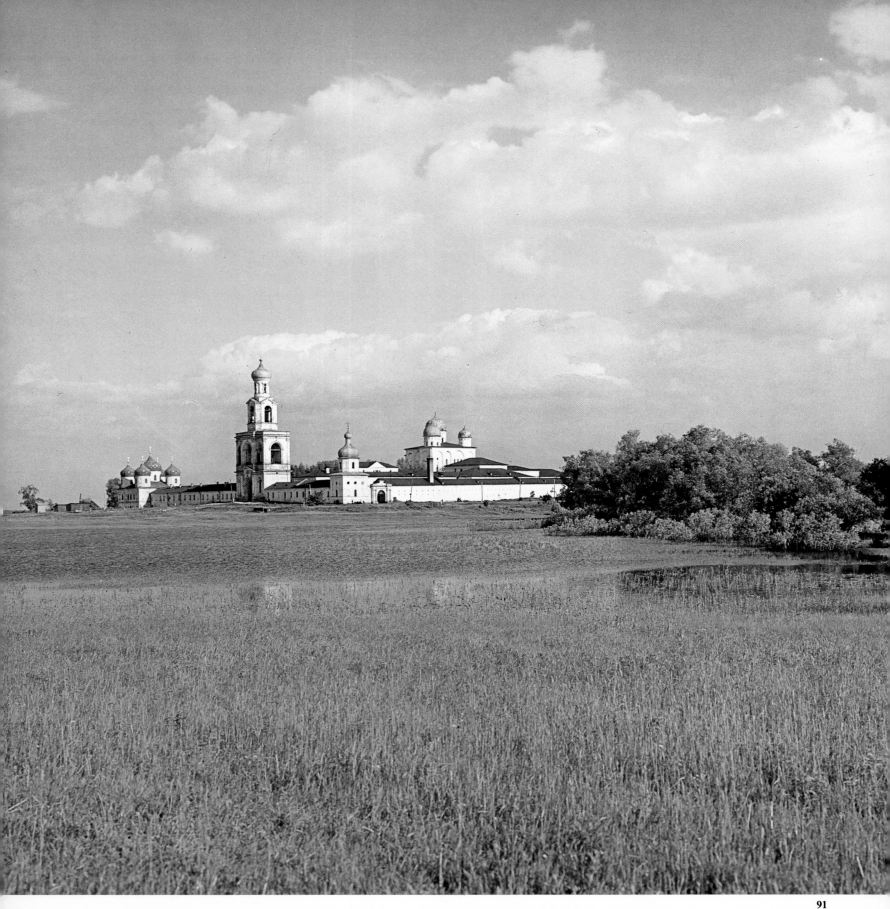

91 View across the River Volkhov at Novgorod. The northernmost point of Byzantine cultural influence in Russia, Novgorod is a waterside city which grew up on both banks of the River Volkhov. The Russians learned the architectural skills of the Byzantine Greeks through building cathedrals and soon developed their own local style, chiefly characterized by the use of onion-shaped domes. The church of the Monastery of Yuryev in the background is one result of this movement, which began in the 12th century.

Right:
92 Cathedral of St Sophia, Novgorod, USSR, 1045–1052. Built at the instance of Prince Vladimir and inspired by its larger namesake in Kiev, it has a cross-in-square plan with a nave and four aisles, and the vertical axis is strongly emphasized. The stone and brick construction is typically Byzantine, but the walls were plastered over, and a kind of Romanesque gallery was added in the 12th century. The onion domes were also a later addition.

Pages 176–177:
93 Cathedral of the Assumption, Vladimir, USSR, rebuilt 1185–1189. The basic plan, with a nave and four aisles, and the shape of the domes, follow those of the old cathedral at Kiev. However, the use of stone throughout and the blind arcades on the external walls give the building a monumental aspect which is typical of the architecture of this area. It is the largest church in northern Russia.

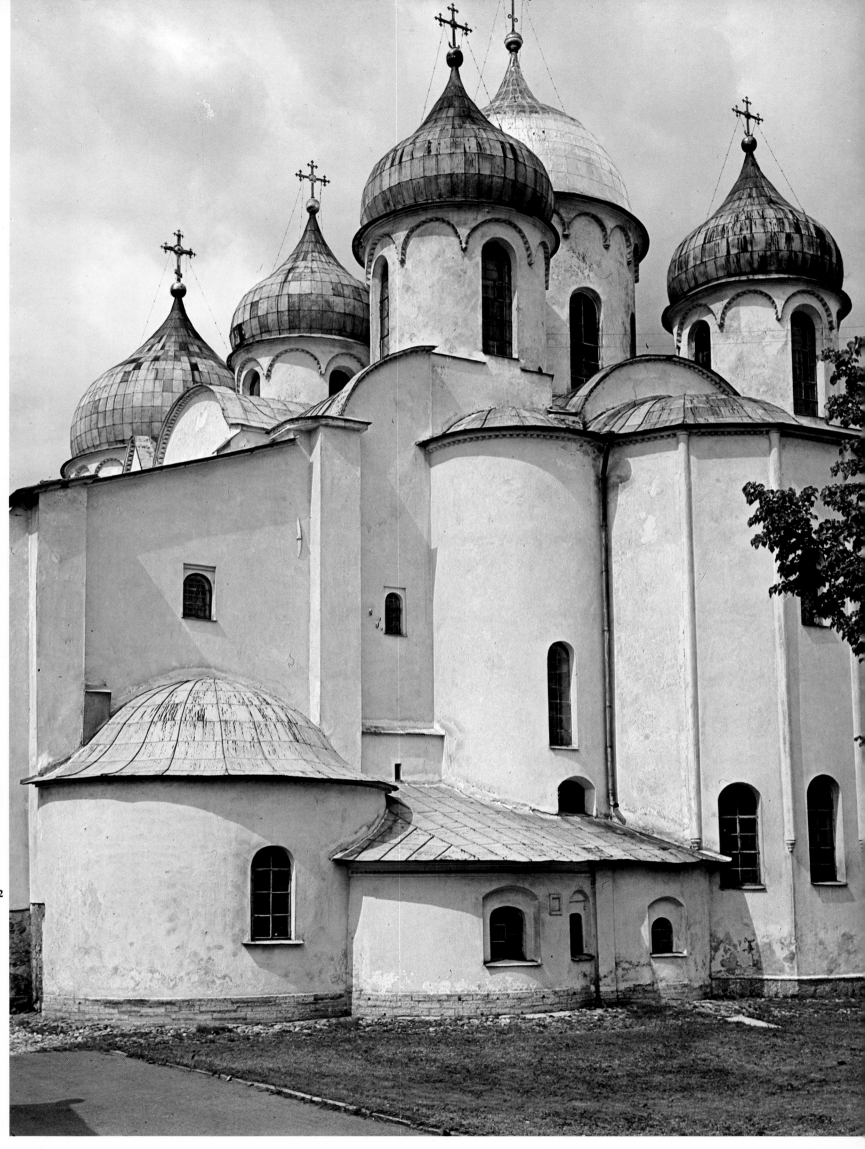

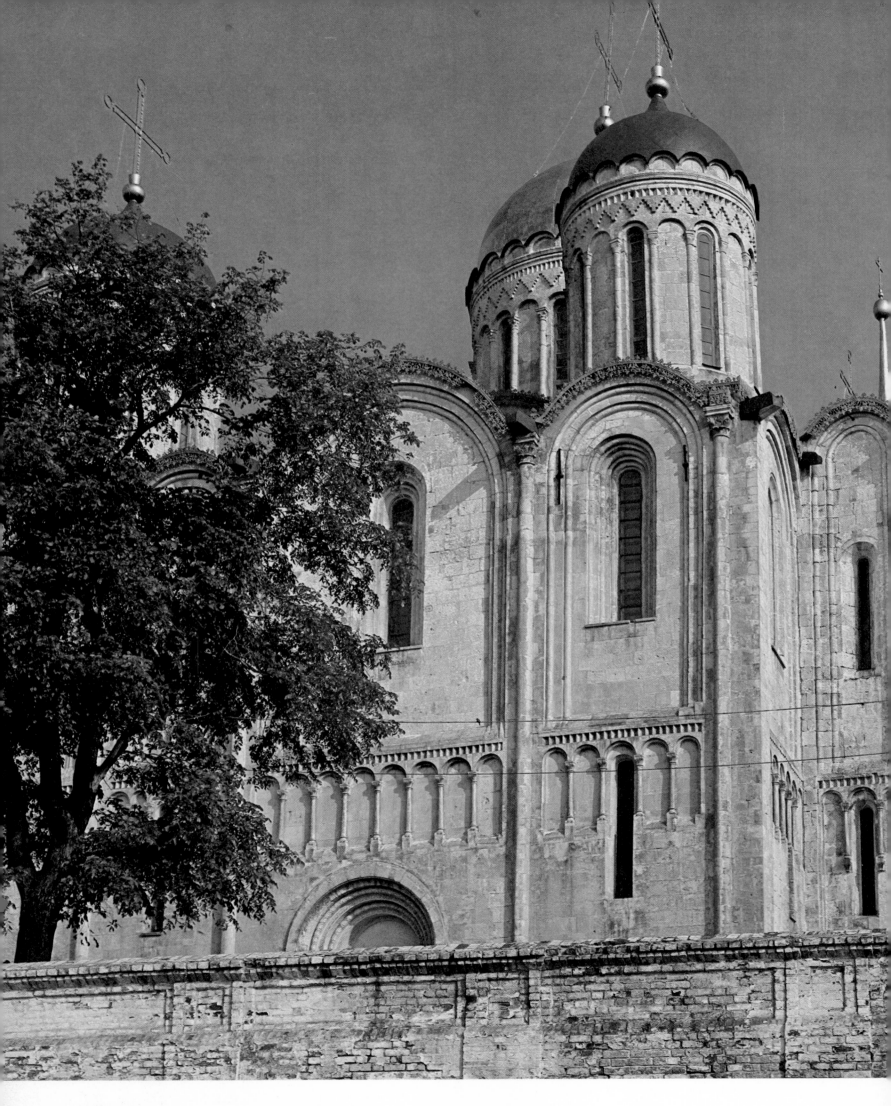

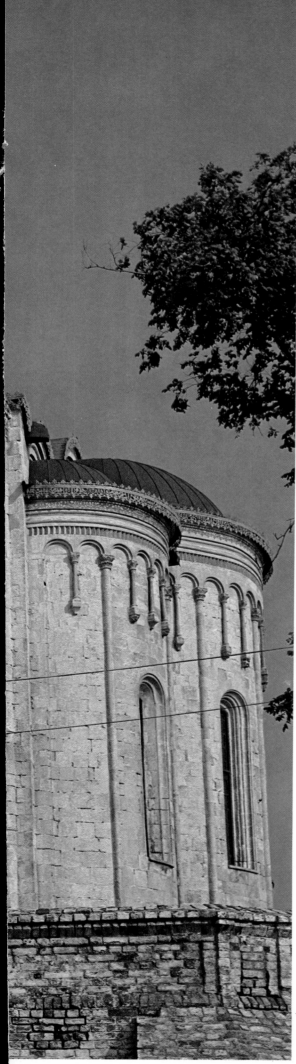

complex, more or less rectangular shape. This new style of construction was combined with another innovation, the use of a pitched roof, and spread from Novgorod to Pskov and other places in north-west Russia, creating the foundations of a national style of architecture.

While Novgorod lay at the north-western limit of the area of Byzantine cultural influence centred on Kiev, the town of Vladimir may well be thought of as a second Kiev, since it was from here that the Byzantine style spread to north-east Russia. In 1169 Kiev was conquered by Prince Andrei Bogolyubsky, the ruler of the province of Susdal. He then abandoned the city and founded a new capital at Vladimir, to the south of Susdal. Vladimir had long been famous as a centre of stone building, and among the many people who flocked to the new city were craftsmen from the ruined south of Russia, hoping to make a new life for themselves. As a result, Vladimir, with its rich natural endowments and easily defensible position, rapidly came to rival Kiev as a cultural centre. New churches began to appear in the city, and these combined the traditional style of Kiev, which was already current in Susdal, with the later style brought from Kiev by the removal of the prince's residence to Vladimir. The Cathedral of the Assumption, completed shortly before the removal of Andrei's residence to the city, almost certainly showed some similarities of design with the original Church of St Sophia in Novgorod, but in any case it followed the traditional style of the Cathedral of St Sophia in Kiev.

The interior of the Cathedral of the Assumption was decorated at the time of its construction with murals by Greek artists. The present form of the building is the result of alterations and rebuilding carried out by Andrei's younger brother Vsevolod. The cathedral represents a fundamental change in the character of the traditional Byzantine church, exemplified by the unusual facing of compact limestone slabs. From its beginnings, the city of Vladimir had close links with Armenia and Georgia, at the eastern borders of the Byzantine Empire, and successive generations of its rulers were linked by marriage with the regions on the Volga River. The non-Byzantine reliefs on the Church of St Demetrius and the small Church of Prokov on the River Nerl' were no doubt the result of this eastern connection. At the same time the ornamental motifs at the entrance to the latter include a number which are reminiscent of the architectural ornaments on Romanesque churches. There is no concrete evidence as to whether these are really Western importations, but it is known that quite a few Western Europeans visited the city during this period, and the latter was undoubtedly an important centre of communications between East and West. The churches built in this part of Russia were planned according to the Byzantine concept, and the interiors were painted by Byzantine artists from Greece who passed on their skills to native Russian artists. Some examples of their work survive in the church of St Demetrius.

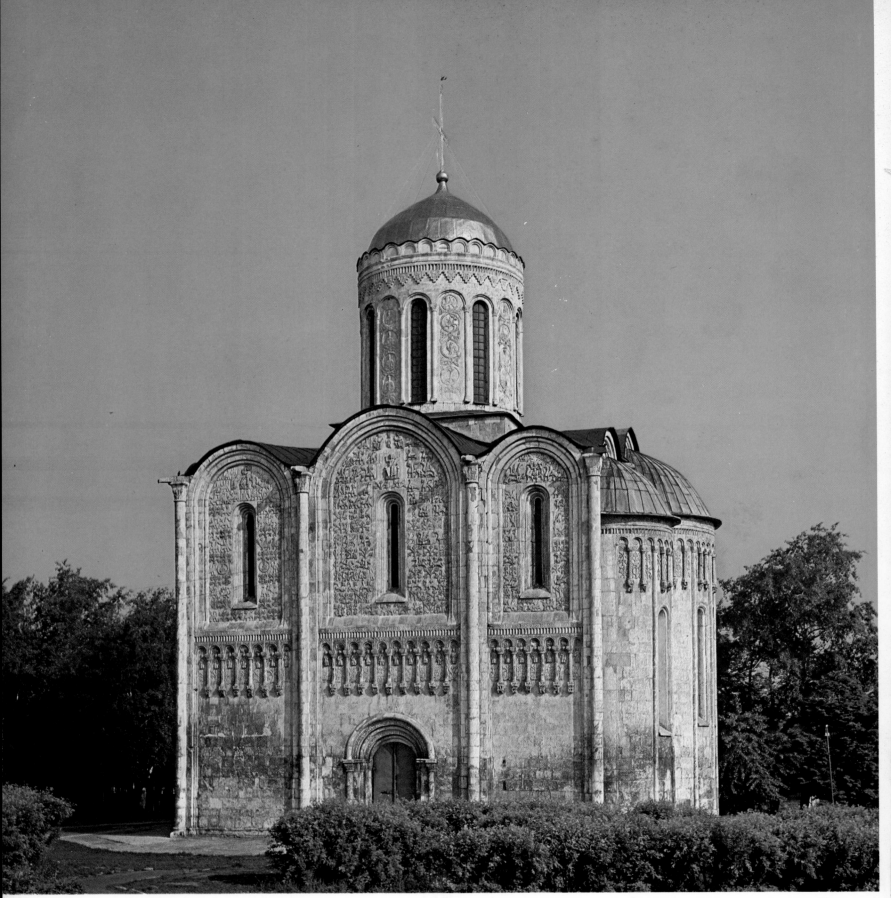

Above and right:

94, 95 Church of St Demetrius, Vladimir, 1194–1197. The second ruler of the province of Vladimir, Andrei Bogolyubsky's younger brother Vsevolod, built this church in the precincts of his castle at the same time as he undertook the rebuilding of the Cathedral of the Assumption. When completed, it housed the relics of a saint. It is based on a simple cruciform plan with three apses at the eastern *end, and there are entrances on the three remaining sides. The relief decoration shows certain similarities with that on Armenian churches. The half-columns suspended below roof level on the outer walls are particularly alien to the Byzantine style and serve as a reminder of the close contact between north-eastern Russia and Armenia. The interior of the church, however, contains murals painted by Greek artists and their Russian pupils, thus providing an interesting contrast of styles.*

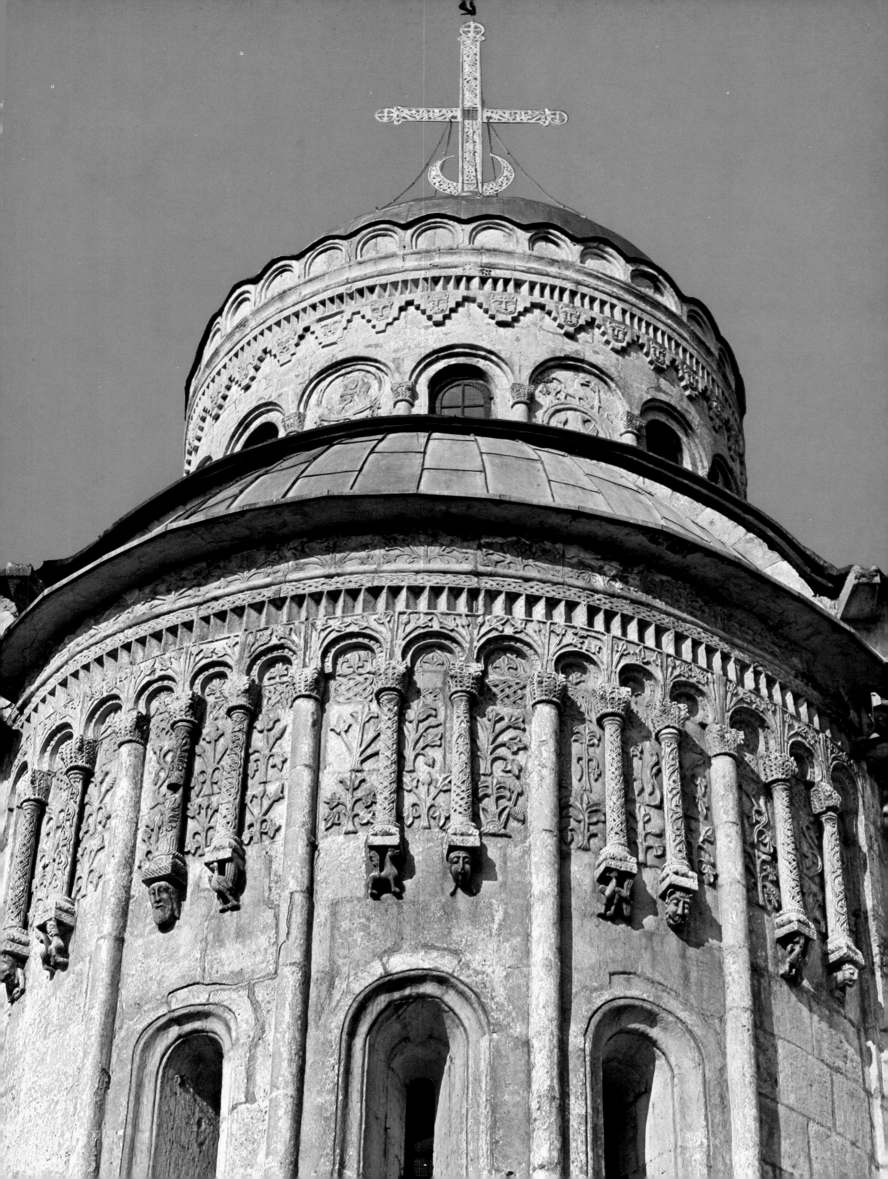

Icons

Possibly the most important single item which identifies the Orthodox Church as the main vehicle of Byzantine culture is the icon. An icon is a devotional picture of Christ or one of the saints, painted on a wooden panel in tempera or the technique known as encaustic which used wax colours. The name itself is derived from the Greek word 'eikon' which means 'image'. In the Orthodox Church, icons were hung in rows on the iconostasis or screen which separates the public part of the church from the sanctuary. Small icons were also hung in Christian households, where they became objects of everyday worship. Despite their difference of subject matter, the origin of icons can be traced back at least as far as the portraits of Egyptian mummies dating from the Roman period.

Portraits of Christ appeared in various places in the Early Christian period, and there are a number of references to them in historical accounts. Some members of the Eastern Church had adopted the Jewish interdiction against graven images, and they raised strong objections to the depiction of saints. From the beginnings of Christianity, this question was the subject of violent controversy, but initially it was the iconodules who prevailed.

Judging by the comments of St Augustine and others on the worship of religious images, portable pictures of saints already existed in this early period. In the time of the emperor Justinian a belief gradually grew up that icons were imbued with some special mystical power. An icon of the Virgin and Child from this period, done in the technique of encaustic, has been preserved in the Monastery of St Katharine on Mount Sinai. However, icon painting did not develop on any large scale until about the 10th century, when the Iconoclastic conflict which had rocked the Byzantine world in the 8th and 9th centuries was over, and the dogma and liturgy of the Greek Orthodox Church had begun to take on a clearly defined form. In the 12th century, the images on icons became more tranquil and refined than they had been hitherto, and this new development is exemplified by the 'Virgin or Vladimir' which became a model for Russian icons.

By the 14th century, the iconostasis had grown from its relatively modest beginnings into a massive screen covered in row upon row of icons. The theory of a transcendental connection between these images and the subjects which they represented had been expressed among others by St Basil the Great, who in the 4th century had stated that 'the object of veneration is not the picture itself but the essence which it expresses'. This idea had become established in the 7th to 8th centuries, and the icon generally came to be regarded as 'the reflection of an original image in the heavenly world'. But in addition to this theological interpretation of the nature of icons, there had developed almost unnoticed a popular tendency to venerate the picture itself and even to ascribe super-natural powers to it. As a result, legends about icons possessed of miraculous power became widespread.

Portable icons spread to many parts of Eastern Europe in the wake of the Orthodox Church, and in the 10th century they began to be produced regularly in various different places. Large numbers of icons were painted particularly in the Balkans and Russia, where the Orthodox Church had been most wholeheartedly adopted, and by the 14th century each area had its own style of painting. In the first golden age of Bulgaria in the 10th century, icons were produced chiefly in Preslav, the capital at that period. Some outstanding icons have survived in the form of terra-cotta plaques decorating the walls of churches. Subsequently, Bulgaria developed its own simple but powerfully expressive style of icon painting, while simultaneously adapting the Byzantine style to meet its own requirements. Many icons from Macedonia, which had close links with Byzantium, reflect the dignified, refined style of the Greek painters. From about the 11th century magnificent icons were produced in the area around Ohrid, and these were related to the local style of

96 *Church of the Patron Saints and Mediators on the River Nerl' near Vladimir, USSR, 1166. This small church stands in open country, reflected in the still waters of the river, and is nick-named the 'Swan of Nerl''. In all its details it has the archetypal form of church architecture in Vladimir.*

180

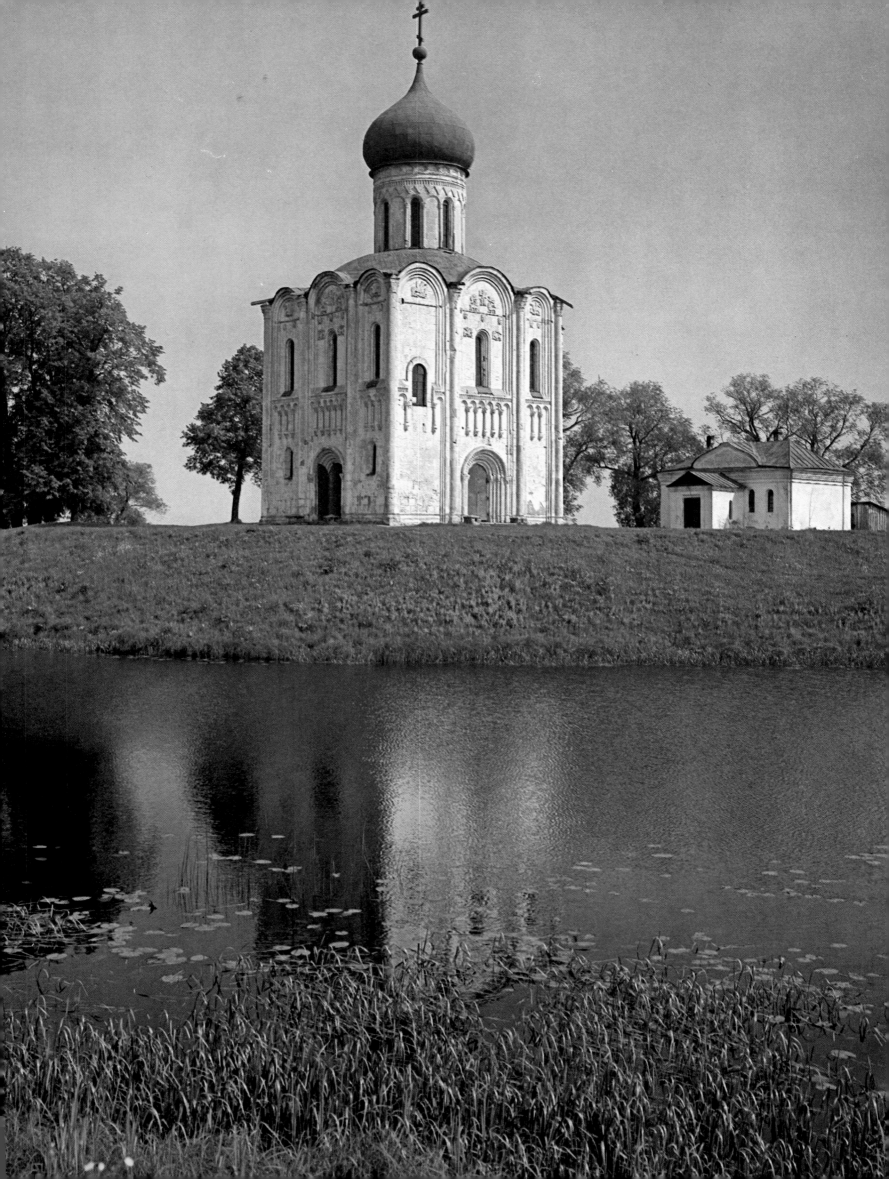

Left:
97 *The Last Judgment by Andrei Rubliev, Cathedral of the Assumption, 1408. The murals in the old church of 1161, done by Greek artists, were replaced in the reconstructed building by the work of Andrei Rubliev and one of his predecessors. Rubliev was the greatest Russian painter of his time and this is one of his best works, illustrating the individual style which he developed from the traditional manner of Byzantine painting.*

Right:
98 *Cathedral of the Archangel Michael, Moscow, 1509. The introduction of European architecture into Moscow brought about a transformation of Russian churches. This building, which is in the Kremlin, was probably built by the Italian Alevisio Novi. Despite its clearly European inspiration, the cruciform arrangement of the interior is unmistakably Byzantine, as it is in other churches of a similar nature. The illustration shows the iconostasis, with icons from the 15th century.*

painting. St Sava, the 13th century founder of the Serbian Church, spoke in favour of icon worship in his Homilies, stating that to look at an icon was 'to open the eyes of the soul to the source of the holy image painted on it'.

It was in Russia, however, that icons became most widespread and found lasting popularity. The Orthodox Church, introduced via Kiev in the 9th century, gradually spread across this vast land, and in the 16th century the autonomous Russian Orthodox Church was established. Like the Christian buildings and murals, icons were initially produced by Greeks. Many Byzantine icons were also introduced into the country, but after the centre of cultural activity had moved from Kiev to Novgorod, a new, strongly national style of icon painting began to develop in Russia. The school of Novgorod, which flourished in the 14th century, was largely inspired by Greek icon art

Page 184:
99 *The Holy Trinity, icon by Andrei Rubliev, Tretyakov Gallery, Moscow. This work is one of the most important masterpieces of Russian icon art. The symbolic trio of angels is rendered with graceful brushstrokes and elegant colour tones. Rubliev painted in the Byzantine manner, adapting the traditional style to meet his own needs and adding to it a depth of expression which was entirely his own.*

and its simple compositions were executed in light, warm areas of colour surrounded by dark outlines. Novgorod became the centre of icon painting in Russia, and the national style was transformed by the outstanding artistic personality of Theophanes the Greek, who came to Russia from the homeland of Byzantine icon painting around 1370. Under his influence, Russian icon painting acquired a livelier style of drawing and more refined colour sense. His disciple Andrei Rubliev (*circa* 1360/70–1427/30) is generally considered the greatest painter Russia has ever produced. He left only a few scattered masterpieces, but his genius shaped the future for the whole of Russian painting. After Rubliev, Russian icon painting in the 15th century was represented by Dionisii (1440–1501), whose style was characterised by its boldly constructed figures.

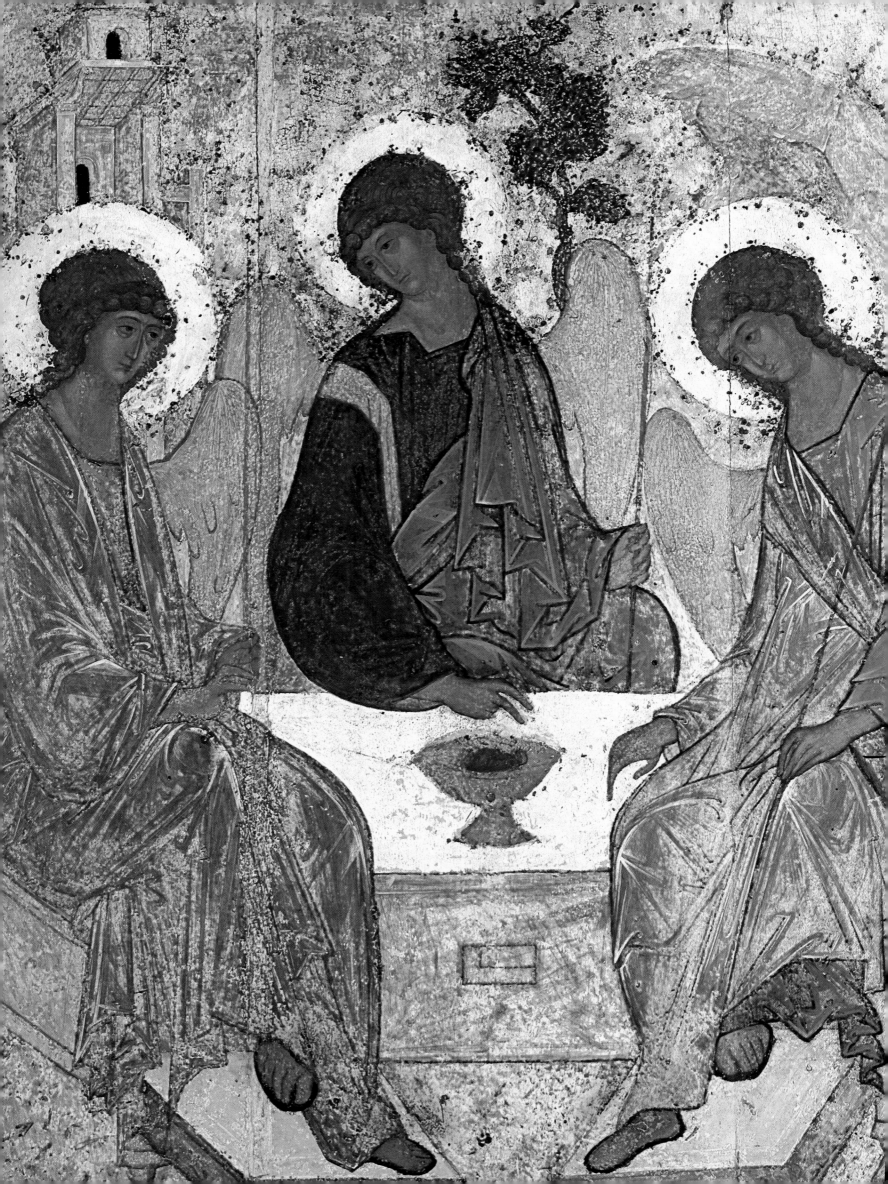